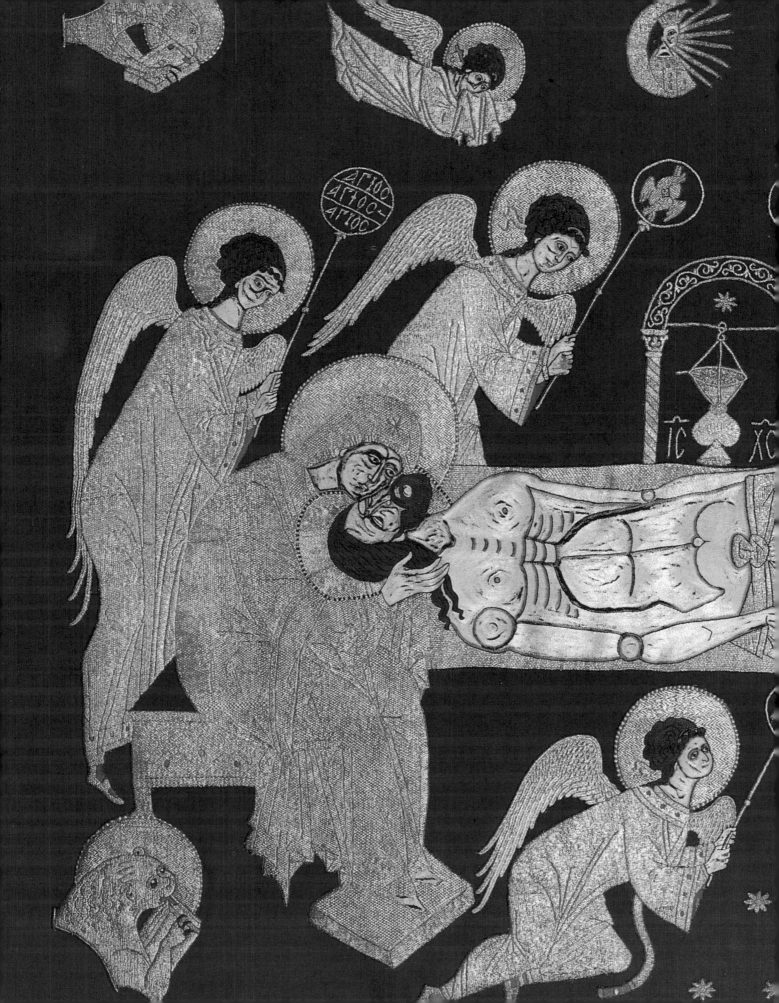

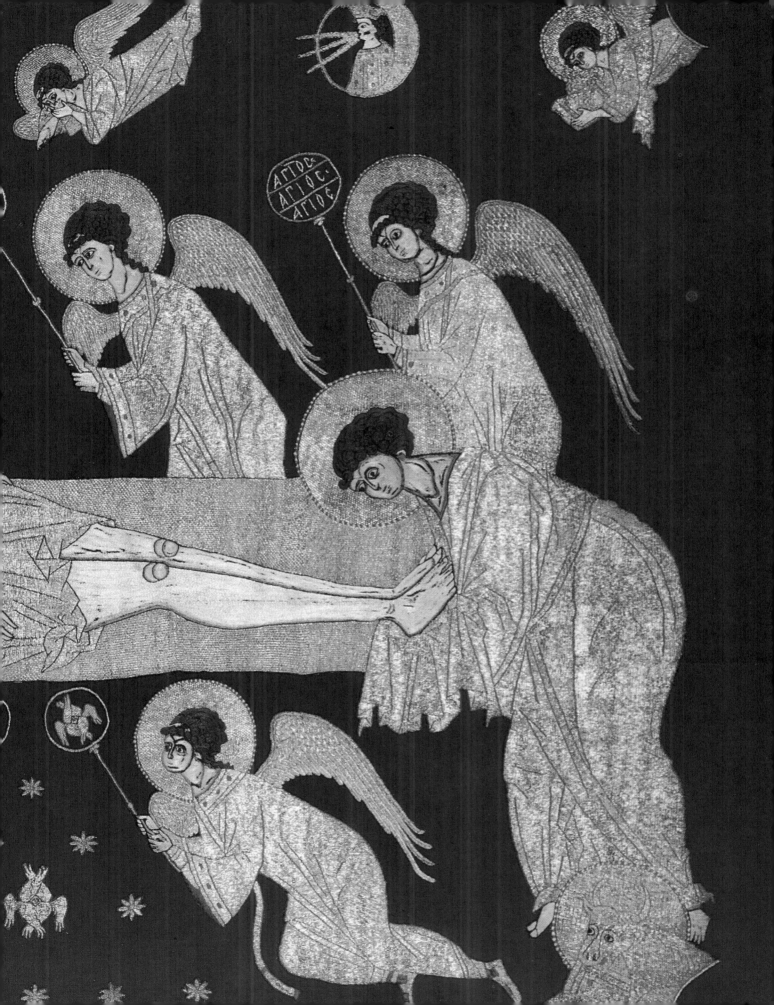

Gates of Mystery

THE ART OF HOLY RUSSIA

Edited by
RODERICK GRIERSON

THE WALTERS ART GALLERY
Baltimore, Maryland

THE ART MUSEUM, PRINCETON UNIVERSITY
Princeton, New Jersey

THE DALLAS MUSEUM OF ART
Dallas, Texas

THE MEMPHIS BROOKS MUSEUM OF ART
Memphis, Tennessee

THE ART INSTITUTE OF CHICAGO
Chicago, Illinois

THE VICTORIA AND ALBERT MUSEUM
London

INTERCULTURA

INTERCULTURA
3327 West Seventh Street
Fort Worth
Texas 76107

The catalog is made possible by a grant from the
Meadows Foundation, Inc., Texas.

The Exhibition is made possible by grants from the
National Endowment for the Humanities and the
National Endowment for the Arts,
federal agencies; and an indemnity from the
Federal Council on the Arts and Humanities.

Additional support has been provided by
the Meadows Foundation, Inc., Texas; the Trust for
Mutual Understanding, New York; the William E.
Scott Foundation, Texas; the Bass Foundation,
Texas; the Eugene McDermott Foundation, Texas;
the Katrine Menzing Deakins Charitable Trust-
NationsBank Trustee, Texas; Mrs Philip K.
Thomas, Texas; Mr. and Mrs. Claude C. Albritton,
III, Texas; The Sands Foundation, Texas;
Mr. Lawrence S. Pollock, Jr., Texas; and
Deloitte & Touche.

Designed and produced by
The Pen and Ink Book Company Ltd,
Huntingdon, Cambridgeshire, England.
Creative direction by James Bradburne

Printed in Italy by Grafiche Milani, Milan.

Photographs have been kindly provided by the State Russian
Museum, the Ministry of Culture, Avant Garde/Flammarion,
and Editions Citadelles (p. 16).

ISBN 0 9635374 0 7

ACKNOWLEDGEMENTS

Roderick Grierson

The catalog is dedicated to Fr. John Meyendorff, whose life was devoted to the Orthodox faith and the study of the Byzantine legacy in Russia. In addition to him, there are many others to whom our gratitude must be offered for their encouragement and assistance during the past four years.

In its earliest days, the project relied on the erudition of Speros Vryonis, Director of the Onassis Center of Hellenic Studies in New York, whose knowledge and enthusiasm for all aspects of Byzantine and Slavic history proved an essential foundation for our plans.

The success of our first discussions in Moscow was entirely due to the excellent advice offered by John Bowlt, Director of the Modern Russian Institute at the University of Southern California, and throughout every stage of the project he has continued to offer his extensive knowledge of Russian art history with extraordinary generosity.

During the diplomatic manoeuvres necessary to place the project on the agenda of the Ministry of Culture of the USSR, the American ambassador Jack Matlock and his wife Rebecca offered us the hospitality of the Spaso House on innumerable occasions. Since an exhibition of Orthodox art was seen in many Soviet circles as politically sensitive, the advice and the assistance of the ambassador and his staff were essential elements in the success of the project.

Similarly, without the friendship and the support of Genrikh Popov, who served the Ministry for many years as Chief of Fine Arts, the project would never have progressed beyond an initial proposal.

While I was engaged in doctoral research at Oxford, the interest shown by Sebastian Brock in all aspects of Eastern Christian culture encouraged me to venture beyond the caves of the Syrian ascetics. A special interest in icons and in Russia was kindled after Jinty Money-Coutts introduced me to Dick Temple, whose unique insight into the mysteries of the icon has always been an inspiration. I first met Yanni Petsopoulos while I was living in Istanbul, and his passionate convictions and acute observations about Byzantine and Russian art have contributed enormously throughout the following years.

The support of the National Endowment for the Arts and the National Endowment for the Humanities has been acknowledged in the conventional manner on an earlier page, but only those who have had the privilege of working with the staff of these institutions can have some idea of the extent to which their expertise has contributed to the project. Not only has the financial support of these government agencies made the project possible, the advice of Marsha Semmel and other staff members influenced the form it assumed at several critical points.

In addition to the National Endowments, we owe an enormous debt to several private foundations, especially the Meadows Foundation in Dallas, the Bass Foundation and the William E. Scott Foundation in Fort Worth, and the Trust for Mutual Understanding in New York. The many sponsors of InterCultura have shown an extraordinary commitment, and I should like to offer special thanks to Elizabeth Armstrong, whose confidence in the earliest days of the project was an essential encouragement, and Anna Belle Thomas, whose interest in the Christian East made us all believe in the value of bringing its treasures to American museums.

The devotion of the board of directors and the staff of InterCultura has given us all a privileged position in which to work, and during the past year Lori al-Aqqad, Melanie Benjamin, John Davis, Sherri MacNelly, and Marcus Sloan have been invaluable colleagues. Margaret Lorimer Booher has provided a sure administrative hand throughout all the demands of exhibitions and catalogs, and until her family took her to California, Nicole Holland offered enthusiastic advice and assistance.

In St. Petersburg, the Director of the Russian Museum, Vladimir Gusev, and the Deputy Director for Scientific Research, Evgeniia Petrova, generously provided the facilities of

one of the leading cultural institutions of Europe from the moment we first discussed the project with them. All the members of their staff, including Liudmila Likhacheva, Izilla Pleshanova, and Tatiana Vilinbakhova, and their colleagues in the Department of Old Russian Painting and the Department of Old Russian Applied Art, have labored ceaselessly to ensure the success of the exhibition. The staff in the restoration workshop, especially Rudolf Kesarev, have worked with Manuel Theodore, the consultant conservator to the project, and Dietmar Hardekopf of Hasenkamp, to ensure that fragile objects could leave the safety of the Russian Museum without undue risk.

Throughout the production of the catalog and almost all other aspects of the project, James Bradburne has performed the work of at least three people with unfailing good humour. The contributions of Gerold Vzdornov, Charles Barber, Andrew Spira, Emile Salmanov, and Carolyn Grierson have also been invaluable. Tony Leonard, Tim Peagram, and their colleagues at Pen & Ink have addressed all the challenges of design and production with skill and patience despite a difficult schedule.

The energy and devotion of Tatiana Abalova enabled countless obstacles throughout the last four years to be overcome or avoided.

Advice about many areas of Byzantine and medieval Russian culture was offered by Robin Cormack and Simon Franklin in Cambridge, and by Nicholas Gendle in Oxford. The staff of the National Art Library, the Library of the School of Slavonic and East European Studies, and the London Library have all provided invaluable assistance.

As so many visitors to Fort Worth will attest, Gordon and Beverly Smith demonstrated all the warmth for which the hospitality of Texas is famous. In London, Lennox Money and Charles and Georgina Allen displayed a boundless generosity to visitors from Turkey, while the encouraging words of Michael Onslow and Nicholas and Matti Egon revived frozen travelers from the snows of Moscow.

To three people in particular I owe a special debt:

Dee Smith, one of the founders of InterCultura, with whom the earliest dreams of the exhibition were shared;

John Stuart, Russian Consultant at Sotheby's in London, whose profound knowledge of Russian art and the Orthodox faith was offered without hesitation, and whose friendships in St. Petersburg and Moscow enabled the project to rely on the advice of the leading Russian historians;

Gary Vikan, Deputy Director of The Walters Art Gallery, whose extraordinary ability to see with the eyes of the art historian, the theologian, and the man in the street provided a sure guide to the challenges of presenting an exhibition of Eastern Christian art.

Contents

Preface

Evgeniia Petrova

The history of Russian art begins little more than a thousand years ago, when the conversion of the grand prince Vladimir brought Kievan Rus into the cultural orbit of Byzantium. A thousand years may not seem like a long time if one thinks of ancient civilizations like China or Greece, but few of us would question the intensity with which Russians have responded to spiritual and aesthetic experiences throughout the subsequent centuries.

The visual legacy of this earliest period of Russian history is usually known as Old Russian art, since there was no ancient classical culture to precede it, but it corresponds more properly to what Western art historians would term medieval. Even though Russians appropriated elements of a foreign culture in midstream, as indeed they were to do on several later occasions as well, they nevertheless soon produced work of undisputed excellence, maturity, and individuality. The art of this Old Russian period occupies a unique position in art history.

In the 19th and 20th centuries, Russia earned international acclaim with the literature of the Silver Age and the theater of Stanislavskii and Meyerhold. Diaghilev and the Ballets russes gained a passionate following abroad, and the flame of the Russian avant-garde burned brightly. Yet it is nevertheless the achievements of Russian artists of the earliest period that are most deserving of respect. It was in this period that Russia began to assume its characteristic identity, and many of the traditions that would prove so fruitful to artists of later periods were formed.

Old Russian architecture, icons, and frescoes emancipated themselves very quickly from the Byzantine models that served as their base and evolved into an independent, original, and creative system of art in their own right, incorporating and developing the spiritual and aesthetic potential of their Byzantine precursors. The speed of the assimilation and the originality of the transformation of the Byzantine legacy resulted in works of extraordinary complexity, spiritual integrity, and refinement, and is an impressive achievement which still fascinates specialists in Old Russian art. Architecture and painting based on Byzantine models were both the symbol and the reality of Russia entering the civilization of medieval Christendom, and were its first contributions to the treasure house of human cultural achievement.

The Russian contribution to human culture has often been uneven, due to the accidents of history and politics, but few would deny the significance of this contribution. Moreover, despite the difficulties Russians have faced with the collapse of the Communist system, we can be confident that they have by no means made their last contribution. The deep traditions and rich sources of Russian culture, and the ability of Russian artists to adopt and adapt new influences with extraordinary speed, serve as grounds for optimism.

Although we cannot transport a church or a monastery and display it as part of a museum installation, Western visitors to GATES OF MYSTERY will be able to see paintings, textiles, manuscripts, metalwork, wooden sculptures, and other objects created for the celebration of the Orthodox liturgy. Their appearance is the outward and visible sign of a spiritual approach to the divine mystery of the universe. For many modern visitors, living in a secular world where the experience of art is often confused with mere entertainment or visual hedonism, the idea of Russian icons functioning as windows to eternity may remain incomprehensible.

In a short preface I can only touch briefly upon some of what I consider to be the important characteristics of Old Russian culture. My colleagues will explain in detail the relationship between the aesthetic qualities of this art and its spiritual or metaphysical nature. It is in the interplay of these two elements, the aesthetic and the spiritual, that we can trace the origin and development of the Russian achievement. What follows now is a brief introduction to the State Russian Museum and its role in the collection and preservation of Old Russian art.

All the objects in GATES OF MYSTERY have been selected from the collection of the State Russian Museum in St. Petersburg. Despite the

fact that the Museum is less than 100 years old, it is recognized as the largest and most comprehensive collection of Russian icons and liturgical art. The doors of the Russian Museum opened to visitors in March 1898, as the first state museum of Russian art. Such a museum had been a dream for many generations of connoisseurs and art historians, and it was established in the imperial capital at the initiative of the emperor Alexander III. The collection was installed in one of the most beautiful palaces in the city, designed by the Italian architect Carlo Rossi.

In contrast to the Tretiakov Gallery in Moscow, which began as the private collection of Pavel Tretiakov, the Russian Museum began as a national public collection. At its beginning, the Museum included fewer than 400 objects, but it soon grew rapidly. Within ten years it possessed a remarkable collection of paintings from the 18th and early 19th centuries. Enthusiastic curators acquired paintings and graphic works by artists such as Valentin Serov, Mikhail Vrubel, and Ilia Repin directly from exhibitions and studios before they were widely recognized. After the Revolution of 1917, paintings, furniture, and works of decorative and applied art were delivered to the Museum from the palaces and private residences of St. Petersburg, and by the middle of the following decade the Museum possessed a comprehensive collection of all aspects of Russian art. The structure of the Museum and its various departments was established at this time.

When the Russian departments of the Hermitage and the Academy of Art were transferred to the Russian Museum, its collections of 18th and early 19th century art were naturally increased, but if the Museum ever gave the impression of being little more than an opulent home for relics of the imperial age, this was transformed in 1926. A collection of avant-garde painting and sculpture was brought from the Museum of Culture, which had been a storehouse for works by the artists of the early part of the 20th century before it was closed and dismantled by state decree. The sister of Pavel Filonov and the wife of Kuzma Petrov-Vodkin also presented a large number of paintings to the Museum, while a great many works by Alexander Rodchenko, Vasilii Kandinskii, and other exponents of the avant-garde entered the Museum at various times, creating one of the largest and most comprehensive collections of Russian avant-garde art in the world.

The Russian Museum continues to increase its collection through purchase and donation, and at the moment contains more than 380,000 items, including paintings, drawings, engravings, sculpture, and examples of decorative, applied, and folk arts from the middle of the 10th century to the end of the 20th century.

As Liudmila Likhacheva confirms in her account of the Department of Old Russian Art, the collection of early icons, textiles, and liturgical art is one of the treasures of the Russian Museum. It is often assumed that the collections of Old Russian art in the state museums are simply the result of Soviet policy after the Revolution of 1917, but this is not true. Of course, the closure and destruction of so many churches and monasteries as part of the Soviet campaign against religion did result in the deposit of icons in the state museums, and others were rescued by expeditions organized by museum curators to save what they could from ruined sites. But in fact, private collectors had already begun to assemble collections during the 19th century, purchasing objects that had become too fragile for liturgical use and for which the church could not provide adequate conservation. Most medieval icons were covered with so many layers of paint and grime that they had become quite unrecognizable, and it is no wonder that the Russian public was astonished when icons and frescoes painted by Andrei Rublev were uncovered by restorers during the first decade of this century. These discoveries provoked a wave of national enthusiasm for Old Russian art and encouraged a return to Russian sources by artists as diverse as Mikhail Nesterov and Viktor Vasnetsov on the one hand, and Nataliia Goncharova and Kazimir Malevich on the other.

GATES OF MYSTERY will enable Western visitors to experience something more than the pleasure of admiring visual beauty, however valuable that might be. By contemplating the legacy of the medieval world, those of us who live in the 20th century can recover at least a part of the perfect harmony to which Russian artists and patrons aspired. The spirit of past centuries can live again and replace our mundane distractions with a vision of life which possessed the strength and ability to arrange all human experiences in their proper order: the permanent and the transitory, the earthly and the divine. It is to make such an experience possible that the Russian Museum has worked with InterCultura to present the most important selection of Old Russian art to travel to the West for more than 60 years. Together with the American and British colleagues who have participated in the project, we offer it to the public.

INTRODUCTION

Roderick Grierson

'The distinction of North and South is real and intelligible . . . But the difference between East and West is arbitrary and shifts round the globe.'

Edward Gibbon, *The History of the Decline and Fall of the Roman Empire*[1]

Two centuries after Gibbon composed his account of the collapse of the Roman empire, and 15 centuries after the sack of Rome itself, we still move uneasily between two visions of East and West. Sometimes the Orient appears to begin at the ancient frontier of the Roman empire and the kingdoms which lay beyond it to the east, and at other times within Europe, on the border between the western and eastern empires established by Diocletian in the 4th century. While Rome itself fell to barbarian armies in 410, the eastern capital Byzantium survived for another thousand years, bequeathing a structure of church and state to the lands within its orbit which continued to order life throughout the centuries and into our own age. In Eastern Europe, the 'Byzantine Commonwealth' as Dimitri Obolensky has taught us to call it,[2] the features which have marked the cultural history of the West were not to be seen. There was no Renaissance, and there was no Reformation. In Russia, which entered the Byzantine world in 988 with the conversion of Vladimir of Kiev, the Middle Ages continued until the reforms of Peter the Great at the beginning of the 18th century.

The concept of art and artists with which most of us are familiar in the West was unknown in Byzantium, and it remained unknown or at least foreign in Russia until that time. The art of medieval Russia was a ritual art, created for public or private devotion, and in order to see it as anything more than an exotic curiosity, we need to acquire at least some familiarity with the world in which the rituals were performed.

The *Primary Chronicle* records how Russia was converted to Orthodoxy when the ambassadors sent by the prince of Kiev to Constantinople described the splendors of the liturgy they had witnessed in Haghia Sophia, the Church of the Divine Wisdom. 'We knew not whether we were in heaven or on earth, for surely there is no such splendour or beauty anywhere upon earth. We cannot describe it to you. We only know that God dwells there among men. For we cannot forget that beauty.'[3]

Russia had remained isolated from the classical civilization of late antiquity, especially from the literary culture preserved in the Greek and Latin languages, and it was the visual legacy of Byzantium which therefore had the greatest impact. Its transformation in Russian hands has left a spectacle of such diversity and intensity that it is often seen as the crowning achievement of the Byzantine tradition. The purpose of the exhibition and its catalog is to give the general public in the United States and Great Britain an opportunity to see some of the finest examples of medieval Russian art in each of the media employed by medieval artists, including panel paintings, textiles, manuscripts, metalwork, and woodwork. The objects have all be selected from the oldest and most comprehensive collection of medieval Russian art, the State Russian Museum in St. Petersburg, and they are accompanied by the results of research undertaken by leading scholars in each country.

An exhibition of this significance has not been seen in the West for 60 years, and for many Western visitors it will be a first encounter with the Christian East. The way in which Western savants have imposed their own fantasies on the realities of Eastern life has recently become a subject of scholarly interest and political urgency. When Edward Said produced an eloquent denunciation of European illusions about the Islamic world,[4] he began a debate which has by no means run its course, and in her inaugural lecture at King's College in London, Averil Cameron questioned the

extent to which Western attitudes to the Byzantine world have been conditioned by a similar set of prejudices.[5]

While Said dwelt primarily on Western contempt for Islam, he also raised the more interesting question of a Western longing for the mysterious, a frustration with life in a society whose sense of mystery had been reduced by the harsh practicalities of the Industrial Revolution. The Byzantine world too has had its enthusiasts in the West, as well as its detractors. Sixty years ago, the English art historian Robert Byron insisted that compared to Haghia Sophia, 'a church consecrated to God and to reality,' St. Peter's in Rome was nothing more than 'a salon for His agents, consecrated to illusion.'[6] However justified this opinion might have seemed in Orthodox circles, Byron provoked the lasting enmity of the Catholic convert Evelyn Waugh, who denounced Haghia Sophia as 'a great toad, impressive only because of its size, 'Byzantine muck' which no one would in Europe would have admired if only Byron had kept quiet.[7]

Nevertheless, to regard the East as a fountain of holiness or depravity, and the West by definition as the opposite, would seem to unlikely to lead to a clear understanding of either. For over a hundred years the discussion of the relative merits of the Byzantine world and the West has been greatly influenced by the defensive positions taken in Eastern Europe and Russia after Hegelian philosophers in Germany claimed that the Slavic world was a cultural backwater which had made no contribution to human civilization. Slavophile intellectuals like Ivan Kireevskii, Alexei Khomiakov, and Ivan Aksakov replied by claiming that Russia represented a quite different type of social order. The Byzantine legacy had saved Russia from the alienation inflicted by the legalism and rationalistic hubris of the West, and Russians could therefore guide the rest of humanity along the road to future happiness.

The impact of their claims can be seen in Russian novelists like Dostoevskii who are widely read in Western languages. They also continue to provide the basis for the accounts of Orthodox culture in general and the visual arts in particular given by many introductions to the subject, where the Orthodox world is distinguished from the West by possessing, or at least having possessed, the following characteristics: harmonious relations between the church and a sacred emperor, in contrast to the arrogance and presumption of the Roman pope; a ritual worship dedicated to uniting heaven and earth beyond the limits of space or time, and therefore distinct from the merely intellectual or emotional appeal of Western preaching; a holistic spirituality which avoids the morbid obsessions of the West, and offers a way of restoring body and soul to their original glory; and a sacred art providing access to a transcendent reality, unlike the naturalistic mimicry of Western painting and sculpture.

These claims are all aspects of a single issue which Peter Brown has termed 'the locus of the holy,'[8] the point at which heaven and earth are believed to meet, and the following essays will seek to describe the ways in which Orthodox attitudes to this question are essential to an understanding of the Byzantine legacy in Russian art. Despite official censorship in questions of religious iconography during the Soviet period, Russian art historians have continued to display an interest in the spiritual qualities of medieval art, and even those who are not themselves Orthodox often reveal a greater degree of personal commitment to the subject than we in the West display towards our own culture.

Western attitudes are changing however, and it may be that a 'post-modern' concern with issues beyond formal description may lead to greater concern with the hermeneutic circle within which many Russians still write. Not only are most Western scholars outside this circle, they have also had almost no opportunity to become familiar with Russian objects, since very few examples are preserved in the West. At the same time, however, Russians have not had as much contact with the methodological experiments of Western medieval and Byzantine scholars as they would have liked.

The conference at Princeton University will provide an opportunity to explore many of these questions, and should help to establish lines of collaboration for the future. For the moment, the catalog is fortunate to include not only object descriptions and articles by the curators of the Russian Museum, but also introductory essays by leading historians in Moscow, such as Sergei Averintsev, Olga Popova, and Engelina Smirnova. It also includes essays by Western specialists like Robin Cormack and Simon Franklin, and one of the last writings by a unique authority who was Russian, European, and American, Fr. John Meyendorff, to whom the book is dedicated.

The Savior from the Zvenigorod Deesis, attributed to Andrei Rublev, Tretiakov Gallery.

Visions of the Invisible

THE DUAL NATURE OF THE ICON

Sergei Averintsev

The word icon is derived from the Greek word for image (*eikon*). The word is not only a name given to a type of Orthodox sacred art, it is also a theological term which is central to the Orthodox understanding of the world. Visible things are revealed images (*eikones*) of invisible things, declares an anonymous author of the 5th century, whose writings have survived under the name of Dionysios the Areopagite. What this means is that the material world is a single icon, and at the same time the sum total of icons.

Yet, this idea of the icon is not confined to the created world. In his Epistle to the Colossians (1:15), St. Paul asserts that Christ Himself is the image (*eikon*) of the invisible God, and it is from this claim that the icon derives its significance for our understanding of the Incarnation of Christ as the central event in the history of Creation. Through this event, He who is entirely beyond the sensual world has opened Himself to our senses. He has become visible to human eyes and tangible to human hands because the Life-giving Word is made flesh.

This teaching is precisely expounded in a Byzantine hymn composed in the 9th century, once the Triumph of Orthodoxy had restored the veneration of icons after the Iconoclastic Controversy: 'The uncircumscribed Word became circumscribed when it took flesh from you, O Mother of God, thereby restoring the sullied Image to its ancient glory and filling it with divine beauty. This is our Salvation. We confess it in deed and word and we depict it in holy icons.'[1]

The human image is therefore permeated with a divine beauty that is not of this world. Human flesh is transfigured. It is even 'deified,' according to the Orthodox mystics who observed the consequences of the Incarnation and the activity of the Divine Energy in the lives of the saints. This is the real basis of iconic representation. The icon does not depict the Godhead in the mythological or allegorical manner of pagan antiquity, but displays a realism based on the Gospel of John (1:18): 'No one has seen God face to face; the only begotten Son who is in the bosom of the Father, He has made Him known.' It is significant that canonical iconography always avoided the representation of God the Father as a venerable old man with white hair and a beard. Such imagery only appeared in the period of decline, and even then it provoked strong objections, including the protest made by the scribe Viskovatyi at the Moscow Church Council of 1553-54.

The subject matter of an icon is not the natural flesh and blood which St. Paul maintained was incapable of inheriting the Kingdom of God (I Corinthians 15:50). The icon has nothing of the courtly charm of the Renaissance Madonna, the muscular corpulence of baroque saints, or the bourgeois coziness of scenes by the Dutch Old Masters. It lacks the sensuality that permeates the treatment of sacred themes in Western art as a consequence of the triumph of the naturalistic approach. The icon lies on the border between the material and the immaterial, between the visible and the invisible. If one may so express it, the icon is focused on the point where the boundary between these two worlds is transcended through the Incarnation. In the words of St. Germanos, Patriarch of Constantinople (715-30), 'We represent the image of the Lord's holy Flesh in icons.'[2]

In 787 the Seventh Ecumenical Council proclaimed: 'Although the Catholic Church depicts Christ in human form, it does not separate His flesh from the Divine Being which is united with it; on the contrary, the flesh is deified, thus becoming one with the Divine Nature according to the teaching of the great

Gregory the Theologian and in conformity with revealed Truth.'[3]

The possibility of depicting the Divine in an icon is therefore derived from the reality of the Incarnation. Even when icons depict the Mother of God or the saints, rather than Christ himself, the model depends upon and is derived from the same principle. What is depicted is not a human being in the natural, physical sense, but a vision of a human nature so transparent that the light of the Divine Nature shines through it.

Leonid Uspenskii, a distinguished painter and interpreter of icons in our own century, explored this theme in his book *Theology of the Icon*:[4] 'Just as the fullness of the Godhead lives physically in the God-Man Jesus Christ (Colossians 2:9), the Church, as the body of Christ, is an organism which is both divine and human. It combines two realities: the historical earthly reality on the one hand, and the reality of the grace of the Holy Spirit on the other. Sacred art is dependent upon being a visible and a visual witness of these two realities, and this double realism is the reason why sacred art is distinct from other forms of art, just as sacred literature is distinct from secular literature.'

Let us return to the hymn mentioned above. Its words evoke both polarities of the icon: 'the uncircumscribed Word became circumscribed, when it took flesh from you.' That which is beyond representation is infinite, uncircumscribed, and devoid of image. It dwells outside time. This is the absolute light of Divine Being, which preceded the creation of any finite form. As the First Epistle of John tells us (1:15): 'God is light and in Him there is no darkness.' This affinity of the Divine energies and light, beyond the sensual world yet still perceived in concrete terms, became recognized as Orthodox doctrine through the mystical experiences of the hesychasts, foremost amongst whom is the 14th century theologian St. Gregory Palamas. In art, the symbol of light is gold, and the golden background of an icon signifies the unapproachable light that existed before Creation, and in which St. Paul tells us that God dwells (I Timothy 6:16). While technical reasons may require an artist to apply gold to an icon before paint, at the same time there is a symbolic and metaphysical meaning to this order. When He created the world, God's first words were 'Let there be light.' On an icon, precedence is given to an element which is completely non-figurative as a symbol of the uncircumscribed.

The opposite polarity of the icon reflects the Absolute through the Incarnation, the result of God becoming fully human. Form appears from the formless, and the Face appears from the abyss of light. While the process of painting begins with a golden background, the Face is the focus of the whole process, and calls to mind the creation of humanity as the crowning achievement of the entire six days of Creation.

The faces of the saints depicted in the icon are not left to the artist's imagination, as became customary in the West. They are fixed by Orthodox tradition. Although icon painters did not need to rely on attributes of the sort employed by Western painters to identify the saints, it was always considered necessary to adhere to the precise forms laid down in pattern books or manuals, which indicated, for example, even the exact shape of the beards of quite minor saints. While this may seem surprising, we ought not to forget that the underlying reason for it is a determination to preserve some degree of historical realism. One of the greatest theologians to defend the icon, St. Theodore of Stoudios (759-826), declares that reverence is due to an icon not because it departs from likeness, but insofar as it represents a likeness. The demands of historical realism are therefore balanced by the demands of spiritual realism. The proportions of the face represent qualities of sanctity that transcend the character of the individual: the eyes are large, the forehead broad, the nose finely elongated, and the lips devoid of sensuality.

The entire icon is marked by the same double realism as the painting of the face. Its spiritual nature is expressed through stylization, and although everything is drawn with precise lines, it is at the same time transparent. There are faceted spurs of small hills, between which a tough shrubbery is growing, but instead of the sky there is a golden background. If we consider that Russian icons retained this visionary landscape until the 16th century, despite being painted among the forests and snows of the north, we can see the extent to which the scheme is derived from an historical realism. The cliffs, the tough shrubbery, and the golden sky all conform to the pilgrims' accounts of the Holy Land.

To quote from Uspenskii once again: 'Holiness sanctifies everything with which it comes into contact. This is the beginning of the coming Transfiguration of the world . . . This is why everything surrounding a saint on an icon is transformed . . . People, landscape, animals, architecture have all lost their usual chaotic appearance and have become orderly instead. The saint, and everything around him, submits to a rhythmic order, reflecting the presence of God, moving closer to Him and drawing us closer to Him as well. The entire created universe, including plants and animals, is not shown in a natural fallen state, subject to decay, but reveals the process of the sanctification of humanity and of the environment in which we live.'[5]

The architecture in the background of an icon is stylized in order to represent the house that was built by Divine Wisdom, according to the Proverbs of Solomon (9:1), rather than any specific building. There is never an enclosed architectural space on traditional icons; the event depicted has a meaning that cannot be confined by space or time. It occurs not in a single location and a single moment, but always and everywhere. This is why the rules of naturalistic perspective, which serve to accentuate the viewer's subjective vision, are incompatible with the cosmology of the icon. What is sometimes termed 'reverse' perspective serves to shift the attention so as to focus on the sacred face or theme. It is this denial of naturalistic perspective that made the icon so alien and so incomprehensible to Western taste during the 18th and 19th centuries. Only during the 20th century, when artists revised the schemes of perspective inherited from the Italian Renaissance, has it become possible to appreciate the creative force and ordered sequence of iconic perspective.

The defence of iconic perspective by the distinguished theologian, mathematician, and art theorist Pavel Florenskii is significant: 'One might say that it is impossible to see three walls of a house at once. But if this is correct, then one should be logical and take the question further. It is not only impossible to see three walls at the same time, it is impossible to see two walls, or even one wall. Our eyes can only see a small section of a wall at any single moment and even this is not registered immediately. Our image of a house is real enough, but it is not constructed all at once, and it consists of four walls rather than just three. This is how we conceive and imagine the building. Our imagination works through a continuous stream of changing, pulsating, and contradictory impressions. Our perception never rests on a dead stereotyped scheme.'[6]

After Post-Impressionism, Cubism, and more recent developments in painting during the 20th century, this observation requires no further explanation. But the icon is different in that it possesses a metaphysical basis in a tradition preserved through many centuries. Icon painting flourished in Byzantium at a time when doctrinal issues were in the process of being articulated, and it absorbed their ordered structure. In Russia, where intellectual controversy and dogmatic disputes were not as frequent, the icon assumed an even more central role, and can be described as a kind of philosophy in color. The iconostasis not only consists of a series of panels arranged in a specific order, it is also a structured diagram that serves to articulate a cosmology and a sacred history.

As the contrast between icons and Western painting is obvious, it is no surprise that when Western minds try to understand the icon, they perceive it as Oriental in character. Instead of spontaneous movement, there is tranquility, meditation, symmetry, and hieratic frontality. Large expressive eyes hold the onlooker in their power. The art of the icon is intended to encourage prayer and meditation, and therefore reminds the Western mind of the sacred geometry of Hindu or Buddhist imagery.

This initial impression is quite understandable. To Western eyes the contrast with the conventions of European painting and its three-dimensional perspective is immediately apparent. However, the icon actually holds Eastern features in balance with more recognizably Western qualities inherited from Greco-Roman antiquity. In this respect as well, the icon has a dual nature.

While the icon avoids excessive sensual illusionism, it never pursues the austere two-dimensionality of Islamic pattern. The use of light and shade to give shape to the human figure is never abandoned and although the third dimension is modified, it is never absent. Despite the new spiritual dispensation of the Christian faith, the figures retain an obvious connection with the portraits of late antiquity that aspired to reproduce the individual traits

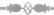

of the personality depicted. This relationship is not just an empirical fact; it reflects a more profound reality as well. Christian mysticism, as distinct from Oriental mysticism, is essentially focused on the person. In the icon, tranquility prevails over movement, in accordance with the priority given to it by medieval philosophers and theologians, but this tranquility is not absolute in the manner of Tibetan sacred art. The God of Christianity is, in the language of the Bible, a Living God; Eternity is not Nirvana, but Eternal Life. For this reason we can sense in the icon a quiet but distinct movement of the eyes, we can feel a breathing of the image. The sacred symmetry is supplemented by a degree of asymmetry, in the tilt of an eyebrow, for example, in the rhythm of Christ's hair, or in the arrangement of His garments. A strictly ordained ceremonial mystery is supplemented by freedom and humanity, by the kindness of St. Nicholas, or the maternal tenderness of the Mother of God.

This is the paradox of the icon. On a theological level its subject matter is located at the border of the visible and the invisible, of the material and the spiritual, of nature and grace. In the story of the history of world culture, the icon exists at the border of East and West, of image and sign, of portrait and sacred geometry. The icon represents the materialization and the humanization of ritual, and the transfiguration of the portrait, all at the same time.

The halo drawn around the head of the saint represents the element of light within the precise limits of a circle. When we see this, we may recall the Platonic thesis of a God continuously engaged in geometry. At the same time, in the center of this circle of light, we see a human face that bears the features of an individual person, and yet conforms to a heavenly pattern. The heritage of Greco-Roman portraiture has been transformed and transfigured by the contemplative nature of the icon, but it has not been lost. The face is at the center of the halo, and the fulfillment of Eternity is Eternal Life.

The Death of Eternity

Roderick Grierson

When the armies of Alaric the Goth entered Rome late in the summer of 410, it seemed as if the unimaginable had actually occurred. The greatest city of the ancient world, the imperial capital whose church had been founded by the Apostles Peter and Paul, was pillaged by the barbarians.

Across the Mediterranean, a Christian bishop named Augustine began to address the confusion and despair of his people in the pages of a massive treatise entitled *The City of God*. The catastrophe seemed to have destroyed any belief in the continuity of the Roman empire and the kingdom of heaven, and Augustine, the greatest theologian in the Latin West, set out to explain how it could have happened and what it might mean.

It is perhaps not as surprising that the shock had occurred as that the identification had ever been made. The Christian faith emerged in the midst of the apocalyptic speculations of Palestine, where ancient Semitic prophecies had collided and merged with the international Hellenism carried east and south by the armies of Alexander the Great three centuries before the birth of Christ. While Christ himself may have been prepared to render unto Caesar the things that were Caesar's, he was equally certain that his disciples should lay up their treasure in heaven rather than on earth, and by the time St. John the Divine received his Revelation on the island of Patmos, the emperor of Rome was being denounced as the worst of monsters. Not surprisingly, Christians were subject to repeated persecution by the Roman state for their refusal to honour the divine status of the emperor by offering prayers and incense to his image, and occasionally the victims horrified their oppressors with their enthusiasm for martyrdom. They were convinced that the end of time was already upon them, the moment when the evil powers of the world would be swept away, and those who sought to save themselves would lose themselves instead.

The Thirteenth Apostle

Yet all this was to change. In his biography of Constantine the Great, Eusebios of Caesarea recounts that as the emperor prepared for the Battle of the Milvian Bridge in 312, a cross appeared in the sky. The vision, or the victory that followed it, sealed the emperor's conversion, and what had once been a criminal superstition became the religion of the *pontifex maximus*, the high priest of the pagan cult. A complete reappraisal of Christian attitudes to the empire and the emperor was obviously required, and Eusebios provided it by claiming that Constantine was the heir of Abraham as well as Augustus, the fulfillment of the promise of God to the patriarch that his children would be as numberless as the sands of the sea. The two worlds of classical and Semitic tradition were united in him, and the achievements of the pagan empire had been baptized into a new life.

As a Christian, Constantine found the pagan temples and sacrifices that filled his capital abhorrent, and in 324 he founded a new Rome on the Bosphorus, at a cite called Byzantium. Nevertheless, it was not until almost 50 years after his death that his successor Theodosios established Christianity as the religion of the state, and almost two centuries later that Justinian promulgated the symphony of secular and sacred power which characterized the Byzantine theocracy, the emperor and the patriarch possessing a duality of authority. ' I recognize two authorities, priesthood and empire,' wrote the emperor John I Tzimiskes during the 10th century, 'the Creator of the World entrusted the care of souls to the first and the control of men's bodies to the second.'[1]

The emperor was held to be the representative of God on earth, the 13th apostle, and to

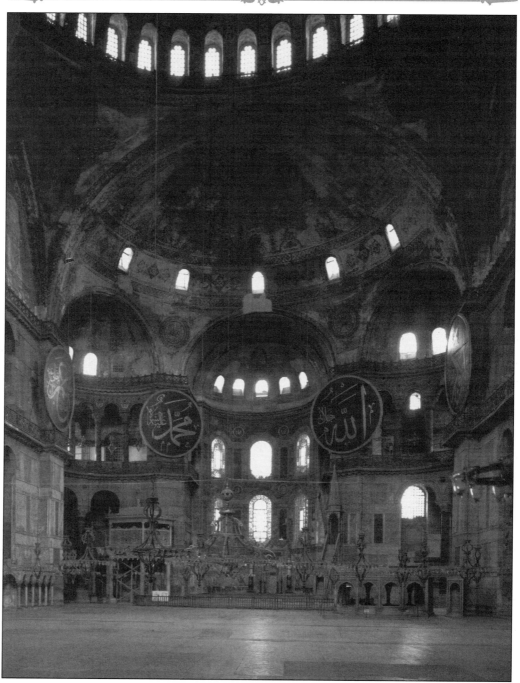

Haghia Sophia in Constantinople. The church was used as a mosque after the Ottoman victory of 1453, and the calligraphic medallions display the sacred names of Islam.

have dominion over the entire created universe. The other kings of the world were all subordinate to him as sons to a father, and the life of his court came to be conducted with an elaborate ceremony, intended to reflect the harmony of the universe. 'By such means,' the emperor Constantine VII wrote in his treatise *De ceremoniis*, based on court manuals from the time of Justinian, 'we figure forth the harmonious movement of God the creator around this cosmos.'[2]

During his reign in the 6th century, Justinian had embarked on a building program that transformed the centre of Constantine's capital, great churches like the Cathedral of the Divine Wisdom creating a 'spiritual theater' in which Christian ceremony became the focus of the empire. The result was an image of the kingdom of heaven so convincing that those who set themselves up as rivals to Byzantine power seemed incapable of imagining its destruction, but set their hearts on seizing the city for themselves, or declaring their own capitals to be the 'Second Rome' in its place.

As a more recent foundation, Constantinople had been without the apostolic authority enjoyed by the ancient cities of the empire, but the standing of its church was elevated by the presence of the emperor. The authority of the universal church resided in the five patriarchs of Rome, Jerusalem, Alexandria, Antioch, and Constantinople, who exercised their authority as colleagues under the guidance of the Holy Spirit, with no single patriarch dominating his fellows.

Only Rome, the eldest of the patriarchates, lay in the West, and with the collapse of the civil authority in the barbarian invasions, the church of the old imperial capital was the remaining link with the imperial past. In the hands of ambitious men like the 6th century pope Gregory the Great, the claims of the papacy began to be asserted in ways which were seen in the East as a violation of the proper relationship between the several patriarchs, as well as of the relationship between the spiritual and the temporal orders.

In the East this was felt to be a denial of the proper role of the Holy Spirit, under whose guidance the councils of the church were believed to meet, and it was compounded by the addition of the Latin phrase *filioque* to the Nicene Creed. This indicated that the Holy Spirit proceeds 'from the Father *and from the Son,*' and as a doctrinal innovation, it was believed to be unacceptable on two counts: it was a distortion of the Holy Trinity, especially the role of the Holy Spirit, and it had been introduced in an arrogant and illegal manner. The patriarchs of the East had not been consulted.

The status of the papacy and the *filioque* clause were to remain the principal elements in the dispute between East and West. Although the formal separation is often thought to date from 1054, when the cardinal Humbert and two other papal legates placed a bull of excommunication on the altar of Haghia Sophia, other disputes had arisen and been resolved in earlier centuries, and even as late as 1089 the patriarch of Constantinople informed the papal legate that he saw no evidence for a formal schism. The final blow would seem to have been the sack of Byzantium in 1204 by the armies of the Fourth Crusade and their Venetian allies. From that time, Byzantine sources display a marked hostility to the West, and even when the Ottoman armies were camped before the walls of Constantinople, the grand duke Loukas Notaras is said to have spurned the conditions of military aid from the West with words: 'Better the Sultan's turban in our midst than the Latin mitre.'[3]

While arguments ranged over a number of details, the main problem was really that both East and West had evolved into completely new societies, despite the apparent continuity of institutions in the East and the frequent attempts by the emperors at *renovatio*, a return to the glories of past centuries.

In the West, the church was not only the guardian of learning, it also assumed an increasing role in legal affairs, and by the 12th century the papal court had become a vast forum of litigation. Nevertheless, the secular arena had not completely disappeared, and barbarian kings soon aspired to the ancient glory of Rome. When Charlemagne was crowned as emperor in the West in 800, he set out to establish his own capital at Aachen as a 'Second Rome.' From the Byzantine perspective, however, such a development could only be an act of usurpation, even if the emperor was to grant Charlemagne the title of *Basileus* in 812. The sacred function of the monarchy was not itself the point of contention between East and West. The problem was one of legitimacy, including the preservation of what was

thought to be an appropriate balance between church and state.

Yet even in East the ancient system could not survive unaltered. The virtual disappearance of the antique life of the city during the 7th century led to the rise of a feudal aristocracy, and the continuing victories of Muslim armies to the south and east reduced the power of the emperor and contributed to a 'clericalization' of Byzantine life and culture.

Despite the claim of the patriarch Anthony in 1397 that 'it is not possible to have a church without an empire,'[4] this is eventually what occurred with the Fall of Constantinople in 1453. Orthodox princes did, of course, continue to rule in Russia, but their position was very different from the Byzantine emperor. The system of appanage by which the princes divided land between their sons had produced a number of small principalities, and when the princes of Moscow were able to reverse this process through a subtle combination of collaboration and resistance during the Mongol occupation, their power in the unified Russian state they created was to become so absolute that any possibility of a Byzantine duality was swept away.

In any case, there is no evidence that a *translatio imperii* between Byzantium and Russia ever occurred, despite claims occasionally made for the significance of the marriage between Ivan III and the Byzantine princess Zoe Palaiologina in 1472, or the pronouncement by Philotheos of Pskov that Moscow had become the 'Third Rome.' Ivan IV in fact specifically rejected the position of ecumenical emperor in 1582, when he announced to a papal envoy: 'we do not want the realm of the whole universe.'[5] The heir of Byzantium in Russia was really the church and not the state, and during the 14th century when Byzantine monasticism exerted an enormous influence in Russia, the monks had begun to speak of the international authority of the patriarch of Constantinople in terms reminiscent of the claims of the papacy.

The Divine Image

When the empire had become Christian, a great deal of the imperial cult had survived, especially the use of images. By the 4th century, most of the Christians of the empire were of pagan rather than Jewish ancestry, and the Semitic suspicion of pictorial representation reflected in the fourth of the Ten Commandments had been tempered by the legacy of classical art. The heroes of the Christian drama of salvation began to be depicted as the heroes of classical antiquity, Christ in a bucolic setting as the Good Shepherd, for example. In part, this was a useful way of reducing the risk of discovery during periods of persecution, since the image could be claimed as pagan rather than Christian, but it was also a reflection of the visual vocabulary on which patrons and artists could rely. Such images tended at first to be decorative or didactic, and the imperial cult played a major role in introducing an element of veneration. As the Syrian philosopher Severianos of Gabala explained, 'The image of the emperor replaces him when he is absent . . . and the people revere it, honouring not the image but the person of the emperor.'[6]

In the Christian period this practice continued. Imperial portraits were carried in procession, and candles were lit before them. They were displayed in law courts and public places as substitutes for the emperor himself, and when a new emperor ascended to the throne, his image was sent throughout the empire so that his subjects could swear allegiance to it.

On a more humble level, popular devotions before the images of pagan divinities were transferred to images of Christ and his Mother. Supernatural powers were more easily ascribed to these Christian images since the most famous of them were believed to be of supernatural origin and 'not made by hands.' As early as 586, such images of Christ were carried in battle, and 40 years later they were displayed on the walls of Constantinople as a defense against the siege of the Avars and the Persians.

While the apparent success of such icons in repelling invaders was a stimulus to greater devotion, it also meant that the cult would be vulnerable if the imperial armies were defeated. In the early 8th century, precisely such a crisis began to unfold. Shortly after the death of the Prophet Muhammad in 632, the armies of Islam began a rapid series of conquests. Large tracts of the Byzantine empire passed under the domination of a new religion, or rather, of what purported to be a very old religion, since Islam was proclaimed as a return to the pure faith of Abraham which both Jews and Christians had abandoned. The threat to Christian belief in the power of the holy

images to guarantee success in battle was intensified when the caliph Yazid II (720-24) decreed that images in Christian churches should be destroyed. The armies of Islam had begun to wage a war on idolatry.

The existence of the Fourth Commandment meant that the veneration of images was always open to criticism, and since the success of the Muslim generals seemed to be proof that God had rejected the Christian empire, a crisis of belief ensued. In 726 the emperor Leo III is said to have ordered the removal of the famous icon of Christ above the Chalke Gate in Constantinople. Mosaic icons were cut from the walls in Haghia Sophia, and the patriarch Germanos was deposed for resisting the iconoclasts. After Constantine V imposed iconoclasm as the official policy in 754, it remained in force until the Council of Nicaea condemned it as a heresy in 787; it was then imposed again in 814 by the emperor Leo V, and condemned again with the Triumph of Orthodoxy in 843.

These events have perplexed a number of modern historians, who have found it difficult to believe that arguments about painting could have disrupted an empire for more than a century. But given the Islamic agenda, and its apparent success, there seems no reason not to accept Byzantine accounts of the crisis as an accurate reflection of the anxieties of the time. The survival of the empire had been seen as guaranteed by images, the patriarch Sergios crying out from the walls of Constantinople in 626, 'The fighting is wholly against these icons, you foreign and devilish troops.'[7] When those guarantees seemed to have been proved false, an entire society was thrown into confusion.

The fact that iconoclasm was imposed by imperial decree suggests that the debate was about who controlled access to the supernatural. The emperors themselves may have brought the cult of icons into imperial ceremonial during the 6th century, but within a short time the cult could have been a threat to their status. While it was usually the local bishop who raised the icons when hostile armies marched into view, the defence of the empire was really the responsibility of the emperor. Especially since icons could be produced relatively easily and could be displayed in a thousand places at the same time, while the person of the emperor was subject to the usual human limitations, it is not surprising if an emperor should have attempted to assert his prerogatives against the images.

In order to defend the veneration of icons, theologians like John of Damascus and Theodore of Stoudios emphasized that the veneration offered to the images was in fact directed towards the person depicted rather than the object itself. They also appealed to the doctrine of the Incarnation, maintaining that since God had assumed material form when Christ was born, he could be depicted in material form. Indeed, such images continued the work of the Incarnation, and failure to produce them might actually undermine the Incarnation.

Behind these claims lay a hierarchical view of the universe propounded by the so-called Pseudo-Dionysios, a mysterious author of the 6th century whose works had achieved wide circulation under the name of an Athenian converted by the speech of St. Paul on the Areopagos. The Dionysian texts present a Christian version of Neoplatonic speculation that the physical and spiritual worlds are parts of a general hierarchical order, in which the realm of the senses is a reflection of the realm of the spirit. The contemplation of visible images therefore allows the spirit to ascend towards the divine, and by employing symbols in the material world it can aspire to the heavenly hierarchy.

If the intention of Byzantine art was to create images as 'doors' to another world, as they were called in the *Life of St. Stephen the Younger*,[8] what did contemporary viewers think they saw when they looked at them? Did the image represent the material world, or had its appearance been altered in some way to depict a higher reality, as recent Orthodox writers have maintained? Certainly by the 17th century, traditionalists like Avvakum, the Russian priest who led opposition to the reforms of the patriarch Nikon, denounced Russian icon painters who had been seduced by Western technical innovation, depicting Christ 'with a puffy face, and red lips, curly hair, fat arms and muscles, and stout legs and thighs; and all this is done for carnal reasons, because the heretics love sensuality and do not care for higher things.'[9]

However, Byzantine witnesses themselves seem to have been greatly impressed by what they regarded as the extraordinary realism achieved by the artists of their day, and refer to

the images as having captured the appearance of the subjects just as they appeared in life.[10] These statements have intrigued modern critics, and may simply repeat the literary formulae of the time. If these were the terms in which portraits had been praised by the great writers of antiquity, their Byzantine successors may have been anxious to prove their knowledge and skill in reproducing antique models.[11] Furthermore, they may have hoped to recreate the intense emotional impact of the visual experience through literary means, rather than provide a description of the appearance of the image.[12]

However realistic the achievements of Byzantine artists might have been thought to be, there was clearly a range of styles in which they could work. In the 3rd century they had begun to impose a hard angularity on both flesh and drapery to produce imposing images of power and authority. While it has been suggested that this style arose through a collapse of the artistic standards of classical antiquity,[13] incompetent classicism would seem to be quite a different thing.[14] The issue has also been confused by the modern tendency to assume that a classical style represents a more sophisticated engagement with the real world, whereas it may be a retreat to the cliches of an inherited visual vocabulary.[15]

Even if the more vigorous 'sub-antique' style did suggest the possibility of artists altering the proportions of the human form to convey an inner purpose or state of being, we have no account of their intentions during the Late Antique period. As a result, the most interesting cases where style might have been employed deliberately to depict an ideal, non-material world are those where two different styles are juxtaposed: the mosaic icons in the church of St. Demetrios of Thessalonike, for example, in which the idealized image of the saint is in marked contrast to the portraits of the two donors; or the icon preserved on Mt. Sinai of the Mother of God with St. Theodore, St. George, and two angels, in which the angels are depicted with rapid strokes creating a dynamic and ethereal impression, in contrast with the more solid flesh of the human bodies.

Whatever the intentions of the artists in such cases, the conventions of Byzantine or post-Byzantine Orthodox painting certainly do not correspond to the systems developed in the West to imitate the appearance of the natural world. There is no uniform source of light, no single point of vision, and no illusion of interior space. While there is a marked awareness of the boundaries of the pictorial field, pictorial space itself is eliminated and the number of elements reduced. Distance is not indicated by gradations of colour, and the size of figures depends on their importance rather than on their location. The resulting impression that Byzantine perspective is 'reversed' or 'inverted,' since elements in the background may be set farther apart rather than closer together, has been cited as an indication that Byzantine artists were making an explicit statement that their images depict a supernatural rather than a natural reality.[16] While Byzantine artists did display sophisticated techniques to avoid optical distortion on curving surfaces, and neither their technical skill nor the complexity of contemporary optical theory should be underestimated, in the absence of any examples of scientific perspective it is difficult to understand how an artist for whom this technique was simply not available would have had the option of rejecting it in order to make a statement about his intentions.

In any case, it is not clear why an active spiritual agenda for the visual arts would necessarily require that physical appearances be altered or distorted, or why realism must be seen as devoid of spiritual purpose. During the Counter Reformation of the 16th century, techniques of meditation like those of St. François de Sales or St. Ignatius of Loyola emphasized a vivid imaginative recreation of detail and this has been seen as encouraging the use of realism by artists like Bernini.[17] The choice might depend, of course, on precisely what sort of spiritual techniques were being advocated, but this is not a point on which a simple contrast can be made between the spiritual values of East and West. During the Iconoclastic Controversy, the Western response recorded in the *Libri Carolini* represented a middle path between the two Eastern positions, but even if the veneration of icons was not adopted in any formal sense in the West, accounts of the spiritual value of art can be found which seem very similar to the claims of iconodule theologians, and even draw on the same sources. The Abbé Suger who presided over the reconstruction of the Abbey of St. Denis in the 12th century and the birth of what came to be called the Gothic style, saw art as a means to make 'the dull

mind rise to truth through that which is material,'[18] and to support his claim he employed the Neoplatonic hierarchies of the Pseudo-Dionysios after whom his abbey was named.

Given the problems of discovering motives for changes in style, it may be more helpful to consider the role of iconography. For example, natural space and time are both clearly violated by an icon like that of St. John the Baptist standing in the desert and carrying an additional head on a platter, a symbol of his future martyrdom in Jerusalem. Icons which depict the ritual significance of events, rather than the events themselves, are also clearly intended to stand outside linear time. For example, the *plashchanitsa* which depicts the dead body of Christ, with his mother and St. John the Divine, also includes angels holding *rhipidia*, the liturgical fans carried to symbolize the seraphim who flew before the throne of the Lord of Hosts, and who were believed to be present during the liturgy when the death of Christ was enacted through the sacraments. Such a view of sacral time was certainly familiar to Byzantine commentators like Symeon, bishop of Thessalonike during the 15th century, who described the significance of the image of Christ in the Deesis: 'His Mother and the Baptist are on either side of him with angels and archangels, the apostles and the rest of the saints. This signifies Christ in heaven with his saints, Christ as he is with us now, and Christ who will come again.'[19]

This should not be taken to mean, however, that icons are completely divorced from historical time. The point of icons 'with scenes from the life' (*s zhitiem*) is surely to represent the life of the subject in a comprehensible chronological sequence, and although many subjects are painted according to traditions inherited from earlier centuries, icons like the famous 14th century image of St. Boris and St. Gleb in the Russian Museum depict the saints dressed in the kaftans, boots, and fur caps characteristic of medieval Russia.

The Sacred Theater

With the Triumph of Orthodoxy in 843, the mosaic icons were restored in Haghia Sophia, and the great cathedral became a model for church decoration as it developed throughout the empire. The so-called 'Middle Byzantine' program which was established during the following century included Christ Pantokrator surrounded by four archangels in the main dome, the Mother of God enthroned with her infant son in the semi-dome of the apse, the cycle of the Passion and Resurrection in the narthex, and large numbers of saints almost everywhere else.

This program and the central dome on which it was depicted are often said to create a cosmic diagram quite unlike churches in the West. While the church building has indeed been described by Eastern fathers as a 'heaven on earth,' and symbolic interpretations given to its various parts since the dome of the church at Edessa was compared to the dome of heaven in the 6th century,[20] it is nevertheless both more and less than a miniature universe, and not as different from the West as is often claimed.

Commentators like Germanos of Constantinople were careful to emphasize the historical element of the Christian faith as well as the mystical or cosmic, and maintained that the church also symbolized the crucifixion, burial, and resurrection of Christ. Indeed the narrative element of the decorative program was to acquire an even greater emphasis during later Byzantine centuries when it was used to fill the longer narthex favored at the time.

While Orthodox churches should therefore be seen as possessing a rich symbolism beyond the theme of the microcosm, it is also important to remember that their decoration depicts a specific type of cosmology, a heavenly version of the imperial court with Christ Pantokrator in the central dome and serried ranks of angels and saints below him. This constitutes a more narrow approach than one sees in medieval Western cathedrals, which provide a *speculum mundi* filled with a host of additional themes including the virtues and vices, and men and women about their daily tasks.[21] The great advantage of the Orthodox approach is that the program, or at least its main elements, can be recognized more immediately. If ritual art needs to communicate effectively, a more limited and conservative iconographic program is certainly more effective than the complexity and innovation in which Western patrons and artists often indulged.

Alongside the walls of the church, an additional program of iconography developed on the iconostasis, a screen separating the sanctuary from the nave. By the end of the 5th century, the waist-high screen used in the earliest

basilicas had been increased in height, and during the 6th century the screen in Haghia Sophia was given a vertical extension of 12 colonettes with an architrave and icons placed above. In Russia during the 15th century, the screen was to become a solid wall of icons, an important step occurring in 1405 when the famous painter Theophanes the Greek worked on the Cathedral of the Annunciation in the Moscow Kremlin. He enlarged the dimensions of the individual panels, and introduced a Deesis tier in which all the icons portrayed their subjects in full-length. At the same time, a precedent was set for five or even six tiers, with permanently fixed icons on the local tier at the bottom.[22]

Although the iconostasis has been described as an Orthodox *Summa Theologica*, an encyclopedia of Christian doctrine, this claim can be rather misleading. If one is borrowing theological terms, it might be more accurate to call it a *Heilsgeschichte*, a 'history of salvation' displaying the working of God's plan for the redemption of the world through tiers of icons depicting the patriarchs and prophets of the Old Testament, followed by the great events of the Incarnation described in the New Testament and commemorated in the cycle of festivals throughout the church year: Annunciation, Nativity, Epiphany, Presentation in the Temple, Transfiguration, Dormition of the Mother of God, Raising of Lazarus, Entry into Jerusalem, Crucifixion, Resurrection, Ascension, and Pentecost. In this sense, it is also misleading to compare the iconostasis to more purely contemplative art like the mandalas of Tibetan Buddhism. The iconostasis is not a comprehensive and unified diagram of the universe. Not only do its tiers represent a progression of events, and contain an obvious historical element, the local tier in particular displays a certain independence from the organizing principle, and consists for the most part of an arrangement of whatever icons held special significance for the local community. While it might lack the appeal of exotic spirituality for Western readers, a more helpful comparison might be made with the reredos or altar screen, especially before the complex array of saints was reduced to a single pictorial space.

Byzantine commentators applied the same sorts of symbolism to the liturgy itself, the enactment of the drama of salvation within the setting established by the frescoes and the iconostasis, and employing a further range of textiles and liturgical vessels whose decorations repeated the themes of the great programs around them. By the 3rd century, the sacramental meal of bread and wine which the Gospels record as instituted by Christ during the Last Supper was being interpreted by the Alexandrian theologian Origen as a symbolic account of the union of the soul with God.[23] Once again, the symbolism of Byzantine writers was not confined to mystical themes, and especially after Theodore of Mopsuestia emphasized the principle that the liturgy was also a memorial of the life of Christ, both mystical and historical symbolism were used by liturgical commentators throughout the Byzantine era, culminating in the work of Nicholas Kabasilas in the 14th century.[24] Symbolic accounts of the liturgy are also found in medieval Western commentators like Durandus,[25] but they are often forgotten, and Western handbooks to the liturgy now concentrate on the evolution of ritual rather than its symbolism.[26] How has this difference arisen?

In the Christian East the most dramatic consequence of the rise of Islam had been the Iconoclastic Controversy, but in the West an intellectual revolution erupted five centuries later when Arabic texts which were themselves translations of Greek philosophical, scientific, and medical treatises began to be translated into Latin. Aristotelian philosophy was now available along with the commentaries of Muslim scholars, and the application of Aristotelian logic led to the development of an academic theology in universities like Paris and Oxford, especially the formulation of the Scholastic system which was to seem so coldly intellectual to later Orthodox writers. The duality of the old relationship between church and state was now altered by the addition of a third element, the university. As the Franciscan Jordan of Giano pronounced, the *studium*, the *sacerdotium*, and the *imperium* were to be the foundations of the Christian faith.[27]

An increasing interest in the recovery of classical sources became characteristic of Western humanist scholarship during the 15th and 16th centuries, and this movement back to original texts was concerned not only with pagan antiquity but with the Christian past as well. Humanist scholars displayed a new fascination with the texts of the Greek and Hebrew Bibles, and the principle of *sola scriptura*, an appeal to the authority of scripture interpreted in the

light of the individual conscience rather than obedience to the traditions of the church, was proclaimed during the Reformation launched in 1517 when Martin Luther nailed his theses to the door in Wittenberg. Once John Calvin began to formulate a theology which followed the tendency of late Scholastics to make a rigid distinction between the natural and the supernatural, the implications of this further Calvinist Reformation shattered the medieval order and played a crucial role in both the scientific revolution and the rise of capitalism.

The echoes of the old world faded slowly in the West, as we can see from the importance given to elaborate court ceremonial during the 16th and 17th centuries, where even in Protestant societies art was used to present a symbolic account of the role of the king in the harmony of the cosmos. Nevertheless, the emphasis which Calvin and his followers placed on the word rather than the image, on the church as a venue for sermons rather than a temple for the sacred mysteries of the liturgy, meant that our conception of the church became increasingly Semitic rather than Greek, more like the synagogue or the mosque. Despite attempts at Counter Reformation, the success of Calvinist teaching set the terms in which even those who were not Calvinists began to see their own traditions. As the Orthodox would maintain, the impact first of Scholasticism and then of Calvinism has meant that we see ourselves as rational rather than mystical.

The Athletes of the Spirit

In the East, however, the movement was in the opposite direction, away from academic theology rather than towards it. There had been a tradition of philosophers and theologians in Constantinople, but even before the Ottoman conquest of 1453, centres of learning in the West like the university of Padua had begun to attract Greek humanists. During theological disputes and ecclesiastical negotiations with Latin scholars, they had been surprised at the intellectual advances made in the West, and after the victory of monastic spirituality in the East when the Councils of Constantinople in 1347 and 1351 endorsed the mystical teachings of the Gregory Palamas, they began to realize that their gifts might be more appreciated there.

The distinction between humanists and hesychasts should not be treated as absolute, however. Certainly Palamas was both a learned and subtle theologian, and his follower Nicholas Kabasilas has been called with some justification a 'mystical humanist.' The difference was rather one of emphasis on 'Inner Learning' rather than 'Outer Learning,' and the hesychast goal of mystical experience meant that the achievements of the intellect could be of value as long as they did not distract from the higher purpose.

The name 'hesychast' refers to the 'silence of the heart' (*hesychia*). Through the constant repetition of prayer and the techniques of breath control and meditative posture, the hesychasts attempted to penetrate the mysteries of the heart and attain direct knowledge of God through a vision of the same uncreated light which had been revealed to the disciples during the Transfiguration.

The practice seems to have arisen during the 7th century among monks in Egypt who followed a life of withdrawal from the world which began during the 3rd century, when Anthony the Great took the Biblical commandment in its literal sense, sold everything he had, and gave it to the poor. While Anthony lived alone in the desert, wrestling with demons, another Egyptian, Pachomios, began to organize a communal form of life, and soon great monastic communities arose in the Nile valley and the deserts on either side. The fame of these Desert Fathers spread throughout the Christian world during the 4th century, and visitors like John Cassian and Jerome flocked to Egypt and spread news of the movement throughout the Christian world.

At much the same time, St. Basil the Great developed a life of organized asceticism in Cappadocia, and in Syria the 'sons of the covenant' began an ascetic tradition described by Syriac writers like Aphraat 'the Persian sage' and St. Ephrem of Nisibis. In each of these regions, the ascetics were seen as athletes of the spirit who had passed beyond the limits of human existence and entered the realm of the angels through their constant battle with the flesh. The most dramatic symbols of the ascetic life were the stylites of Syria, who lived in the midst of the people, and yet rose above them into the sky on pillars. They were exposed not only to the sun and the wind, but also to constant demands for advice or intercession. The vermin and the other

revolting signs of the flesh which fell from the pillars offered proof of their triumph over the body.

The monastic movement drew on pagan traditions including the Stoic doctrine of interior detachment and tranquillity and the Platonic view of matter and spirit, as well as on Jewish institutions like the sacred vows of abstinence made by the Nazirites. Even in its earliest days, the movement displayed a wide variety of belief and practice, with some Egyptian monks regarding the Greeks as too intellectual and sophisticated to comprehend the mysteries of God, and some Greeks believing the Egyptians to be too dull. A fusion of intellect and experience was advocated by Maximos the Confessor in the 7th century, and while the roots of hesychasm may extend back to these earlier times, the first detailed description of the program was given in the 13th century by Nikephoros the Hesychast. During the following century it came under attack, and accounts of the famous controversy between Barlaam of Calabria and Gregory Palamas provide a guide to the essential elements of the practice.[28]

Barlaam insisted that God was beyond human knowledge, and that as a result, the vision of the uncreated light which the hesychasts claimed to achieve was in fact merely a vision of a created light. The techniques of posture and breath control by which they claimed to achieve the vision were therefore symptomatic of superstition and gross materialism.

In reply, Palamas agreed that God was indeed unknowable, but he distinguished between the essence of God and the energies of God, in other words between his inner being and his actions. According to Palamas, these actions were not a sort of intermediary between God and the world, but were the living God himself. It was therefore possible for the hesychast to have a direct experience of God without compromising the transcendence of God. As for the techniques of posture and breathing, Palamas maintained that no great emphasis should be placed on them, and that in fact they were more suitable for beginners. However, since body and soul were a unity, they could certainly be justified: through the posture of the human body, the human soul could be trained to be attentive.

The victory of Palamas established a tradi-

tion which, it is claimed, is more holistic and optimistic than the austere spirituality of the West, where the attainment of any vision of or union with God in this life is denied. However, an intense awareness of the predicament of the individual soul is not limited to the West. It is especially noticeable among Syrian mystics, and in the central figure of the Armenian tradition, St. Gregory of Narek. Indeed, the obsessions of the central figure of Western spirituality, St. Augustine, may be due in part to his early life as a Manichaean, and represent another manifestation of Syrian hostility to the flesh. In any case, a rigorous asceticism may not be the result only of a fragmentation of the human person or a denigration of the body. For Western fathers like Tertullian, it was precisely because the body mattered that such a strict asceticism was necessary: the body was an essential part of a creature made for eternal life.[29]

The question is also made extremely difficult by the nature of the record. Mystical experiences are often said to be beyond words, and even if the descriptions seem to differ, the experiences may have been very similar or even identical. Western theologians like Gregory the Great relied on Augustine and Cassian to maintain that a direct vision of God was not possible in this life, but one should not necessarily read this as a specific rejection of the possibilities claimed by later Orthodox mystics. And even if one did, the West is by no means monolithic. There have been mystics in the West who described experiences rather similar to Palamas' accounts, and some who even used the term 'deification' in a way which seems very similar to his claims for the involvement in the body as well as the soul in the process of becoming God (theosis).[30]

In Russia, the influence of the hesychast tradition was certainly pronounced after 1793, when Paissii Velichkovskii produced a Slavonic translation of an anthology of mystical texts entitled Philokalia, 'Love for the Good,' but it is difficult to tell from the biographies of earlier saints like Sergei of Radonezh whether they were hesychasts or not. It would not be unreasonable to assume that they were. Certainly the influence of Byzantine monasticism was greatest in Russia after the victory of Palamas, and St. Nil of Sora, the leader of the Non-possessors, is known to have visited Mt. Athos during the 15th century. Even so, there are no descriptions of the details of mystical tech-

nique one finds in Byzantine literature, and the harsh austerities of the Russian tradition suggest the influence of the Syrian as much as the Greek tradition.

The Non-possessors were one of the parties in a controversy about the proper role of the monasteries, and believed that they should be devoted to an interior life pursued in poverty and detachment from responsibilities of a more worldly nature. Their opponents, the Possessors, believed that the resources which could be obtained from large estates were essential if the monasteries were to fulfill their responsibilities to society, promoting scholarship, teaching, and the patronage of the arts necessary for public worship. When the Non-possessors opposed Basil IV in his desire for an additional marriage contrary to the letter of Orthodox law, the Possessors assumed the ascendancy, and it was their vision of the close relationship between church and state which contributed to the eventual submission of the hierarchy to the princes of Moscow.

Some of the greatest achievements of Russian artists may be due as much to the Possessors and their emphasis on the beauty of ceremony as to the Non-possessors and their emphasis on interior vision. As is often the case, however, the contrast between the two positions can be exaggerated into a simplistic dichotomy. It may be that the greatest of Russian monastic leaders, like Sergei of Radonezh, were able to hold two essential elements of the Christian life in balance, but that after their deaths the balance collapsed.

The Invention of Tradition

For many of us in the modern world such controversies may seem obscure, but within them lies much of the meaning of Orthodox art, its significance as part of a tradition which set out to unite heaven and earth. For many of us in the West this art may seem too familiar to hold such a mystical key, if we compare it to the more exotic images of Tibetan or Zen Buddhism, for example. At the same time, it may seem too strange to be immediately comprehensible. The saints and the festivals are often different from those we have known since childhood, and the relative tenacity of tradition means that the stylistic innovation to which we have become accustomed in Western art may seem to be lacking, even if other eyes more familiar with Orthodoxy discern enor-mous variation between different regions and different centuries.

Aside from the argument that medieval Russian art is beautiful, and should therefore be interesting in itself, what are the reasons for us to take the time to look at it? For anyone concerned with Russia or Eastern Europe, it is of central importance, since the image rather than the written word was the primary form of public communication during the formative period of these societies. No one would claim that medieval Russia produced theologians whose subtlety and elegance could rival those of Byzantium, but one could quite reasonably maintain that the technique and vision of an artist like Andrei Rublev or Dionysii equal or surpass anything that survives from Constantinople.

For those of us in the West, medieval Russian art can also serve as a dramatic reminder of the world we have lost, through the consequences of the Renaissance, the Reformation, the Enlightenment, and the scientific revolution which have isolated us from our medieval past. Even if we feel we are living in a post-Christian world, for which the Christian legacy has become an irrelevance, our neighbours may not agree. Muslims, for example, when discussing relations between West and East, or the place of Muslim citizens in a society like England or France, often begin with the legacy of medieval Christendom, and we can find ourselves responding from this position, often to our own surprise.

The criticism made by Orthodox writers that medieval Western liturgical commentators were indulging in symbolic associations without any justification in tradition, and were therefore pursuing aims quite different from those of their Byzantine counterparts, reveals the central complaint in the Orthodox view. Once the barbarian invasions had shattered the established order in the West, especially the existing relationship between the spiritual and the temporal spheres, the attempt to reconstruct or invent a tradition appeared by definition to be an illegitimate and unjustifiable rejection of the structure which survived in the East. Yet the Eastern institutions were not capable of recovering the West, which increasingly had to fend for itself, and in the competition between the different elements of Western society which attempted to fill the vacuum lies the basis of the Western achievement.

This is not something to be dismissed lightly. Even in religious terms, as Solzhenitsyn has observed, the behaviour of the Orthodox church in Russia under an atheist and tyrannical state may seem to compare badly with that of the Church of Rome in Poland, however different the circumstances may have been.[31] Nevertheless, the Western achievement has been purchased at the price of alienation from tradition.

One should, of course, avoid the temptation to compare the reality of the West with an ideal and imaginary East, and one should recall that the Byzantine system too was eventually shattered by the Ottoman conquest, and that Holy Russia was abolished *de iure* by the reforms of Peter the Great, and *de facto* by the impact of three centuries of Western education, literature, and philosophy culminating in the horrors of a supposedly scientific Marxism in the 20th century. One should also remember that adherence to tradition can encompass a greater degree of evolution or manipulation than is sometimes admitted in Orthodox circles, even central events like the Triumph of Orthodoxy in 843,[32] and that the West has embarked on innovation precisely because it is searching for a more ancient and therefore more legitimate version of tradition. Nevertheless, the point is still valid.

In attempting to look more critically at postulated differences between East and West, one should not exaggerate the extent of common ground. This has occasionally been a fault of conservative Anglicans, anxious to turn towards Constantinople and away from the uncomfortable claims of the papacy. The histories of East and West have been very different, but there are still enough similarities to allow us to see Orthodox tradition as meaningful in many ways for us as well. Even where it is not, an encounter with such a tradition can throw unique elements of our own society into relief and enable us to understand them more clearly. At a time of rapid cultural change in both East and West, this is an invaluable gift.

The Origins of Russia and its Culture

Simon Franklin

Russia has many beginnings. As a powerful centralized state, Russia emerged in the late Middle Ages, when the rulers of Moscow gradually but relentlessly expanded their small principality into a powerful empire and elevated themselves from princes into tsars.

As a territory ruled by the ancestors of those tsars, the origins of Muscovy can be traced back another couple of hundred years, when the princes of Suzdal, Rostov and Vladimir – ancient cities which now form the 'Golden Ring' to the north and east of Moscow – established a flourishing autonomous principality in the 12th century.

But for the beginnings of the dynasty itself and, more significantly, for the origins of Russian culture, one must go further back and further afield: to the emergence of the ' Land of the Rus,' from which Russia received its name.

In Latin from as early as the 10th century – and thence eventually in English – the Land of the Rus becomes 'Russia.' Confusingly, however, the Land of the Rus (also known as Kievan Rus or Kievan Russia) is the forerunner not of Russia alone. Russians are East Slavs. So are Ukrainians, and so also are Belorussians. All three trace their roots to the Land of the Rus. The separation of the East Slavs into distinct groups occurred slowly and much later. In the early Middle Ages the East Slavs were in culture and language one people.

Still more confusingly, the original Rus were not in fact Slavs at all, but Scandinavians.[1] A modern mental and linguistic geography seems to obscure as much as it reveals. Let us start from the earliest of the beginnings.

Picture first the land. The area corresponds roughly to the European part of what used to be the Soviet Union. This area can be split horizontally into three broad bands: in the north the vast, thick forests; in the south the open steppes, or prairies, extending east into central Asia and west to Hungary; in the middle a narrower band of mixed woodland and steppe. The East Slavs inhabited the central zone and parts of the northern forests, which they shared with Finnic and Baltic populations. The steppes, from the edge of the central zone down to the Black Sea and the Caspian Sea, were the preserve of Turkic nomads (dominated in the 9th and 10th centuries by the empire of the Khazars). Almost all communication was by river. Trade along the river-routes was the principal catalyst for the emergence of Kievan Rus. Fortified trading posts turned into towns, while measures to maintain and protect the long-distance routes stabilized into rudimentary forms of state administration.

The most ambitious and successful colonizers of these river routes were the Vikings, or 'Varangians,' as they are called. In the mid-9th century, according to the standard legend of the Russian chronicles, one group of Varangians, known as the Rus, led by a certain Riurik, was asked by the people of the northern town of Novgorod to come and rule over them, 'because our land is great and abundant, but there is no order in it.'[2] Over the following decades – again according to legend – Riurik's kin moved south and captured Kiev. The Riurikids thus secured for themselves both the northern and the southern ends of the main vertical route between the Baltic and the steppes, which was to become the backbone of

Apse mosaic of the Mother of God, Haghia Sophia in Kiev.

Kievan Rus. They also established a dynasty whose right to rule was to be unquestioned for a thousand years. All the princes of Kievan Rus, and the tsars of Muscovy, were (according to legend) descended from Riurik the Varangian.

Riurik's Rus were unlikely to have been motivated by an altruistic wish to solve the Novgorodians' domestic problems. The prize was more distant and far more lucrative, and it lay beyond Novgorod, beyond the steppes, beyond even the Black Sea. To open and control the river routes from Novgorod to Kiev meant control of a major part of the route from the Varangians to the Greeks: that is, from Scandinavia to Constantinople, wealthiest city in the known world. The northern forests and their inhabitants could be plundered for raw materials – furs, honey, wax, slaves – and these gave access to the luxury markets of the Byzantine empire. Chapter 9 of the *De administrando imperio*, a work compiled in the mid-10th century under the patronage of the Byzantine emperor Constantine VII Porphyrogennetos, describes in detail how the Rus, still clearly Scandinavians, organized annual trading expeditions to Constantinople. These were large-scale enterprises. First the Rus from the central and northern towns would join those of the south in a grand gathering at Kiev, whence they set off in their dugout boats (the first Black Sea fleets of the Rus) down the Dnieper across the fearsome series of rapids and past the equally fearsome steppe nomads, onward to the imperial capital across the sea.[3]

The Rus did not come to Byzantium as meek and dumb supplicants. Their raiding could be as vigorous as their trading. Several times over the 9th and 10th centuries they were bold enough or rash enough to attack Constantinople and its outlying areas. They were never ultimately victorious, but they won treaties, trading concessions, and a reputation for bravery, loyalty, and brutality. Byzantine emperors took to employing Varangians as palace guards.

The Rus may have been aggressive, but they were also receptive. On the one hand they consolidated their hold on the commercial routes and imposed themselves on the local tribes; but on the other hand they were open to the cultural influence of those with whom they lived and of those with whom they traded. By the end of the 10th century, 150 years after Riurik, the ruling elite of the Rus had assimilated the language of the East Slavs and the religion of the Byzantines. This synthesis of three elements– Riurikid rule, the Slavonic language, and Eastern Christianity – came to form the stable core of a sense of national and cultural identity among the Rus and the Russians throughout the Middle Ages. Promoted by princes, propagated by chroniclers, seeping by degrees into popular consciousness, almost impervious to changes in political geography and state structure, this distinctive synthesis became the basis of national and cultural myth.

Distinctive syntheses sounds abstract. Myths need heroes, and in the emergence of a Slavophone Riurikid Christian Rus the central hero is Vladimir I, prince of Kiev at the turn of the millennium, from 980 to 1015. The central date is 988 when, according to chronicles and convention, Vladimir made Christianity the official religion of his land and of his people.

Why did Vladimir choose to convert his people to the faith of the Byzantines? We cannot know his mind, but explanations in the early chronicles (all written long after his death) tend to fall into five categories: political, diplomatic, economic, aesthetic, and providential. Modern interpretations tend to remix the same categories according to taste, judgment, or prejudice.

In domestic politics the acquisition or imposition of a single, central cult could help to provide a framework of legitimacy for the prince of a large, recently assembled, multi-ethnic territory. Chronicles reveal that Vladimir first tried to achieve religious integration by setting up a kind of pantheon composed of his various peoples' pagan deities.[4] But the wood and the gold of the idols crumbled at the advance of a new technology on offer from the foreigners – writing. To be awed by the pantheon, the people had to come to Kiev. With writing, the cult could be replicated, explained, and standardized across vast distances. So Vladimir explored the 'religions of the book,' which just happened to be the religions of his most powerful neighbors: the Islam of the Volga Bolgars to the east, the Judaism of the Khazars to the south, the Christianity of the Latins to the west, and the Christianity of the Greeks across the sea in Constantinople.

As a result of their commerce and diplomacy Christianity was not entirely new to the Rus. A Byzantino-Russian trade treaty of 944 refers to Christians among the Rus. In the 950s,

Vladimir's grandmother Olga, who as regent traveled to Constantinople and was received by the emperor Constantine VII Porphyrogennetos himself, had been baptized, though her son, Sviatoslav, remained pagan. Vladimir pushed his grandmother's diplomacy a stage further. As the price of military aid to the emperor Basil II (later famous as 'the Bulgar-Slayer') he demanded Basil's sister Anna as his wife, and as the price of an imperial bride the Byzantines demanded that Vladimir be baptized.

Byzantium was wealthy, certainly the most majestic city in Vladimir's known world. To join the family was good for business. And perhaps Byzantium's very prosperity was also proof of the efficacy of the Byzantines' faith. If wealth was not enough, then there was beauty, the spectacle and entrancement of Hagia Sophia where, according to the famous legend of the chronicle, Vladimir's envoys did not know whether they were in heaven or on earth. The Muslims' alleged counter-proposal of unlimited fornication was alluring for a man of Vladimir's alleged habits, but was more than canceled by their ban on alcohol. 'Drinking,' said Vladimir, 'is the joy of the Rus. We cannot live without it.'

Finally, or perhaps primarily, there was the Grace of God and His Providence. Whatever the material causes, for chroniclers and eulogists the conversion of Vladimir and the Rus was a miracle. Vladimir led the Rus from darkness into light, from bondage to freedom, from the shadow to the Truth. He fulfilled among the Rus the Biblical prophecies about the nations of the gentiles.[5] Even at the eleventh hour he brought them to their ordained place in the Divine Plan for mankind. The last shall be first.

Despite the effusions of the chroniclers and the eulogists, Vladimir's achievement was still more notional than actual. The land of the Rus was not transformed overnight merely as a result of a mass and often forced dip into the Dnieper.[6] The myth of the Christian nation is associated with Vladimir, but the continuous history of a Christian culture starts at least half a century later, in the reign of Vladimir's son Iaroslav (1037-1054). Though there was certainly some cultural activity in the post-conversion years (such as the construction of Vladimir's fine church of the Mother of God, destroyed in the Mongol invasion of 1240),

there is nevertheless a kind of invisible barrier that falls away in the middle decades of the 11th century. Where previously there are only hints, fragments, and surmises, now suddenly, across a wide social, geographic, and cultural spectrum, the extant remains begin to appear and multiply: the earliest surviving manuscripts, starting with the Ostromir Gospel produced in Novgorod in 1056-57; the earliest surviving churches; the earliest murals and mosaics; the earliest surviving native literature; the earliest documented monastic foundations; and a proliferation of extraordinarily varied inscriptions, from the seals of bishops and princes to the birch-bark memos of Novgorodian debt-collectors to the doodles and devotional graffiti scratched in the plaster of church walls.

The first was perceived also as the best. The period from the start of Iaroslav's sole reign to the death of his grandson Vladimir Monomakh in 1125 constitutes the Golden Age of the culture of Kievan Rus, to which later writers and rulers looked back with wistful admiration. It set the models, the pattern, and the boundaries; it established the tradition.

Creating the tradition was above all the self-conscious achievement of just two small groups of people: first the bookmen, architects, craftsmen, and artists who worked under the direct patronage of Iaroslav himself; then the monks of the Kievan Monastery of the Caves. Iaroslav made Christianity visible. Through a huge program of public building he remodeled Kiev in the image of a Christian capital. He sponsored the construction and decoration of the great Cathedral of St. Sophia with its sumptuous mosaics and frescoes (ca. 1037-47), as well as the churches of St. Irene and St. George and the Church of the Annunciation on the Golden Gates.[7] He was probably also responsible for commissioning the Novgorodian version of St. Sophia. 'Behold,' wrote the palace priest Ilarion in the late 1040s, speaking just of Kiev, 'behold the city shining in splendor! Behold churches blossoming! Behold Christianity growing! Behold the glittering city, illuminated with icons of saints and scented with incense, resounding with praises and songs to the Lord!'[8] Soon afterward Iaroslav appointed Ilarion metropolitan of Kiev, head of the church of the Rus.

The Monastery of the Caves also contributed architecturally, through its Church of the Dor-

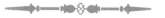

mition, completed in the early 1070s, but its cultural role was more subtle and varied. It became the main training establishment for native higher clergy; Nestor of the Caves wrote the *Lives* of the first native saints– the martyred princes Boris and Gleb and the monastery's own abbot Feodosii; monks of the Caves played a significant part in compiling the *Primary Chronicle*, which came to serve as the standard introduction to virtually all subsequent chronicles in Rus and Russia until the 18th century. The *Paterikon of the Caves* is the most detailed, vivid and influential compendium of native spirituality from Kievan Rus.⁹ In many respects posterity came to view the culture of Kievan Rus through spectacles carefully tinted by the monks of the Monastery of the Caves.

The Golden Age of culture in Kievan Rus, like the conversion itself, was imposed from above. Christian culture was an instrument of state policy. The Church owed its status to the State, and it repaid by elevating the status of the State. The dominant mood is celebratory, propagandistic, solemnly self-congratulatory for monumental public display; the Rus had arrived in civilization and sacred history. There is a sense of completeness, of something achieved and fulfilled, of a past perfected in the present and with little thought for the future.

The image was of course a delusion. For at least 200 years after Vladimir, Christianity was confined mainly to the towns and to the relatively prosperous strata of society. The days of the peasant piety of the muzhik in the heartlands of Mother Russia were still in the very distant future and in another place. In fact, the elite Golden Age culture-builders were a beleaguered group, trying to give luster to what was still a perilously thin cultural veneer. As late as the 1070s there were pagan riots in Novgorod, where the chronicler admits that only the prince and his retinue sided with the bishop against the mob. In the 1080s Metropolitan John II wrote reassuring answers to a perplexed priest who wanted to know how to cope with, for example, the fact that only the princes and boyars bothered to get married properly in church, while the common people continued their old custom of 'taking wives as if by abduction, with much leaping and dancing and hooting.' This was a full century after Vladimir's conversion.¹⁰

The Golden Age of Kievan Rus was a prod-uct of wishful thinking. The miracle, perhaps, is not that the wish is often mistaken for the truth, but that in time the truth adapted itself to match the wish.

The Golden Age was also borrowed. It was Byzantine not only in inspiration, but – as far as possible – in form and execution as well. For contemporaries this was a point of pride, not of embarrassment. The metropolitanate of Rhosia (as the Byzantines called it) was an ecclesiastical province of the patriarchate of Constantinople. The prestigious churches of St. Sophia in Kiev and Novgorod, as well as the Church of the Dormition at the Monastery of the Caves, were built and decorated by architects and artists imported from Constantinople for the purpose. The monks of the Caves were proud to trace their spiritual heritage both to the asceticism of Mt. Athos and to the communal discipline of the Monastery of Stoudios in Constantinople, whose Rule they imported. Ilarion marvels at how Vladimir was swayed by hearing of 'the devout land of the Greeks.' With just two exceptions, all metropolitans of Kiev for the first 300 years were 'Greeks' appointed from Constantinople. In the mid-11th century it was even fashionable to use the Greek language in public display: in the mosaic inscriptions in St. Sophia and on the seals of princes and bishops.

Byzantium was the measure of civilization. To be Christian, to be civilized, to build, write, paint, or worship in a respectable and civilized way meant to do such things in the same way as they were done by the Byzantines. In a sense, the Golden Age culture was made as a kind of icon of its Byzantine equivalent. And since – also in a sense – subsequent medieval Russian culture was made as a kind of icon of the Golden Age, in the image and likeness of the culture established by the Rus and perceived to be the national tradition, so medieval Russian culture was made and remade in the image and likeness of Byzantine models.

Much of the borrowing, even at the start, was at second hand. The Kievans did not scour Constantinopolitan libraries for texts to take back home and translate. Instead they received the written heritage of Orthodoxy for the most part (perhaps entirely) pre-packaged, via Slavonic translations previously prepared by those earlier Slav converts, the Bulgarians.¹¹

Where, then, does medieval Russian culture fit in the broader context of Eastern Christian-

ity? Virtually all of Kievan elite culture was borrowed directly or indirectly from Byzantium, but the Kievan elite did not borrow anything like all of Byzantine culture. In particular, the Rus were wholly uninterested in and unaffected by the secular, classicizing, imperial dimensions of Byzantine culture. The key to the Byzantines' own national myth lies in the miraculous synchrony of Christ and Augustus, of the incarnation of God and the foundation of the Roman Empire. Clearly the two earthly universal realms, spiritual and temporal, were divinely ordained to be in harmony. The implications of this Providential synchrony were brought to fulfillment by Constantine the Great, when the empire of the Romans became Christian. For themselves the Byzantines remained *Rhomaioi* and classical pursuits, conducted in the proper spirit, were a crucial part of their sense of cultural identity and dignity, at least among the intellectuals of the capital. Students practiced the ancient arts of rhetoric, scholars wrote in tortuous and antiquated atticizing Greek, bishops wrote commentaries on Homer, emperors were augustly universal in their notional status.

All of this was utterly alien to the Rus. They always called the Byzantines Greeks, defining them by language rather than by imperial heritage; and the language was that of contemporary communication, not of archaizing imitation. There was no classical education in Kiev. Certainly 'Roman-ness' was no part of the Kievans' sense of their own identity, so they felt no need to bedeck themselves with the linguistic or scholarly accoutrements of a classical past. Thus (they boasted) the Scriptures became accessible in their own Slavonic tongue and (they also boasted) by elevating Slavonic alongside Greek and Latin they took their place in the universal (or European) culture. They failed to note that by sticking to Slavonic and ignoring Greek and Latin they also cut themselves off from the cultural past and the occasional cultural stimuli that the rest of educated Christian Europe took for granted.

The Rus borrowed only the religious component of Byzantine culture. Attempts to find significant secular borrowings usually over-strain the term. But in the religious sphere, too, the borrowing was functional rather than speculative. The priority, in a land still largely pagan, was to have what was necessary for the liturgical and communal life of churches and monasteries and for the edification of laymen, to learn and teach the proper ways to eat and fast, the proper ways to deal with birth, sex, and death; not to engage in theological or philosophical debate. Spiritual examples, wise maxims, and narrative illustration took precedence over theoretical inquiry or systematic investigation.[12]

What, then, of the glories of the Russian tradition? Was the Golden Age merely an enthusiastic but pallid copy, a third-hand provincial version, shrunken and parochial, just as the Kievan Church was a province of the Constantinopolitan patriarchate? Was the high culture of the Rus no more than the low culture of the Byzantine? Or was it nevertheless a creative adaptation, a national culture simply exploiting imported forms? Or was it in fact a genuine participation in the 'real' and deep Byzantine culture, while the 'high' culture of Byzantine higher learning was merely the affection of a handful of Constantinopolitan snobs?[13]

Such questions have vexed modern scholars deeply,[14] though they were of no interest whatever to the Rus of Kiev and Novgorod. The answers, should one wish to be anachronistic and pursue them, depend partly on one's own sense of cultural and spiritual values (and hence reveal more about the present than about the past). And partly they depend on how on a broader level one understands the relationship between imitation and originality, on complex semantics of the translation of culture into a new geographic, social, and linguistic environment.

Such questions are also premature. Let us take the story forward in time.

The virtually undisputed pre-eminence of Kiev lasted into the early decades of the 12th century. By the 1150s and 1160s the political map had changed. The cause was not the decline of Kiev, but the rise of the principalities. Outposts of the minor Riurikids grew in prosperity and influence, their princes built churches, acquired bishops, formed new alliances, even conducted their own foreign policies. The old north-south, Novgorod-Kiev axis was no longer the dominant feature of political or economic geography. The lands of the Rus had become more ample, more fragmented, polycentric, and the newly powerful branches of the Riurikid dynasty jostled for position.

A new pattern emerged. In the center and the south, the Rostislavichi of Smolensk and the

Olgovichi of Chernigov fought for control over Kiev and for reimposition of the old order. In the west the Iaroslavichi of Galich faced two ways: they were sporadically involved in the tussles of the southern Riurikids, while being at the same time part of a separate nexus of alliances and rivalries with their western neighbors Poland and Hungary. In the northeast the Iurevichi of Suzdal and Vladimir became ever more aloof from Kievan affairs. In the 1150s Iurii Dolgorukii (Long-Arm) of Suzdal, son of the legendary Vladimir Monomakh and reputedly founder of Moscow, spent year after year battling with his nephew Iziaslav for possession of Kiev. His son Andrei Bogoliubskii instigated the sack of Kiev in 1169, but installed his brother Gleb as prince while himself remaining in the northeast. After Gleb's death in 1171 no prince of Suzdal took an active role in southern politics, either in the context of inter-Riurikid disputes or in collective defence against outsiders, be they the Polovtsian nomads of the steppes or eventually the invading Mongols.

The only area of common contention was Novgorod. With the slackening of its almost automatic association with the princes of Kiev and their sons, Novgorod became a Riurikid no-man's-land and a highly tempting object of desire. It had a vast hinterland with rich pickings in fur-bearing animals, and it had a flourishing trade with the towns of northern Europe, run by a prosperous class of literate merchants and boyars through stable institutions of urban self-government. Novgorod acquired its princes by agreement, not by heredity. By the 13th century the role of the Riurikid prince in Novgorod was that of a kind of defence contractor, with rights, rewards, and responsibilities legally defined.

From the 1220s the Novgorodians negotiated the defence contract exclusively with the princes of Vladimir and Suzdal. The lands of the Rus could now no longer be conceived as emanating outward from the vertical line down from the Baltic to the steppes. Instead they were split into two broad zones separated horizontally, or at least diagonally; in the south and the west the principalities of the woodland and steppe borders; in the north and northeast a new and relatively stable axis through the forests from the Baltic to the Volga, linking Novgorod and Suzdal on the trade routes between northern Europe and the East. Thus

before the Mongol invasions, the East Slavs had realigned themselves into blocs whose mutual borders, at any rate north of the steppes, were not so drastically different from those that separate European Russia and Ukraine today.

Culture followed wealth. With the proliferation of prosperous principalities came a proliferation of patrons and sponsoring institutions. Culture, like politics, became polycentric, or more parochial. Local traditions of chronicles and narrative developed not only in Kiev and Novgorod but in Galich, Suzdal, and Riazan. The most eminent preachers of the 12th century were a rather fussily rhetorical bishop of Turov (Cyril, whose works survive) and a fire-and-brimstone monk of Smolensk (Avraamii, whose *Life* was written by a disciple). Daniel the Exile, an enigmatic assembler of aphorisms and witticisms, addressed his literary supplication to a local prince. In middle of the century Klim, metropolitan of Kiev, conducted an epistolary polemic with the priest Foma via the court of the prince of Smolensk. Church architecture, while sticking rigidly to the borrowed cross-in-square plan, nevertheless began to acquire local features: the raised, tower-like drum supporting the central dome, for example; or, especially in the buildings sponsored by Andrei Bogoliubskii in Vladimir and the northeast, carved exterior decoration.[15]

While becoming more diffuse, culture also became more enclosed. Paintings and artists and luxury goods and craftsmen were transportable or mobile, and in the development of painting among the Rus there were sporadic fresh infusions of contemporary Constantinopolitan or Balkan fashion. But in building, writing, reading, praying, and thinking, the Rus now looked mainly to their own tradition, for which they drew authority from the Kievan Golden Age. The Kievan translation of Byzantine culture now became the source to be retranslated through time into its new localities. Greek lost its luster even as visual display. Horizons narrowed. Gone was the exhilaration of self-discovery under Providence, the thrill of first strutting onto the stage of world history. Chronicles stuck to local news: historical writing only reacquired its breadth of vision in the 16th century. Churches were houses of worship, not universal declarations: nothing on the scale of the Kievan St. Sophia was attempted for centuries, until the tsardom of

Moscow emerged to lay its own claim to grandeur.

Not all was division. There was still one dynasty. Despite all disputes every prince of every principality, large or small, was still a Riurikid. And there was still one Church, a single hierarchy still headed – with increasing anachronism – by the metropolitan of Kiev, who was still almost always a 'Greek' from Byzantium. At some ideal level the old Kievan Rus still existed, and as the gap between contemporary geopolitics and the old ideal grew wider, so the voices of nostalgia grew louder: in the obscure and poetic *Tale of Igor's Campaign*, which both mourned and celebrated a defeat by the Polovtsians in 1185, and in the haunting and fragmentary *Tale of the Ruin of the Land of Rus*. But the wistful tone merely emphasized the depth of change. Self-assertion had given way to self-contemplation.

In 1223 the princes of southern Rus, in alliance with the Polovtsians, advanced into the steppes to engage the forces of Genghis Khan. The combined army was utterly destroyed. Then, to the chroniclers' mystification, the Mongols disappeared as suddenly as they arrived. But they returned. In 1237 under Genghis Khan's grandson Batu, they ransacked the towns of the northeast. In 1240 they swept across the steppes as far as Hungary, devastating Kiev on their way. They were an irresistible, inescapable elemental force, the scourge of God, like a plague or an earthquake, 'sent for our sins.'[16] By 1246 all the main princes of the Rus had traveled to the Horde at Sarai to acknowledge the Mongols as their overlords. Those who refused or wavered were killed. By the mid 1270s all the lands of the Rus had been subjected to Mongol censuses, leading to the imposition of Mongol taxes and to the supply of men for the Mongol armies.

In theory, therefore, all the lands of the Rus were once again united under one authority. In practice the pre-Mongol division first deepened, then widened into a chasm. Internal trade between north and south collapsed with the wreckage of the urban economy in Kiev. At the same time Alexander Nevskii, great-grandson of Andrei Bogoliubskii, last in the line of the powerful princes of Vladimir and first in the line of successful north eastern appeasers of the Mongols, preserved and even strengthened the Vladimir-Novgorod axis. His interests coincided with those of the Mongols:

he enforced their census, they left Novgorod alone, and the profits of Novgorodian commerce were enough for everybody, despite the disgruntlement of Novgorodian merchants. After Alexander's death in 1263, power in the northeast, rather as in the old Riurikid lands in the previous century, became polycentric, dispersing through new, ambitious, and fractious regional branches of the dynasty. Suzdal, Rostov, Pereiaslavl, and Vladimir had to cope with upstarts from Kostroma, Murom, Tver, and the ultimate (but not inevitable) victor, Moscow. In the southwest, more remote from the Mongols, Galich was squeezed between empires. In the 1250s Daniel of Galich tried to play the western card, but the pope sent only a crown and blessings. Without troops to match, Daniel was forced to accept the Mongol census. His successors, too, had to bow to changes in the prevailing wind. Over the 14th century, as the Mongols weakened in their capacity or desire to defend the western extremities, so Galich and the south (including Kiev) were absorbed into the expanding empire of Lithuania.

Thus the lands of the East Slavs were carved up between two intrusive superpowers. Both sects of invaders were initially pagan. One eventually turned to Catholicism, the other to Islam. The legacy of the Rus was divided.

The Church faced a problem: what to do with the metropolitanate of *Rhosia,* based in Kiev? If *Rhosia* was still notionally one land (as the Byzantines consistently maintained), then where now was its center, where was the appropriate seat of the metropolitan? The choice was made early. Cyril II, appointed metropolitan of Kiev under the auspices of Daniel of Galich in 1242-43, resided in the northeast for much of his long tenure, as a fervent supporter of the policies of Alexander Nevskii. One can (and scholars do) speculate as to whether he was motivated more by hatred of the Latins who held Constantinople from 1204 to 1261, whom Alexander had fought as prince of Novgorod in the 1240s, and with whom Daniel was doing diplomatic dances in the 1250s. Perhaps he was corrupted by the lure of Mongol tax exemptions for the Church, or simply reckoned that the right and proper place for the metropolitan was next to the grand prince, which meant next to the ruler of Vladimir, as the Mongol rulers of the country saw it. It may have been diplomatically convenient for the Byzantines to have Cyril as an agent operating

closer to the heart of the Mongol empire, for in 1261 he even established a bishopric at Sarai, capital of the Golden Horde. Piety, profit, and prudence could all point to the same decision. The rightness or wrongness of the decision is, of course, an entirely different issue.

The result, whatever the reasons, was that Byzantium recognized Vladimir as the successor to Kiev, as the ecclesiastical center of *Rhosia* at first *de facto*, by the early 14th century *de iure*. The political and ideological repercussions are plain. Occasionally during the 14th century separate metropolitans were appointed to minister to the Rus who had been absorbed into Lithuania, but for most practical purposes Vladimir, and later Moscow, was recognized by Constantinople and by the Church as the successor state.[17]

Muscovite legitimacy and identity were derived above all from the idea of the Kievan succession, the preservation of the Riurikid dynasty, the Slavonic language, and the Orthodox Church. As the principality grew into a centralized and bureaucratized empire, especially after the fall of Constantinople to the Turks in 1453 and the formal end of tribute payments to the Mongols in 1480, some elements of a grander and more imperial myth occasionally appeared: Riurikid genealogies traced back to Augustus; the notion of Moscow not just as the second Kiev but as the Third Rome, taking over the Providential mission and the universal status of Constantinople. But these were late frills and their importance, whether in Muscovite policy, culture, or consciousness, is often exaggerated.

To what did Moscow succeed? The cultural consequences of the Mongol invasions were diverse and in some ways paradoxical. In the most visible areas of culture, the Mongol impact was destructive. Urban economies were pushed into sudden decline (except for that of Novgorod) and the flourishing regional programs of church building were abruptly curtailed. In the late 13th and early 14th centuries the stream of native writing dried to a trickle, and most of that reflects the migration of bookmen (like and perhaps with Metropolitan Cyril) from south to north. For example, Galician literary features turn up in the *Life of Alexander Nevskii*,[18] and the preacher Serapion of Vladimir was an exile from Kiev. Indeed one could even claim that, ironically, the notion of a single *Rhosia*, whether for the ecclesiastical

structure or in politics, was in fact a southern import.

However, in less public areas of culture there was uninterrupted growth: a steady overall (though regionally uneven) increase, for example, in the numbers of extant manuscripts, or of inscriptions, or of birch-bark letters from Novgorod. There was a steady or even accelerated expansion of the Church itself, out of the towns and into the countryside and villages, beyond the elite and among the peasantry. Prompted in part by tax exemptions and monastic colonization, the wider and deeper Christianization of Russia gathered pace during the period of Mongol rule. The late medieval culture of Tver, Novgorod, and Moscow was more solidly based, more securely rooted than its Kievan, Galician, or Vladimirian precursor.

In a wider perspective the Mongol invasions accentuated still further the isolation of Russian culture, its reliance on its own resources. Indeed, this had become part of the tradition. After the initial massive infusion from Byzantium – some of it direct, some via Bulgaria – the Rus and the Russians were remarkably uncurious and unreceptive. Some further borrowed elements can of course be uncovered: perhaps some romanesque influence in architectural details in the 12th century; a comparatively mild additional infusion from Mt. Athos and the Balkans among a small group of prominent churchmen, bookmen, and painters from the late 14th century. But the overwhelming impression of a closed, self-sufficient, self-regenerating system.

The impression is both true and false: true if one looks only at sources, false if one assumes that cultural receptiveness only relates to the outside work. The trick and the lure of traditionalism is that it appears to transcend time. Yet in time, culture changes even by standing still. Consider, for example, the language. In Kievan Rus the Church Slavonic inherited from Bulgaria was perhaps difficult, but still the boast was that the language was accessible, that the Rus had the Scriptures in their own tongue. In the 10th and 11th centuries regional differences between the Slavonic languages were relatively minor. Post-Mongol Russia received and assiduously preserved the Church Slavonic sacred tongue, even from time to time cleansing it of what were seen as modern impurities. But in the meantime the

vernacular had changed radically, with major shifts in the structure of sounds and forms. The result was that a liturgical language specifically designed to be accessible became, in effect, the preserve of the learned, like Latin in the West or like atticizing Greek in Byzantium. Formal traditionalism led to a complete transformation of cultural function. Values were reversed in the name of their preservation.

Language is not a special case. One could explore equivalent processes in any area of culture. A particularly vivid illustration is provided, for example, by the cult of saints. Boris and Gleb were the first canonized native saints of Kievan Rus. Sons of Vladimir, they were, according to the story, murdered by their power-hungry brother Sviatopolk. Their sanctity, according to the 11th-century legends, lay in their humility, their lack of resistance, their innocence, their acceptance of death. The cult seems to have been genuinely popular, and it was also useful for the early Christian Riurikids to number saints among their kin.[19] In the late 13th century Boris and Gleb continued to be patrons of the dynasty. In the *Life of Alexander Nevskii* these heroes of non-violence became militant, rushing (in a vision) to help Alexander in battle:[20] traditional saints in a traditional role which is nevertheless a travesty.

Pre-14th century Rus provided late medieval Russia with its cultural vocabulary. Without this sense of basic continuity the emergence of Russian national culture world be unthinkable. But one may have a cultural identity without having an identical culture. As to how the Novgordians, Tverians, and Muscovites used their inheritance, how they re-translated the culture of their assumed past, what qualities typified their culture both in itself and in tradition- these are topics for other contributors to the present volume.

The Legacy of Beauty

LITURGY, ART, AND SPIRITUALITY IN RUSSIA

John Meyendorff

When Fedor Dostoevskii wrote his famous sentence that 'beauty will save the world,'[1] he exercised his acknowledged gift of prophecy. But he may not have foreseen how, very concretely in the late decades of the 20th century, the rediscovery of beauty in their Christian past by so many Russians would prove decisive for their cultural self-determination in the post-Marxist era.

Byzantine Orthodoxy Transmitted to Russia

The 11th-century *Primary Chronicle* describes the return of ambassadors sent by prince Vladimir of Kiev to several lands, to investigate religions that the newly-born state of Rus might accept to replace its former paganism. Reporting to the prince after visiting the Cathedral of Haghia Sophia in Constantinople, the ambassadors said: 'We went to Greece, and the Greeks led us to the edifices where they worship their God, and we knew not whether we were in heaven or on earth. For on earth there is no such splendor or such beauty, and we are at a loss how to describe it. We know only that God dwells there among men, and their services are fairer than the ceremonies of other nations. For we cannot forget such beauty.'[2]

Over the centuries that followed, the initial amazement of the ambassadors as they discovered the liturgical and ascetic expression of Christianity in Constantinople was never disavowed. Not only the Scriptures, but also all the cycles of the Byzantine liturgical tradition would be used in Slavic translation, an immense wealth of hymnology that covers not only the Eucharist, but all the festivals starting with Easter and including particularly the period of Lent and the twelve major festivals of the calendar year. The translation was begun already in the 9th century by St. Cyril and St. Methodios in Moravia, and was continued in other Slavic countries, including Kievan Rus. The policy of translating Scripture and all ecclesiastical literature into languages understandable by the peoples converting to Christianity was characteristic of the Orthodox East, and a contrast with the West where Latin was the only language admitted by the Church in its liturgy. Thus, St. Cyril, in the *Proglas* (Introduction) to his translation of the Gospels, quotes St. Paul: 'I would rather speak five words with understanding, than ten thousand words in an [incomprehensible] tongue' (I Corinthians 14:19).

The language used in the translations, known as Church Slavonic, would become the channel, common to all Orthodox Slavs, by which the literary and poetic forms of Christian Hellenism would become accessible to the Russians. The language itself was actually created in order to reflect these Hellenic forms. It followed not only Greek syntax, but even the order of words found in the original. At the same time, being translated into the vernacular, the liturgy would become for the Russians (and the other Slavs), the matrix of their own Christian culture, leading them to develop their own literary creativity, their own perception of the liturgical and spiritual tradition of Orthodoxy. It is through the church and its liturgy that the modern Russian language retained a Greek plasticity – traits that allowed the poet Osip Mandelshtam (1891-1938) to call it a hellenic language.[3] Anton Chekhov (1860-1938), in one of his famous short stories, wondered that the beautiful and distinctively Greek poetic expressions of the so-called *Akathistos* hymn to the Mother of God could be distinctly perceived in their Slavic translation, by the most simple of Russian faithful: 'O tree producing-bright-fruit,' and 'whose-leaves-provide-pleasant-shade.'[4]

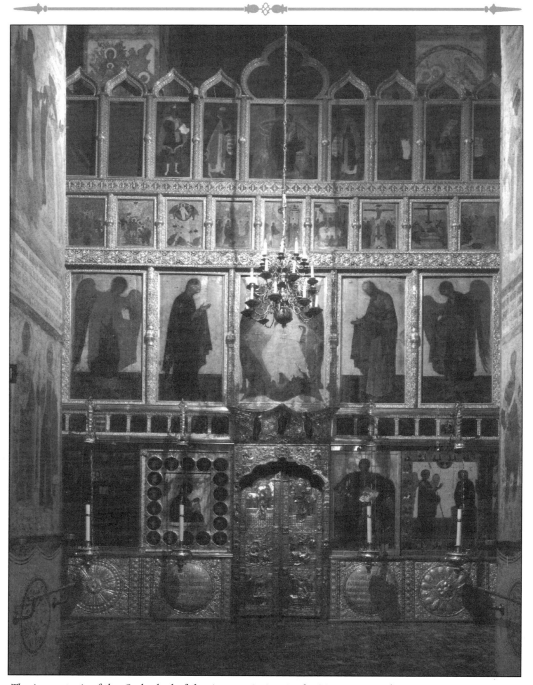

The iconostasis of the Cathedral of the Annunciation in the Moscow Kremlin.

Russians could not immediately assimilate all the rational theological concepts proclaimed by the Byzantine liturgical texts, but the Gospel itself was accepted at the very beginning of the long process of Christianization, which started in 988: the joy of the Resurrection; the heavenly patronage of the woman who had become Mother of God, and is therefore more honorable than the cherubim and more glorious than the seraphim; the acknowledgment that the figures of Christ and the saints appearing on icons, on mosaics, on frescoes, manifested a new, mysterious, deified reality. Throughout this process the aesthetic element, the manifestation of the divine presence as beauty, was never forgotten in Russia. Even a modern *troparion*, composed in 1917 in honor of all the saints of Russia, addresses them as 'the beautiful fruit of Christ's saving sowing,' and reflects the same perception of beauty as an essential manifestation of the Christian faith.

This does not mean, however, that Byzantine Orthodoxy, as it was transplanted onto Russian soil, lost its theological dimension and was reduced to aesthetic emotionalism. Through the liturgy, it retained all the fullness of its traditional contents.

The Liturgy and the Temple

Since early Christianity, the Christian community was centered around the celebration of the Eucharist, a mystery perceived both as a commemoration of the Last Supper of Christ with his disciples on the eve of his death and resurrection, and as an anticipation of his second coming. The Eucharist is thus both a remembrance and a revelation of things to come.

The Byzantine Orthodox eucharistic liturgy includes the main features present in all the ancient liturgical traditions of East or West. It includes a first, didactic, part centered on the reading of Scripture and, eventually, a sermon, and a second sacramental part, the eucharistic prayer itself. Within the latter, the commemorative aspect is present in a recollection of the Last Supper and of Jesus' words: 'This is my Body . . .' and 'This is my Blood . . .,' but the anticipatory or eschatological emphasis is stronger in the Eastern liturgy than in the West. It appears in an invocation of the Holy Spirit, called upon to accomplish the transformation of bread and wine into the Body and Blood of Christ. It is further emphasized following communion: 'Make us to commune with You even

more fully in the unending day of Your Kingdom . . .'

The Christian temple is essentially designed to house the eucharistic celebration, which involves an assembly of people. Unlike pagan temples, built to house the statue of a god, to be visited and worshipped by individuals, the first Christian churches were assembly halls. Since Christ promised that an assembly of even two or three in his name implied his personal presence, a gathering of people who together constituted the Church of God was essential to Christian worship. Such a gathering did not actually require a special building. However, if a building was to be built to house the assembly, it had to reflect the assembly's nature and purpose, as an anticipation of the Kingdom to come. A figure of the coming Christ, or Pantokrator, became the central image appearing either in the apse (as in early Christianity), or on the inner wall of the dome (as in later Byzantine and Russian churches), dominating the assembly and manifesting the eschatological dimension of the eucharistic gathering.

But since an assembly in Christ implied also the presence of his entire Body, which includes not only the living, but also the dead (who are nevertheless alive in him), the images of the Mother of God and the saints found their natural places on church walls. A writer of the 1st century, Ignatios of Antioch, wrote: 'Where Christ is, there is the catholic church.' This original meaning of catholicity did not involve geographical universality, but the idea of wholeness and comprehensiveness, manifested in every local eucharistic assembly. The Church encompasses the whole of the redeemed humanity and the Christian temple was seen as the home of all the saints.

Over the centuries, the eucharistic liturgy was embellished with many features determined by cultural circumstances. Much of the pomp which characterized it in the late Middle Ages and is often maintained today came from the ceremonies of the Byzantine imperial court. Of course, artistic forms and aesthetic tastes have varied and not all the contemporary liturgical practices have the same traditional value. But the intention has always been to make the liturgy beautiful, because the Kingdom of God was identified not only with a triumph of ethical principles, or the understanding of conceptual truths, but also with eternal beauty.

A Theology in Color

The history of art in Byzantine Orthodox Christianity is dominated by the consequences of a long struggle that took place in the 8th and 9th centuries between Orthodox Christians and the so-called Iconoclasts. The latter denied the legitimacy of images in Christian worship. They referred to the Old Testament prohibitions of idolatry and were also influenced by Platonic philosophy, which identified God exclusively with the spiritual, immaterial, or intellectual realm. Furthermore, the competing religious ideology of Islam revived the prohibition of Idolatry and the Byzantine emperors of the 8th century became sensitive to this criticism. To justify their position, they offered a peculiar doctrine of the Eucharist, which they presented as the only legitimate image of Christ, the only memorial established by Jesus, before his passion.

Against iconoclasm, the Orthodox invoked the specifically Christian doctrine of the Incarnation. Neither the Old Testament, nor Platonism, nor Islam, but only Christianity, believed that the Word became flesh (John 1:14), that the ultimate and fullest revelation of God occurred in the visible, historical person of Jesus of Nazareth, who was both God and man. If one were to deny his visibility and therefore his being representable and depictable in accordance with his historical, human features, one would also deny the reality of his Incarnation, of his humanity, which was similar to ours in every way, except sin (Hebrews 4:15). An image of Christ is, therefore, in itself a confession of faith in the Incarnation. It also challenges the artist with an extraordinary task, to represent a historical, human individual through whose human, visible features the beholder or the true worshipper beholds and worships God himself.

The means used by the iconographers to express this mystery include conventional signs and inscriptions. Christ is depicted with what was believed to have been his human, historical features, but, in the halo surrounding his face, three Greek letters point to his divine personal identity: O ΩN the Greek translation of the sacred Hebrew name of God, 'the One who is.' The letters are often included in the branches of a cross, reminding the believing beholder that the incarnate Word was also the Redeemer, who died a human death on the cross.

But clearly, artistic style and the personal inspiration of the artist were also determined by the spiritual purpose of Christian iconography. The challenge was in representing Christ not only as a historical figure of the past, but also the 'One-Who-Sits-On-The-Right-Hand-Of-The-Father,' as the 'One-Who-Comes-Again,' as the One whose body and blood is being partaken in the Eucharist. These artistic goals were achieved in a variety of ways, by representing Jesus as ineffably merciful or as the Teacher of ultimate truth, or as a stern Judge at his last coming. But whatever option was chosen by the artist, the image of Christ had to reflect his two natures, the divine and the human, and the belief that now Jesus is glorified, that in him and through him participation in divine life (*theosis*, 'deification') is made accessible to all the faithful.

One of the most striking long-term consequences of the struggle against iconoclasm is the appearance of the iconostasis, which today is a characteristic feature in Orthodox churches. In the early centuries in both East and West, the sanctuary was separated from the nave by a range of columns, or some other form of open or low barrier. Gradually, however, perhaps in reaction against the iconoclastic view which considered that the elements of bread and wine transformed into the Body and Blood of Christ were the only acceptable images established by Christ himself, an entire array of images was established on the sanctuary screen. By the end of the Middle Ages it had become a compact wall hiding the sanctuary which contained no images but only mysteries. However, the iconostasis also offered an entire program of images to the veneration of the faithful. The central or royal door of the iconostasis, through which Holy Communion is brought out and offered to the faithful, is always flanked by an image of the Mother of God on the left and Christ in Majesty on the right. Thus, the images of the First and Second Comings of Christ surround the intermediary period of time, which is that of the Church and of its central mystery, the Eucharist.

In the entire Christian East, the 16th century was marked by a disintegration of the Byzantine vision of liturgical art. In Russia also, post-Renaissance Western ideas began to dominate political thinking, literary styles, and artistic taste. Conservative forces reacted and provoked controversies but they lacked compe-

tence, consistency, and creativity. The events of the 17th century – the 'Time of Troubles,' the Polish invasion, the tragic schism of the Old Believers – were followed in Russia by the state-sponsored imposition of enlightenment ideas and style during the reforms of Peter the Great.

In many ways, those changes were inevitable, and were largely accepted by the popular mind. Today, the most cherished style of iconography in most Russian churches is connected only indirectly with the spiritual and theological vision described above. Similarly, it seems that the majority of Russians liked the polyphonic, essentially Western, style of liturgical music that has been accepted since the 17th century. However, precisely because it reflected a lasting theological vision and not only a style, the tradition of iconography never died completely. It was maintained by the Old Believers and is now seeing a revival. On the eve of the Revolution of 1917, the intelligentsia manifested a new awareness of the iconographic tradition shown for instance in E.N. Trubetskoi's public lectures on icons, published in 1915 and 1916. During the Revolution, and the anti-religious campaign that followed it, innumerable art treasures perished. Others, paradoxically, became much better known than before, because they were removed from liturgical use in churches, cleaned, and restored. The scholarly work, undertaken by many highly competent art historians, provided a new foundation for the initial, inevitably emotional and romantic intuitions of Trubetskoi.

Today, as Russians recover their cultural and religious roots, they begin to rediscover, together with millions of non-Russians who appreciate the legacy of Russian icons, the search for God as beauty which fascinated their forefathers when they visited Haghia Sophia in Constantinople in 988. They also can realize that the veneration of icons in the Orthodox Church does not involve an aesthetic experience only, but the discovery of human destiny as deification. The religious art of Orthodoxy is inseparable from the awareness that man was created as the image of God and that the saintly figures on the icons are manifesting a holiness which, in the mind of God, is destined to all and is actually being made accessible to all in the liturgy. 'The concordance between hearing and seeing, together with the appeal to all five senses that the apologists for icons were defending, came in the setting of worship, where the worshipper could smell the incense, be touched by the holy chrism, taste the divine Eucharist, hear the world of God and the chants, and see the icons.'[6]

Ecclesial Structures and Spiritual Tradition

By translating the Scriptures and all the liturgical texts into a language understood by the Slavs, the Greek missionaries indigenized Christianity. Thus, the whole set of perceptions which characterized Eastern Christendom in general and its vision of the Christian Gospel also were transmitted. Within that vision, the Church, as a historical reality and as an organization, was viewed not so much in terms of the categories of power – the latter being identified with the emperor and the state – as in terms of an experience of the Kingdom of God, revealed in the liturgy and the witness of the saints. Ecclesial structures and the officials responsible for them, the bishops, led by regional primates (metropolitans or patriarchs) were themselves seen primarily as ministers of the sacramental, particularly the eucharistic, needs of the faithful, united both locally and universally as a communion of faith. Furthermore, side by side with the official hierarchy of the Church, the personalities of the holy monks and the communities created by them were seen as necessary, prophetic witness to the coming Kingdom of God. The monastic world encompassing thousands of men and women was not competing for power with the bishops, but it represented something of a corrective to trends that would identify the Church as an institution of power only. Actually, especially in the 14th century, bishops themselves were chosen from among the monks.

In terms of canonical organization, Russia was an ecclesiastical province of the patriarchate of Constantinople from the time of the baptism of Vladimir of Kiev (988-9). Only in 1448, within Muscovy, did the Russian bishops begin to elect their own primate. Before that date, a prelate, appointed in Constantinople and generally a Greek by birth, was the head of the church, with the title of metropolitan, a common designation of provincial primates in the Byzantine church.

Paradoxically, the Church was the only national institution. There was no central political power over the numerous principalities, divided between the descendants of Riurik and

Vladimir, but this single institution, dependent upon distant and foreign Constantinople, stood above local politics and represented, in Russia, a vision of Christian universality.

The 13th century was a tragic one for the Orthodox East. Latin Crusaders had sacked and occupied Constantinople in 1204 and the Mongol Horde had conquered Russia, destroying Kiev in 1240. As a consequence of these events, a weakened patriarchate of Constantinople, first exiled in Nicaea (1206-61) and then restored in the old capital, adopted a more flexible attitude in Russia. A Russian, Cyril, was appointed metropolitan (1242-81), and a policy of alternating Russian and Greek candidates for the position became the norm. The see of the metropolitanate, meanwhile, was moved away from the old capital of Kiev, destroyed by the Mongols, to the northeastern grand-principality of Vladimir. Starting with Metropolitan Peter (1308-26), the head of the church kept his traditional title as metropolitan of Kiev and all Russia but resided in the newly prospering city of Moscow. All the immediate successors of Peter – the Greek Theognostos (1328-53), the Russian Alexei (1354-78), the Bulgarian Cyprian (1375-1406) and the Greek Photios (1408-31) – used their spiritual authority and political influence to enhance the prestige of the grand prince of Moscow, who, in spite of being a vassal of the Mongol khan, succeeded in establishing a permanent dynasty and in building the foundations of a future empire. Constant challenge came from the West, where the Lithuanian grand princes and the Polish kings were also gathering the principalities of the former Kievan Rus under their power. They were also succeeding occasionally in creating separate Orthodox metropolitanates in Lithuania and Galich. In 1386, however, as the Lithuanian grand prince Jagiello converted to Roman Catholicism by marrying the heiress to the Polish throne, Moscow became the indisputable centre of Orthodox Christianity. It felt betrayed when the Greek Metropolitan Isidore (1437-41) returned to Moscow from a unionist council in Florence, carrying the title of Roman cardinal. Rejecting Isidore, the Russians elected their own metropolitan Jonas (1448-61). In 1589, the metropolitan of Moscow, Job, was elevated to the rank of patriarch by the visiting patriarch of Constantinople, Jeremiah II.

The history of medieval Rus is full of political tragedies, foreign invasions, institutional dislocations and religious schisms. Yet, against this background of bloody divisiveness, one can also contemplate the saintly figures represented on the icons. In the saints, even more than in the institutions of the church, the people could discern preeminence of divine grace in their midst. In an iconographic form, they saw that which represented their own best aspirations and ultimate human ideals. Significantly, the first saints to be canonized were not resplendent bishops or triumphant princes: not even Vladimir, who would be formally considered a saint only in the 16th century, but his two sons, St. Boris and St. Gleb, who failed to resist assassination by a brother seeking political power. Their moral image, a glorification of non-violence and spiritual humility which Fedotov calls *kenosis*,[7] tells us much concerning the perception of Christianity in early Russia. Other princes would be canonized as martyrs of the Christian faith during the Mongol yoke, but only one, St. Alexander Nevskii, prince of Novgorod and grand prince of Vladimir (1252-63), was a canonized saint who was also politically successful. His success, however, was also seen in spiritual terms: it included the defence of the faith against Western intruders (Swedes and Teutonic knights) and a wise loyalty to Mongols who did not threaten the integrity of Orthodoxy in Russia.

But the traditions of spiritual beauty, referred to earlier, were inseparable from the other pole of Russian Christianity, monastic sainthood. In the midst of historical catastrophes and political ambiguities, the great figures of monastic spirituality maintained a remarkable integrity in their witness to the eternal, eschatological Kingdom of God.

The ideals described in the person of the second saint to be canonized in Kievan Rus were also ones of poverty and humility. St. Feodosii (d. 1071), was the disciple of a lonely hermit and cave-dweller, St. Anthony, and was called to establish the first monastic community in Kiev, the famous Monastery of the Caves, introducing the Rule of the Constantinopolitan Monastery of Stoudios. St. Anthony and St. Feodosii are thus venerated as the founders of monasticism in Rus. A history of the monastic saints living in the Kievan caves during the following two centuries constitutes the famous *Paterikon*. The community counted among its members a scholarly chronicler, St. Nestor, and

an iconographer, St. Alypius.

In northern Russia, the monastic tradition came later under the direct influence of hesychasm (from the Greek *hesychia*, quietude), or contemplative mysticism, which triumphed in Constantinople in the middle of the 14th century. This Byzantine hesychasm involved a theological justification of Christian religious experience. Its leader, St. Gregory Palamas (d. 1359) defended a monastic spirituality inspired by the ascetic struggle for sanctification (deification, *theosis*) of body and soul through divine light, the light that shone from the body of Jesus on Mt. Tabor on the day of his transfiguration.

The main intuition of the movement was that real communion with God is possible and desirable not only after death but even in this life, and that in virtue of baptism and eucharistic communion with the Body and Blood of Christ, all Christians are called to experience it. Modern theologians speak of this experience as realized eschatology. The saints are those persons who realized it more perfectly than others, so that divine presence shone through them and could be seen by others. The task of the iconographer consists in showing that presence, not only in the person of Christ, in whom the Second Person of the Trinity is contemplated directly, but also in the person of the saints, sanctified in their souls and bodies.

St. Sergei of Radonezh (ca. 1320–92), whose biography by a contemporary, Epifanii the Wise, has left us with a faithful image of his personality, is the father of Russian monasticism in the forests of northern Russia. The founder of the Monastery of the Trinity, now the great Lavra , Sergei lived during the period of Mongol rule. He was a desert dweller by vocation, although in Russia the forest replaced the desert known to early Syrian or Egyptian ascetics, and he sought solitude and prayer. Nevertheless, he was soon joined in his retreat by numerous disciples, including the painter Andrei Rublev, the creator of the famous icon of the Trinity, which belonged to the main church of St. Sergei's monastery. The charity of the great founder and his participation in political events, such as the blessing given to prince Dmitrii to fight the Mongols, were quite extraordinary. He became a leader and a model. Hundreds of monks followed his example and led the development and colonization of northern Russia. Each new monastic establishment implied the beginning of an agricultural enterprise, soon enriched by princely donations and the arrival of labor. Historians have compared enterprising Russian monks to the Western Cistercians.

It is impossible to list here all of Sergei's disciples and followers. They include St. Stephen of Perm (1340-96), the missionary among the Finnish tribes of the Zyrians; St. Cyril of the White Lake, a Muscovite who founded the great northern community near the White Lake (d. 1447); St. Ferapont, in whose monastery the famous frescoes of the painter Dionysii are still preserved; and hundreds of others. The monastic movement generated by and around St. Sergei, led to the creation of communities as far north as Valaam (St. Sergei and St. German) and Solovki on the White Sea (St. Zosima and St. Savvatii).

But with the growth of Muscovite Russia and the ever-increasing wealth of the monasteries, a major spiritual debate took place in the first half of the 16th century between the followers of St. Sergei. St. Nil of Sora (1433-1508) defended the original poverty of the community, within the framework of hesychast spirituality; poverty secured independence and freedom from the state. On the other hand, St. Joseph of Volotsk (or Volokolamsk) (1439-1515) defended monastic possessions as tools for social work and influence. The debate between Possessors and Non-possessors ended with a victory of the Josephites. The monasteries kept their wealth, but their social influence would soon be limited by the autocratic, Western-oriented, and increasingly secular policies of the Muscovite rulers. In the 18th century, the empress Catherine the Great secularized almost the totality of the monastic holdings. Meanwhile, the mystical tradition of hesychasm, going back to Nil of Sora and the original founders of Russian monasticism, would eventually be able to attract Kireevskii, Gogol, Dostoevskii, even Lev Tolstoi and other representatives of the modern Russian intelligentsia to return to the faith of their fathers.

The major inner crisis of Russian Orthodoxy would occur in the 17th century and would involve two types of Josephites which, each in its own way, wanted to maintain Holy Russia as the centre and last refuge of Christian Orthodoxy. The patriarch Nikon (1652-28), an authoritarian prelate, sought power over the tsar himself, but he also decided upon a minor

liturgical reform, which would put the Russian Church in formal harmony with contemporary Greek Orthodoxy. Millions of the faithful, led by people like the famous archpriest Avvakum, rebelled against this reform because it seemed to cast doubt upon the authenticity of the faith held in Holy Russia. The crisis led to the dead end of schism.

The secularizing measures taken by Peter the Great, including the suppression of the patriarchate in 1721, seemed to reduce the Russian Church to a purely state institution. And yet, during the short period of relative democratic freedoms that preceded the Revolution (1905-17), it succeeded in undertaking significant and creative reforms, which made the quick restoration of the patriarchate possible. Furthermore, under fierce persecution that lasted decades, the Church produced thousands of true martyrs of the faith and is reviving, with spectacular vigor, in the extraordinary years that mark the end of the second millennium.

There is no better way to understand the secret of these repeated survivals than by contemplating the beauty of the Old Russian icons, studying their original and their historical context, discerning the meaning of the tradition which created them. The theology in color that they carry with them proved to be more difficult to eradicate than any other manifestation of Christian culture, and it expresses not only a witness to the past, but also, quite certainly, a first-fruit of things still to come.

Medieval Russian Painting and Byzantium

Olga Popova

The Byzantine Commonwealth displayed an enormous cultural variety. Within this diverse world, Russia came to occupy an important place, and it is therefore essential for the student of Russian history to establish precisely which Byzantine sources nourished and enriched Russian culture, and to define the nature of the Russian response to the Byzantine creative achievement.

This brief review is an attempt to sketch in the broadest of outlines the relationship of Byzantine and Russian painting from the 11th to the 15th century, drawing not only on the icons displayed in this exhibition, but on a wide range of material including mosaics, frescoes, and manuscripts.

Attitudes to the relationship between Byzantine and Russian painting have varied considerably over the years. Even during the past five decades, the manner in which it was approached in Russian art historical studies has changed at least three times. In books and articles published during the 1940s and 1950s, and even to some extent the 1960s, it was officially approved policy to stress the exceptional originality of Russian art. The official position was that the national Russian school, although it derived from 10th century Byzantine painting, quickly broke away. Throughout the subsequent centuries, it developed independently not only of Byzantine painting, but also of medieval Christian art as a whole.

During the '60s and '70s, a different tendency appeared, and Russian works of art were examined in relation to artistic developments throughout the Byzantine world, taking into account the nature of international contacts between diplomats, church leaders, and artists. The main theme of such studies was the direct influence of Byzantine and Serbian art on Russian art, and the method was to find individual Russian works that fitted into the extensive Byzantine family, and then compare these individual works with a mass of Russian material which had previously been seen as purely Russian artistic tradition remote from the Mediterranean world.

This approach became extremely widespread, and was perfectly understandable since it was prompted by a desire to rediscover the patterns of international contact. In recent years, a new approach has become noticeable, in which all medieval Russian art is seen as part of Byzantine culture. Every Russian work, regardless of its content, its quality, or even its place of origin, is interpreted as a reflection of Byzantine ideas, and contemporary Byzantine ideas at that. As a result, the whole of Russian painting is simply seen as Byzantine. Even when Russian art is obviously provincial, this

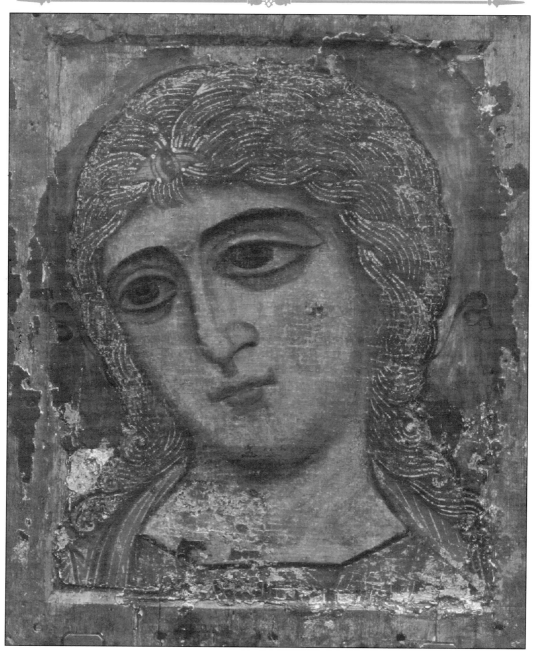

The Angel with Golden Hair, Russian Museum.

is not regarded as an impediment to the assimilation of contemporary Byzantine developments, but rather as as stimulus to their reproduction.

This new approach made itself felt with great emphasis and a certain tension, in the exhibition BYZANTIUM, BALKANS, RUSSIA: ICONS OF THE LATE 13TH TO THE FIRST HALF OF THE 15TH CENTURY, organized at the Tretiakov Gallery in Moscow for the 18th International Congress of Byzantine Studies in August 1991. It not only inspired the selection of objects, it was also the main thesis of the catalogue. In this article, the author proposes to set out her own views on the subject.

The world of Orthodox art was always a single entity. In the paintings of Cappadocian churches one can detect echoes of the art of the Byzantine capital. The painting of Serbia, Macedonia, Mt. Athos, and Russia is remarkably similar at certain periods, because it derives from the same Byzantine source. This much is common knowledge, and the question is not whether Russian art shared features with Byzantine art, but when, how, and in what ways these common features manifested themselves. From the extensive world of Byzantine ideas, precisely which ones were assimilated in Russia? Why were these particular ideas assimilated, and not others that existed in the Byzantine world at the same time? There is a further question that is of great interest, especially to Russians. Was there an art in medieval Russia so original, so distinct from that of Byzantium, that it could be called a national art? If so, where exactly would we find this unique Russian identity?

Let us begin at the very beginning, in the period between the 11th and the early 13th century, which is usually termed the pre-Mongol era. In fact, this period is far from homogenous, and the culture of 11th century Kievan Rus was very different from that of the principalities during the 12th and early 13th centuries. In Byzantium such diverse styles of art were produced during those years that historians have divided it into different periods: the end of the Macedonian period, in the first half of the 11th century; and the Komnenian period, from the second half of the 11th to the 12th centuries. Both coincide with Kievan Rus. Consequently, a number of different Byzantine styles penetrated Russia during the pre-Mongol period, and there can be little point in uniting them under the single concept of Byzantine influences.

Furthermore, one wonders whether there is any justification in describing the events occurring in the Russian artistic world at the time as 'influences.' It is clear from historical documents that Greek painters worked in Russia. Extant sources confirm that a whole series of mosaics and frescoes in the churches of Kiev, Vladimir, and Novgorod were produced by Greek artists. A considerable number, if not the majority, of Russian icons of the pre-Mongol period are practically indistinguishable from Byzantine examples. This is becoming increasingly clear in the light of present research, and in relation to the early period we can speak not so much of the influence of Byzantine art on Russian art, but of its almost total identity. We must admit that the painting of Kiev, Vladimir-Suzdal, Galicia-Volynia, and Novgorod during the pre-Mongol period is a part of Byzantine art in the fullest sense.

Yet this is true only of the early period, and it was never to be true again. During the 13th century, which brought catastrophe to both Byzantium and Russia, the relationship changed completely, and as Russia gradually recovered from the Mongol invasion it changed once more. In the early 14th century, we find evidence of individual Byzantine masters and teams working in Russia, and a few Russian monuments do resemble Byzantine prototypes. In the second half of the century there is another convergence of the Russian artistic environment with that of Byzantium, but without a total fusion. In the final decades, many Russian artists worked side by side with Greeks, from whom they learned the essentials of their craft without completely sacrificing their own identity. As we could see in the exhibition BYZANTIUM, BALKANS, RUSSIA, Russian icons stand out perceptibly. They have their own individual character.

Then came the 15th century, during which Byzantine painting was characterized by conceptions that were less broad and less elevated, but nevertheless display fine nuances in both style and iconography. For Byzantine art this was not a time of development but of decline; in Russia, however, the 15th century witnessed what was perhaps the highest concentration of spiritual and artistic forces. Russia remained faithful to the art of Byzantium until the empire fell to the Ottoman Turks. However, the flow-

ering of Russian art coincided exactly with the decline of Byzantium. Russian painting, for all its continuing similarity to Byzantine painting in terms of both style and technique, became an independent tradition of Orthodox art. Indeed, 15th century Russian art knew no equal in the Orthodox world. Russian art displayed original values, at the basis of which lay its own selection from the Byzantine, or rather the Orthodox Christian program, its own spiritual organization, and its own style. Byzantine art was only a memory, and Russian painting acquired a unique character.

Let us now trace this process through specific examples. We shall concentrate more on the early period, when the art of Russia was barely distinguishable from Byzantine art, and on the final phase, when the two had almost nothing in common.

During the early period of Kievan art, a single great monument stands out clearly from the rest: the Cathedral of St. Sophia, built and decorated with mosaics and frescoes during the reign of Iaroslav the Wise some time after 1037. This vast ensemble of paintings was executed by a team of excellent Constantinopolitan masters invited to Russia. The scale of the undertaking was so vast that some local artists may well have been hired as assistants. The entire scheme, including the iconographical program with its rich symbolic and theological conceptions and the overall style, is totally unified as a result of the spiritual and artistic premises of the Greek masters from the Byzantine capital. As a result, one of the most important Byzantine compositions of the late Macedonian period was created in Kiev.

It is now assumed that there are four great surviving monumental cycles that fall within the first half of the 11th century. These are the Kievan St. Sophia, the mosaics of Hosios Loukas at Phokoi, the Nea Moni on Chios, and the frescoes of St. Sophia in Ochrid. All four resemble one another in style and content. It is significant that at the very beginning of a new Christian culture in Russia, Kiev should have received something of outstanding significance from the Byzantine world. All talk of the provincialism of the Greek team must be firmly rejected, along with theories about the local Kievan nature of this art, its so-called Russian heroism, courage, and primeval force. Such painting belongs to precisely the same family as the three Greek ensembles mentioned above. All are individual works of art by different teams and none is completely identical. More important than their differences, however, is the fact that all these monuments share the overall vision and world view of Byzantine art during the late Macedonian period.

This art is instilled with an austere asceticism. Its images are elevated above the world of ordinary associations and its forms are static, schematized, and eternal. Everything is brought to a state of the highest order and peace. The hieratic artistic language of the 6th century mosaics of Ravenna and Sinai is resurrected, and even the same treatment of human form is repeated. In Byzantine art all the essential features were already found during the 6th and 7th centuries and were reborn throughout the following centuries. The ideological program that we see in the Kievan St. Sophia was also repeated through the centuries, but it found its most perfect embodiment during the 6th century, and again during the first half of the 11th century.

We believe that this program was spiritually the most intense of all those ever offered by Byzantine art. Although the traditions of classical antiquity remained alive in Byzantium, and later appeared in a variety of forms during the 6th and the first half of the 11th centuries, they were largely rejected in favor of a more purely spiritual ideal. This ideal demanded discipline, great austerity, and a rejection of emotional and psychological elements. Such exacting demands on the inner content of the image, such concentration on the attainment of its mystical essence, such absolute spiritual discipline and stylistic abstraction were all characteristic of the art of Kiev from the very beginning.

Nevertheless, the rosy faces, rounded cheeks, and plastic forms in St. Sophia are undoubtedly echoes of the painting of the Macedonian Renaissance from the middle of the 9th to the middle of the 10th century. These individual features do not, however, determine the overall conception, which is quite different from classicism. Values of another order are asserted: the tranquility of ideal aloof figures and ideal dense forms.

We believe that this circle of early Kievan art also includes the famous double-sided icon of the Mother of God, with St. George on the reverse, preserved in the Cathedral of the Dor-

mition in the Moscow Kremlin. It may perhaps have been painted by one of the Greek masters who worked in St. Sophia in Kiev. The similarity is striking and it is very possible that this superb icon was painted for Iaroslav the Wise, whose baptismal name was George.

Byzantine art of the second half of the 11th century is an entirely different phenomenon. Only two mosaic ensembles are known from this period, the time of the Komnenian dynasty. These are in the Church of the Dormition at Nicaea (1065-67) and at Daphni (ca. 1100). There was once a third, in Kiev, the Church of the Dormition in the Monastery of the Caves, to which Byzantine artists were invited in 1083. This monument was destroyed in 1941, during the Second World War, and its loss has impoverished our awareness of how Kiev once more took its place in the mainstream of Byzantine art.

A large number of illuminated Greek manuscripts of exceptional quality have survived from this period, such as the sermons of St. John Chrysostom in the Bibliothèque Nationale in Paris. The premises of this art differ greatly from the first half of the century. The proportions of human figures are now closer to life and their faces more individualized portraits. The figure is no longer a reflection of the spiritual element alone. It reveals other possibilities: intellectual, psychological, and emotional. The prevailing ideal is one of classical beauty, and the conventional and abstract style of the first half of the 11th century has been replaced by a more flexible style with fine nuances. All the figures and forms are filled with a subtle spirituality, and many special devices are used to achieve this. The main aim is the spiritualization of matter and of flesh, which retains its classical beauty. This is one of the many attempts made at different periods to find a balance between the human and the divine, the visible and invisible, and it represents an ideal harmony between them in which neither aspect dominates the other.

The icon of St. Peter and St. Paul from the Cathedral of St. Sophia in Novgorod may belong to this circle of painting. Its poor state of preservation, especially the absence of the original faces, makes it impossible to be certain. However, the proportions and the extant fragments of the garments suggest that it was painted not in the middle of the 11th century, as is usually suggested, but slightly later.

In its mature phase during the 12th century, Komnenian art again displays a different orientation from that of the previous period. It is extremely diverse and includes many tendencies, all of which attempt to enhance the spiritual element.

The main tendency that runs throughout the whole of the 12th century is still based on the classical style of Komnenian painting. However, the harmonious balance of the earlier period has tilted in favor of the spiritual. The earliest extant Byzantine monument of this type is again found in Kiev: the mosaics of the Monastery of St. Michael of the Golden Roofs (1108), now preserved in the Tretiakov Gallery. In comparison with the ensemble at Daphni, which was created not long before, we notice several changes. These herald the beginning of a new epoch with new ideals. The figures are shedding some of their classical beauty and acquiring a profound and contemplative spirituality. The style is becoming less harmonious, but more incisive, and it now seems less solid, even incorporeal. Once again Kievan Rus is at the center of the most crucial developments of Byzantine art, and judging by the painting that embellishes its monuments, the young Slavic state should not be seen as merely a provincial variant of events elsewhere.

Later monuments of this same type are also found in Russia. The frescoes in Vladimir in the Cathedral of the Dormition (ca. 1189) and the Cathedral of St. Demetrios (ca. 1195) are both the work of masters from Constantinople. Almost a century lies between these two ensembles and the Monastery of St. Michael in Kiev, and it is not surprising that the style was changing. It was becoming more fragile, even mannered.

In 1155, the Constantinopolitan icon of the Mother of God of Tenderness (*Eleousa*), known in Russia as the Vladimir Mother of God was moved from Kiev to Vladimir. Unfortunately, it is not known when it arrived in Kiev from Constantinople, but it seems to have remained there for some time. Judging from what we know of its history, as well as its style, it can be dated to the second quarter of the 12th century. The icon is among the finest Byzantine icons of this period, and became the most sacred palladium of the Russian state. It belongs to the same category of Komnenian art: a classical image endowed with a profound spirituality.

Several other famous icons in Russia would

seem to belong to this same category of classical Komnenian art: Christ Emmanuel flanked by two angels, probably painted in Vladimir during the late 12th century (Tretiakov Gallery); St. Nicholas the Wonder-Worker with Saints on the border, painted in Novgorod at the end of the 12th or the beginning of the 13th century (Tretiakov Gallery); and the early 13th century Angel with Golden Hair (Russian Museum).

While the most classical of Komnenian painting appeared in Russia during the 12th century, there was also another style that appears in a number of Novgorodian churches in the early 12th century: the frescoes of the prophets in the drum of the Cathedral of St. Nicholas in the Court (1113), the Cathedral in the Monastery of St. George (1119), and the Monastery of St. Andrew (1125). While there are differences between them, the differences are less significant than the similarities. Something quite distinct from the mosaics of the Monastery of St. Michael or the icon of the Vladimir Mother of God can be discerned, even though they were executed around the same time. These Novgorodian frescoes are similar to wall paintings of the early 12th century, such as the Asinou and Amasgou in Cyprus, and are late echoes of the great artistic phenomenon embodied in the mosaics and frescoes of the first half of the 11th century. As was always the case in Byzantium, the style did not die out, but continued as a secondary current distinct from the prevailing trend. This older style also existed in the second half of the 11th century, and even at the beginning of the 12th century.

A team of Greek artists from this circle came to Novgorod at the beginning of the 12th century, and evidently worked there for the first three decades. The team probably also included local craftsmen, but the character of the work was determined by the Byzantine artist in charge. It is pointless to look for a specifically Novgorodian style in these paintings. The art is essentially Byzantine, and it is not the location that is most important, but the stylistic orientation.

It is interesting that this art was already archaic when it was created. The masters who came to Novgorod may have been from the provinces. It is even possible that painting of this kind could still have been produced in Constantinople, more simple than the refined Komnenian style, but also more powerful and more able to recall the earlier legacy of ascetic spirituality. Why the art exported to Novgorod should have been of a different kind from that which found its way to Kiev and Vladimir is difficult to say, and in the absence of any documentary evidence it is difficult to see where an explanation could be found.

The next development in Russian painting appears in those monuments which survive from the 1150s and 1160s, the fresco ensemble in the Monastery of the Savior on the Mirozha in Pskov (1156) and in the Church of St. George in Staraia Ladoga (ca.1167). Master painters commissioned by Archbishop Nifont worked in the monastery in Pskov, and judging from the program of the painting, the general character of the frescoes, and the archbishop's own Greek origin, it is likely that he brought artists from Byzantium. The Greek team would hardly have been invited to work in one church only, since the journey was too long and dangerous, and we know that the painting in the Church of St. George in Staraia Ladoga was executed only a few years later. Until a full restoration of the frescoes in the Mirozhskii monastery has been completed, it is impossible to describe their style with precision. It is, however, clear that they represent a new phenomenon in both Byzantine and Russian painting.

This style was already tending toward the expressive; the highlights on the robes and the individual white strokes on the faces are executed with great energy. The overall balance is, however, not yet disturbed. Restraint and harmony still prevail in the scheme as a whole. Within two or three decades this harmony would be replaced by a more overt 'expressionism,' but for the time being only its first signs can be detected. In fact some features of this expressionism appear even earlier, notably in the miniatures of certain Greek manuscripts painted before the middle of the 12th century. But as a fully developed style, it appears during the 1160s at Nerezi, where it can be observed in the portrayal of some of the figures of the church fathers in the sanctuary. The frescoes of Staraia Ladoga, which also belong to this decade, and the paintings in the Mirozha monastery allow us to offer an even earlier date for the appearance of the new style between 1140 and 1150. Once more, it seems, we find in Russia the earliest monument of a

new artistic climate in the Byzantine Commonwealth.

The frescoes of Arkazhe (1189) and Nereditsa (1199) in Novgorod coincide with the late Komnenian period. One of its most characteristic variants was the dynamic or expressive style widespread in the painting of many different regions, including the frescoes in the Church of St. George in Rasa, in the Monastery of Vatopedi on Mt. Athos, and in Aquilea, as well as in a number of icons on Mt. Sinai. Evidently it was not confined to the imperial capital, but was widespread on the periphery of the empire as well.

Both Novgorodian ensembles are from the same circle. There can be no doubt that they were executed by visiting Byzantine masters, and indeed the work of at least one Greek painter in Novgorod at that time has been confirmed by archaeological excavation. The painting of Mirozha, Nerezi, and Staraia Ladoga represents the threshold of this art, and the closing decades of the 12th century witnessed the most vivid realization of the style. It is now far removed from classicism. Balance and calm have been abandoned. The figures are energetic, powerful, and at the same time dramatic, even tragic. Based on contrasts and dissonance, the style is full of an exaltation never before attempted. In everything there is an exaggeration of a type alien to Byzantium, and this exaggeration can appear harsh or even barbaric when compared to the classical ideal. However, despite its obvious departure from the Byzantine legacy, this style reveals a tense spirituality, achieved through the unusually strong radiance of light which the artist used as a means of depicting the transfiguration of the material world. Against the background of the characteristic nobility and harmony of Byzantine art, this artistic experiment is one of the most original. It was a search at the very limit of the permissible. It is once again an art of great asceticism, but now achieved at the price of exaggeration. This was precisely the type of art which found favor in Novgorod, and judging from subsequent artistic activity there, it was to appear more than once.

In order to understand the artistic atmosphere of medieval Russian towns, it is important to understand the differences between the Byzantine sources which nourished Vladimir and Suzdal on the one hand, and Novgorod and Pskov on the other. The frescoes of the Cathedral of St. Demetrios in Vladimir and Nereditsa in Novgorod were painted at the same time. Greek artists were invited to both places, yet they were exponents of completely different trends in late Komnenian art. Whether the choice was random or deliberate is impossible to say, for there is no documentary evidence. However, we suspect that it was not a random choice, and cannot be attributed to the personality of individual patrons. The final result coincides remarkably with what we know of the different cultural climates of the two towns: the greater aristocratic and classical nobility of Vladimir-Suzdal, and the austerity of Novgorod. Such characteristics survived for many years.

If it is interesting to know precisely which elements in Russian art were received from Byzantium and which were created in Russia, it is no less interesting to establish which of the Byzantine elements did not appear in Russia. This may be explained not only by random historical events, but also by the fact that the elements received were those which corresponded to local tastes and were therefore capable of being assimilated. In this connection, we should merely point out that two major examples of Byzantine art of the second half of the 12th century produced no response in Russia: the frescoes of Nerezi, apart from the church fathers in the apse; and the frescoes of Kurbinovo. Both are examples of late Komnenian mannerism, and it is possible that there was no place in Russia for an art so elitist and refined.

Between 1190 and 1220 there emerged a new stylistic trend in Byzantine art that provided a counterpoint to the dynamic style of late Komnenian mannerism. The new stylistic trends take a variety of forms because they derive from different sources. The late 12th century frescoes in the Monastery of St. John the Divine on Patmos, with their strong solid forms, bright rich colors, rounded pink cheeks, and heavy petrified matter, derive from painting of the first half of the 11th century, such as that in the Churches of St. Sophia in Kiev and in Ochrid. By contrast, the frescoes in the Church of the Mother of God at Studenica, painted at much the same time, display elongated figures, delicate modeling, and subdued shades of color characteristic of an ideal type of classical Komnenian art. These are new variations on old themes, and in both cases are imbued with a

calm dignity, pathos, and majestic monumentality. In all this we find a new approach, a break with the instability and disharmony of the late 12th century.

In Russia there are echoes of these developments, with such icons as St. Demetrios of Thessalonike (Tretiakov Gallery), the Iaroslavl Mother of God (Tretiakov Gallery), and the Angel with Golden Hair (Russian Museum) resembling the Patmos frescoes. However, one can occasionally detect a combination of the different styles that existed at the same time. The Angel with Golden Hair is similar to the angels in classical late Komnenian art seen in the frescoes of the Cathedral of St. Demetrios in Vladimir.

There is another circle of associations. Such icons as the early 13th century Deesis and Dormition from the Tithe Monastery in Novgorod (Tretiakov Gallery) are close to the frescoes in the Church of the Mother of God at Studenica. In both icons, the human proportions used by the Studenica masters are reproduced with remarkable accuracy.

It is interesting to note how readily Russian painting joined in Byzantine developments. We have already seen how some variations were executed in the Greek world and in Russia simultaneously. By Russian painting we are not, of course, claiming that all these works were painted by Russian masters. In fact, we are sure that many of them were painted by Greek artists working in Russia for Russian patrons. But we do not think that such distinctions are especially important at a time when Byzantine art presented a uniform face throughout the Orthodox world. Art was literally the common inheritance of all Orthodox people.

During the 13th century Byzantium and Russia both suffered catastrophes. Between 1204 and 1261, Constantinople and its territories were overrun and occupied by the soldiers of the Fourth Crusade, while Russia was laid waste between 1240 and 1300 by the Mongol Horde. Byzantine painting recovered remarkably quickly from the shock. In fact, its development was hardly interrupted at all. Greek artists were able to emigrate to neighboring Orthodox countries, such as Serbia, where they found patrons. Russia, on the other hand, took many years to recover. Art, and indeed the whole of life, seemed to stand still. Far from Mediterranean culture and the rest of the Orthodox world, Russia was isolated.

Admittedly, one link with Byzantium was not entirely severed. The Russian Church was directed by a metropolitan appointed by the patriarch of Constantinople. Even this link was precarious, however, since it was by no means always easy to reach Byzantium across the territories occupied by the Mongols.

The Mongol invasion came at the time when Byzantine art was again gathering its strength, as we can see in the frescoes at Milesevo, which were painted in the year of the invasion and represent a trend destined to nurture the classical ideal throughout the rest of the 13th century. It was quite distinct from the classical tradition of Byzantium and the Balkans, and is connected primarily with Novgorod and Pskov, and with a few individual works painted at the end of the century in Iaroslavl, Rostov, and Velikii Ustiug.

For all their differences, these icons share elements of a specifically Russian identity which emerged during the troubled century. The imagery is austere and the features sometimes bear the imprint of asceticism. There is no trace of a classical search for beauty and nobility of expression. The simplicity of the image is accompanied by great clarity and a naive freshness. All this is expressed in extremely laconic artistic language: simple lines, clear colors, elementary modeling, and generalized silhouette.

One is tempted to explain this artistic phenomenon in terms of the harsh realities of Russian life during the 13th century. However, while life may have been hard under the Mongol yoke, this is unlikely to be the sole explanation, and it may be that enforced isolation from Byzantium allowed the local mentality to exert itself.

For all the common elements described here, one can also discern a number of individual features, some of which clearly resemble the painting of Western Europe. The Mother of God on a red background from Pskov reminds one of Romanesque art. The famous Novgorod icon of St. Nicholas the Wonder-Worker painted by the master Aleksa Petrov in 1294 is reminiscent of figures in Gothic stained glass. Novgorodian merchants who visited Hanseatic towns such as Lubeck, where the Gothic church of St. Mary was already standing, may have absorbed this Gothic taste

and brought it home. Another slightly earlier Novgorodian icon of St. Nicholas from the Monastery of the Holy Spirit bears a certain resemblance to icons commissioned from Byzantine artists by Crusaders in Palestine.

Panels from Novgorod with red backgrounds form a special group, including the icon of St. John Klimakos, St. George, and St. Blasios in the Russian Museum, and Christ Enthroned and the Royal Doors from the village of Krivoe, now in the Tretiakov Gallery. Although this background is often regarded as characteristically Russian, in fact it appears to be of antique origin. There are Greek icons with red backgrounds, and the predilection of Greek artists for bright colors is well known. A striking example is provided by the red, blue, and green haloes with outlines in different colors which appear in Greek mosaics during the first half of the 11th century. While these Novgorodian icons might be linked with some local Greek or Balkan center of the 13th century, there is no need to claim foreign influence in this instance. It could represent a parallel development at a time when somewhat similar situations existed in different localities.

One of these icons, St. John Klimakos, St. George, and St. Blasios stands out clearly for the unusual intensity of its imagery. The extreme inner tension, concentration and extraordinary depth of expression in the eyes create an image of spiritual power and great asceticism. Is this the unique achievement of an unknown master? Or did a spiritual environment exist in Novgorod during the second half of the 13th century, created by the ideas of ancient eremetical monasticism and reflected in this icon? It is impossible to say, but the question remains one of great importance for the history of Russian spirituality.

Full-length frontal portraits of saints on colored or gold backgrounds are typical of 13th century Russian icons. Similar figures with laconic silhouettes are found in provincial Greek icons preserved on Mt. Sinai, as well as in the icon of the Archangel Michael from the Church of the same name in Iaroslavl.

The Archangel Michael (Tretiakov Gallery) displays characteristic features of Russian icons dating from the second half of the 13th century, including an active expression, lively eyes, strong facial plasticity, and unusually red cheeks. Similar features are found in the Mandylion from Rostov painted around 1300

(Tretiakov Gallery). Both icons are usually regarded as creations of a Iaroslavl school. In fact, while they do display some minor features of local taste, they are nevertheless in the mainstream of late 13th century Byzantine style, and can be compared with the frescoes of the Church of the Peribleptos in Ochrid, as well as with icons from Ochrid. They reveal the same energy, powerful form, intensity of color, general monumentality, and pathos. It is, however, typical that they are less concrete, less perceptibly corporeal than contemporary Byzantine work, and this greater abstraction and smooth rendering of form is evidently in keeping with Russian predilections.

The 14th century witnessed a flowering of Byzantine art through almost every decade. In Russia, too, it was a period of growth, although at first the process was slow and hard. The Mongol yoke was weakening, but had by no means disappeared. Independence did not come until the end of the century, and even then it was not complete.

The metropolitan see of the Russian Church had moved from Kiev to Vladimir, and then to Moscow where it was destined to remain. The center of artistic life shifted accordingly, and ecclesiastical, cultural, and diplomatic relations between Byzantium and Russia responded to the new focus on Moscow.

The period of office of Metropolitan Peter (1308-1326) coincided with the age of the Palaiologan Renaissance in Byzantium, while that of Theognostos (1328-1353) coincided with the troubled period in Byzantine history known as the 'Age of Ecclesiastical Disputes.' In the first of these periods, Russian art produced only a weak response to the Byzantine program. In the second the response was very clear, even if the output was small.

Few works of Russian painting survive from the first half of the 14th century, despite the number of centers where they were produced. Virtually nothing of what survives is dated. Attribution to the first third of the century or even to the following decades is a difficult and controversial task. Nevertheless, we shall now try to set out our understanding of the process.

Among early examples, there are none that correspond to the painting in the Pammakaristos or the Chora in Constantinople or, more broadly, to works of Byzantine art of this metropolitan circle. The phenomenon of the Palaiologan Renaissance during the first third

of the century was unknown in Russia. There was simply no environment in which it could flourish. However, individual echoes are found in certain Russian icons and manuscripts. These include the icon of the Trinity in the Cathedral of the Dormition in the Moscow Kremlin, which has only partially been freed of 18th century over painting but nevertheless promises to be one of the finest creations of Muscovite painting during the age of Metropolitan Peter. Undoubtedly Russian in execution, and already possessing subtle nuances of local imagery, it corresponds to some extent to the most classical painting of the Palaiologan Renaissance.

We believe that the full-length icon of St. Boris and St. Gleb from the collection of N.P. Likhachev (Russian Museum), belongs to the same phase of Russian painting, and that it was probably painted in Vladimir. It comes from Murom in the region of Vladimir , and was painted during the period before Metropolitan Peter moved his see to Moscow (ca. 1326). Traditional features similar to the style of 13th century Russian icons are combined with the lively, plastic painting of the faces. This suggests the artistic climate of the 14th century, since it is reminiscent, albeit indirectly, of the painterly conventions of the Palaiologan Renaissance. The icon was undoubtedly painted by a Russian artist.

This icon and another of the Dormition in the Moscow Cathedral of the Dormition are surviving witnesses to the artistic flowering which occurred during the time of Metropolitan Peter. Instilled with a radiant splendor, both icons produce an effect of freshness and optimistic elation. In both we find echoes of the classical harmony extolled in the art of the period of Andronikos II Palaiologos.

Artistic experiments of a similar kind were carried out in Novgorod at the same time. One such example is the miniature of Christ appearing to the myrrh-bearing women in the Khludov Psalter (Historical Museum, Moscow), where the image of the Savior is typologically close to that in the *Anastasis* of the Chora. Another example is the face of St. George, repainted either at this time or slightly later, on the 12th century Novgorodian dedicatory icon from the Cathedral in the Monastery of St. George near Novgorod (Tretiakov Gallery). Both works are similar to Byzantine painting of the same period.

It is interesting that we discover a more expressive version in the icons of Novgorod and a more classical version in the icons of Moscow and Vladimir. Such a difference seems to be characteristic of their local culture. But we would also want to stress that in Russia very few icons of this period survive. All of them are of local workmanship based on local traditions derived from 13th century Russian painting. They are all masterly and in all of them we find small nuances of mood and style that suggest a certain familiarity with developments in early 14th century Palaiologan painting. At the same time, there are also Russian works that bear no relation to Byzantine examples, such as the painting in the Snetogorskii Monastery near Pskov (ca. 1313), where a purely local artistic language was developed and proved definitive for two centuries of Pskovian art.

Very little of Russian painting has survived from the period between 1330 and 1360, the age of Metropolitan Theognostos, and the little that has survived is directly linked with the Byzantine world. Theognostos was a Greek from Constantinople and friend of the Byzantine humanist philosopher and historian Nikephoros Gregoras. He was close to the circle of Palaiologan humanists and was known for his anti-Palamite views during the ecclesiastical disputes of the period. At his invitation, artists from the Byzantine capital came to Moscow in 1344 to paint the Cathedral of the Dormition in the Kremlin. These frescoes have not survived and we have no idea whether they might have been in the style of Palaiologan classicism, or in the new 'post-classical' style. No definite answer can be given to the question, but it is nevertheless of great importance for the history of Russian art, as the frescoes must have served as models for a generation of Russian painters.

Two icons from the Moscow Kremlin that undoubtedly belong to this decade have survived. Both show the head and shoulders of the Savior. One of them, known as 'the Savior of the Fiery Eye' can be compared with certain icons at Decani. The image is typical of the tense and emotional style of the time. It was evidently created within the circle of artists working for Theognostos, and while we shall not venture to say whether the painter was Greek or Russian, we suspect the latter. The name 'the Fiery Eye' by which it is known is

late and does not fully express the idea underlying the image, more sorrowful than awe-inspiring.

The other icon of the Saviour, usually referred to as 'the Head and the Shoulders,' shows a high quality of execution and is also probably of Russian workmanship. There are various theories as to its origin. In our opinion, this icon was also produced in the circle of Metropolitan Theognostos during the 1340s, while the Greek team he had invited to Moscow was working there. The image of the Savior is of a type and style close to that of the Chora. But here one can also see abstraction, contemplation, and idealism. In our opinion, these qualities are explained not so much by Russian psychology, as by the slightly later date of the painting. There is another view, namely that the icon was painted sometime during the first three decades of the 13th century for the Cathedral of the Dormition erected by Metropolitan Peter in 1326. This would make it coincide directly with the classical phase of the Palaiologan Renaissance. Without developing the argument here, we would merely wish to state our opinion that the second icon is a product of the period of Theognostos and not of Peter, since it is consistent with the theological and cultural assumptions of a man of the Palaiologan Renaissance. In the complex and contradictory struggles of this period, a central issue was the role of contemplation as a means of obtaining spiritual enlightenment. This icon, for all its Renaissance legacy, contains something new that heralds the coming age, when the hesychast movement was destined to triumph despite Theognostos' personal opposition to Palamas.

Let us now imagine that the original Cathedral of the Dormition in the Moscow Kremlin was painted in this style, or a similar style, by artists from Constantinople. Would not Andrei Rublev have become familiar with 14th century Byzantine painting from these works? His Savior from the Zvenigorod Deesis would seem to be connected with the Savior of the Head and Shoulders in a number of ways.

In the second half of the 14th century, Russian art becomes even more complex. While relatively few monuments have survived, there are more than in the preceding period and they suggest a considerable variety of style. Russians were increasingly gaining their independence from the Mongols, and Moscow was becoming the metropolis of the nation. Relations with Byzantium were restored, probably to the level of the pre-Mongol period, and this affected all aspects of life including art. It was no longer a rare occurrence for Greek artists to come and work in Russian towns, or for icons to be brought from Byzantium to adorn Russian churches and monasteries.

In Byzantium, the victory of Gregory Palamas in 1351 had led to the complete triumph of hesychasm in both spiritual and artistic spheres. Art could now absorb the intellectual currents of the age, its fascination with the vision of God and the operation of divine energies as light. Painting could be spiritualized to an even greater degree. In consequence, Byzantine painting enjoyed an extraordinary flowering. Russian painting was in close contact with it, but by no means all the explorations and variations of the Byzantine artistic process were reflected in the north. Only a few can be distinguished, and whether this was a conscious decision or the result of historical circumstances is difficult to say. Examples of Russian painting which are similar to Byzantine painting are certainly well known, but purely Russian creations which correspond to Byzantine examples only on the most general level are no less remarkable, since they are the embodiment of Russian spirituality and perhaps of a purely Russian vision.

Many churches were painted in Novgorod, and in nearly all of them the masters in charge were visiting Greeks or Serbs. There was obviously more than one team. Artists from abroad worked in Russia in every decade of the second half of the century, and in the 1360s some very fine Greek masters painted the church in Volotovo, whose imagery and style are similar to the frescoes at Ivanovo in Bulgaria. In 1378 Theophanes the Greek painted the Church of the Transfiguration in Novgorod and provoked general amazement. He remained in Russia for many years and became celebrated in his lifetime for a tense, expressive, and mystical style of painting, an extreme form of Palaiologan art. It was rare enough in Byzantium, but it stands as a unique example in Russia. There were a few painters who tried to imitate him, but the imitations which do exist, such as the frescoes in the Church of St. Theodore Stratelates in Novgorod, are rather weak.

During the 1380s Serbian painters may have worked in Novgorod, at Kovalevo in 1380 and at the Nativity in the Cemetery (1381-82). Clearly Novgorod was provided with a variety of excellent painting imported from the south, although it consisted entirely of monumental cycles of a sort which has not survived in Moscow.

It is interesting that the icons found in Novgorod which date from the second half of the 14th century are nearly all of a local character. Most of these icons have little in common with Palaiologan painting. We find more animation, or more plasticity, or more refinement of image and style. In a few of them, we do not see direct analogies with any of the important elements of late Palaiologan painting. There may have been a few exceptions, but on the whole, Novgorodian icon painting remained a local phenomenon.

Much the same could be said of icons from Pskov. This characteristic and expressive style can hardly be associated directly with Theophanes the Greek or with any other Byzantine artist of the day. The energy and animation of the style is in keeping with the overall atmosphere of late Palaiologan art, but only in the most general way. This was a unique, local variation invested with striking freshness and sincerity. The the rules of style are first discerned at Snetogorii (1313) and had a remarkably long life. They are repeated almost exactly in the frescoes of Meletovo (1462-63), and are far removed from the main trends and central problems of Palaiologan painting.

The leading center of artistic production during this period was, of course, Moscow. Theophanes the Greek worked there as well as in Novgorod. Although he could not have been the only foreign master to do so, we do not now think that there were many artists from abroad working in Moscow in the latter part of the 14th century. On close inspection, the overwhelming majority of icons from Moscow and centers close to it turn out to be Russian. One icon that we believe to have been painted by a Byzantine master in Moscow is the large Praise to the Mother of God with the *Akathistos* from the Cathedral of the Dormition in the Kremlin. In our opinion it was created by a master from Constantinople, probably in the 1360s.

We shall not list all the icons of foreign workmanship that survive or are known from historical documents, since there are a large number. We shall merely mention one group, as it represents a great event in the history of Russian culture: the full-length Deesis on huge panels from the Cathedral of the Annunciation in the Moscow Kremlin. We believe that these icons, or at least most of them, were painted at the end of the 14th century by Theophanes. They were brought to the Kremlin during the reign of Ivan the Terrible from another church, possibly in Kolomna, where Theophanes had worked. There is a remarkable similarity between these icons and the Mother of God of the Don (Tretiakov Gallery), which is almost certainly also the work of Theophanes, even if there is no documentary evidence. Admittedly, its character is quite different from that of Theophanes' frescoes in Novgorod, which are more classical and moderate. There is no expressionism here; every element is subordinate to the harmony of radiant spiritualized flesh and material form. This was the main trend of late Palaiologan painting, and as an artist of quite exceptional talent, Theophanes had obviously mastered the style so much admired in his homeland.

There are a few more icons in the Tretiakov Gallery which are reminiscent of Theophanes and often ascribed to him. In our opinion, they are the work of Russian masters who followed Theophanes more or less successfully. They are as follows: the Dormition on the reverse of the Mother of God of the Don, the Transfiguration from Pereiaslavl, the Four-part icon, and the Six-part icon. The two latter icons have very close analogies to miniatures in Russian manuscripts of the early 15th century from both Moscow and Novgorod. They are characterized by a quick and expressive style, not as a response to any Byzantine monuments but as an exploration of the legacy of Theophanes the Greek.

We have left to the end a whole series of icons painted during the late 14th and early 15th century in Moscow and the neighbouring regions, as well as in northeast Russia, especially Suzdal and Rostov. Their individual differences cannot hide their essential similarity, and this constitutes the most precious aspect of the Russian contribution to Byzantine painting during the late Palaiologan period. It is also, by the way, the essence of the Russian contribution to Orthodox spirituality.

There are quite a number of these icons,

including: the standing St. Boris and St. Gleb from Kolomna; the Descent into Hell from Kolomna; the Mother of God *Hodegetria* from the Simonov Monastery, which St. Cyril of the White Lake kept in his cell; the double-sided icon of the Savior and the Mother of God *Hodegetria* from the Convent of the Intercession in Suzdal; the Trinity (ca. 1411), originally from the Trinity-St. Sergei Monastery; the Mother of God Enthroned with St. Sergei of Radonezh, now in the Historical Museum, Moscow; St. Nicholas of Zaraisk from the village of Pavlovok; St. Nicholas, the personal icon of St. Sergei of Radonezh; the Savior with Apostles from Rostov; and St. Nicholas and St. George from the Glushitskii Monastery.

These icons are reflections of the age of St. Sergei of Radonezh and his direct disciples. They all bear witness to the special atmosphere of unprecedented spiritual growth during his life (ca. 1321-92), which spread from his monastery near Moscow across the vast expanse of Russian territory. Eleven monasteries were founded by his disciples during his lifetime, and this monastic expansion coincided with the flowering of hesychast spirituality in Byzantium. In the Russian world, monasticism was somewhat less mystical than in Byzantium. The main emphasis was placed on contemplation and moral values, and the latter were considered as important as the former. This emphasis can be discerned in the written biographies of the saints, and it is also visible in icon painting.

Such icons reveal serene figures, compassionate faces, meek expressions, a sense of quiet, and a heartfelt passion. Sometimes the figures are so radiant, as in the Mother of God with St. Sergei of Radonezh (Historical Museum, Moscow), that they provide a perfect embodiment of spiritual world of St. Sergei. They are a direct and literal response to the example of his life and his teaching. In all these icons, we find similar stylistic features: flowing silhouettes, soft tones, simplified linear structures, smooth blending of color on the faces, and an overall harmony. While Byzantine painting also displays a sense of harmony, it invariably relies on the classical ideal. This accounts for the sense of volume and plasticity, and the richly nuanced painting with its multitude of shades and half-tones. Russian masters were obviously not concerned with classical norms. What is important is that they managed

perfectly well without them and succeeded with the means at their disposal to give expression to the essence of Orthodox spirituality.

In this connection, the icon of St. Nicholas that St. Sergei kept in his cell is of interest (Trinity-St. Sergei Monastery). It is a very simple kind of painting, reduced to essential elements, and it moves the spectator by its spiritual sincerity. St. Sergei's personal requirements were obviously very basic. He did not require icons to be rich and beautiful. The same can be said of an icon with a portrait image of St. Cyril of the White Lake (Russian Museum) which according to tradition was painted by Dionysii of Glushitsa (1362-1437), a follower of St. Sergei who founded a monastery on the bank of Lake Kubenskoe and was known for his humility and disregard for worldly possessions. On this small plain icon is a remarkably humble and compassionate image of a monk.

The fact that the personal icons used by Russian saints seem to have been very simple conforms with the character and spiritual image of the Non-possessors, who eschewed the ownership of property. However, a more aristocratic ideal was also created during these times of ascetic spirituality. Naturally, such icons were not painted in remote hermitages in the forest, but in the cities, among which Moscow was the most important. Other centers must have existed in Vladimir, Suzdal, Rostov, and Iaroslavl. The difference between such icons, wherever they may have been painted, lies only in nuances. In our opinion, such nuances depend not so much on the local school as on the particular qualities that the artists selected from the general range of spiritual and moral ideals. They could stress silent contemplation, the prayer of the heart, humility, meekness, or love.

The art of Andrei Rublev appeared at the beginning of the 15th century against such a monastic and artistic background. Preceding him was the life and spiritual experience of St. Sergei of Radonezh, who had died only a few years before. The monastic movement was gaining momentum when Rublev was young and Russian culture was experiencing a revival based not so much on political consolidation as on spiritual growth.

Andrei Rublev is known to have worked in Moscow with Theophanes the Greek in 1405. While he must have learned from such a famous Byzantine master, he absorbed nothing

of the exultant and expressive mysticism of Theophanes' frescoes. Perhaps this is because he worked with Theophanes in Moscow, rather than Novgorod and learned the classical Byzantine style that Theophanes used in creating the icons of the Deesis in the Cathedral of the Dormition and the Mother of God of the Don, a style involving form, plasticity, graduated modeling, and sculptural precision.

In Moscow, Rublev would have been able to study and contemplate the frescoes of the Cathedral of the Dormition, painted in 1344 by the team brought from Constantinople at the order of Metropolitan Theognostos. As we have suggested above, they may have been painted in a classical style recalling the Palaiologan Renaissance. Rublev would also have known the Byzantine frescoes in the Cathedral of the Dormition and the Cathedral of St. Demetrios in Vladimir, ideal examples of 12th century Komnenian style. Such were the classical sources of Rublev's art, and through them the same lessons could be learned in Russia as in Constantinople.

It was this heritage, the classical Byzantine foundation which Russian masters did not previously possess, that Rublev combined with the new Russian style. It needed a genius to create this ideal synthesis of all that was best from the entire 14th century, and Rublev was such a genius.

His painting in Russian towns and monasteries took place during the first third of the 15th century. The works that we can regard as either definitely or probably created by Rublev are: the miniatures in the Khitrov Gospel from the late 14th and early 15th century; the Zvenigorod Deesis from the early 15th century; the 1408 frescoes of the Cathedral of the Dormition in Vladimir; the 1408 icon of the Vladimir Mother of God; and the Trinity, painted either in 1411, or more probably, between 1425 and 1427.

The imagery is very close to the broad circle of Russian icons of the late 14th and early 15th centuries described above, which accompanied the growth of Russian monastic expansion associated with St. Sergei and his disciples. As for his style and his painting, they are so perfect that they surpass all the creations of this period in Russia except those of Theophanes the Greek. The content of his images is far more profound and more exalted than all the experiments by Russian artists of his circle.

Their silent contemplation reaches the heights from which the vision of the celestial world begins. What is more, the images are themselves the embodiment of the practice of the hesychast prayer of the heart. We venture to suggest that no one else reached such heights in either Byzantine or Russian art. This imagery is accessible only to a few seers of the Divine Light, the hesychasts, among whom his biography suggests St. Sergei should be numbered.

Another point must be stressed. All Russian painting of this type from the late 14th and early 15th centuries, including that of Andrei Rublev, has a parallel in the artistic phenomenon in the Balkans known as the 'Moravian school.' The similarity is superficial, however. While these paintings do share a soft image and a lyrical coloring, in Russia the style grew from monastic asceticism and a profound spiritual life. There was none of the secular element characteristic of Serbian painting.

Icon painting connected with Rublev and the masters of his monastic circle clearly dominated the first half of the 15th century. During the second half of the 15th century it became virtually the only artistic current. A great many icons survive, including whole iconostases like those from the Monasteries of St. Cyril and St. Ferapont, and large dedicatory or church icons from Moscow, the Trinity-St. Sergei Monastery, Dmitrov, Suzdal, and elsewhere. Compared with the icons of the age of Rublev, these are more refined. They have a touch of festive solemnity, compared with which the icons of the first half of the century seem modest. Style has become delicate and fragile, and all forms seem incorporeal. The smooth modeling of the faces is refined and almost transparent, which removes the pictorial surface from any sensual association. The intention is to ensure that nothing distracts anyone who looks at the icon from pure contemplation, but the bright resplendent colors are so beautiful that at times they seem unsuited to the world of spiritual concentration and monastic asceticism, even if they do suggest a perfect celestial harmony.

Generally speaking, these were the characteristics of late 15th century painting, although local variations still occurred in Novgorod and Pskov. The leading master of this style was Dionysii. His manner is well known, for quite a number of his works survive. Even if some of

them are attributed only to his workshop, their essential nature is no different. They are very similar to works that have been firmly attributed to his hand. Among the finest are portrait icons of great Russian saints and elders: St. Cyril of the White Lake, St. Dmitrii of Prilutsk, and the metropolitans Peter and Alexei. Their faces bear the imprint of a refined and aristocratic spiritual maturity, serene, and immersed in contemplation. The spiritual ideal that so enriched Russian art at the time of St. Sergei of Radonezh and Andrei Rublev has been preserved, but there have been changes as well. For all the spiritual concentration of the faces, there is something superficial in these icons. They are somehow too beautiful and resplendent, too rich and decorative.

In the work of Dionysii these various qualities can exist side by side. A master of exceptional talent who responded to all the main currents of church life in his day, he could not fail to respond to the most profound and serious of them, the teaching of St. Nil of Sora (1433-1508). St. Nil was yet another great Russian spiritual ascetic who followed the example of St. Sergei of Radonezh, a wilderness-dweller who retreated to a forest hermitage and taught the blessings of poverty and contemplation. Russia had gained a new teacher of moral purity, and Dionysii was not the only one who responded to his ideals. All Russian art during this time draws on the same spiritual source.

However, St. Nil was not the only pivot of spiritual life at that time. The other great figure was St. Joseph of Volotsk (1439-1515), who enriched monasteries and embellished churches and acted as a patron for Dionysii, rewarding him generously. In some features of his work Dionysii was clearly responding to Joseph's aims, and these were perhaps not always the best features. The outward brilliance, splendor of form, and aristocratic refinement undoubtedly instill his works with too great an awareness of beauty, and this is not always in keeping with the ascetic concentration on the faces of his portraits. Dionysii's art is an unusual compromise, an attempt to combine two elements which cannot be combined: an internal purity and an external ritualism.

To some extent he succeeded, although his followers did not. In the 16th century, the Russian church became entirely 'Josephite,' and the followers of St. Nil of Sora suffered a total defeat. This was a tragedy for Russian spirituality, and a tragedy for Russian painting, which lost the true depth of its spiritual image and acquired in exchange an external beauty and a ritual formula. Even after Dionysii there were exceptions, but while excellent icons were still painted during the later 16th and 17th centuries, the flowering was at an end.

THE SCHOOLS OF MEDIEVAL RUSSIAN PAINTING

Engelina Smirnova

In 1967, V.N. Lazarev delivered a report to Moscow University in which he described his alarm over the way in which Russian art history had been practised during the past decades:

'We have seen a recent trend which insists on the independence of Old Russian art, treated in complete isolation from the art of Byzantium and the Balkans. This . . . has taken such an extreme form that it has lost all historical perspective, and has ascribed incredible qualities to the painting and architecture of old Russia. Such an attitude is partly due to the surge of patriotism during the Second World War, when we lamented the loss of so many wonderful monuments. Even more crucial was the mistaken view of foreign influences imposed during the campaign against cosmopolitanism, when any links between Russia and either the West or the East were seen as "insults to the great culture of Russia."'[1]

While Stalin's obsession with pernicious cosmopolitan influences produced an especially dangerous and extreme form of censorship, the question of the origins and diversity of Old Russian art has been regarded for many years as of great significance for the cultural identity of the nation. The first attempt at scientific research was undertaken during the middle of the 19th century by the distinguished scholar D.A. Rovinskii. He argued from the experience of amateur collectors, mainly Old Believers, who tended to divide the old icons of their collections into groups, which they described as schools, styles, or manners depending upon the method of painting. Some of these stylistic tendencies were named after urban centres such as Novgorod, while others had the names of small towns such as Kargopol or Tikhvin, whose role in the formation of a style can hardly have been of much importance. A third group was named after regions such as Pomore, while terms like *Friazhskie*, derived from the word 'Frank,' pointed to stylistic influence from Western Europe without specifying an exact country. There were still other terms which bore the name of individual families, such as the Stroganovs, who were known for their patronage.

The early 20th century offered an opportunity to approach the problem of local artistic centres from a more historical perspective. At that time, many more ancient icons were discovered underneath later layers of renovatory painting and darkened polish. Once the original painting had been revealed, it was obviously easier to identify various stylistic qualities. Local variations were now connected with the major political and cultural centres of Old

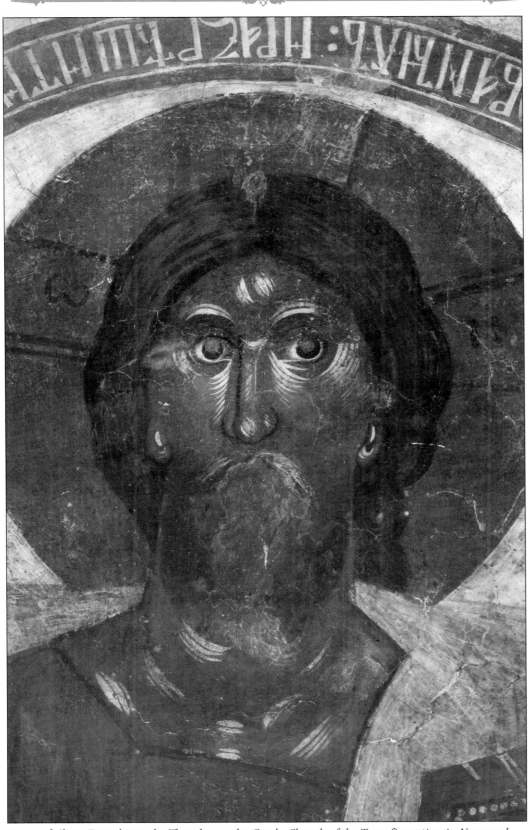

Fresco of Christ Pantokrator by Theophanes the Greek, Church of the Transfiguration in Novgorod.

Russia, such as Kiev, Novgorod, and Moscow, each of which was perceived as having evolved a specific painterly system or school.

The greatest scholars of the period, such as N.P. Likhachev and P.P. Muratov, tended to emphasize the Novgorod school as the most significant in the history of Russian icon painting. The political structure of Novgorod, with its popular assembly (*veche*) was seen as a democratic environment conducive to a specifically Russian spirit and creative energy. Art historians would even ascribe to Novgorod panels which were unquestionably of Muscovite origin, including all those painted by Dionysii during the late 15th century. The authority of Novgorod was raised still higher at the beginning of this century by the fact that Western painters such as Matisse saw similarities between the icons of Novgorod and the experiments of their own time.

Only during the 1920s, as a result of an extensive program of accumulation and restoration under the auspices of I.E. Grabar, did a clearer vision of other artistic centres emerge. Icons of the 11th and 12th centuries were discovered, and the specific characteristics of centres such as Moscow and Pskov began to be understood. At a later period, between the 1940s and 1970s, a great deal of new material was discovered by V. N. Lazarev, and most of the books on the history of Russian art were usually devoted to discussions of material relating to different schools.

Until very recently, the analysis of schools provided the main focus of Russian national art history. The topic was invariably included whenever Russian icon painting was discussed, and indeed the official cultural program since the 1940s stressed Russian national identity by accentuating the importance of local artistic currents, and emphasizing folk art as a formative influence in a national style independent of the Byzantine legacy. The glorification of local Russian schools of painting was encouraged as a vital expression of patriotism.

During the last few decades, however, Russian art history has become more objective. Emphasis has been attached not so much to individual centres of production as to more general developments throughout the culture of the medieval period. The main focus now is on the connection between Byzantine and Russian art, and on the assimilation of Byzantine ideas within Russian culture.

The unity of Orthodox culture is no less important than the diversity which can be detected in localized artistic production, and if Russian medieval culture is indeed a unified whole, then the local schools are no more than sub-cultures within it. These sub-cultures did not take shape all at once. Four separate stages in their formulation can be distinguished. The first stage embraces the 11th and 12th centuries, when Russia was absorbing a Byzantine culture which had already achieved an exceptionally high level of development. The stamp of local Russian culture may be more discernable in architecture, since this was more dependent on the individual taste of the princes and church hierarchs who commissioned it, as well as on purely material factors such as building technology and the individual skills of local craftsmen. The architectural forms favoured in Kiev and Chernigov are rather distinctive, as are those in some principalities of the west and southwest of Russia, especially in Novgorod and Vladimir. In painting, meanwhile, local features emerged through the selection of themes from the repertoire of Byzantine painting.

Two major regions were destined to play a prominent role in Russian art: Central Russia, especially Vladimir; and Novgorod. Each had its own specific cultural climate.

The culture of Novgorod during the 11th and 12th centuries was already marked by a spirit of austerity, which one can feel in the terse aphoristic phrases of the chronicles, and in the monumental simplicity of church buildings. The mentality of the city was based on an ideal of devotion to valiant exploits, constant struggle, and an intense spiritual effort to achieve divine grace. The painting which survives has an epic character appropriate to a society of warriors from the North, reflecting life in a harsh environment.

Painters in Novgorod assimilated a number of the trends from Byzantine art of the 12th century. Frescoes commissioned by bishops, such as those of the Mirozhskii Monastery at Pskov (ca. 1150) and the Church of the Annunciation in Arkazhe (1189), or by local princes, such as the murals in the Church of the Transfiguration on the Nereditsa (1199), are marked by expressive painting, by sharp alternate patches of light and shade, and by contrasting colors. The sorrowful faces of the saints which peer down with knitted brows, protruding lips

and a sparkling glare, conform to Novgorod taste.

The princes of Vladimir, however, regarded themselves as heirs to the honour and authority of the Grand Principality of Kiev, where dynastic relations and cultural initiatives were focused on Constantinople. As a result, the culture of the city was aristocratic and metropolitan. The compositions of the painting both in the Cathedral of the Dormition (1189 or 1193) and in the Cathedral of St. Demetrios (c.1190) are rhythmically subtle, and the faces of the saints reflect a pensive calm and inner concentration. The Byzantine icon known as the Vladimir Mother of God, which was brought to Kiev from Constantinople and transferred to Vladimir in 1155, became the highest embodiment of a culture which reflected more clearly than that of other Russian principalities the ideal beauty and harmony of the world as the creation of God. In the fulness of time, the culture of Vladimir and of other Central Russia centers was destined to be inherited and assimilated by Moscow.

The second stage in the formation of the schools occurred during the 13th century. The seizure of Constantinople in 1204 by the soldiers of the Fourth Crusade weakened relations between Russia and Byzantium, and local artistic tendencies began to emerge. Another change occurred when Vladimir lost its power to Rostov and Iaroslavl. The devastation of Russian territory by the Mongols during the 1230s and 1240s crippled the principalities of Central Russia for half a century, while Novgorod was fighting for its survival against the Teutonic Knights and had little time to construct or decorate churches. Nevertheless, the cultural life of Russia was not extinguished, and Novgorodian icons of the 13th century are especially impressive. They are distinguished by massive figures, austere faces, and bright colors applied with smooth, wide brush strokes. Cinnabar red plays a leading part in the color scheme. Icons from Rostov and Iaroslavl, on the other hand, are characterised by rhythmic, flexible drawing and delicate coloring. They are imbued with greater poetry than those of Novgorod, but their forms are heavier and their colors are deeper and more intense than those of the 12th century. The main tendency of Russian icon painting during the 13th century was to create a strong heroic image without psychological nuances, which could appeal to a wide public in cities, villages, and monasteries.

The third and most significant period in the history of the schools began with the revival of Russia at the end of the 13th century. The following two centuries witnessed the formation of the Russian state, and by the end of the 15th century a united Russia had emerged under the leadership of the princes of Moscow.

After the resumption of close contacts with Byzantium during the 14th century, Russia received new impulses which served to develop her cultural life. The Byzantine empire was now politically weak, but still retained its position as the unchallenged center of Orthodox religion and art. The most remarkable period in this respect was the second half of the 14th century, when Russia played a prominent role in Byzantine political life. Byzantine ambassadors arrived in Russia with gifts, including icons, and many Greek and Southern Slav craftsmen emigrated to Russia in flight from the Ottoman armies. Meanwhile, the teachings of Gregory Palamas had brought a creative renewal to Byzantine religious thought; the themes of the vision of God and the divine energies which revealed the light of the Transfiguration were destined to strike a responsive chord in Russia.

Towards the end of the 13th century, Central Russia began to recover from the ravages inflicted by the Mongol hordes, and this recovery occurred more quickly than in Kiev. In 1299 the metropolitan Maxim moved his see from Kiev to Vladimir, while his successor Peter chose to settle for the most part in Moscow. The presence of the metropolitan and the political manoeuvering of the princes of Moscow secured the triumph of the principality over its rivals Tver and Novgorod. Even if the Muscovite princes met with occasional setbacks, their influence and power grew with the century. Novgorod was annexed in 1473, and within three decades all of Russia was united under the grand prince of Moscow, Ivan III.

Several factors ensured the successful development of Muscovite culture. In the first place, Moscow inherited the artistic foundation of the Central Russian principalities of the 12th and 13th centuries. Secondly, through her own political and ecclesiastical contacts, Moscow had established strong relations with the patriarchate of Constantinople. Thirdly, it was during the second half of the 14th century that the

spiritual program of Gregory Palamas reached Moscow.

The history of Muscovite art dates from the first third of the 14th century, that is to say from the period of the fruitful partnership between Prince Ivan I and Metropolitan Peter. In 1326-27, the first stone building in Moscow, the Cathedral of the Dormition, was constructed. It was followed by several other churches, including the Cathedral of the Dormition. Judging from the archaeological remains discovered under the present building of 1475-79, the cathedral repeated the building and architectural schemes of Vladimir and Suzdal churches of the first half of the 13th century.

Unfortunately, very few 14th century Muscovite paintings can be dated before 1382, when the Tartar Khan Tokhtamysh ravaged the city. The first important ensemble of frescoes in Moscow had been executed by Byzantine artists from Constantinople in 1344. These painters were surely masters of the highest rank, for they were brought to Moscow by the metropolitan Theognostos, himself an educated Greek from the Byzantine capital. Within a short time skilled Russian painters also appeared on the scene. In 1344-46 the Church of the Archangel Michael was painted by Russian artists trained by Greek masters and commissioned by the grand prince Semen Ivanovich, while yet another team commissioned by the grand princess worked on the Church of the Transfiguration of the Savior in the Wood.

International contacts were of great benefit to Muscovite painting during the late 14th and the early 15th century, the period of its greatest achievements. The dedicated service of the metropolitan Cyprian, the immigration of artists from Byzantium and Southern Slav lands after the Ottoman expansion, and the energetic political activity of the grand prince Dmitrii Donskoi and his successors following the victory over the Tartar Khan Mamai in 1380 all contributed to the emergence of Moscow as one of the great centers of late Byzantine culture.

Among the artists who worked in Moscow during the late 14th and early 15th centuries Theophanes the Greek stands out as quite exceptional. Before he arrived in Moscow, he had worked in Novgorod where he painted the Church of the Transfiguration in 1378. He also spent some time in Nizhnii Novgorod. The great reputation enjoyed by Theophanes in Moscow is attested by his Russian contemporaries. A few extraordinary late 14th and early 15th century icons have survived from churches in and around Moscow, and even without documentary evidence they have been ascribed to him. The most important of these icons of the Deesis tier in the iconostasis of the Cathedral of the Dormition in the Moscow Kremlin.

A noticeable feature of Muscovite painting at the end of the 14th century is the great number of panels depicting the Mother of God. Their number and quality reflects not only her veneration as the guardian of Russia, a cult which began before the Mongol invasion, but also the impact of the miracle-working Vladimir Mother of God. In 1395 this Greek icon of the Komnenian period was solemnly transferred from the Cathedral of the Dormition in Vladimir to the Cathedral of the Dormition in Moscow, and thereafter was only returned to Vladimir for occasional and brief visits. The characteristic feature of many late 14th and 15th century Russian icons portraying the Mother of God is a lyricism often described as a joyous sadness, produced by the beauty of the silhouette, and an emotional range of colors.

A formative influence in the final evolution of the Moscow school of painting was exercised by Andrei Rublev (ca. 1360 – ca. 1430). Commissioned by the grand prince, he painted frescoes and panels for the churches of the Kremlin in 1405 as well as for a number of monasteries near Moscow, and around 1408 he also began work on the metropolitan cathedral in Vladimir. Poetic, contemplative images are characteristic of Muscovite and Russian painting in general during the early 15th century, and they were also known in other regions of late Byzantine culture, such as Serbian painting of the Moravian school. Nevertheless, the painting of Andrei Rublev and his associates is quite distinct. No other painters achieved the same rhythm or transparency of color, which gives the impression of being illuminated from within by a light from another world.

The painting of Rublev clearly reflects the classical legacy in Byzantine art, but it does not reproduce the sculptural image of classical forms. Instead, the rhythmic proportions of the stylized silhouettes give the impression that

the figures are projected onto a flat surface. Only the school of Moscow is so reminiscent of Byzantine art of the Komnenian period, an artistic system widely disseminated in Vladimir-Suzdal Rus. Both the composition of the faces in Rublev's work and the technique of applying thin translucent layers of paint suggest the technical tradition to which the Vladimir Mother of God belongs. The icon was well known to Rublev, and it is also no accident that his frescoes in the Cathedral of the Dormition of Vladimir closely follow the iconography of the frescoes in the Cathedral of St. Demetrios in the same city, which evidently served as a model.

Several teams of artists were influenced by Andrei Rublev, and it is likely that they worked under his direct supervision. During the first three decades of the 15th century, such teams painted a series of multi-tiered iconostases for the churches of Moscow and the surrounding districts. Although the icons of these screens are less refined than the images attributable to Rublev's own hand, they are none the less accomplished in their own way.

Muscovite artists of the later 15th century, among whom Dionysii was undoubtedly the greatest, developed and transformed Rublev's techniques. In their hands the theme of the Mother of God as the patron of Moscow and all of Russia continued to play a leading role, but now the hymns which glorified her began to be illustrated with increasing frequency. Indeed, verses from the *Akathistos* provided the main subject matter for the frescoes painted by Dionysii and his sons in 1502-03 at the Monastery of St. Ferapont. Scenes of miraculous apparitions of the Mother of God were also popular, as were symbolic compositions portraying her as a personification of the Heavenly Jerusalem, the Kingdom of God. In these paintings, the figures begin to appear elongated and almost weightless; their pastel colours, dazzling white and gold were chosen to reflect the divine light which permeates the holy images.

Particular attention during the later 15th century was given to the painted scheme of church interiors as a whole, including the frescoes and the iconostasis. By the beginning of the 15th century, the iconostasis had grown in height and number of tiers, and these were treated not merely as separate individual compositions, but as components in the whole scheme. At the end of the 15th century, it was accepted that the parts of church decoration should correspond harmoniously, both in symbolism and composition. The major churches of the Moscow Kremlin underwent reconstruction at the end of the 15th century, and along with their interior decorations and iconostases they were believed to glorify Russia in general, and the 'God-protected' city of Moscow in particular.

The ideals of moral self-perfection and monastic asceticism were already widely disseminated in Moscow by the end of the 14th century, and Muscovite artists and patrons became enthusiastic towards the end of the 15th century for portraits of church leaders and holy monks. In the late 15th and the early 16th century, Muscovite artists painted several icons of important figures in the history of Russian monasticism, including pupils and followers of St. Sergei of Radonezh who were commemorated for having founded monasteries, and for inspiring the people by their sanctity, their miracles, or their intercession in wars and political disputes.

The territories of Novgorod escaped the Mongol occupation during the 13th century, and prospered during the 14th century. Among the many reasons for this success were access to the natural wealth of the northern forests, lakes, and rivers, and a network of trade with the European cities of the Hanseatic League. Novgorod had a public assembly (*veche*) of its own, and a secular executive authority presided over by a governor and a military captain. In this system, land-owning boyars and merchants possessed great influence, and the people as a whole played a role in the political life of their city. Many churches in Novgorod were constructed and decorated with funds collected by people living in the area where the church was being built. At other times the funds were provided by boyar or merchant families. The most powerful figures in Novgorod were churchmen, however, and there were a great many churches and monastic establishments throughout the vast territory under Novgorodian jurisdiction. It was the archbishop of Novgorod and his closest associates who commissioned the most important churches, summoning whole teams of builders and painters, as well as scribes for copying and illuminating manuscripts. Representatives of his court also took part in deciding the iconographic and symbolic programs with which

churches should be painted, and through their mediation Byzantine masters were often invited to participate.

Between the beginning and the middle of the 14th century, the contribution to the art of Novgorod made by the archbishops Basil (1330-52) and Moses (1325-29; 1352-59) was considerable. Judging by the few icons, illuminated books, and examples of applied art which have come down to us, the art of Novgorod had no sooner based itself upon local tastes than it came into contact with contemporary Byzantine Palaiologan style.

During the second half of the 14th century, Novgorod maintained contact with Byzantine art mainly through fresco painting, and the expressive trend in Byzantine art can be seen in the paintings in the Church of the Dormition in Volotovo from 1363, which was unfortunately destroyed during the Second World War, in the Church of the Transfiguration in Elijah Street, painted by Theophanes the Greek in 1378, and in the Church of St. Theodore Stratelates on the Brook, painted the late 1370s. The frescoes of the Church of Transfiguration in Kovalev (1380) specifically reflect the classical trend of Byzantine-Slav monumental painting, while the Churches of the Nativity of Christ in the Cemetery and the Church of the Archangel Michael at the Skovorodskii Monastery (1400) already display the lyrical intonations which were to become characteristic of the art of the 15th century.

During the 15th century, artists in Novgorod began to approach monumental wall painting as a form of panel painting. The paintings in the Church of St. Sergei of Radonezh at the archbishop's quarters (ca. 1460), as well as in the Church of St. Symeon the God-Bearer at the Zverin monastery (ca. 1467), and in the Church of St. Nicholas in Gostinopole (ca. 1475), seem very much like panels produced on a monumental scale .

At the same time, popular taste had a much greater impact on panel painting in Novgorod than on monumental painting. If we compare Novgorodian panels with their Muscovite equivalents, they seem more provincial but also more expressive. They are characterised by heroic intonations, by clarity of composition and by carefully constructed geometric forms. They have the characteristics of a tradition which spread throughout the trading quarters before being systematized and polished in the workshops at the court of the archbishop.

Ordered compositions composed of several saints are very typical of Novgorod panels, and are sometimes employed as expressions of precise ideological programmes. They usually include the saint to whom a specific church or chapel was dedicated, and were placed in the local tier of the iconostasis, or elsewhere in the church. In Novgorod and the surrounding regions, many churches constructed of wood or even of stone lacked monumental painting, and such icons often took their place. Images of St. Paraskeve and St. Anastasia usually appear together. The citizens of Novgorod venerated the two martyrs as healers who came to the aid of women, but also saw them in a more general sense as symbols of the great events in the history of salvation. According to tradition, St. Paraskeve was born on Friday, and her nickname *Piatnitsa*, meaning 'Friday,' links her with the suffering of Christ on Good Friday. The name Anastasia is the Greek word for 'Resurrection.'

The people of Novgorod created some of their own iconographic representations, but within generally accepted Byzantine norms. One of the most famous of these is the depiction of the miracle performed by the icon of the Mother of God, when the Novgorodians repulsed the army of the Suzdal prince in 1169. Traditional Byzantine compositions often received quite peculiar interpretations in Novgorod. In one of the depictions of the Dormition, the Apostles are not included, and a special emphasis is given to the role of the bishops who recorded the event: James of Jerusalem on the left, and Ierotheos, or Timotheos on the right. A heightened interest in the images of bishops was quite natural in Novgorod, where the bishop possessed a supreme authority.

The lyricism characteristic of the art of Moscow and of Byzantine painting during the Palaiologan period found no reflection in the icons of Novgorod. Even the images of the Mother of God with the infant Christ show her mournful courage at the thought of suffering to come, rather than maternal tenderness or aristocratic beauty. Instead, the icons of Novgorod are noted for symmetrical compositions, clear-cut drawing, and brilliant colors, with strong contrasts of cinnabar red, greenish-blues, golden-ochers, browns, and violets. By the end of the 15th century, tastes were changing, compositions became more rhythmical

and refined, and forms grew softer to the point of delicacy, but they never lost the peculiar expressiveness so characteristic of Novgorod.

The art of Pskov is a quite unique phenomenon, which seems to reveal the mysterious meaning of sacred history and the mystical inner light of the personalities depicted. Hence the excited poses of the saints, their quick agitated movements and thin dark faces, the obscure themes and the edifying parables. It seems that Pskovian religious thought was fully expressed not in verbal categories but in pictorial form, although among the monasteries of Pskov there may have been oases of theological speculation which are still unknown to us. It is interesting that the late 15th century thesis of Moscow as the Third Rome first appeared in Pskov, and that during the 16th century Pskov painters reveal a thorough knowledge of iconographic subtleties.

In general terms, the social order of Pskov was very close to that of Novgorod, with a powerful church hierarchy and a vigorous public assembly (veche). For many years Pskov was politically subject to Novgorod, but even after 1348, when Novgorod relinquished its authority over the citizens of Pskov and no longer appointed governors (posadniki), Pskov remained within the diocese of Novgorod and was described as 'the younger brother.' In Pskov, however, the public played a greater role than in Novgorod, since Pskov did not have a powerful centre like the archbishop's court to regulate both political and cultural life. Some icons and manuscripts from Pskov bear inscriptions describing how they came to be commissioned, and these indicate the role of church wardens, priests, and ordinary parishioners who had collected money to finance the projects.

During the 12th century the culture of Pskov was indistinguishable from that of Novgorod. The oldest stone construction to have survived in its original form, the cathedral in the Ivanovskii Monastery, is merely a simplified version of a large Novgorodian six-pillared church of the early 12th century, and such common features continued to be found even in later periods. The culture of Pskov continued to develop throughout the 13th century, a period from which very few examples of its art survive, and then matured during the 14th century. The distinctive iconography of Pskov emerges in the decoration of churches such as

the Nativity of the Mother of God in the Sneto-gorskii Monastery (ca. 1313), where the idea of the miraculous intercession of the Mother of God is expressed by a unique fresco at the end of the apse. She stands with her right palm turned to the spectator and the infant Christ on her left arm, and in this way the image combines the two iconographic types: the Orans or Great Panaghia who prays for humanity, and the Hodegetria who formally presents Christ to the world. Here one can also see the composition known as the Pokrov or 'Protecting Veil of the Mother of God,' which recalls a miracle which took place at the Blachernai church in Constantinople, along with a number of other allegorical scenes in praise of the Mother of God. The western part of the church is occupied by a detailed composition of the Last Judgement, illustrating texts from the Apocrypha frequently employed by the artists of Pskov.

Frescoes painted in 1464 for the Church of the Dormition at the village of Meletovo, near Pskov, display a unique iconography, including a series of vignettes illustrating themes borrowed from rare literary sources like the Limo-nis, a collection of stories about monastic life based on the Paterikon composed at the Monastery of St. Catherine on Mt. Sinai. The ideas permeating the decoration of the Mele-tovo church repeat the main theme of the entire Pskov painterly tradition. They evoke the rule of the cosmos by the Divine Wisdom, the mysterious power behind the events of history which reveals itself only to the believing heart.

The themes of Pskovian icons are less diverse than those encountered in monumental painting, since icons were subject to a much more rigorous canon. The subjects chosen are similar to those encountered in Novgorodian icons: St. Nicholas, the Prophet Elijah, warrior saints, and female martyrs were among the most popular, along with Christ and the Mother of God. However, the different iconography employed by painters creates a quite different impression. The famous dedicatory icon from the Church of St. Barbara, for example, which dates from the late 14th century and is now in the Tretiakov Gallery, shows not just a full-length static figure, as was usual in Novgorod, but a series of figures in action. It depicts the triumph of St. Barbara: Christ Emmanuel stretches out his hands above her head and angels fly towards her, while the

martyrs Paraskeve and Uliana on either side of her seem to be lost in a mystical conversation.

Many details in the imagery of saints underline the fortitude and heroism of their exploits. St. Demetrios of Thessalonike is portrayed in a 15th century icon as spiritually alert, his dark face reflecting an intense concentration. In his hands he holds a massive, richly decorated sword and a cross, the symbols of his own martyrdom and the sacrifice of Christ.

The identity of the Pskov school of painting was formed only gradually. In works of the late 13th century and in some icons of the first half of the 14th century, a very distinctive and characteristic combination of dark-red, brown, and deep-green is used, often overlaid with a dense net of golden lines. This range of colors was popular in Byzantine art of the 13th century, and penetrated the art of Pskov to such an extent that it became an established feature of the local style, and was repeated with minor variations throughout the 14th, 15th, and even 16th centuries.

By the beginning of the 14th century, the imagery had become more expressive, and the intense spiritual emphasis more accentuated. The dynamic graphic highlighting scattered on faces and garments, as well as on the ledges of rock formations, is a prominent component of painting in Pskov, and was a response to the motifs of Byzantine art during the second half of the 14th century. As a consequence of the victory of hesychasm, the theme of the Divine Light which illuminates the universe became central to religious thought, and therefore began to influence painting as well.

Another center of artistic production was Tver, a city which played a very considerable role in the political life of the late 13th and 14th centuries, when its princes were rivals of the princes of Moscow. After the Mongol invasion, construction in stone had resumed more quickly in Tver than in Moscow, the first stone church being erected as early as 1285. According to chronicles and other sources, monastic life in Tver was highly developed and contacts were maintained with monastic centers throughout the Orthodox world, especially with the famous monasteries on Mt. Athos. A remarkable episode in the chronicle of 1399 recounts how Mikhail Aleksandrovich, the prince of Tver, received an icon of the Last Judgement as a final blessing from the patri-

arch of Constantinople. The story reveals the emphasis given to humility and repentance in the spiritual life of Tver, and the importance of contemplative prayer offered before icons. The court of the prince with its aristocratic refinement and the monasteries with their austere spirituality together provided an extraordinarily influential model which left a specific imprint on the culture of Tver.

Since Tver lost the political struggle with Moscow, its churches and monasteries were burnt and much of its culture has disappeared from view. We can see traces of its former grandeur, but the few monuments which survive belong to a provincial variant of the style. Some of the surviving icons from Tver resemble Novgorodian prototypes with their massive figures, broad forms, and bright colors, but they also possess individual features of their own. A remarkable pigment, almost white, was used in the painting of faces, and probably repeats a device employed by some Byzantine masters during the late 13th and early 14th century. Another feature is a pensive, austere facial expression, which might be explained by artistic fashion, or by some nuance of local piety.

The status of local centers of culture within the unified Russian state was transformed during the 16th and 17th centuries. Distinctions became less perceptible, although they did not disappear entirely. New centres and artistic formations were emerging, and common ideas and stylistic devices became more important than individual local characteristics. These two centuries form the final or fourth period in the history of the Russian schools of painting.

During the first three decades of the 16th century, a period which coincides with the reign of the grand prince Ivan III (d. 1505) and his son Basil III (1505-33), one can find similar characteristics in the works of various regions: an emphasis on elegant composition, calm facial expression, and translucent color with gold ornament. These features developed along the lines elaborated by Dionysii, although his contemplative mood and light touch were replaced by an exaggerated fascination with external magnificence. Such features can be seen not only in the icons of Moscow, but also of Novgorod and Pskov, even if some individual features of the local schools survived.

During the 16th century, the circumstances

of political and cultural history brought the two major traditions of painting from Novgorod and Moscow closer together. Between 1526 and 1542, Archbishop Makarii played a significant role in the development of Novgorodian culture. When he moved to Moscow in 1543 to become the metropolitan of Russia, he was guided and inspired not only by the cultural inheritance of Moscow, but also by the traditions of Novgorod where he had spent so many years.

After the disastrous fire during the summer of 1547, Ivan the Terrible invited painters to Moscow from various Russian cities, particularly Novgorod and Pskov, to repair the damage to the churches of the city. He sought to enhance the prestige of his state as a glorious successor to the old Russian lands and ordered sacred relics and venerated icons to be brought to the capital from Vladimir, Novgorod, and other ancient centers. Many replicas were made from these icons, and while some of the originals were returned to their place of origin, others remained in the capital. When the artists which Ivan had summoned to the capital returned to their native cities, they brought with them the new experiences they had acquired, a process which does much to explain the gradual convergence of local schools.

The attempt to provide a visual account of the details of Orthodox doctrine also encouraged the elimination of stylistic differences throughout the 16th century. The illustration of hymns like the *Akathistos* changed the very essence of the icon, which began to lose its position of intermediary between the believer and a heavenly archetype, and became instead the demonstration of an ideological formula or concept.

Some of the most complex 16th century compositions based on liturgical texts and hymns are found in the Cathedrals of the Dormition and the Annunciation in the Moscow Kremlin. Some icons of this sort were ordered in Moscow from painters who came from Pskov, and many are highly complex, with multi-figured allegorical compositions and an abundance of narrative and symbolic detail. Nevertheless, they retain their rhythm, contour, and elegant silhouette, and possess a clarity of colour with an abundance of white and gold. A number of especially beautiful compositions are balanced by shining white churches sur-

mounted by brightly coloured roofs crowned with golden cupolas. In these examples, the styles of more than one school can be discerned, and it is not surprising that arguments continue as to whether icons like the *Pokrov* (Cat. No. 53) from the N.P. Likhachev collection, the Vision of John Klimakos and the Vision of Evlogii (Cat. Nos. 51, 52) should be ascribed to Moscow or Novgorod.

A convergence of styles also resulted when masters from different regions came together to work on a single iconostasis. By the 16th century, the iconostasis consisted of many tiers constructed on an imposing scale to conform with the increased size of church buildings, and the size of the structure and the number of artists required explains why icons representing various styles can be found in a single program. For instance, the Moscow tradition is revealed clearly in the Savior in Glory from the Cathedral of the Dormition in Tikhvin, whereas the Nativity of Christ from the festival tier of the same iconostasis displays stylistic features of the local district or possibly of Novgorod.

During the 16th century, painting flourished in provincial regions, especially in the far North between the White Sea and the White Lake. The western part of these lands belonged to Novgorod, whereas the eastern part had close contacts with Rostov and later with Moscow. To this peasant culture, with remote monasteries and clusters of villages situated at great distances from each other, icons were brought from metropolitan centers. Local styles of painting gradually began to appear and even to flourish during the 16th century. The art of the region under the influence of Novgorod naturally drew upon Novgorodian tradition, while being at the same time deeply permeated with folk elements. At the settlements along the banks of the Northern Dvina, and in the northern city of Vologda in particular, connections with Central Russia were strong and icons were more monumental and imposing.

Although the cultural life of the provinces persisted throughout the 16th century and local painting continued to develop, the integration of the local schools was marked. Now that the princes of Moscow had unified Russia under their own authority, the centralization of art was perhaps inevitable. The best painters were attracted to the courts of the tsar and the

metropolitan in the Moscow Kremlin, where the best minds addressed the problems of iconography. It is not surprising, therefore, that yet another artistic movement emerged in 16th century Moscow. It was a variation of the culture of the capital and it has been called 'Stroganov,' a name which was first used by private collectors during the 18th and 19th centuries. The Stroganovs were merchants and patrons of the arts who owned lands in north west Russia, in the region of Solvychegodsk, and who patronized Moscow artists of a certain type. Many masters of the Stroganov school signed their names of the reverse of their panels, and archival documents make it clear that these painters worked mostly in Moscow at the court of the tsar, and not on the Stroganov estates as earlier collectors and scholars had assumed.

The figures depicted on Stroganov icons are elongated, with high waists and small hands. Their feet scarcely touch the ground, and their arms are very frequently raised to the chest in a gesture of prayer. Their round faces have small features and glitter with the subtle distribution of white highlights; their garments are elaborately ornamented, and enriched with borders of pearls and precious stones. The painting is always delicate and detailed, and the fine drawing is achieved by using brushes of the thinnest hair. The backgrounds are generally a rather dense and dark olive color, offset by sparkling gold haloes and ornaments, while favourite colors for the garments are red, pink, and blue. As a rule, these icons were the size of devotional books, since they were intended for private prayer and for close inspection in the home or private chapel. But even when Stroganov masters painted a complete iconostasis, such as the one made in 1627 which survives in the Church of the Deposition of the Robe in the Moscow Kremlin, their icons retain a private quality and a sophisticated miniature style.

Stroganov icons are far removed from the Byzantine tradition. They are rather precious and make no attempt to reproduce hellenistic proportions in the figures, or antique and classical motifs in the architectural compositions behind them. Their dark backgrounds, unlike the gold used in earlier centuries, does not convey an idea of divine light and infinite space. These are works of the late Middle Ages, and they resemble late Gothic or Persian miniatures.

What is surprising, however, is that these icons do represent an attempt to revive the Byzantine tradition in one specific sense: by creating an image which could serve once again as an object of prolonged quiet contemplation, as a mediator in the communion with the divine world, and a link with a heavenly prototype. Indeed, the quiet contemplation and precious refinement of Stroganov icons is a conscious attempt to recreate a celestial beauty.

The Stroganov school had a long life during the 17th century, and several of its features were later adapted by a new generation of painters, first among whom was Semen Spiridonov Kholmogorets. The subtle gold-embellished miniature painting of these 17th century icons was perceived as the very essence of Russian icon painting throughout the next two centuries. This was the source that nourished the famous icon painters of the 19th and 20th centuries from the villages of Palekh and Mstera whose style is so popular even today. In addition, the thoughtful faces and smooth silhouettes which can be seen in the secular Russian painting of the 19th and 20th centuries, produced by Aleksei Venetsianov or Pavel Kuznetsov, continue a tradition which can be traced back through the miniature icon painting of the 16th and 17th centuries to the ideals of Dionysii and Andrei Rublev.

The history of local centers of painting concludes with yet another school associated with the Armory in the Moscow Kremlin, in close proximity to the court of the metropolitan. Simon Ushakov stood at the head of this school, and elaborated its artistic principles and trained a host of its artists. The most active period in Ushakov's career stretches from 1660 to 1680, and the works which emerged from the Armory during this period speak with a markedly different accent from anything seen previously. The naturalistic forms modelled in soft gradations of light and shade and the accurate representation of the eyes reached Russian painting from the West, probably from northern Europe. As has been noted recently, the icons of the Armory resemble portraits by Memling, with which Russian painters had evidently become acquainted through some unknown intermediary. It is remarkable that the faces depicted in this naturalistic manner are combined with a traditional formal background and clothing, while the whole image is suffused by an unnatural light, resulting in an uneasy and incomplete fusion of East and West.

The art of Simon Ushakov and his followers is parallel to the important church reforms instigated by the patriarch Nikon during the 1650s, with the aim of bringing the Russian church into harmony with the rest of the Orthodox world. As the only Orthodox state free from Muslim domination, Russia was expected to play a leading role as the protector of the Orthodox, and Nikon believed that the liturgical differences between Moscow and Constantinople made this difficult. The masters of the Armory school, for all the eclecticism of their language, succeeded in formulating a counterbalance to the miniaturist art of the Stroganov masters, and in this way returned the icon to large scale monumental imagery.

The choice of subject and iconography in his most significant works distinguishes the art of Simon Ushakov as the main figure of the Armory school. The most famous among these are replicas or paraphrases of celebrated icons in Russia and other Orthodox nations. He painted, for example, the Kykko Mother of God, a copy of the most famous miracle-working icon of Cyprus. He also painted several icons of the Savior Not Made by Hands, as well as replicas of miracle-working prototypes venerated in Russia, such as the Trinity of Andrei Rublev, and the Vladimir Mother of God. That the art of Simon Ushakov was constructed in this way as a means of spiritual renewal, and that it was linked to the ecclesiastical reforms of the Patriarch Nikon, bears witness to the central role still played by icons in the public life of 17th century Russia.

THE ENTOMBMENT

Moscow
1592

The shroud depicting the Entombment was used during the procession of the Burial of Christ on the Saturday before Easter, the central festival of the Orthodox year. The form was adopted from the Byzantine *epitaphios,* which itself evolved in the 14th century from the *aer* placed over the vessels containing the sacramental bread and wine, symbols of the sacrificial death of Christ.

Shroud (*Plashchanitsa*)

183 cm x 264 cm
Damask, embroidered with silk, silver, and gilt thread.

Received in 1923 from the Monastery of Solovki.

Inventory No.
ДРТ 286

The body of Christ is surrounded by his Mother, who embraces his head, and St. John the Divine who embraces his feet. The angels above and below the body are holding *rhipidia,* fans carried during the liturgy to represent the seraphim who fly before the throne of God (Isaiah 6). The seraphim themselves are depicted in the corner of the textile. In the corners of the central panel are the symbols of the four evangelists, and between the lamenting angles above the body is the dove which symbolizes the Holy Spirit.

The shroud is characteristic of a group of 16th century shrouds based on models produced under the supervision of Princess Evfrosiniia Staritskaia, and especially on a shroud donated in 1561 to the Cathedral of the Dormition in the Moscow Kremlin and now in Smolensk. Shrouds of this type are distinguished by a large number of figures, life-like details, and an emphasis on human emotion. The prayer inscribed on the lower border is followed by two dedicatory lines: *In the year 7100 [1592 AD] this holy shroud was embroidered under the Abbot Jacob of Solovki by the master seamstress Reverend Mother Feogniia Ogneva Novago.* The Reverend Mother Feogniia Ogneva was abbess of the Alekseev Convent. One is struck by the enormous size of the work and by its splendid state of preservation, particularly by the fact that the original crimson and blue damask background has remained intact.

The technique employed here comprises a wide variety of stitches, including attached and unattached couching in silver and gilt thread, and split satin and couching stitches in silk thread. The faces and the body of Christ are embroidered in split stitch with yellow silk in the traditional manner, with shading. The shroud was restored in 1967.

Liudmila Likhacheva

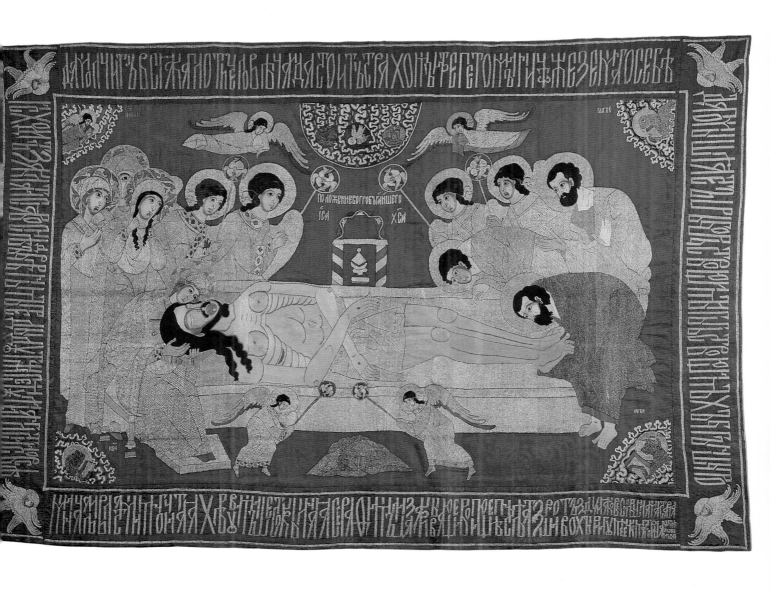

Catalog No. 2

DISKOS

Pskov
16th century

A *diskos*, or paten, is a eucharistic vessel on which sacramental bread is arranged in a precise order according to Orthodox tradition. At the center is a piece of bread called 'the Lamb,' symbolizing Christ; at the sides other pieces of bread are placed in remembrance of the Mother of God and the saints. The *diskos* symbolizes the plate used at the Last Supper. The present example consists

Height: 11.5 cm,
Diameter of base: 17.5 cm,
Diameter of plate: 35.5 cm
Plate: silver, hammered,
engraved, partially gilt
Base: cast, chased,
engraved, gilt.

Acquired in 1930 from the
Sacristy of the Cathedral of
the Trinity in Pskov.

Inventory No.
БК 3010

of a large flat plate on a low octagonal stem, its petals connected with the base. At the bottom of the *diskos* we see the Crucifixion, with angels beside the top of the Cross and the skull of Adam in the cave below. The Cross is flanked by women at the left and men at the right. Behind these figures can be seen the two thieves who were crucified with Christ. In the distance are the walls of Jerusalem.

The scene is surrounded by engraved and gilded floral ornament. Along the flat gilded frame runs a eucharistic inscription, cut in a fine ligature and embellished with floral motifs. The inscription is surrounded by a carved ornament with four engraved rosettes.

Only a few works of decorative and applied arts from Pskov have survived. Although Pskov became part of the centralized Russian state in 1510, the Pskovians retained and developed their own artistic traditions throughout the 16th century. The silversmiths of Pskov, largely employing techniques of engraving and gilding, created various types of ornament as well as exquisite inscriptions. One of their most outstanding achievements is this *diskos* from the Cathedral of the Trinity.

Izilla Pleshanova

Catalog No. 3

ZVEZDITSA

Height: 13.8 cm,
Width: 18.6 cm
Silver, hammered, gilt , with
filigree, and paste.

Acquired in 1920 from the
Sacristy of the Cathedral of
the Trinity, Pskov.

Inventory No.
БК 3025

A *zvezditsa* (from the Russian word for 'star') is constructed from two metal bands shaped as a half circle, connected with a pivot in the middle. When open, they form a cross. The zvezditsa is placed on the *diskos*, which bears the image of the Lamb of God, and itself symbolizes the star which appeared over the manger where Christ was born. It also protects the sacramental

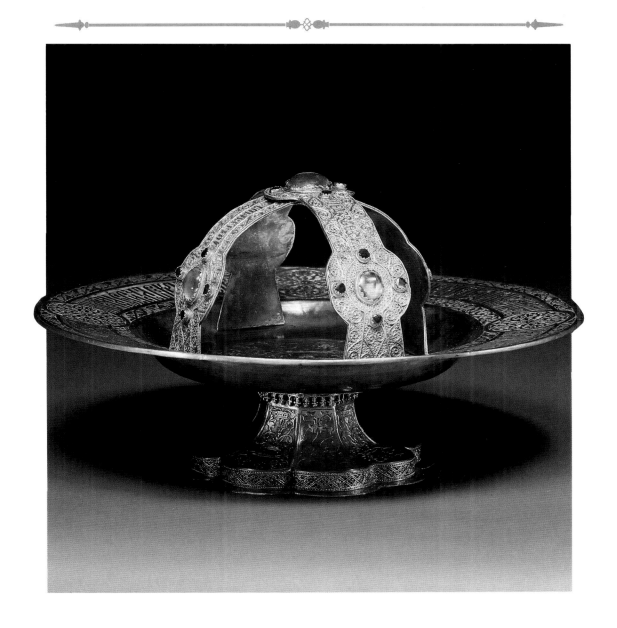

bread when the pokrovets is placed over it. The Pskov *zvezditsa* consists of two hammered bands with three circular bezels each. Each bezel has a large convex paste with four smaller pastes around it. In the paste on the top of the *zvezditsa* depicts the Golgotha Cross in a mandorla against a golden background.

The surface is embellished with filigree; the pattern is made from wires, while the background is of twisted rings. The inscription reads: *the star went, stood over, came where the young child was* (Matthew 2:9).

Izilla Pleshanova

CHALICE

Moscow
1574

The symbolic prototype of the chalice was the cup used at the Last Supper, and during the eucharist it holds the wine which symbolizes the blood of Christ shed upon the Cross ('Drink ye all of it; for this is my blood' Matthew 26: 27f, etc.). This particular example was acquired from Tikhvin, and consists of a wide bowl on a tall massive stem, both of silver-gilt. On one side, the chalice is

decorated with an engraved Deesis, comprising a finely executed half-length Savior, the Mother of God, St. John the Baptist, and two archangels, all placed in ornamental cartouches. The figures are accompanied by inscriptions: *Archangel Michael, Mother of God, Jesus Christ, St. John the Baptist, Archangel Gabriel.*

The other side of the bowl shows the Golgotha Cross in a similar frame, also flanked by inscriptions: *King of Glory, Jesus Christ, Victory, Golgotha.*

Along the top of the bowl runs the Eucharistic inscription: *Drink ye all of it; for this is my blood of the New Testament, which is shed for many for the remission of sins.*

The stem consists of several parts, with the upper part overlaid with twisted silver. The upper part of the baluster knob (or 'apple') is decorated with a chased floral pattern and hammered, the lower part with a rosette of leaves. The stem rests on a wide base with the dedicatory inscription: *In the Year 7082 [1574 AD] , on March 25, this chalice was given by the order of Tsar Ivan Vasilevich of All Russia from his royal treasury to the Monastery of the Oten Hermitage of Abbot Dionysii.*

The Oten Monastery, located 45 km from Novgorod, is mentioned in chronicles as early as the beginning of the 15th century. According to these sources, the monastery received donations from the tsar in the 16th and 17th centuries. During the Time of Troubles and the Polish occupation, the monastery was destroyed by fire. In 1617, soon after the Romanov dynasty was established, Tsar Mikhail Fedorovich issued a deed of gift to restore the monastery. In 1730 the monastery was again destroyed by fire. It was probably as a result of these calamities that the chalice ultimately found its way to the Great Monastery of Tikhvin.

The chalice is characterized by the complexity of its execution, by the exquisite quality of its engraving and chasing, and by its images and its inscriptions. It is not clear whether the craftsman came from Moscow or Novgorod. During the 16th century, the most talented craftsmen were invited from all over the country to work in Moscow.

Izilla Pleshanova

Height: 26.7 cm,
Diameter of base: 17.6 cm,
Diameter of bowl: 17.6 cm
Silver, hammered, chased,
engraved, gilt.

Inventory No.
БК 3005

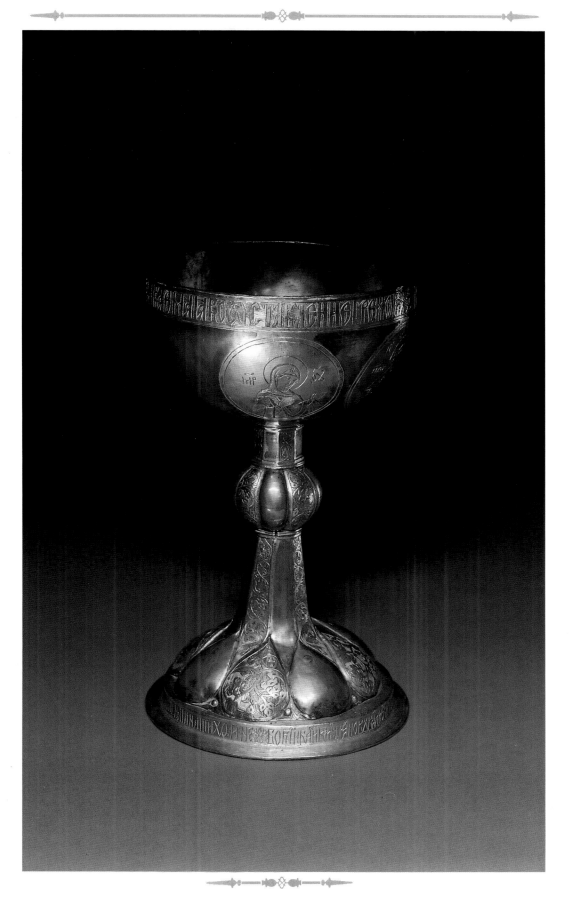

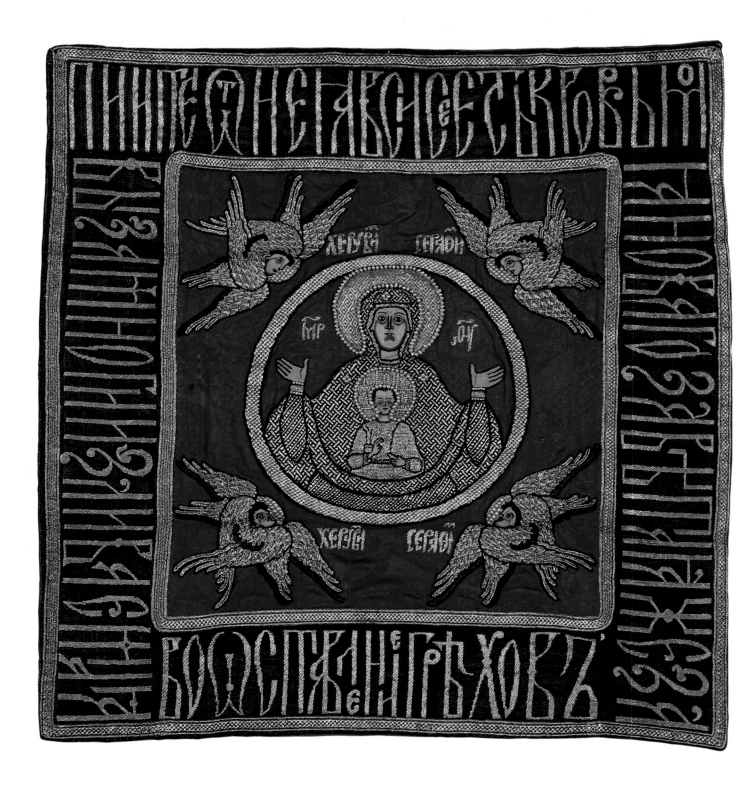

THE MOTHER OF GOD OF THE SIGN BEHOLD THE LAMB, AND CHRIST ENTOMBED

Moscow
1643

These three textiles were made to be used during the divine liturgy. The cover with the representation of the Mother of God of the Sign was generally placed over the chalice, while the cover depicting the theme Behold the Lamb was placed over the paten. The altar cloth was then placed over both the covers. All three works are embroidered on damask, crimson at the centre and dark blue around the borders. The cover with the Mother of God of the Sign bears a dedicatory inscription:

In the reign of the God-fearing Sovereign Tsar and Grand Prince Mikhail Fedorovich of All Russia, three works were created by order of the Reverend Mother Princess Alexandra Golitsyna for the Convent of the Most Holy Ascension and for prayers for the eternal memory of her soul. In the year 7151 [1643 AD].

The linings of the works are embroidered with inscriptions, one repeating the original dedication and another referring to events in 1913: *By order of the Great Sovereign Emperor and Autocrat of All Russia, Nikolai Alexandrovich and the Sovereign Empress Alexandra Fedorovna, in the year 1913 on the 14th day of February, the day of the commemoration of the holy icon of the Fedorovskaia Mother of God, to honour and celebrate the 300th anniversary of the election to the throne of the Sovereign Tsar and Grand Prince Mikhail Fedorovich of blessed memory, these covers were placed on the holy vessels during the celebration of the Holy Eucharist at the Imperial Fedorovskii Church in Tsarskoe Selo.* The church of the village of Federovskoe at Tsarskoe Selo was built in 1909 and many holy relics connected with the tsars of the Romanov dynasty were transferred there, especially from the Novospasskii Monastery in Moscow and from the Ascension and Chudov Convents in the Moscow Kremlin. The three textiles in the Russian Museum were among these works.

The Convent of the Ascension in the Moscow Kremlin, built in the 14th century by Evdokiia Dmitrievna, the wife of Prince Dmitrii Donskoi, and demolished in 1929, served as a burial place for grand princesses, tsaritsas, and their daughters. Domestic life at the convent was well regulated and the art of embroidery reached a high level from the time of Reverend Mother Martha Ivanovna, the mother of Mikhail Fedorovich, who lived there from 1613 to 1631.

Under the guidance of Alexandra Golitsyna the convent produced embroideries for various churches and monasteries. The altar cloth depicting Christ Entombed contains a detail typical of products of the Golitsyn workshop. The prayer embroidered around the borders is followed by the word *Golitsyny*.

Liudmila Likhacheva

Received in 1934 from the Museum Fund through the Hermitage. Originally in the Fedorovskii Church at Tsarskoe Selo. Damask, embroidered with silk, silver, and gilt thread.

Vessel-cover (*Pokrovets*): *Mother of God of the Sign* 48.0 cm x 46.4 cm

Inventory No. **ДРТ 89**

Vessel cover (*Pokrovets*): *Behold the Lamb* 49.5 cm x 49.0 cm

Inventory No. **ДРТ 86**

Altar cloth (*Vozdukh*): *Christ Entombed* 60.6 cm x 82.0 cm

Inventory No. **ДРТ 78**

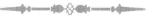

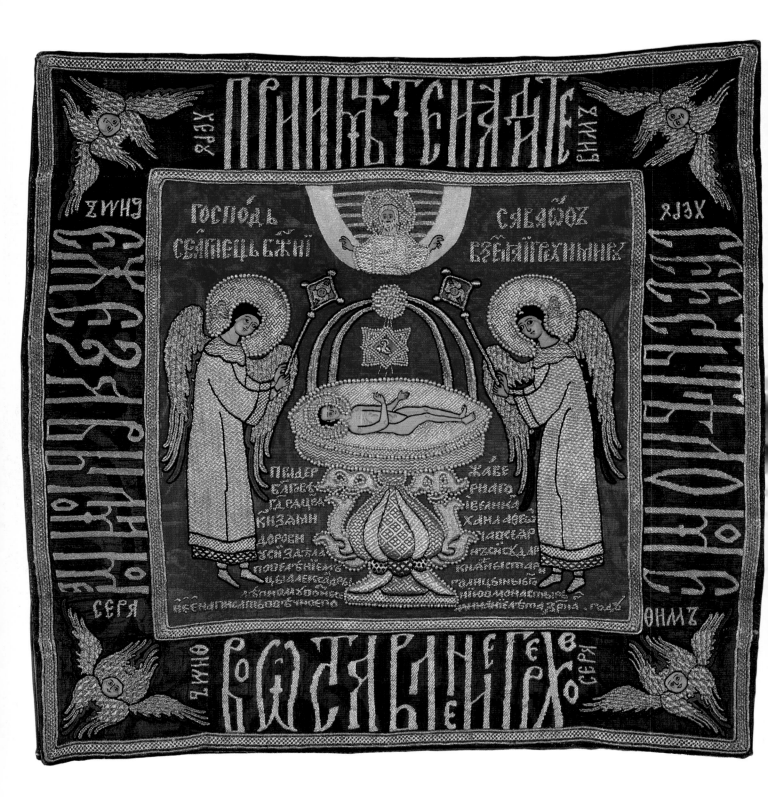

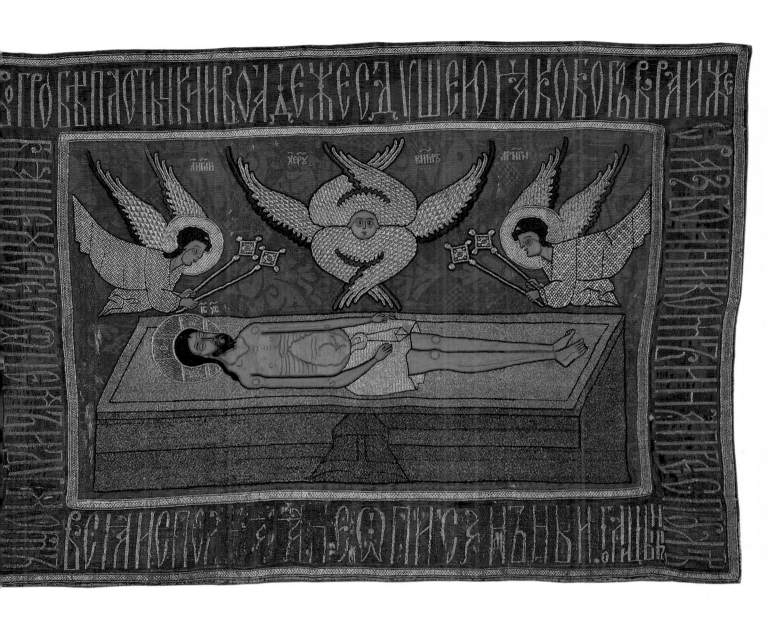

BASIN FOR HOLY WATER

1647

The basin consists of a large bowl on a stem base, and was used for the sanctification of water. The ritual of sanctification is based on the Baptism of Christ and involves the immersion of a cross into water, a process which is repeated three times and accompanied by prayer and chanting. This ritual is represented iconographically on the cup. The bottom of the inside surface has an applied

Height: 36.6 cm,
Diameter of base: 34.6 cm,
Diameter of bowl: 42.0 cm
Silver, hammered, chased, engraved, gilt.

Acquired in 1923 from the Monastery of St. Alexander Svirskii.

Inventory No.
БК 3017

gilded plaque with a chased image of the Cross of Golgotha on a rocky hill. In a cave at the bottom of the hill is the skull of Adam. The cross is adorned with a wreath, and is flanked by a spear and a staff. The inscriptions read: *King of Glory, Jesus Christ, Victory, Spear, Staff.*

The stem of the cup is characterized by a knob (or 'apple') with four carved, gilded rosettes decorated with a floral ornament. The base has convex areas (or 'spoons'), alternately of plain silver or gilded with chased floral ornament.

The side of the bowl is supplied with two cast handles hanging from rings. The inscription along the gilded rim of the bowl reads: *In the Year 7155* [1647 AD], *on February 20, this silver cup was given to the Church of the Appearance of our Lord and Savior Jesus Christ, the Kozheozerskaia Hermitage, in commemoration of the secretary of the council Grigorii Vasilevich Lvov, whose monastic name is Gerasim.*

The Kozheozersk Monastery of the Appearance of Christ is in the province of Arkhangelsk. It was founded in the middle of the 16th century, but was closed in the 18th century when it became a parish church. It was restored as a monastery in the mid-19th century.

Izilla Pleshanova

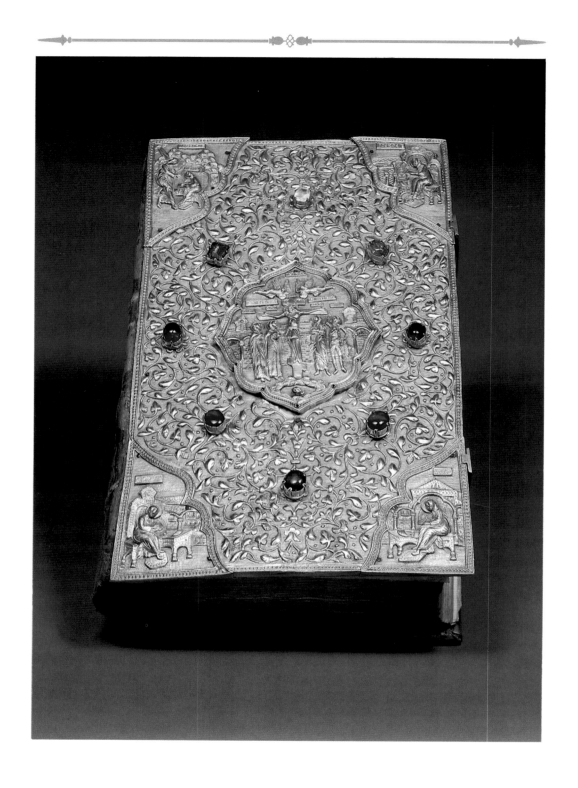

GOSPEL COVER (*OKLAD*)

1644
Moscow

During the liturgy, the Gospels are placed in the middle of the altar to symbolize the presence of Christ in the church. They are an indispensable item of the Orthodox service. This gilt-edged Gospel book was printed in Moscow in 1637. It contains four engravings depicting the evangelists with their symbols and initial decorations with floral patterns for each of their books. At the beginning and the end of the text, there are cursive inscriptions indicating that the book was given to the Tikhvin Convent of the Presentation of the Mother of God in 1644 by Ivan Koltovskii, to commemorate Semen Koltovskii and his wife Bufiniia, who had entered the convent.

The *oklad* consists of boards covered with gilt velvet and a chased plate decorated with floral patterns. The plate is overlaid by plaques in the center and at the corners. The central plaque depicts the Crucifixion flanked by four figures, with the walls of Jerusalem as a background.

The corner plaques depict the evangelists, with Prochoros standing beside St. John.

The figures are elegantly rendered in high relief, with careful and clearly defined chasing.

The obverse is decorated with eight gems around the central plaque. The reverse has five silver plaques with carved floral ornament.

The clasps of the cover are of later date.

Izilla Pleshanova

39.5 cm x 25.0 cm x 10.5 cm
Silver, hammered, chased, engraved, gilt; with velvet, gems, and casts.

Acquired from Tikhvin.

Inventory No.
БК 3080

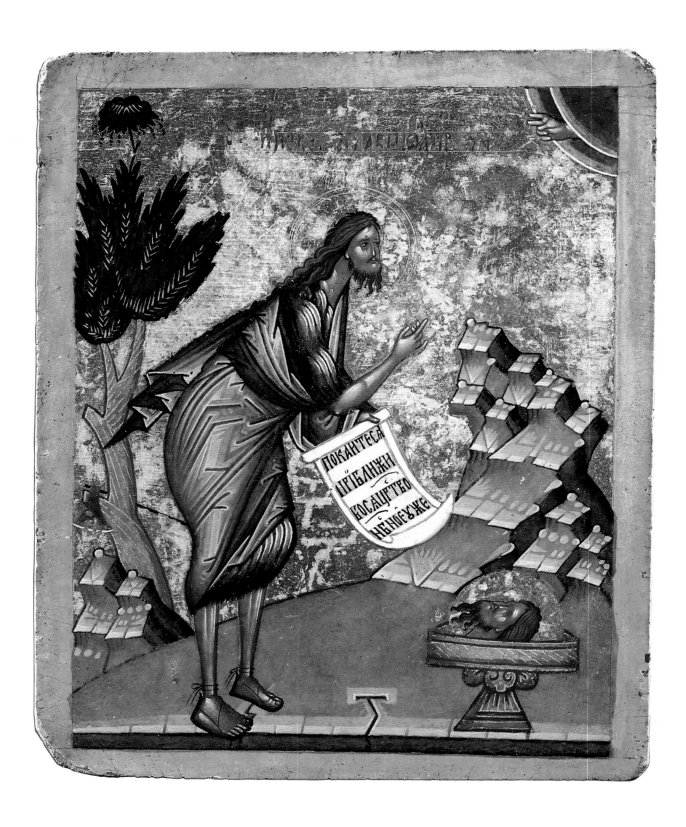

THE BEHEADING OF St. JOHN THE BAPTIST AND St. PROKOPIOS, St. NIKETAS, St. EUSTATHIOS

Novgorod
Late 15th century

The icon is from the Cathedral of St. Sophia in Novgorod. It is one of 18 tablets discovered in the sacristy of the cathedral in 1908 by restorers G. O. Chirikov and P. I. Iukin, and was acquired by the Russian Museum in 1934 from F. A. Kalikin. It was restored before its acquisition by the museum, in the 1910s by its two discoverers. It was freed of overpainting by I. V. Iarygina at the Russian Museum in 1971.

Tablets are small double-sided icons executed in egg tempera over a gesso ground on several layers of canvas pasted together. In earlier centuries these miniature icons were called 'towels,' from the Russian words for cloth or linen. The description 'tablet' was first applied by A. I. Anisimov.

Thematic compositions are placed on one side of the icon and depictions of the saints on the other, thereby illustrating the *menologion*, a collection of prayers and narratives from the *Lives* of saints organized by days and months. The tablets were kept in special cases in the sanctuary, or were placed on the interior walls of the church. On festival days or saints' days the tablets were placed on lecterns. Tablets were easy to carry and served as iconographic patterns for artists. They were frequently mentioned in written sources like monastic inventories.

V. N. Lazarev connects the origin of tablets with special icons known as *menologia* which depicted the saints in accordance with the church calendar. These devotional icons could have been taken down from an iconostasis and placed on the lectern on the dedication days. It is not known whether the tablets were used in Byzantium as no examples have been discovered. The extant Russian tablets are dated to the 15th century, when series of tablets became widespread.

The most complete cycle of *menologia* is made up of the tablets executed in a major icon workshop in Novgorod for the Cathedral of St. Sophia during the time of Archbishop Gennadii (1484-1504). According to the cathedral inventory of 1617, there were 36 small icons preserved there. At present, 25 tablets comprising the St. Sophia church calendar are dated to the late 15th century. Five more comprise a later part of this group executed in the mid-16th century. Depicted on the reverse are the saints who were canonized at the Church Councils of 1547-49. As a church calendar, the depictions of the festivals in the St. Sophia series of tablets represent the yearly liturgical cycle. They include Christological and Mariological compositions, episodes from the life of St. John the Baptist, and other festivals. Fifty saints are represented on the backs of the tablets with two, three, or four figures in each. The selection of saints for each tablet was determined either by the

24.1 cm x 19.6 cm x 0.3 cm
Double canvas, interlaid with paper.

Inventory No.
ДРЖ 233

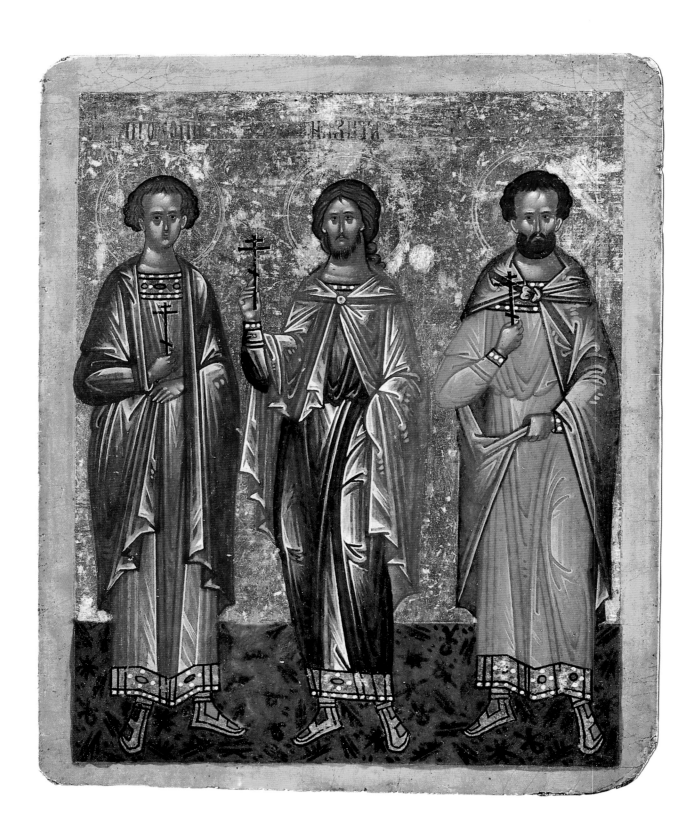

proximity of their commemoration days, or by their place in the church hierarchy.

The tablets from St. Sophia exerted a strong influence on Novgorodian painting of the 16th century. For example, the iconography of the tablets was repeated in the icons of the Passion cycle of the festival tier of the cathedral in 1509 and in the festival icons of the Cathedral of the Dormition in the Monastery of St. Cyril of the White Lake. Iconographic outlines of the St. Sophia tablets are also reproduced in the compositions of other series of the same subjects which were executed throughout the 16th century, whether they were stylistically related to the art of Novgorod or not.

As E. S. Smirnova has noted, the arrangement of the saints on the St. Sophia tablets forms a carefully considered program, which took account of Novgorodian tradition. At the same time, the tablets include iconographic patterns related to icons which were venerated in Central Russia during the 15th century. These include icons which have been preserved in the cathedrals of the Moscow Kremlin and others by Andrei Rublev and his followers, and by Dionysii.

Painted at the turn of the 16th century, the St. Sophia tablets summarize the previous development of Novgorodian icon painting. In the decades that followed, Novgorodian painters played an active role in the evolution of Russian art. On one hand, Novgorodian features can be seen in the style of the tablets. They employ bright colors in dense paint, proportional compact figures, and coarse drawing. At the same time, the tendency toward ideal images, diminutive facial features and compositional details, as well as the abundance of gold, speak for an assimilation of Muscovite style.

V. N. Lazarev evaluated the St. Sophia tablets as follows: 'There is nothing in Novgorodian icon painting of the 16th century that equals the tablets in brilliance of execution. Even if they lack the freshness and ingenuousness of perception of earlier Novgorodian icons, for delicacy and ele-

gance of rendition they remain unsurpassed.'

The tablet depicting the beheading of St. John the Baptist belongs to the earliest group of the series. There are three military saints on the reverse: the martyrs Prokopios, Niketas, and Eustathios. The tablet was painted on a gold background with a wide ocher border. The bright colors of the garments are rendered by dense paint, and the folds are represented by transitional tones and colored highlights. The faces are painted on greenish *sankir* with highlights in ocher and wide strokes of white lead. The areas of white lead on the rocks are characteristic of Novgorodian painting and are accented by cinnabar shadowing. The ground under the feet of the saints is covered by ornamentation of a Novgorodian type known as *kovrik* ('small rug'). The gesso ground is incised with halos, the contours of the figures, the delimitation of borders and ground, and the inscriptions. In the painting of the obverse, the influence of Muscovite icon painting of the epoch of Dionysii is strongly felt. The elongated figure of St. John the Baptist has the graceful gesture and the detailed features characteristic of Muscovite style. The harmony of the entire composition, in which a cold blue and green dominate the palette, is also derived from the painting of Moscow.

The beheading of St. John the Baptist is commemorated on August 29. The depiction of the saint is based on the texts from the Gospels (Matthew 3: 11.1–14; 14: 1–12; Mark 1: 2–14; 6: 14–29; Luke 3: 1–22; 7: 19–29). After St. John had baptized Christ, he was imprisoned and executed by Herod Antipas on the demand of Herodius. His head was buried in a clay vessel on the Mount of Olives while his body was buried by his disciples in the town of Sebaste where a church dedicated to him was built during the reign of the Byzantine emperor Constantine.

The tragic image of the prophet who stands at the juncture of the Old and New Testaments, who came to the world not only to herald the birth of the Savior, but

also to prefigure Him by his martyr's death, is complete. The composition selected by the painters of the Novgorod tablets allows it to be expressed in full. St. John is depicted in a lifeless desert. His rough clothing of camel hair, his unkempt beard and shaggy hair indicate that he is an ascetic who has rejected normal human desires. As he bows before the divine right hand, he expresses his desire to fulfill the will of God. Behind him stands a tree with a splendid crown, while an ax is laid at the root of it. These are intended to illustrate the text of his sermon on repentance (Matthew 3: 10; Luke 3: 9). At the same time they could be interpreted as symbols of the cleansing of humanity at the second coming of Christ, when any tree of unrighteous life will be cut down and thrown away. The decapitated head in the foreground symbolizes his death as a martyr. It is placed in a bowl which could be seen in as a counterpart to the eucharistic chalice with the image of the Divine Infant lying in it, indicating the redemptive sacrifice of Christ and of his forerunner.

The iconography of St. John the Baptist on the St. Sophia tablet was used in several extant icons including a border scene of the four-part icon of the late 14th century ascribed to the circle of Theophanes the Greek (Tretiakov Gallery).

Other icons depicting St. John the Baptist employ a different iconography to depict the theme of his death as a martyr and his mission as a preacher, for example, the winged Angel of the Desert which became increasingly popular from the mid-16th century and eventually replaced the pattern under consideration. It is connected with the fact that St. John the Baptist was believed to be the patron of Tsar Ivan IV (the Terrible), the name-day of the tsar falling on the commemoration day of the beheading of the saint.

The reverse of the tablet depicts three warriors who suffered martyrdom in the first centuries of Christianity and were greatly venerated in Byzantium.

St. Prokopios (commemorated on July 8) was born in Jerusalem, and his noble origin allowed him to pursue a military career at the court of the Emperor Diocletian (284-305). After he was appointed proconsul in Egypt, he received a vision of a shining cross which converted him to Christianity. He was then arrested, and after prolonged torture was beheaded.

According to legend, St. Niketas (commemorated on September 15) was a Goth who converted to Christianity and tried to encourage it among his own people. He was burned 370 for his efforts, and his body was buried in Cilicia and later transferred to Constantinople. When he was in prison, the devil is said to have tempted him with the chains in which he was shackled. This legend laid the basis for his veneration as a saint who offers protection from the evil spirit. This subject was widely known in Russia and was very popular, mostly in the plastic arts. Churches dedicated to Prokopios and Niketas were built in Novgorod.

The martyr Eustathios (commemorated on July 28) was also a warrior in the 4th century. According to legend, he converted to Christianity after a miraculous apparition of the cross which appeared on the horns of a deer in the forest. Eustathios and Prokopios were often painted together in Byzantine art, and depictions of the three martyrs are also to be found in Novgorodian applied arts.

The icon has small splits in the canvas on the margins and losses of background in the corners. The gold of the ground is effaced, and there are scratches on the pigment layer.

Irina Soloveva

MENAION FOR DECEMBER

Moscow
1569

menaion is an ecclesiastical compendium of services, chants and lives of the saints for every day and month of the year. Painted monthly calendars emerged in Byzantine art in the 11th century, and in the 14th century cycles of paintings on this theme became widespread in Balkan churches. The earliest representations of the *menologion* in Russia, the frescoes in the

Church of St. Symeon at the Zverin Monastery, date to the second half of the 15th century.

In the mid-16th century, considerable attention was paid to the compilation of various collections of the lives of the saints, together with legends about them and services dedicated to them. This work was initiated by the *Illuminated Annals and Great Menaion Readings* of Metropolitan Makarii. The same trend may be observed in the icon painting of the time, which showed an increasing interest in complex compositions with many figures. This was probably the time of the re-emergence of *menaion* icons, which were placed on the pillars of churches or hung on the walls like their Byzantine prototypes.

An interesting feature of our *menaia* is that they include 'the new Wonder-Workers,' the Russian saints canonized at the Councils of 1547 and 1549.

The MENAION FOR DECEMBER is one of 12 *menaia* icons which originally comprised a single whole. Only five of these icons have come down to us: the *menaia* for September and November are preserved in the Tretiakov Gallery, and those for December, June, and August in the Russian Museum.

The cycle of *menaia* was painted in Moscow at the order of Lavrentii, Bishop of Kazan, and was installed by him in the

Church of the Dormition of the Mother of God in the Monastery of Joseph of Volotsk for the inheritance of eternal blessing. This may be seen from the inscription on the reverse of the icon: *In the year 7077* [1569 AD] *in the reign of the pious and Christ-loving Tsar and Grand Prince Ivan Vasilevich, Autocrat of All Russia, and his noble sons Tsarevich Ivan and Tsarevich Fedor. Under the holy Metropolitan Cyril did Archbishop Lavrentii of Kazan and Sviazhsk, former Abbot of the Monastery of the Holy Mother of God and St. Joseph place these twelve menaion icons with the new wonder-workers for the inheritance of eternal blessings under the Abbot Leonidas.*

It is interesting to note that this dedicatory inscription begins with the first month of the old Russian calendar and ends with the last. The inscription apparently covered the whole cycle of *menaia*, which were placed side by side on a single stand. This is confirmed by the inventory of the Cathedral of the Dormition for the 1570s, in which it is stated: 'Behind the left-hand pillar of the church, in a *kiot*, there are three tiers of 12 images against a gold background, paintings of all the saints for the 12 months of the year. The *kiot* is painted in colors and is covered with an ancient red silk cloth, which was the shroud on the tombs of the princes of Vologda.'

55.4 cm x 45.5 cm x 2.3 cm
Panel of two boards with two inset struts.

Received from the State Restoration Workshop in 1934

Inventory No.
ДРЖ 1565

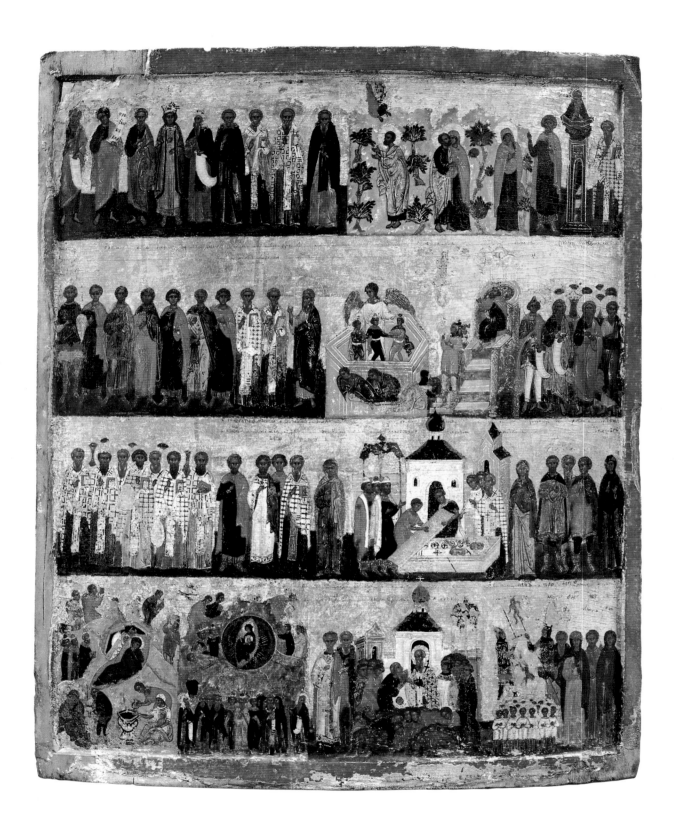

The *menaia* were placed in three tiers with four icons in each, and formed a wall about two meters in height, completely covered with images of saints and festivals. In the creation of this artistic complex, similar in some ways to an iconostasis, the overall decorative scheme of the interior of the Cathedral of the Dormition was undoubtedly taken into account. The wall paintings and icons of Dionysii and his school set the stylistic trend for many other works, among them monthly calendars of much later dates. In the light of all this, it is understandable that the style of the painter of the *menaion* for December, who followed the school of Dionysii closely, should have become a model for the painters the other icons, despite the evident enthusiasm for a more miniaturistic approach.

The characteristic features of the Dionysian style are tranquil and well-defined compositions, pure and brilliant pigments, and a gentle blending of colors. The elongated figures of the saints, with expressive gestures and flowing outlines, seem to revert to the tradition of the wall paintings in the Monastery of St. Ferapont. In our icon, all this appears alongside completely different aesthetic principles quite foreign to the early 16th century: a preference for miniaturistic painting and meticulous technique. The figures of the saints show the fragility and mannered attitudes that were soon to become characteristic of the so-called Stroganov school.

The complicated iconographical program on which the twelve *menaia* are based, the quality of their execution, and the obvious fact that several artists were involved in the work, are sufficient grounds for assuming that the cycle was created in a large workshop. Archbishop Lavrentii most probably ordered the icons in Moscow, where his frequent visits had made him familiar with artistic circles.

For several centuries, the *menaia* were to be found in one of the most revered of Russian churches, the Cathedral of the Dormition in the Monastery of Joseph of Volotsk, which was founded by St. Joseph of Volotsk in 1479 and became one of the leading artistic and cultural centers of Russia. In 1486 the original wooden church was replaced by the stone Cathedral of the Dormition, with wall paintings by Dionysii and his pupils. In the 16th century the monastery became a place of worship for the tsar, whose frequent visits with his courtiers became a source of substantial donations. A large number of superb works of art were thus accumulated.

In 1911-12 a survey of the churches and sacristies of the Monastery of Joseph of Volotsk was carried out by P. I. Neradovskii and N. A. Okolovich of the Arts Department of the Russian Museum, They prepared an inventory of icons and other objects which were no longer in use at the monastery because they were in urgent need of repair and restoration. In December 1912, with the permission of the metropolitan of Moscow, Neradovskii and Okolovich brought 33 icons and several works of applied art to the Museum. In 1934 several more works, including two *menaion* icons, were received from the Museum workshops after repair and restoration. At the present time, the Museum contains some 60 works from the Monastery of Joseph of Volotsk.

The MENAION FOR DECEMBER is not in good condition, the two parts of the board are badly warped and parts of the upper inset slat are missing. Preliminary cleaning was carried out at the Central Restoration Workshop. The work was completely cleaned at the Russian Museum in 1973-74 by the artist and restorer L. V. Bezymenko. The worst losses are of the paint around the contours of the figures in the center, and of the gesso and linen backing at the left-hand side of the lower border. The entire surface shows small insertions of gesso, as well as more recent inscriptions partly effaced during restoration.

Irina Shalina

CHALICE

16th century

The chalice consists of a wide wooden bowl on a low stem. The inner and outer surfaces of the bowl are painted with cinnabar. A band painted dark green and framed by narrow lines in low relief runs along the rim. Below the band there is a linear ornament. At the center of the band, there is a star, next to which appears the eucharistic inscription: *Drink ye all of it, for this is my blood of the New*

Height: 15.0 cm,
Diameter of base: 11.2 cm,
Diameter of bowl: 10.3 cm
Lathed wood, tempera.

Acquired in 1898 from the Museum of the Imperial Academy of Arts.

Inventory No.
ДРД 398

Testament, which is shed for many for the remission of sins. The inscription is executed in yellow tempera, and the style of the calligraphy suggests that the chalice was made in the 16th century.

Below the band, the busts of the Savior, the Mother of God, and St. John the Baptist are depicted, painted with a thin brush. A partially erased inscription appears above each figure.

On the opposite side, the Cross of Golgotha is depicted against a red background. The stem is painted in dark green tempera, with white lines and a yellow band. At some time the bowl has split into two fragments and these have been glued together. The painting has been cleaned.

Izilla Pleshanova

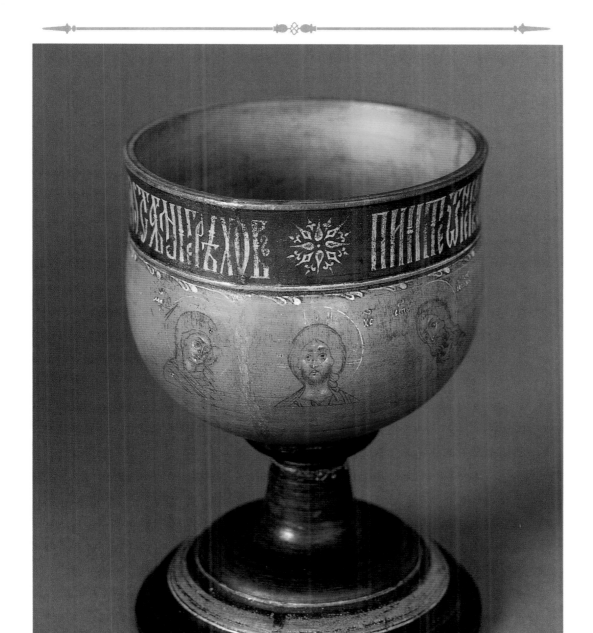

ROYAL DOORS WITH THE ANNUNCIATION, THE EUCHARIST, AND THE FOUR EVANGELISTS

Pskov
First half of the 16th century

The Royal Doors are constructed of two panels located at the center of the iconostasis, and connect the nave with the sanctuary. They are called 'royal' because it is believed that Jesus Christ, the King of Glory, is carried through them in the form of the eucharist. The symbolic meaning of the gates, and of all the images upon them, is closely associated with the perception of the sanctuary as an image of the

spiritual world. This symbolism is apparent during the liturgy. The opening of the Royal Doors signifies the opening of the Heavenly Kingdom for believers. The closing of the Royal Doors reminds them of the eviction from the garden of Eden after the Fall.

There were several iconographic traditions of decorating the Royal Doors. Two were the most widespread. The first depicts the theologians St. Basil the Great and St. John Chrysostom, the fathers of the liturgy. The second depicts the evangelists. The ornate top of the gate always depicted the Annunciation, which is a distinctive feature of Russian iconography. By the early 16th century, the composition of the Royal Doors became more complex with the introduction of an additional structure depicting the eucharist.

The Annunciation is based on the narrative of Luke 1: 26–38. The Archangel Gabriel informs Mary that she will give birth to the Son of God. Gabriel is depicted delivering the good news her, and her open hand is outstretched toward him in a gesture of humility and acceptance. His red fluttering cloak indicates his sudden apparition.

Our attention is drawn to the poised figure of the archangel, with his wings spread as if suspended against the background. A repetitive arcade and a high wall is a typical motif of Pskovian Annunciation icons. The posture of the Mother of God with her left hand resting on her knee is also characteristic. It has none of the spiral turn of the body or the diagonal creasing of the robe which are traditional for Novgorod.

The Annunciation is understood as the beginning of the Incarnation, for which reason it was depicted on the Royal Doors, the entrance to the sanctuary where the liturgy is performed. Christian tradition has interpreted the acceptance by the Mother of God of the news of her miraculous conception as a penance for the Fall of humanity. It contrasts with the disobedience of Eve, who caused the primordial sin. The Mother of God, the new Eve, redeems the Fall of the first Eve and begins our return to union with God. During the liturgy, therefore, the closed Royal Doors are a reminder of the Fall and the loss of Eden.

Our ascension to the Kingdom of Heaven is achieved through our accep-

167.5 cm x 37 cm x 3 cm
Each door a single panel with four struts.

Inventory No.
ДРЖ 1998 а,б

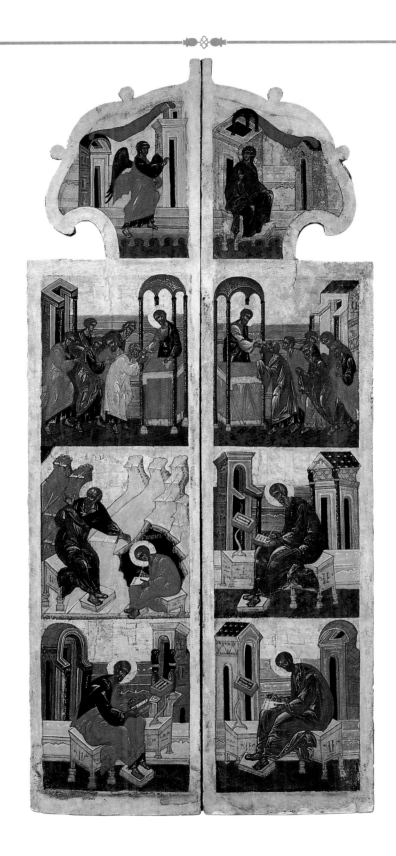

tance of the Gospel. This is why the Royal Doors also depict the evangelists who brought the news of the life of Christ. The Evangelists Matthew, Mark, Luke, and John are represented in traditional compositions adapted from the miniature paintings normally placed at the beginning of each Gospel.

It is through the eucharist that we became 'partakers of his promise in Christ' (Ephesians 3:6). There are two iconographic versions of the eucharist: the historical Last Supper and the liturgical Eucharist or Communion of the Apostles. It was the latter that was always depicted on the Royal Doors. In the imagery here there are two compositions in which Christ is depicted twice. As a priest, he is standing behind the altar under a tabernacle and is giving the Holy Sacrament to his disciples, six of whom receive bread, while the other six receive wine. The composition can be traced back to the iconographic type represented in two icons from the festival tier of the iconostasis in the Trinity–St. Sergei Monastery (1425-27). However, the emphasis there is on Christ's spiritual unity with his disciples. Through his sacrificial body and blood, they become participants in his sacrifice. The bright vermilion table therefore becomes the center and the inner meaning of the composition. Red, the color of suffering and blood, glows in the garments of the apostles who are drinking the sacramental wine, and is echoed in St. Luke's cloak and in the fiery edges of the Gospels. The sacrifice on the Cross is also brought to mind by the red cloth, which spans the two chambers and symbolizes the connection between the Old and New Testaments. It is also associated with the purple cloth for the curtain of the Temple in Jerusalem, on which, according to the Apocryphal Gospel of James, the Mother of God was working when the angel appeared.

The Royal Doors illustrated here have normally been associated with Novgorodian painting of the late 15th and early 16th centuries. However, the active and individual style of painting, based on the contrast between the dark-brown color base and the brilliant white highlights, is more reminiscent of Pskov. The painter places a special emphasis on vermilion, and its combination with dark emerald-green and reddish-brown. The composition of the Annunciation does not depend on the Novgorodian iconography, and the folds on the garments do not suggest Novgorodian style. Wedge-shaped highlights on the knee of the evangelists are similar to the technique used in Pskovian icons, and another typical feature is the use of folds in three waves. Lilac-red tunics with bluish highlights can also be found on Pskovian icons. However, it is difficult to insist on the attribution to Pskov because we do not have any data concerning the origin of the Royal Doors. They may well have been painted not by a Pskovian artist, but under the strong influence of the Pskovian school.

This icon has been restored with new gesso insertions on the margins, in the right part of the top and in the background of the left part of the Eucharist. There are numerous abrasions and losses of gold and inscriptions.

It was cleaned of later layers of paint before coming to the Museum, and was then cleaned a second time, in the Russian Museum by A. A. Rybakov in 1969.

Irina Shalina

THE PROPHETS NATHAN, HAGGAI, AND SAMUEL, AND THE PROPHETS MICAH, ELIJAH, AND GIDEON

Monastery of St. Cyril of the White Lake
ca. 1497

The two icons on display, THE PROPHETS MICAH, ELIJAH, GIDEON and THE PROPHETS NATHAN, HAGGAI, SAMUEL, originally belonged to the prophets tier on the iconostasis of the Cathedral of the Dormition of the Monastery of St. Cyril of the White Lake. They were brought to the Russian Museum from the monastery in 1922. Along with the aforementioned icons, the prophets tier consisted of the

following icons: THE PROPHETS EZEKIEL, ISAIAH, THE PATRIARCH JACOB (Russian Museum), THE PROPHETS HABAKKUK, JEREMIAH, JONAH (Russian Museum), THE PROPHETS ELISHA, ZECHARIAH, JOEL (Russian Museum), THE PROPHETS MALACHI, NAHUM (Russian Museum). The central panel was occupied by an icon of THE PROPHETS DANIEL, DAVID, SOLOMON (Tretiakov Gallery). Another icon from the prophets tier, ZECHARIAH, AARON, MOSES is no longer extant.

There were a total of nine icons representing 26 Old Testament Prophets in the prophets tier of the Cathedral of the Dormition. Each of the icons, except one, has a symmetrical tripartite composition, and each one is quite individual. The whole ensemble is one of the earliest and more fully preserved prophets tiers of the 15th century.

On the basis of the extant icons, the development of the prophets tiers can be ascribed to the early 15th century. Examples known at present are the prophets tiers of the iconostasis of the Cathedral of the Dormition in Vladimir (ca. 1408); from the Cathedral of the Trinity of the Trinity-

St. Sergei Monastery (1425-27); from the Cathedral of the Transfiguration in Tver (1449-50; Tretiakov Gallery; Russian Museum); from the Nativity Cathedral of the Monastery of St. Ferapont (1502; Kirillov Museum, Inventory Nos. 2066-72); from the Church of St. Nicholas in the village of Gostinopolie in the northern province of Novgorod (late 15th-early 16th century; Tretiakov Gallery, Russian Museum).

Characteristic of all of the ensembles mentioned above are the half-length portraits of the prophets. Representations of the prophets as full-length figures only appear in the 16th century. The earliest examples are from the Cathedral of St. Sophia in Novgorod (early to mid-16th century) and those from the Cathedral of the Annunciation in the Moscow Kremlin (mid-16th century). Full-length representations of the prophets do, however, appear in other media before the 16th century. They are, for instance, always to be found in the upper registers of frescoes in 12th-14th century Russian churches. They also occur on an embroidered iconostasis executed in Moscow in the first

Nathan, Haggai, and Samuel:
67.0 cm x 175.3 cm x 3.5 cm
Panel of two boards with
two inset struts.

Inventory No.
ДРЖ 2105

Micah, Elijah, and Gideon:
68.0 cm x 170.0 cm x 3.5 cm
Panel of three boards with
two inset struts.

Inventory No.
ДРЖ 2106

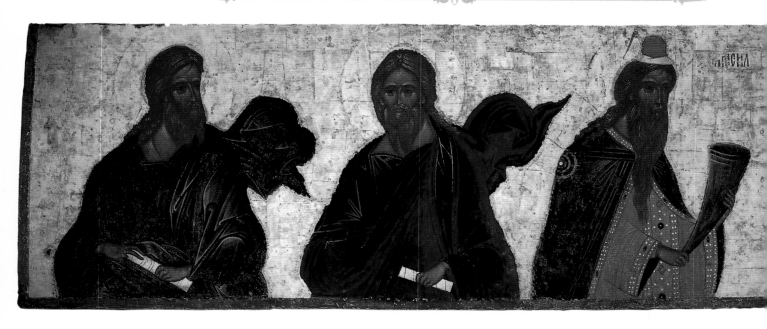

half of the 15th century. Sixteen full-length depictions of the prophets with unfolded scrolls in their hands are to be found in the paginal illustrations of the Muscovite *Book of Prophets* from 1489 (Lenin Library).

The significance of the Prophets in the Christian scheme of things lies in their visionary anticipation of the Incarnation of Christ. In their visions the prophets glorified Mary as a receptacle of God, a corporeal church of the Divine Wisdom, a source of the earthly appearance of Christ. For this reason, the Mother of God *orans* with a half-figure of Christ Emmanuel at her breast was placed at the center of the tier. In Russian iconography this composition was called THE MOTHER OF GOD OF THE INCARNATION or THE MOTHER OF GOD OF THE SIGN. The title 'Sign' is based on the prophecy of Isaiah which fully expresses the message of this tier of the iconostasis: 'The Lord himself will give you a sign. Behold, a young woman shall conceive

and bear a son, and shall call his name Emmanuel' (Isaiah 7:14). Texts from the Old Testament prophetic books were often inscribed on scrolls in the hands of the prophets; more rarely, symbolic attributes of the prophecies were used for a more complete revelation of the prophetic message. The icons of the prophets tiers were placed above the icons of the festival tier, demonstrating the connection between the Old and New Testaments.

A specific feature of the prophets tier of the Cathedral of the Dormition of the Monastery of St. Cyril of the White Lake is the depiction of King David in its center. The author of the Psalms, his victory over Goliath was associated with the victory of Christ over the forces of darkness. He was considered the prototype as well as the direct ancestor of Christ (Matthew 1). In this way, the meaning of the program of the prophets tier, the prototype of Christ in the Old Testament, was expressed in a

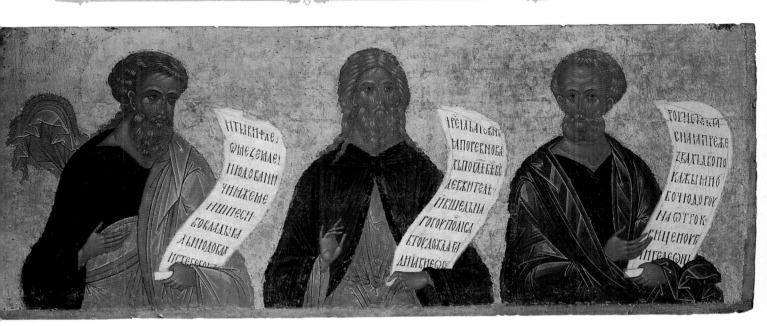

more concealed form than in the composition of the icon THE MOTHER OF GOD OF THE SIGN. According to O. V. Lelekova, such a composition of the prophets tiers was not uncommon in the 15th century.

The order and composition of the prophets tier was not strictly regulated from the 15th century onward. It consisted of the depictions of the major, minor, and other prophets. The program of each ensemble was composed, most probably, individually. There are no prophets tiers that are known to have repeated one another.

The prophet Elijah who lived in the 9th century BC (commemorated on July 20) was one of the most revered Old Testament prophets. He was venerated as an anchorite and ascetic, an Old Testament prototype of St. John the Baptist, who was often called 'the new Elijah' (Luke 1:17). For his steadfast faith and righteous life Elijah was taken up to heaven in a chariot of fire (2 Kings 2: 9–12), and Christ spoke with him at his Transfiguration on Mt. Tabor (Matthew 17: 3). In medieval Russia, Elijah was venerated for giving rain (based on the text from I Kings 17: 5–7; 18: 44–45) and controling fire (I Kings 18: 23–38; II Kings 1: 9–14). In addition, he was venerated for protecting cattle crops, and for healing. In this icon, he is depicted giving his blessing, and wearing a *melote* on his shoulders, a cloak of coarse wool which he used in the wilderness.

The prophet Micah belongs among the 12 minor prophets and lived in the 8th century BC during the time that Jotham, Ahaz, and Hezekiah were kings of Judah. His festival day is August 14. In Micah 5: 2–5, he prophesies the birth of a Ruler of Israel, the Savior of the world, in the town of Bethlehem. He also foretells the Babylonian exile and the return from exile. The iconography of the present icon is repeated in its entirety in an icon from the

Church of St. Nicholas in the village of Gostinopolie on the banks of the Volkhov River, which dates from the turn of the 15th and 16th centuries (Russian Museum).

Some of the prophets depicted in the icons from the Monastery of St. Cyril were only rarely included in prophets tiers. The prophet Nathan was contemporary with King David, and was the last and the most authoritative of the judges of Israel. His festival day is August 20. The prophet Samuel anointed David as king, and is therefore depicted in the icon holding a horn of oil (I Samuel 16: 13). The prophet Haggai, who is commemorated on December 16, lived during the 6th century BC and was one of the last Old Testament prophets. He prophesied after the Jews had returned from the Babylonian captivity, and encouraged them to rebuild the Temple at Jerusalem, through which 'the treasures of all nations shall come in' (Haggai 2: 6–9). The patriarch Gideon is one of the judges of Israel from the town of Ophrah. He demonstrated his humility by refusing to become a ruler of Israel (Judges 6–8). The text of the prophecy of the Mother of God on Gideon's scroll is based on the Biblical account of the miracle in which dew appeared on a fleece of wool as a sign of the will of God. The texts on the scrolls of all the prophets are longer and more complex than in other extant icons.

The icons of the iconostasis in the Monastery of St. Cyril were painted by several artists, some scholars suggesting a large team of Muscovite, Novgorodian, and local icon painters.

E. S. Smirnova singles out three groups of icons which are considered to have been executed by the masters from Moscow, Novgorod, and Rostov respectively. Thorough analysis of the icons from the iconostasis allowed O.V. Lelekova to ascribe them to three artists who had worked together for a long time prior to working at the Church of the Dormition. Each of them had an individual method and was completely independent, yet their collaboration allowed them to paint a brilliant ensemble of icons. They were associated mostly with Moscow. At the same time, there are icons in each tier in which the influence of the Novgorodian tradition is clearly felt. This is true of the central icon of the prophets tier, *THE PROPHETS DANIEL, DAVID, AND SOLOMON*, which displays the characteristic features of Novgorodian icon painting, such as enlarged figures, heavy forms, vigorous modelling of faces, dense and contrasting paints, and monumental images.

The icons of Muscovite style are distinctive for their refinement and elevated beauty, combined with an inner concentration and grandeur. The spiritual energy of the images is perfectly embodied in the variety of compositional and rhythmical solutions. Great importance is attached to the gold ground which encircles the figures, accentuating the silhouettes and uniting them at the same time. The inner emotional state of the prophets, who had heard the voice of the Lord, is rendered by their fluttering garments and large curving scrolls. The concentrated faces with classical features are carefully modeled in light ocher and highlights of white lead. The molding of the figures is achieved by the use of several layers of paint and white lead, as well as by the graphically delineated folds of the garments. The colors used are mostly cool blue, and green, embellished with ocher, pink, and brown.

The icon of Nathan, Haggai, and Samuel shows some damage. The gold of the background has suffered considerable loss. There are repairs in areas where the original paint has been lost. Cinnabar inscriptions adjoining two of the figures are missing, although the inscription to the right of Samuel's head still exists. The gesso ground is split at the margins and there is evidence of nails from the *oklad*, which is now missing. The icon has been restored twice in this century, by M. M. Tiulin in 1923 and by S. I. Golubev and G. N. Popova in 1976.

The icon of Micah, Elijah, and Gideon

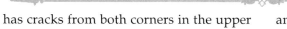

has cracks from both corners in the upper panel, with later insets of wooden struts. Cracks intersect the faces of Micah and Gideon. The gold of the ground and the pigment layer are considerably effaced, and have been repaired. The icon was restored by M. M. Tiulin in 1923 and A .T. Dednenkov in 1976.

Irina Soloveva

THE RAISING OF LAZARUS

ca. 1497

This icon comes from the iconostasis of the Cathedral of the Dormition in the Monastery of St. Cyril of the White Lake. It was incorporated in the iconostasis until 1764, when it was removed to the sanctuary. At the end of the 18th century it was given to the treasury of the Novgorod diocese, from which it was sent abroad for the international exhibition of 1929-32. In 1933 it was acquired by the

72.2 cm x 58 cm x 2.5 cm
Panel of two boards with
two inset struts.

Inventory No.
ДРЖ 2784

Russian Museum from Antikvariat. The icon was cleaned at the Novgorod Museum in 1926-27 by N. E. Davydov. A second cleaning was performed at the Russian Museum in 1975 by I. V. Iarygina. The panel has suffered losses to its surface and along the border. The nail holes indicate that it once had a silver revetment.

The multi-figured composition of the *RAISING OF LAZARUS* developed in Byzantium during the 14th century. Our icon comes from the festival tier of the 1497 iconostasis at the Cathedral of the Dormition in the Monastery of St. Cyril, and follows a rare iconographic version based on a similar scene from the 15th century iconostasis now in the Cathedral of the Annunciation in the Moscow Kremlin. Unlike the usual composition, in which the Jews surrounding Christ and the apostles stand some way off, these two icons represent Christ and his disciples as a single group at the center, thus connecting the apostles to the miracle. The sisters of

Lazarus, Mary and Martha, bow down at the feet of Christ. He raises his hand in blessing to the apostles and to Lazarus, a swaddled white figure rising from the black cavity of the tomb. Three youths remove his bandages and the lid of the coffin. The walls of Bethany are seen in the background, and the people of the city witness the miracle, two old men extending their open palms in wonder.

The icon has been assigned to both Novgorod and Moscow, as it contains elements of both schools. The Novgorodian style is apparent in the treatment of the flesh and in the large weighty folds of the drapery. The energy of gesture and emotion and the use of contrasts on the faces also indicate Novgorod. Muscovite influence is noticeable in the iconography, the elongated figures with their small features, and the predominance of white pigment.

Irina Soloveva

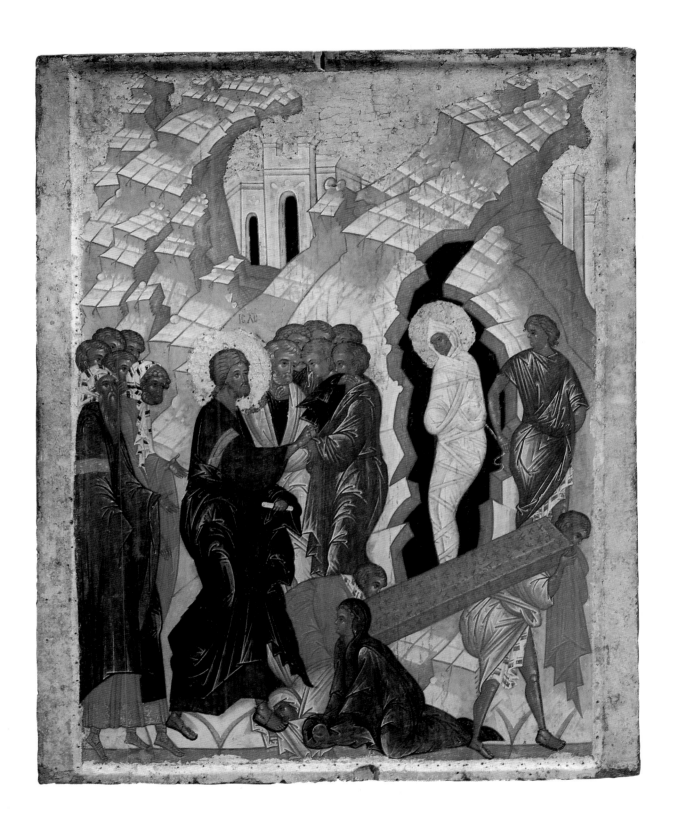

THE APPEARANCE OF THE ANGEL TO THE MYRRH-BEARING WOMEN

Moscow
ca. 1497

T he construction of the Cathedral of the Dormition in the Monastery of St. Cyril of the White Lake was completed in 1497. It is likely that the erection of the original iconostasis took place at the same time. The majority of the icons, about 60, survive. According to the earliest inventory report, from 1601, the deesis tier was originally composed of 21 icons, the festival tier above it of 25 icons, and the prophets tier of ten

icons showing 26 half-length figures. Between 1757 and 1764, the old beamed iconostasis was replaced with a new fretted iconostasis. In 1757 a carved and gilded iconostasis was commissioned for the Cathedral of the Dormition from the local Vologda joiners under the leadership of Vasilii Fedorov Dengin. The present icon belonged to the festival tier of the original iconostasis in the main church of the monastery. Shortly after 1764, when the new fretted iconostasis was completed, 8 icons from the old festival tier (together with 14 icons from the old deesis and prophets tiers) were moved into the sanctuary of the cathedral and placed on beams on the back of the new iconostasis, which had been established there for this purpose. All 22 icons are listed in the inventory of 1773. It appears that about 1919, when a group from the Commission for the Restoration of Icon Paintings in Russia was working in the monastery under the leadership of A. I. Anisimov, the MYRRH-BEARING WOMEN and several other Passion icons were selected by Anisimov for his own collection. Until as recently as 1922, the icons were all stored in a peasant's house in the village of Karbotka, near the monastery. In 1931, as part of the

Anisimov Collection, the icon joined the Tretiakov Gallery. In 1938 it passed to the Museum of the History of Religion and Atheism of the Academy of Sciences of the USSR, and in 1956 it was acquired by the Russian Museum.

Of all the medieval programs, the festival tier from the iconostasis of the Cathedral of the Dormition is one of most complete. It included 24 icons of festivals, along with an extra icon depicting St. Alimpii the Stylite, which has not survived. The Cathedrals of the Dormition in Moscow and Vladimir had the same number of icons in their festival tiers, and these must have served as models for the masters working at the Monastery of St. Cyril. Such extended festival cycles represented the twelve major festivals of the Church, along with twelve further icons illustrating the events from the last week of the earthly life of Christ. Extended festival cycles were already known among the earliest monuments of Byzantium and Serbia. In Russia, they appear most frequently in 14th century Novgorodian fresco cycles. The earliest surviving composite icons featuring Passion cycles are also associated with Novgorod. A very detailed example is a 15th century icon of the *EARTHLY LIFE*

83.5 cm x 62.5 cm x 2.5 cm
Panel of two boards with two struts.

Inventory No.
ДРЖ 2881

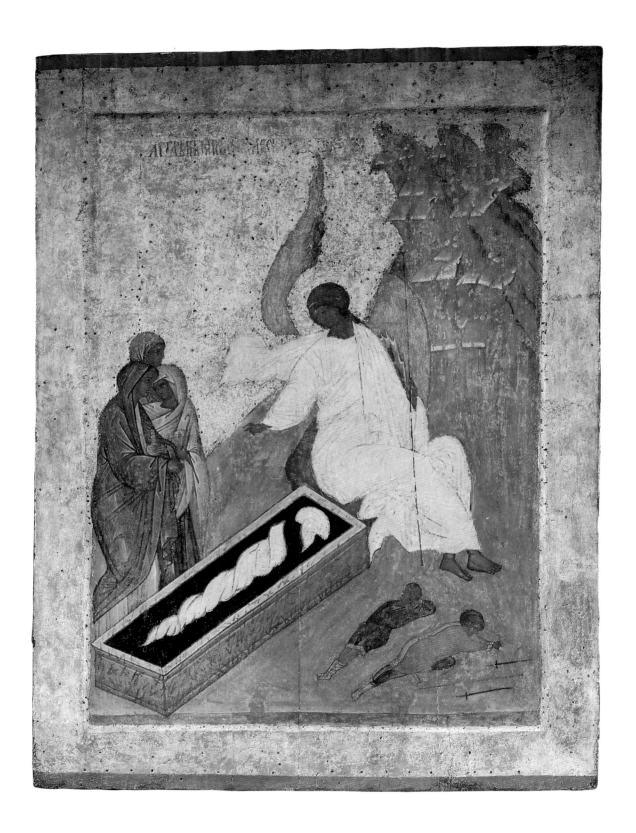

OF CHRIST in 25 parts, and there is also a series of double-sided Novgorodian *tabletki*.

The present icon represents the appearance of an angel to the three Marys who visited the tomb of Christ after his Resurrection. The Resurrection itself, the most mysterious event in the history of Christianity, is not described by any of the evangelists. According to the Gospel narrative, the holy women visited the tomb on the first day of the week, the day after the Good Friday, in order to anoint the body of the deceased with spices in accordance with Jewish custom, whereupon an angel appeared to them and announced the Resurrection. (Matthew 28: 1-7; Mark 16: 1-6; Luke 24: 1–10; John 20: 1). The painter draws upon several Gospels, selecting the details that best suit his purpose.

The painter confines himself to showing only the most essential parts of the narrative, introducing no unnecessary details. The towering rock, the stone door to the sepulcher and the sarcophagus are the basic scenery of the event. Although the iconography of the icon closely follows the canonical text of the Gospel, the pattern created by the artist has no immediate analogies in medieval Russian painting. It should be noted that all the other icons of the Passion from the festival tier of the iconostasis in the Monastery of St. Cyril seem to derive from the calendar icons in the Cathedral of St. Sophia in Novgorod. The painter of the MYRRH-BEARING WOMEN appears to have been following a different model.

The long sarcophagus, diagonally placed in the foreground, forms an important element in the composition of the icon. The tightly shrouded burial clothes stand out against the black abyss. The clothes are represented as a spiralling form, suggestive of the miracle that has just taken place. They are a sign of the Risen Christ who has destroyed the power of death. The juxtaposition of black and white, of dark and light colors, is instrumental in revealing the main idea of the work: the contrast between death and resurrection. An angel is sitting near the sepulcher, on the stone rolled back from the entrance to the cave. His white raiment flutters, as if pierced with light. His image reflects the text of the Easter service: 'The angel has appeared to the women today, as wonderful as the most pure immaterial light, announcing the Light of Resurrection by his glance, and exclaiming: "The Lord is risen!" ' The wing of the angel is swiftly raised, with his robe fluttering in the wind. It is as if he has just flown down to the sepulcher, lightly settling on the stone. With an outstretched arm he indicates the empty tomb, inviting the holy women to witness the miraculous event. The diagonal axis, established by the sepulcher, dominates the composition, and the line of the angel's wing and the figures of the soldiers who had been guarding the entrance to the cave are also incorporated into the design.

The mood of the icon is enhanced by the idea of ascent implied by the mountain, traditionally regarded as a symbol of spiritual elevation. The three peaks of the rock echo the shape of the three women in such a way that the natural world seems to express qualities of human feeling, while the three women reflect the simplicity and grandeur of Nature. The figures and faces of the women are full of a quiet sadness, even though they radiate light and grace. Along with the angel, they bend over the tomb in contemplation. Their gestures and the folds of their clothes communicate their emotions and their awe. The images were presumably conceived in the context of the divine service of the Sunday of the Myrrh-bearers: 'The myrrh-bearing women anticipated the dawn and, like those who seek the day, they sought their Sun, Who existed before the Sun and Who once submitted to the grave. Then the radiant Angel cried to them: "Go and proclaim to his disciples that the Light has shone forth, awakening those sleeping in darkness, and turning weeping into joy ..." '

The icon is characterized by a large area of unfilled gold ground. According to the medieval hierarchy of colors, gold is a symbol of light, manifesting divine energy and the glory of God. By representing nothing in itself, it expressed the unfathomable and ineffable miracle of the Resurrection of Christ.

O.V. Lelekova has established that the icon comes from the 1497 iconostasis of the Monastery of St. Cyril. There has been, however, a considerable debate regarding its exact origin. V.K. Laurina ascribed it to a painter from the circle of Dionysii, but not to the artist who painted the rest of the Passion Week icons. However, Lelekova did believe that the same artist painted all the Passion Week icons, and placed his activity within the Moscow school of the 15th century, while G.V. Popov assumed the icon was from Novgorod.

THE APPEARANCE OF THE ANGEL TO THE MYRRH-BEARING WOMEN is one of the most exquisite and spiritual monuments of medieval Russian painting. The translucent color scheme, based on combinations of green, pink, and ocher hues, conveys the implications of the miracle of the Resurrection through the ethereal quality of the figures. The composition contains nothing unnecessary. Every detail contributes to our understanding of the event, without violating the balance of the whole. Only Muscovite painters were capable of such an exquisite palette, of such skill in the use of different shades of a single color. Nowhere else does one find such refined proportions, such expressive silhouettes, such flowing outlines. The pensive figures of the women and the angel are characteristic of the best Muscovite icon painting of the 15th century, in the manner of Andrei Rublev.

The icon consists of a limewood panel of two sections, with a *kovcheg* and two pinewood struts. Linen covers the entire surface of the panel. There are holes on the ground and at the borders from nails which once secured the *oklad*. The gold ground and the painting are worn in certain areas. The *oklad* was filigree silver-gilt, of the 16th century, and was removed in 1864.

Inventory numbers from various museums can be seen on the reverse. The inscriptions in cinnabar are only partially preserved. There are also remains of an inscription above the lower strut. The icon was cleaned of later painting in 1969-70 by I. V. Iarygina.

Irina Shalina

THE SAVIOR ENTHRONED IN GLORY

Moscow
Mid-16th century

This icon is from the Deesis tier of the iconostasis of the Church of the Dormition in the Great Monastery of the Dormition in Tikhvin. It entered the Russian Museum in 1957. Before the early 17th century the Deesis tier, along with the Festival and Prophet tiers, was part of the iconostasis in the Church of the Nativity of the Mother of God in the Monastery of Konevets. Situated on the

island of Konevets in Lake Ladoga, the monastery was founded by St. Arsenii in 1393. By the early 16th century it was one of the largest and richest monasteries in Karelia, a territory which was administered by Novgorod.

Little is known about the history of the monastery; the archives have not survived and the monastery itself was destroyed during the Russo-Swedish War of the early 17th century. A record of 1554, however, reported a fire that destroyed icons and books in that year. The monastery was rebuilt at the expense of the treasury of the tsar, and from numerous donations by the princes of Moscow. The main iconostasis may have been executed in Moscow or by Muscovite masters at Konevets. It was not destined to decorate the Church of the Nativity for long. During another devastation by Swedes in 1573, the monks were forced to leave the island with all their possessions, including such icons as the miracle-working KONEVETS MOTHER OF GOD, and settled in the Derevianitskii Monastery in Novgorod for 20 years. The government of Tsar Vasilii Shuiskii signed a treaty with Sweden in February 1609, under which a large territory was ceded to the Swedes in exchange for assistance to Russia. The territory included the city of Korela (now Priozersk) and the monaster-

ies of Valaam and Konevets. The monks of Konevets returned to the Derevianitskii Monastery in Novgorod with all their property, reportedly 'the icons, the books, the bells and every church structure.'

Another great fire destroyed the interior of the Church of the Dormition in 1623, according to the records, but analysis of the icons themselves has indicated that the damage was not severe. However, the monastic authorities used the occasion to request that the Konevets iconostasis, which probably remained unused in the Derevianitskii Monastery, should be given to them.

The monastic ledgers make it possible to trace the further history of the iconostasis. Its installation in the Church of the Dormition began in the summer of 1628, under the guidance of the icon painter Ignatii from Tikhvin. In 1641 the silversmith Fedor Poguda was hired at the Tikhvin craftsmen's settlement to decorate the Deesis icons with tooled silver, thereby establishing the date of the icon's *oklad*.

Tentative cleaning of later layers of paint was conducted in the Russian Museum by N.V. Pertsev in February 1957, and a full cleaning was carried out by I. V. Iarygina in 1963-65. In the process of restoration, it was discovered that the icon had already been restored several

213.6 cm x 138.3 cm x 4.2 cm
Panel of four boards with two inset struts, remains of silver *basma* dated 1641-42.

Inventory No.
ДРЖ 3176

times. During these restorations some of the original painting was over cleaned. The areas of green and red, the golden background, and the garments along the panel joint suffered most. When the cracks between boards were filled with mastic, the right side of Christ's face was damaged. The *assist* on the clothes, the white background and the Gospel text were restored. Later paint, mastic, and soiled varnish on the silverwork were removed during the restoration. Because of the poor condition of the original inscription, later painting has been retained on the Gospel book.

THE SAVIOR ENTHRONED IN GLORY is the central image of the Deesis tier. Its iconography dates from 12th and 13th century Byzantium, and is based on the Book of Ezekiel and the Revelation of St. John the Divine.

The symbolism of the image of the Savior is complex and sophisticated. Even after every detail is explained with the relevant Biblical citations, the image remains a mysterious witness to the incomprehensible nature of God.

Christ is shown on a throne with an open Gospel in his left hand and his right hand raised in blessing. Behind him is a red rhombus, an ellipse in two shades of green, and a red quadrangle with concave sides. There are four images in its corners, painted in grisaille: an angel, an eagle, an ox, and a lion. This composition corresponds to the vision of the prophet Ezekiel: 'And I looked, and behold ... a great cloud, and a fire unfolding itself, and a brightness was about it, and out of the midst thereof as the color of amber, out of the midst of the fire. Also out of the midst thereof came the likeness of four living creatures.' (Ezekiel 1:10). Ezekiel goes on to specify: 'as for the likeness of their faces, they four had the face of a man, and the face of a lion, on the right side; and they four had the face of an ox on the left side; they four also had the face of an eagle.' The four mysterious animals were seen as symbols of the four evangelists who were

destined to go to every part of the earth and carry the good news to the world.

The red color of the quadrangle is explained by these words: 'their appearance was like burning coals, and like the appearance of lamps; and the fire was bright, and out of the fire went forth lightning.' The element of fire has always been an attribute of God, especially as a sign of his coming to Earth. The vermilion quadrangle therefore signifies the universal nature of the Kingdom of Christ. The creatures seen by the prophet, the cherubim, are depicted in an ellipse which represents the firmament and seems to be formed by their wings. This firmament is the Glory of God, according to the explanation given by Ezekiel in Chapter 10, where he states that the glory of the Lord was resting on the wings of the cherubim. The vault formed by these incorporeal powers is the celestial firmament resembling 'a sea of glass unto crystal,' (Revelation 4: 6) with 'a rainbow round about the throne, in sight like unto an emerald' (4: 4). This explains why the ellipse in the icon, a symbol of Heaven and the Glory of Christ, is painted green and why the two shades of green represent the refraction of celestial spheres by a rainbow.

'And above the firmament was the likeness of a throne, as the appearance of a sapphire stone: and upon the likeness of the throne was the likeness as the appearance of a man above upon it' ... 'I saw ... as the appearance of fire round about within it ... and it had brightness round about' (Ezekiel 1: 26f). The image of Christ enthroned emphasized the supremacy of God and the divine nature of Christ as the second person of the Holy Trinity. In the icon, Christ is clad in reddish garments covered with a golden *assist*, which seem to be woven of shining light. His figure is positioned in the fiery red rhombus. 'Brightness round about it' means that the image of the Lord is compared to light. In the Revelation of St. John, the appearance of God is compared to the brilliance of precious stones, 'a jasper and a sardine stone,'

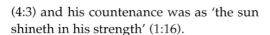

(4:3) and his countenance was as 'the sun shineth in his strength' (1:16).

John saw a book in the right hand of God. In the icon, the Savior is holding a book open to Matthew 11:28-9: 'Come unto Me, all ye that labor and are heavy laden, and I will give you rest. Take My yoke upon you, and learn of Me; for I am meek and lowly in heart: and ye shall find rest unto your souls.'

Icons showing Christ Enthroned in Glory became widespread in Russian art of the 15th and 16th centuries, due in part to the development of the high iconostasis. In this context, images of saints standing before the Almighty King and Judge to pray and intercede for mankind were a logical extension of the symbolism of the iconostasis, drawing primarily upon the theme of the Last Judgment and entry to the Kingdom of Heaven. This symbolism was also reinforced by the architecture of the church. The dome of the church normally bears the image of Christ Pantokrator while the pendentives bear the image of the four evangelists. When looking up from beneath the cupola, the dome becomes a circle, a symbol of the heavens; the pendentives assume the shape of four triangles; and the pillars form a square, a symbol of the earth. Therefore, the composition of THE SAVIOR ENTHRONED IN GLORY is in fact a reproduction of the central part in the cupola.

The composition of THE SAVIOR ENTHRONED IN GLORY is typical of the painting of Moscow and Central Russia. In Novgorod the usual version of this icon did not include the images of celestial beings, or the extensive symbolism of Ezekiel's vision.

Like the entire Tikhvin iconostasis, the icon was believed to have been created in the early 16th century, around 1515 when Church of the Dormition was constructed.

G. D. Petrova dated the iconostasis to 1560, the time when the Great Monastery was founded in Tikhvin. However, a document has recently been discovered which indicates that the icons had been brought from the Konevets Monastery, and requires that this view be revised. The fact that the Konevets Monastery was restored at the expense of the treasury of the tsar leads one to suggest that masters from the capital worked on it, an assumption which is not contradicted by the style and iconographic peculiarities of the icon.

THE SAVIOR ENTHRONED IN GLORY is based on the Muscovite style, close to the manner of Rublev. The composition is so meticulously followed by the painter that even the folds in Christ's clothes, the proportions and the Gospel text are the same. Still closer to the Tikhvin iconography is the 1497 SAVIOR ENTHRONED from the iconostasis of the Monastery of St. Cyril of the White Lake which experts attribute to a Muscovite master. However, both comparisons show how much more monumental and heavier the Tikhvin Savior is. The drawing of the beasts in grisaille, the identical cherubim and the dry *assist* all reveal a specific technique. The painting of the face reveals a tradition which is not one of the early 16th century, and Christ's face lacks the enlightened and vivid expression that was evident in icons of the period of Dionysii.

It is therefore probable that THE SAVIOR ENTHRONED IN GLORY, like the other icons of the Deesis tier, was created in the mid-16th century in the framework of an artistic system still retaining the traditions of classical Muscovite art. Nevertheless, it also displays some features that determine the development of iconography in the second half of that century.

Irina Shalina

THE TRINITY

Novgorod
Mid-16th century

The traditional iconography used to symbolize the Trinity is based on Genesis 18: 1–16, in which three angels appeared as strangers to Abraham and his wife Sarah, near their home by the oaks of Mamre, and foretold the birth of their son Isaac. From the very first centuries theologians have interpreted the food shared by the three angels as the prototype of the Last Supper and of the sacrament of the

eucharist. The angels themselves were interpreted as a symbol of the Holy Trinity. The doctrine of the Trinity occupied a central place in the Christian faith as soon as it was introduced and adopted by the Second Ecumenical Council in 381. However, throughout the Middle Ages theological polemics and controversy never ceased to arise around the issue of Trinitarian unity and often led to the emergence of heretical movements.

Icons of the Trinity adhere to several distinct iconographic types. In one type, only the three angels at a table are represented; in another, as in this case, the scene is complemented by the representation of the hospitality of Abraham and Sarah, and by the slaying of the sacrificial calf. The dogmatic implications of the image do not depend on the number of details; they depend on how the image is interpreted. The question has arisen as to which angel represents which person of the Trinity. The famous icon of the Trinity by Andrei Rublev was for many centuries a model and source of inspiration for Russian icon painters. There seems to have been no common rule for distinguishing the persons of the Trinity, or for depicting them in a specific order. In any case, the issue arose as a matter for discussion at the Council of the Hundred Chapters in the mid-16th century.

If we look from left to right, the Angels are represented according to the Creed: 'I believe in God the Father, the Son, and the Holy Spirit.' This suggestion is proved by the halo of the central angel, inscribed with the Greek monogram of Christ. Abraham and Sarah serve the angels with utmost diligence and zeal, and offer them freshly-baked bread. The servant below is slaying the calf: 'And Abraham ran to the herd and took a calf, tender and good, and gave it to the servant, who hastened to prepare it' (Genesis 18: 8).

In the middle of the table in front of the central angel, there stands a cup with the head of the sacrificial calf seen by early Fathers of the Church as a prototype for the Lamb of the New Testament, a symbol of the redemptive sacrifice of Christ. The sacrificial cup, the compositional and spiritual focal point of the icon, symbolises the sacrifice of the liturgy. The gesture of the central angel, who not only blesses the cup but also partakes of it by touching it, is suggestive of this. The cup of the New Testament 'which the Father has given' (John 18:11) means 'participation in the blood of Christ' (I Corinthians 10:16).

The angels are holding wands or staffs in their hands which indicate the great distance they have traveled, and point to their respective attributes: the wand of the central angel is placed against a tree; that

147.2 cm x 113. 3 cm x 3. 6 cm
Panels of three boards with two struts.

Inventory No.
ДРЖ 2126

of the angel on the left is pointing to a building; the wand of the angel on the right leads our attention to the mountain behind. These three images, featuring in the Biblical narrative as Abraham's house, the oak of Mamre, and the mountain, are identifiable Christian symbols. The well-proportioned edifice behind God the Father symbolizes his wisdom. The oak over the head of Christ is the Tree of Life, the symbol of his Resurrection. According to early Jewish tradition, the dead were buried under a sacred oak tree. The mountain towering above the Holy Spirit is an ancient symbol of the elevation of the spirit.

For medieval Russians, the idea of the Trinity played a central role in religion and in daily life. The Trinity became part of Russian spirituality, a symbol of the lofty human spirit, the criterion of harmony and perfection. Since the time of Sergei of Radonezh (1314-92), the Trinity stood for peace and love, the spiritual unity of the people. Trinity Day was celebrated as an occasion on which differences were settled with love; people remembered their dead, reflecting on the resurrection. The medieval Russian chroniclers would frequently repeat the phrase 'in the Trinity we live and move and have our being!'

It is, however, the circular composition of the icon which best serves to reveal the deep symbolic meaning of the Trinity and its theological implications. A circle in medieval culture was regarded as a symbol of the unfathomable and eternal nature of reality, of diversity in unity. The circle served as the monogram of the One God and as a symbol of the sun regulating the everlasting circuit of the heavenly bodies. In Christian literature, the form of the circle, perfect in all respects, was related to God the Trinity and was compared in the scriptures to the circle of the Sun, and to circular angelic movement. In the 7th century, St. John Klimakos likened faith to a ray of hope, to light and love, to the circle of the Sun, 'but all together they emanate one radiance and one luminosity.' St. Joseph of Volotsk, who founded the famous monastery at Volotsk in the 16th century, remarked that 'just as the circle has no beginning and no end, so also is God without beginning and without end.' The famous writer and publicist of the mid 16th century, Ermolai-Erazm, understood the Trinity as the foundation of world order. In his work *To All Who Believe in the Holy Trinity*, he defined the Trinity as the union of the love of God the Father, the Son, and the Holy Spirit, 'totally renouncing all contrasts and contrarieties.'

In contrast to Andrei Rublev's renowned icon of the Trinity, the circle in the present icon is not formed by the angels alone. On the contrary, all the images participate in it. This consistency can hardly be explained as merely a concern for the compositional clarity of the work. Rather, it was required in order to emphasize the spiritual significance of the icon. The compositional circle of the icon evokes the parallel of the daily and yearly liturgical cycle, with the eucharist at its core. Thus, all the images in the icon are subject to the circular movement and at the same time are all inclined toward the center, toward the cup carrying the eucharistic message of unity with God. The angels bless it, Abraham and Sarah bend toward it offering their gifts, and the unleavened bread of the Old Testament meal becomes a symbol of the eucharistic bread. The head of the sacrificial calf is raised and is also turned toward the cup. The figures of Christ, Abraham, and Sarah form a triangle, repeated by the cup and the gifts for the angels. The composition is unambiguously reminiscent of a triangular particle of the eucharist, cut from the round sacrificial altar-bread during the liturgy. The direction of Christ's hand pointing to the cup indicates the first edge of Sarah's blood-red *maphorion*, and then the calf whose head is lifted up to Him. Following this axis in the reverse direction, one returns to the sacrificial cup with the animal's head.

The color scheme of the icon differs from that of Rublev's *TRINITY*, but every color employed here nevertheless carries a message. The figure of Christ is vested in a *chiton* of violet hue, a color which has various symbolic associations. It was used for the attire of the priests in commemoration of the Crucifixion, and it is interesting to note that the shirt of the servant preparing the calf for the visitors is of the same shade. The red attire of the angel on the left serves to indicate God the Father, and his love of mankind revealed through the sacrifice of the Son. The Holy Spirit is dressed in red and green, the latter color implying hope and salvation. The color red also reminds us that 'everything is purified with blood and without the shedding of blood there is no forgiveness of sins' (Hebrews 9: 22), that 'blood is the life' (Deuteronomy 12:23), and that 'the life of the flesh is in the blood' (Leviticus 17: 11). The same color appears in the garments of Abraham and Sarah.

In the image of the Old Testament Trinity, therefore, two themes, historical and symbolic, become one: the meal of the three angels who appeared to Abraham becomes the eucharistic feast which is repeated in an infinite historical cycle. A momentary episode of ancient time has become the perpetual act of the age to come.

While experts have never questioned the Novgorodian origin of the icon, for a long time it was attributed to an earlier date. Thus, N. G. Porfiridov dated it to the end of the 15th century, and then in his later works to the 16th century. In the catalog of the exhibition PAINTING OF OLD NOVGOROD the icon is dated to the mid-16th century. V. L. Laurina attributed it to the same period.

There are insertions of new gesso with later painting in the lower part of the icon, especially on the border, and also in the halo of the angel on the right. The paint of the wings, as well as the gilt of the ground, borders and halos, is worn. There is evidence of renovation on the wands, the cross, the inscription on the halo of the central angel, and along the edge of the upper margin.

The icon was freed of over-painting before it was received by the Russian Museum. It has been in the Russian Museum since 1933, but its provenance is uncertain. As with other icons of the Trinity of such size and quality, it is likely that it would have been placed in the local tier of an iconostasis, perhaps as a dedicatory icon.

Irina Shalina

CHERNIGOV GRIVNA

Kiev
11th century

This pendant was found in 1821 near the village of Belousova in the region of Chernigov. It was received by the Russian Museum in 1930 from the State Hermitage. The images are executed in high-relief and engraved. On the upper part of the pendant is a loop, which allows it to be worn around the neck or be attached to headgear. On the obverse of the pendant is an image of the Archangel Michael, in imperial garments, and holding the labarum and orb. On the reverse is a naked bust of a woman, from which serpents radiate in a manner reminiscent of Medusa in classical mythology.

The obverse of the disk is framed by palmettes and has a circular devotional inscription in Greek: *Holy, Holy, Holy, Lord of Sabaoth. Heaven and Earth are full* [of your glory].

On the edge of the reverse of the disk there are inscriptions in both Slavonic and Greek. The Slavonic inscription reads, *Lord, help your servant Basil. Amen.* The Greek inscription is obscure, but has been reconstructed to read: *O womb, dark and black, you have coiled like a serpent, hissed like a dragon, roared like a lion:* [now] *sleep like a lamb.*

Applied arts from the pre-Mongolian period are very rare. Those that have been found are mainly articles intended to be worn around the neck or on headgear, cast amulets, body crosses, *enkolpion* crosses, and miniature stone icons. Of these articles, the gold medallion found near Chernigov is one of the earliest. Although it has retained the name given it shortly after its discovery, the term *grivna* in fact refers to a type of collar decoration in the form of a twisted hoop.

As a result of the location where the medallion was found, and of the appearance of the name 'Basil' in the Slavonic inscription on the reverse, the medallion has been linked with the prince of Chernigov Vasilii (Basil), who ruled in Kiev between 1113 and 1125 as Vladimir Monomakh. A model prince, Vladimir was not only a warrior, he was a man of letters who wrote an autobiography, and a book of instruction for princes. He also commissioned an edition of the *Primary Chronicle.* The palaeography of the inscription is characteristic of the 11th century, and Basil is known to have lived in Chernigov between 1078 and 1094.

Female busts with snakes were quite common during the Late Antique and Byzantine periods. Amulets bearing this image were believed to relieve the pain of the womb and to ensure healthy birth. The image is believed to have originated with the Egyptian god Chnoubis, whose amulets were used to relieve abdominal pains. The Archangel Michael was also associated with healing, in addition to his role as the leader of the celestial host.

The amulet is valuable evidence of pagan-Christian syncretism, and of Greek-Slavonic bilingualism in Kievan Rus during the late 11th century.

Izilla Pleshanova

7.8 cm x 7.4 cm x 1 cm
Gold, cast and chased.

Inventory No.
БК 2746

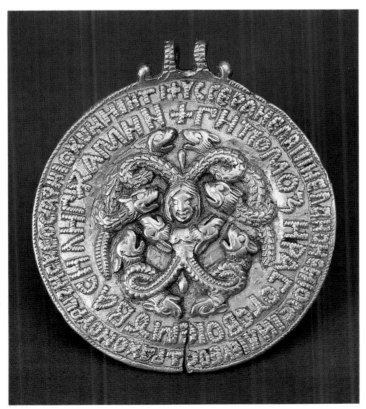

Catalog No. 21

THE MOTHER OF GOD OF TENDERNESS

Novgorod
Late 13th century

5 cm x 4.1 cm x 0.7 cm
Carved stone

Acquired in 1956 from F.A. Kalikin

Inventory No.
ДРКам 242

Carved from fine grain sandstone, this icon was intended to be worn as a pectoral amulet. The image of the Mother of God of Tenderness is inserted into an elaborate and delicately carved frame. The inscriptions read *Mother of God* and *Jesus Christ*. Although the icon was acquired from F.A. Kalikin, it had been in the collection of N.P. Likhachev.

Izilla Pleshanova

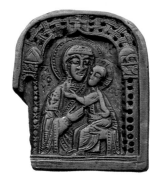
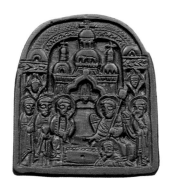

Catalog No. 22

THE HOLY SEPULCHER

Novgorod
Late 13th century

5 cm x 4.4 cm x 0.8 cm
Carved stone

Acquired in 1934 through the Hermitage from the State Museum Reserve.

Inventory No.
ДРКам 39

A pectoral icon with a rounded top, it depicts the tomb of Christ framed by columns and an ornamental vault. An angel stands beside the tomb, and seraphim are flying before the columns on either side. The composition is crowned by a church with three domes. Although the reverse of the icon is severely worn, it still displays an image of two saints dressed in *omophoria*.

Izilla Pleshanova

THE MIRACLE OF ST. GEORGE AND THE DRAGON

Novgorod
14th century

6.3 cm x 5.8 cm x 0.9 cm
Carved stone.

Acquired in 1934 through the Hermitage from the State Museum Reserve.

Inventory No.
ДРКам 54

O n a pectoral icon of grey-green slate the mounted warrior St. George is spearing the dragon. The saint is wearing short armor and boots, with an oblong shield on his left arm. The inscription is deeply carved and reads: *George*. At the right corner is the hand of God in the gesture of blessing. The depiction is characterized by fine linear drawing and flattened relief.

Izilla Pleshanova

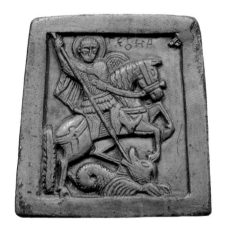

Catalog No. 24

THE HODEGETRIA MOTHER OF GOD

Novgorod
15th century

5.4 cm x 4.7 cm x 0.7 cm
Carved stone.

Acquired in 1934 through the Hermitage from the State Museum Reserve.

Inventory No.
ДРКам 28

T his pectoral icon of dark shale depicts the *Hodegetria* Mother of God of the Smolensk type. She is depicted in a frontal position with the infant Christ on her left arm. The inscriptions read: *Mother of God* and *Jesus Christ*. The icon is in an unusually good state of preservation. The image is carved in low relief and the details are rendered through hatching, which emphasizes their volume.

Izilla Pleshanova

THE ARCHANGEL MICHAEL

16th century

The oval icon of white bone has been encased in an octagonal silver frame with a moveable apex. This gilt *oklad* is decorated with eight pearls and pastes, with another paste on the apex. The reverse is covered by a thin silver plate. The icon represents an archangel in military attire, holding a drawn sword. Inscribed at the sides of the halo are the words: *Archangel Michael*. The miniature image

8.1 cm x 4.6 cm x 0.7 cm
Carved bone
Oklad: silver, filigree, gilt with pearls and pastes.

Inventory No.
ДРК 79

of the archangel with his wings spread, his cloak fastened on his breast and falling in folds at the back, is skillfully placed within the *kovcheg*. The drawing is delicate and well-proportioned. The relief is divided into various levels and is notable for the precision of its modelling.

The Archangel Michael, the leader of heavenly host, is clad in full armor and stands in belligerent posture. There are many parallels for this iconography in Russian art. Michael is known as the guardian archangel, and images of him enclosed in small metal protective icons to be worn on the breast were especially popular.

Izilla Pleshanova

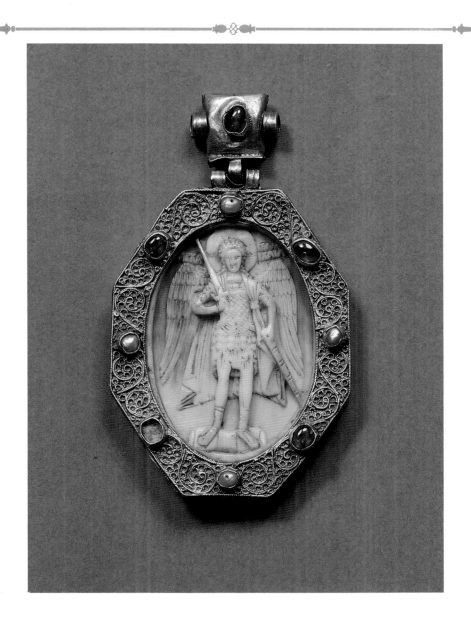

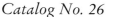

Catalog No. 26

DEESIS

Novgorod
Late 15th century to early 16th century

This icon is a triptych (*skladen*) showing a two-tier representation of the Deesis. The centrepiece displays Christ Pantokrator, the Mother of God, St. John the Baptist, the Apostles Peter and Paul, St. Nicholas, and the Martyr Nikephoros. The left-hand leaf shows the Archangel Michael with St. Varlaam of Khutyn, while the right-hand leaf has representations of the Archangel Gabriel and St. Sergei of Radonezh. The reverse of the leaves shows the righteous thief in paradise.

The triptych is enclosed in a 16th century chased silver casing, covering the background, borders and ends of the central panel and the leaves, as well as the nimbuses of the saints. The design on the casing consists of double coils with spirally twisted ends, on a background of small chased circles. The hinged headpiece with a sculpted image of the Mandylion bears the inscription *Christ*, and the nimbus of Christ contains the Greek phrase *He who is*. The casing bears 11 plaques with niello inscriptions.

The icon comes from the sacristy of the Monastery of St. Cyril of the White Lake and was received by the State Russian Museum in 1923 through the Museum Fund. It was cleaned at the Museum in 1974 by I. V. Iarygina.

The triptych has undergone a number of alterations during its existence. The nimbuses of the saints were originally covered by superimposed halos, as may be seen from the remains of nails and nail holes around their edges. In the mid-16th century the triptych was enclosed in a chased silver casing. It was probably then that the image of the righteous thief and the gates of paradise was applied to the reverse of the side leaves, and the reverse of the central panel was covered with geometrical patterns. In the 17th century the original borders of the leaves were sawn off and replaced by wooden strips which were primed on the reverse and painted with ornamental designs.

Folding icons consisting of a central panel with two, four, or more side leaves were widely used in medieval Russia, and were carried by their owners when traveling as a substitute for domestic *iconostases*. Miniature icons such as the one under discussion were intended to be worn around the neck and were therefore fitted with loops on the headpieces. These icons were often donated to churches and monasteries, either as *ex voto* appendages to venerated icons, or under the wills of their owners after their deaths.

The leaves of the icons contained images of the Crucifixion, the 12 great festivals or selected saints. The painters either followed the wishes of the client or reproduced venerated icons. In addition to painting, such compositions were sometimes cast in metal or carved in wood, stone, or ivory.

The present icon belongs to the Deesis type, widely found in medieval Russian iconography, with half-length images of the saints. The two-tier composition of the icon was determined by the variety of its subjects. The figures of the saints are placed in order of rank according to the

Central panel: 9.5 cm x 9.5 cm x 1.3 cm, Leaves: 9.5 cm x 4.5 cm x 0.7 cm
Triptych of three single panels without struts; chased silver *oklad*.

Inventory No.
ДРЖ 2552

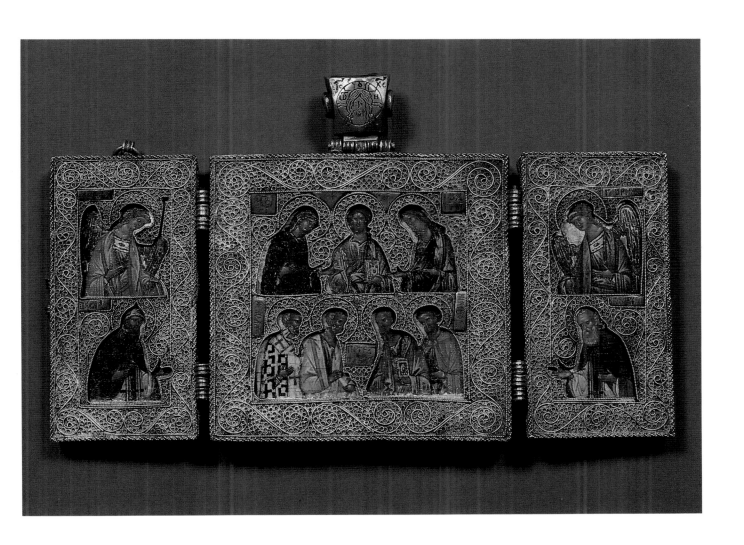

125

traditional hierarchy. The components of the Deesis group on this icon give grounds for assuming that it was ordered by an individual, and that the choice of saints has a patronal significance. The Mother of God, St. John the Baptist, the Archangels Michael and Gabriel, and the Apostles Peter and Paul address their prayers to Christ on the day of the Last Judgment. Of the saints traditionally depicted in the Deesis group, this icon includes St. Nicholas of Myra. The chosen representative of the martyrs is St. Nikephoros. Several saints bearing this name are venerated by the Orthodox Church, and medieval Russian iconographical books include a 3rd century martyr from Antioch with the following description: 'stole and chasuble azure, tunic vermillion.' It would appear that he is indeed the martyr depicted on the present icon. Images of the Martyr Nikephoros are very rare in medieval Russian iconography.

The lower tiers of the side leaves contain images of the St. Sergei and St. Varlaam. St. Sergei of Radonezh, Abbot of the Trinity-St. Sergei Monastery, is one of the most venerated of Russian saints, and personified the Muscovite ideal of monastic life and lofty spirituality. Similar concepts were associated in Novgorod with the personality of St. Varlaam from the second half of the 15th century onward. He lived in the 12th century and founded the Monastery of Khutyn. The veneration of the saint began in Novgorod, and with active support from Moscow spread beyond the surrounding region to cover the entire country. The tradition in Novgorod and Moscow of depicting the two saints together may be explained by a desire to provide a graphic demonstration of the political unity of the two cities. Moreover, it is no accident that images of Sergei and Varlaam, two of the most venerated saints, appear on an icon installed in the largest monastery of the north; and it is perhaps also not accidental that the figures are placed on the side leaves below the archangels, a compositional arrangement which may denote special protection for them in their adoration of Christ.

The image of the righteous thief, who believed in Christ during the Crucifixion and obtained forgiveness of his sins, used to be included in the composition of icons of the Last Judgment. As in the work under discussion, the thief was depicted standing before the gates of paradise with a cross in his hands. In this way, the Deesis group on the obverse of the icon and the images on the reverse of its leaves are united by the single theme of the intercession of saints for mankind before Christ on the day of the Last Judgment.

Scholars hold divergent views concerning the dating of the icon, which has been assigned to various points between the middle of the 15th century and its end. The work is ascribed either to Muscovite painters or to the Novgorod school. A provenance from Novgorod seems to be the more probable, since the icon has close stylistic similarities to the icons executed in the late 15th century for the Cathedral of St. Sophia in Novgorod by an icon painter of the archepiscopal workshop. These similarities are the plastic treatment of the figures and their proportions, the facial types, the thick paint and brilliant colors, the gold background, and even such a small detail as the double grooved lines around the nimbuses.

Each section of the icon is sawn on all four sides along the grain and reinforced by wooden laths. The gold is considerably abraded, as is the pigment layer, particularly around the contours of the figures and the red inscriptions on the background. The obverse contains nail holes and the remains of small nails. The lower right hinge of the triptych is loose, a fragment having been lost. Metal is also missing from the bottom end of the central panel.

Irina Soloveva

THE MOTHER OF GOD OF THE SIGN AND THE HOLY TRINITY

The Monastery of St. Cyril of the White Lake
16th century

The Mother of God is depicted in a rectangular panel with a circular *kovcheg*, her hands raised in a gesture of prayer. In the folds of her *maphorion*, she displays the image of Christ Emmanuel. The inscriptions are as follows: *Mother of God*, *Jesus Christ*. In the corners are trapezoid recesses inscribed *St. Nicholas*, *St. Gregory*, *St. Basil,* and *St. John.* Below these, in two small *kovchegs*, are half-length depictions of monastic saints, inscribed *St. Sergei* and *St. Cyril*.

The reverse of the wing is covered with black silk.

The depictions of St. Sergei and St. Cyril were typical of the art of the Monastery of St. Cyril of the White Lake. Examples of 16th century carvings with similar proportions and in a similar style of flattened relief are preserved in the Kirillov Museum. The diptych was probably one of the versions produced there.

The Holy Trinity is depicted in a matching rectangular panel with circular *kovcheg*. The *kovcheg* bears a number of inscriptions, including *Jesus Christ* and *Holy Trinity.*

In the corners are trapezoid recesses with the symbols of the evangelists and inscriptions.

Below the round *kovcheg* is another rectangular *kovcheg* with a half-length depiction of Artemii the Martyr. The reverse of the wing is covered with dark silk.

Izilla Pleshanova

10 cm x 8.3 cm x 1 cm
Carved wood, tempera.

Inventory No.
ДРД 3

9.9 cm x 8.3 cm x 1.0 cm
Carved wood, tempera.

Inventory No.
ДРД 35

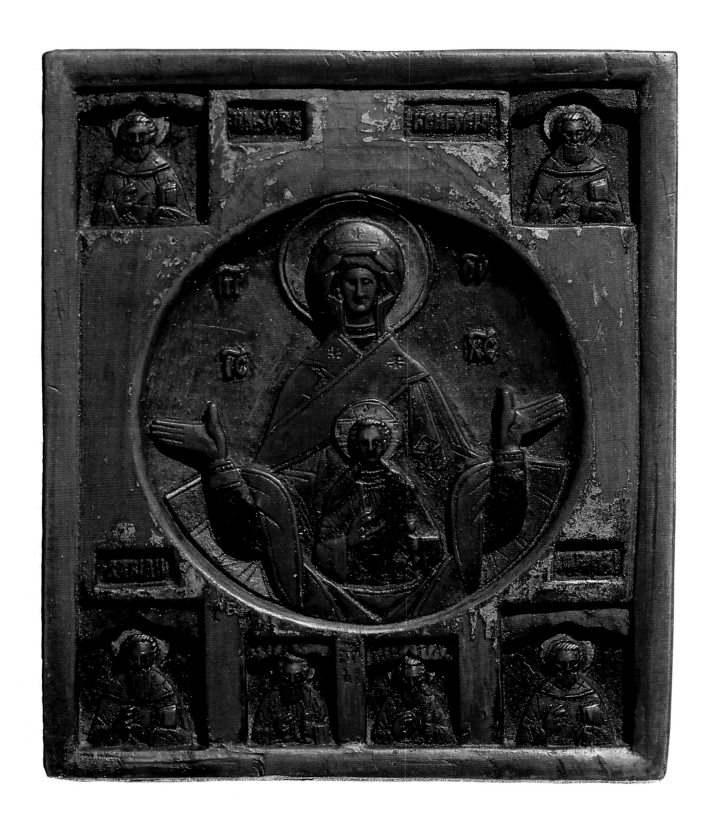

128

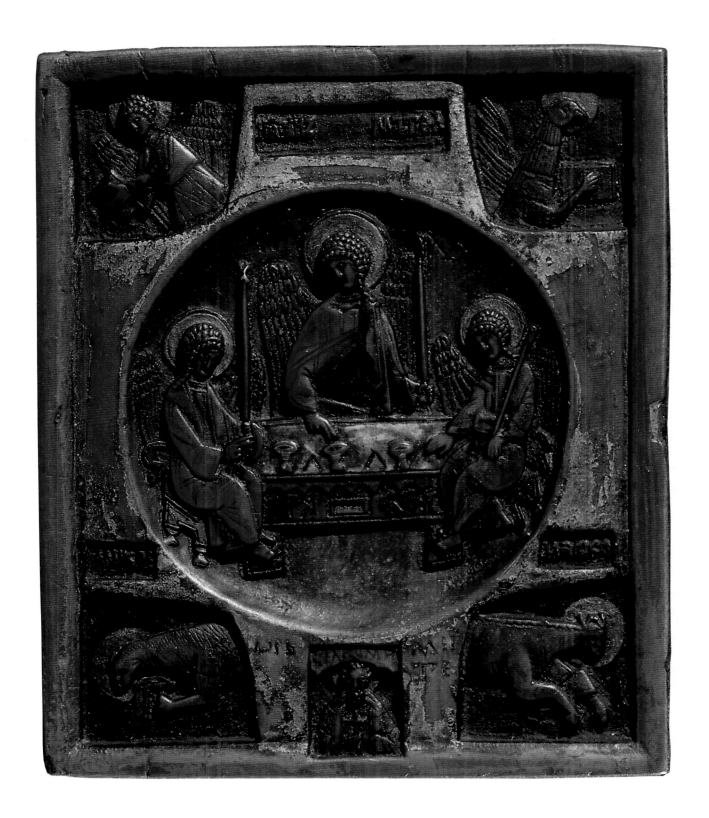

Catalog Nos. 29/30

WISDOM HAS BUILT HER HOUSE AND FOUR FESTIVALS

Master Anania
Pinsk
Late 15th – early 16th century

The carvings may have originated as a single piece, now sawn in two. The composition of the icon '*WISDOM HAS BUILT HER HOUSE*' illustrates Proverbs 9: 1–5: 'Wisdom hath builded her house, she hath hewn out her seven pillars: She hath killed her beasts; she hath mingled her wine; she hath also furnished her table. She hath sent forth her maidens, she crieth upon the highest places of the city,

who so is simple, let him turn in hither; as for him that is void of understanding, she saith to him, "Come eat ye of my bread, and drink of the wine which I have mingled."'

The complexity of the philosophical and theological significance of Sophia, the personification of Wisdom, and the loss of many works of art representing this theme impose a limit on our understanding of the subject. In the literature on Russian iconography two versions of Sophia are commonly mentioned, one associated with Kiev and one with Novgorod. The Kievan version, depicting the Mother of God and the infant Christ, represents the Incarnation. The Novgorodian version represents Wisdom as a fiery-eyed angel ruling the world. He is arrayed in a royal vestment and crown, sitting on a throne supported by seven pillars, his feet resting on a stone, the stone of faith. In this version Sophia is not identified with the Mother of God. In liturgical poetry the image of the Mother of God is understood as an allegory of the Church, the vessel of God.

Both the Kievan and Novgorodian versions imbue Solomon's proverb with Christian significance, although the present composition follows its details liter-

ally. The iconography was probably derived from Byzantine models, now lost. An early Russian example of the composition is found in the murals of the Church of the Dormition in Volotovo. Miniature carvings of the subject from the late 15th to early 16th century also survive. One example was recorded in the middle of the last century in the collection of A. S. Uvarov. A painted icon of the subject, dating from the first half of the 16th century and now in the Tretiakov Gallery, also survives. It originated from the Smaller Monastery of St. Cyril near Novgorod.

The present icon belonging to the Russian Museum represents Wisdom enthroned, adorned with a *chiton* and *himation* which stream in the wind. He blesses with his right hand and holds a scroll in his left. There is an inscription indicating that this is Sophia-Christ. The scenes in the lower part of the icon, the killing of a calf, the mixing of wine, and the distribution of bread and wine illustrate the text of the proverb, and symbolize the eucharistic sacrifice. A temple towers over the light that emanates from the figure of Wisdom, and a round-faced Solomon is shown bending down from one of its structures. The text of the

6.6 cm x 5.1 cm x 0.8 cm
Carved wood.

Inventory No.
ДРД 47

67.0 cm x 5.2 cm x 0.7 cm
Carved wood.

Inventory No.
ДРД 60

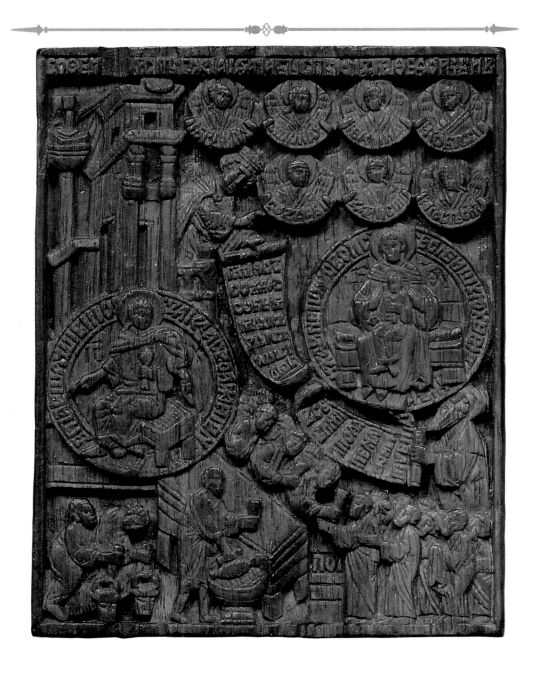

proverb written on his scroll continues the theme of Sophia: *Wisdom hath builded her house, she hath hewn out her seven pillars, she hath killed her beasts, she hath mingled her wine . . .* Opposite Solomon, as if to meet him, stands St. John of Damascus, whose defence of the veneration of icons as part of the doctrine of the Incarnation was essential to the victory of Orthodoxy during the Iconoclastic Controversy.

On a disk in the upper part of the icon, sitting on a throne and surrounded by shining light, are the Mother of God and the infant Christ. Inscribed around the figures is the text of the *troparian: More honorable than cherubim, more glorious than seraphim we sing to thee, Blessed Mother of God, who gave birth to God the Logos, without decay.* The medallions with half-length angels are variously interpreted as the seven gifts of the Holy Spirit or the seven angels in the vision of John the Divine, the author of the Revelation.

In the light of these references, the composition *Wisdom Has Built Her House* illustrates both the ancient allegorical prophecy of building a house of human salvation and its fulfillment in the New Testament. The miniature relief emphasizes the relationship between the Mother of God and the manifestation of Wisdom as Sophia.

The inscription in the upper border of the icon indicates that it was donated by Prince Fedor Ivanovich.

The iconography of the second icon comprises four festivals of the Church: the Nativity, the Transfiguration, the Ascension, and the Dormition of the Mother of God.

The scene of the Nativity includes some apocryphal details. A large star of Bethlehem is seen in the sky. An ox and a donkey are bending their heads over the swaddled infant while angels are singing on the hill sides. In the lower part of the scene Joseph and Solomia can be seen holding the baby.

In the Transfiguration, Christ appears in an oval mandorla and the prophets Elijah and Moses stand on rocky mountain ridges. St. Peter, St. James, and St. John are shown prostrate below, confounded by the divine vision.

In the Ascension, Christ sits on a rainbow blessing the figures below. The light streaming from him is supported by flying angels. The Mother of God is standing among the apostles with her hands raised in prayer.

The last composition is the Dormition of the Mother of God. Her couch is surrounded by the apostles and Church Fathers, and Christ stands in a mandorla holding her soul in his hands.

The two wings echo each other in content, the second illustrating the New Testament theme of the Incarnation of Christ. The Nativity is his arrival in the world and his assumption of human form. The Transfiguration is the moment of the revelation of his Divinity. The Ascension is his return to heaven, leaving the apostles with the commandment to baptize the nations. The Mother of God in the *orans* posture is the image of the Church on earth. The Dormition is included in the twelve principal festivals of the Christological cycle since this was the last occasion when Christ met his disciples in the flesh. The inscriptions are as follows: *Nativity of our Lord Jesus Christ; Transfiguration of our Lord Jesus Christ; Ascension of our Lord Jesus Christ; Dormition of the Holy Mother of God.*

Along the side borders there is an inscription of a historical nature: *Given by Prince Fedor Ivanovich Iaroslavich to Fedor Ivanovich Shchepin. Made by Father Anania.* The precise form of the donor's name was applied in Russian sources only to Prince Fedor of Pinsk. Pinsk fell into Lithuanian hands in the 14th century, but as with other western Russian lands, it kept its language and its Orthodox Christianity. In the 15th century its population resisted increasing Polish influence and compulsory conversion to Catholicism. These national struggles had religious overtones. The situation in western Russia during the late 15th and early 16th century resulted in the spread of the composition

Wisdom Has Built her House, since there had always been marked differences between the Catholic and Orthodox interpretations of Christian doctrine and ritual.

The two wings held by the Russian Museum were executed by the same Anania. Nothing is known of Anania beyond what can be learned directly from works ascribed to him by inscriptions. His carv-ing technique was multi-planar; the background is deeply undercut, and his modelling soft and rounded. The outstanding sculptural and decorative qualities of these works give us some impression of a form of art that flourished in western Russia, but of which few examples still survive.

Izilla Pleshanova

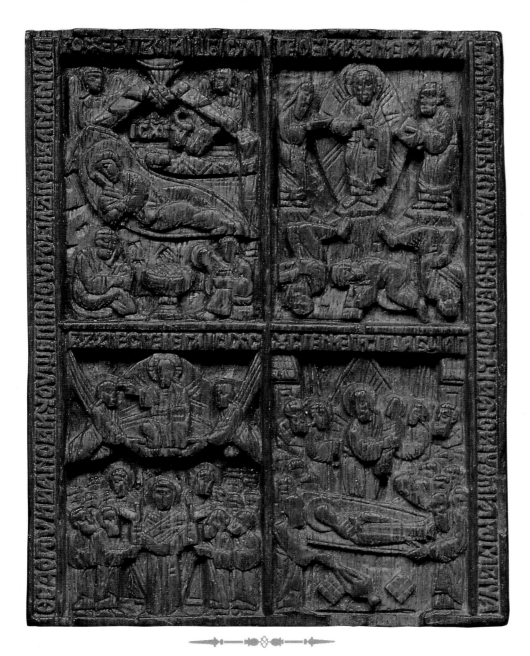

DID STAND THE QUEEN

Suzdal
Third quarter of the 16th century

The icon represents Christ enthroned, his image combining the attributes of King and High Priest. He is dressed in the ceremonial robes of a Byzantine emperor: a *sakkos* with long, wide sleeves, embroidered with crosses; a *loros* draped over his left shoulder; an *omophorion* and a patriarchal staff at his feet, indicating that the episcopacy derives its authority from him. He holds up a

book of the Gospels with his left hand, and his right is raised in blessing. The Mother of God standing by the throne is clothed in royal robes, including a *loros*, and holds a staff in her right hand. On the other side, St. John the Baptist, in a hair shirt and cloak, carries a scroll with the inscription: *He that hath the bride is the bridegroom* (John 3: 29). The background of the icon bears inscriptions explaining its significance, but these are concealed by the metal casing. The inscription at the sides of the cross-shaped nimbus of Christ reads: *Thou art the priest forever after the order of Melchizedek* (Psalm 110: 4). The inscription above the head of the Mother of God reads: *Upon thy right hand did stand the queen vested in gold* (Psalm 44: 10). The inscription over the figure of St. John reads: *John the Baptist.*

The silk cover on the reverse of the icon bears two inscriptions in ink. The inscriptions are very poorly preserved and this has led to a number of interpretations. According to data supplied by V. T. Georgievskii, the icon belonged to the wife of Tsarevich Ivan Ivanovich, Evdokiia Bogdanova Saburova, who took the veil at the order of Ivan the Terrible soon after her marriage, and spent the rest of her life at the Convent of the Protection. It would

seem that Archbishop Leonidas blessed the tsarevich with this icon on the occasion of his marriage in 1571, and that it subsequently passed to his wife.

The painter has followed the iconography of a Byzantine or 14th century Serbian icon, which is preserved in the Cathedral of the Dormition in the Moscow Kremlin. This iconography is quite rare in medieval Russian art, and the surviving examples are mainly connected with Novgorod.

The miniaturism of the forms and the meticulously executed details of the icon associate it with the style of painting which developed in the 16th and 17th centuries, and became known as the Stroganov school.

The reverse of this icon bears traces of thin yellowish silk. The borders and background are covered with 16th century beaten silver, and the icon is adorned with three silver nimbuses, and a crown with chasing, blue and green enamel, and two pearls. There are five silver and blue enamel plaques with inscriptions. The gold and red paint of the clothing and scepter is partly abraded. The inscription on the scroll of St. John the Baptist has been repainted.

Tatiana Vilinbakhova

42.1 cm x 34.5 cm x 2.5 cm
Single panel with
two inset struts.

Received in 1914 from the
Convent of the Protection in
Suzdal. Cleaned in 1915 by
N. I. Briagin.

Inventory No.
ДРЖ 2060

135

ST. KOSMAS AND ST. DAMIAN

Monastery of St. Cyril of the White Lake
ca. 1569

The bone icon is mounted on a wooden panel, and the border is carved in the form of an arch. The background is of repoussé *basma* with a linear decoration. The margin is embellished with sinuous stalks. Within the *kovcheg* there are two full-length figures in low relief, standing on an ornamented base.

20.5 cm x 15.5 cm x 2 cm
Carved bone on wooden panel with silver-gilt *basma*.

Acquired in 1930 from the Department of Byzantine Art in the Hermitage.

Inventory No.
ДРК 103

Above them are the inscriptions: *St. Kosmas* and *St. Damian*. The saints are represented as healers, each holding a medicine chest in his left hand and a medical instrument in his right hand. The figures have broad shoulders and wear cloaks with undulating folds; their pensive gazes are fixed on the spectator. Both are executed in a soft manner and an attempt has clearly been made to mold their rounded features.

The reverse of the icon, covered with red taffeta, displays a label which reads: *The icon of Kosmas and Damian of carved bone and silver was given to commemorate Fedor Vasilevich Suponev and Fedor Andreevich Karpov*. The Register of the Monastery of St. Cyril of the White Lake has the following entry: 'Year 7077 [1569 AD] Antonida, the wife of Fedor Karpov, gave the Church of the Holy Mother of God and Cyril the Wonder-Worker 28 icons of palm size, with silver ... including two carved icons, also with silver.' This donation was to commemorate her father Fedor Suponev and her husband Fedor Karpov. The names of Fedor Suponev and Fedor Karpov are known from other contemporary documents.

Izilla Pleshanova

ST. ANTHONY OF THE CAVES

Late 15th or early 16th century

This work is the only surviving pall from the tomb in Kiev of St. Anthony, who founded the Monastery of the Caves in Kiev along with St. Feodosii. The holy father was born in 983 and died in 1074. The pall was gift to the Monastery of the Caves, where the relics of St. Anthony are preserved, and was received in 1923 from the Monastery of St. Cyril of the White Lake. The border inscription

extolling the monastic life of the holy father has not survived. In 1927 the pall was lined with canvas, and during restoration in 1971-73 the embroidery and the remains of the original background were transferred to silk fabric of a color close to the original.

It has been established from the book of donations for 1622 that the shroud was brought to the monastery by Lev Voksharin in 1586: 'In the year 7094 [1586 AD] Lev Voksharin donated a shroud embroidered with the figure of St. Anthony of the Caves the Wonder-Worker, stitched on satin and around it the *troparion* and *kontakion* are embroidered in gold on white

satin, for 20 rubles.' The shroud is also mentioned in all the inventories of the Monastery of St. Cyril of the White Lake as one of its finest works. The Voksharin family donated many valuable gifts to the monastery.

A striking feature is the idiosyncratic embroidery technique using black silk thread to outline the contours, the folds of the clothing, and the facial features. Another interesting fact is that the shroud was donated to the monastery nearly a hundred years after its creation.

Liudmila Likhacheva

Pall (*Pokrov*)

190 cm x 78.5 cm
Satin, embroidered with silk
and gilt thread.

Inventory No.
ДРТ 305

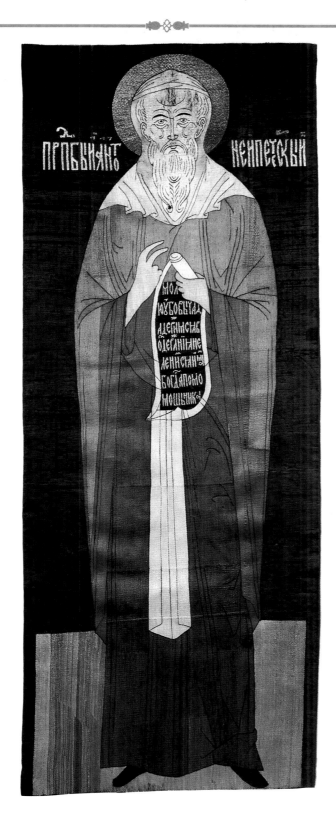

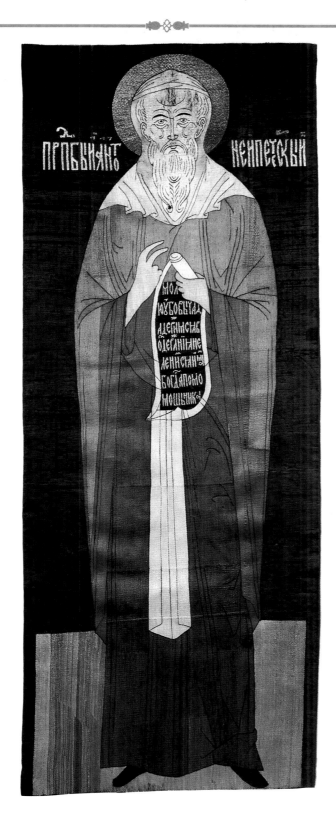ПРПБ ВИЯНТ НЕИПЕТСКЫИ

THE MOTHER OF GOD APPEARING BEFORE ST. SERGEI OF RADONEZH

The Trinity – St. Sergei Monastery
First half of the 16th century

This carved icon depicts a miraculous event associated with the Trinity – St. Sergei Monastery. On the left is the Mother of God with a staff; behind her are St. John and St. Peter. On the right St. Sergei stands with his hands raised in a gesture of prayer; to his right the monk Nikon is coming out of his cell. The architectural background is formed by two buildings with a velum suspended between them and a pink monastery wall. In the upper part of the icon, the patron of a monastery, the Holy Trinity, appears on a relief disk.

The painting is in subdued colors, combining blue, olive-yellow, brown, and pink.

The icon is mounted on a thin panel of red wood inset in a wooden frame. The frame and the tempera on the carving are probably of a later date.

The theme of St. Sergei's vision can be found in icon painting, embroidery, and small sculptures. A version with Sergei kneeling is more popular, but the present version is represented by older works. This iconographic type is typical of the icon painters of the Trinity–St. Sergei Monastery.

In the depiction of the characters, majestic appearance is combined with gentleness, a typical trait of early 16th century works. The balanced composition, elongated figures, and delicate lines and gestures are similar to those of the early 16th century icons of Moscow.

The icon illustrates a vision granted to St. Sergei towards the end of his life. The first biography of the saint was written in the early 15th century, and both the description of his vision and the iconography came from monastic sources. An icon depicting the vision accompanied the Russian army during the Kazan campaign of 1552 and the Polish campaign of 1654.

Written sources and a number of carved icons from the Trinity–St. Sergei Monastery suggest that a local school of carving existed as early as the 15th or 16th century. Our icon probably comes from that school. It should be noted, however, that the technique of low, multi-plane relief with delicate lines and exquisite figures is also associated with the Monastery of St. Cyril of the White Lake, founded by a disciple of St. Sergei. This monastery also possessed an icon of the vision of the saint.

Izilla Pleshanova

27.8 cm x 19.8 cm x 1.0 cm
Carved wood, tempera.

Acquired in 1898 from the Museum of the Academy of Art. Formerly in the collection of V. A. Prokhorov.

Inventory No.
ДРД 171

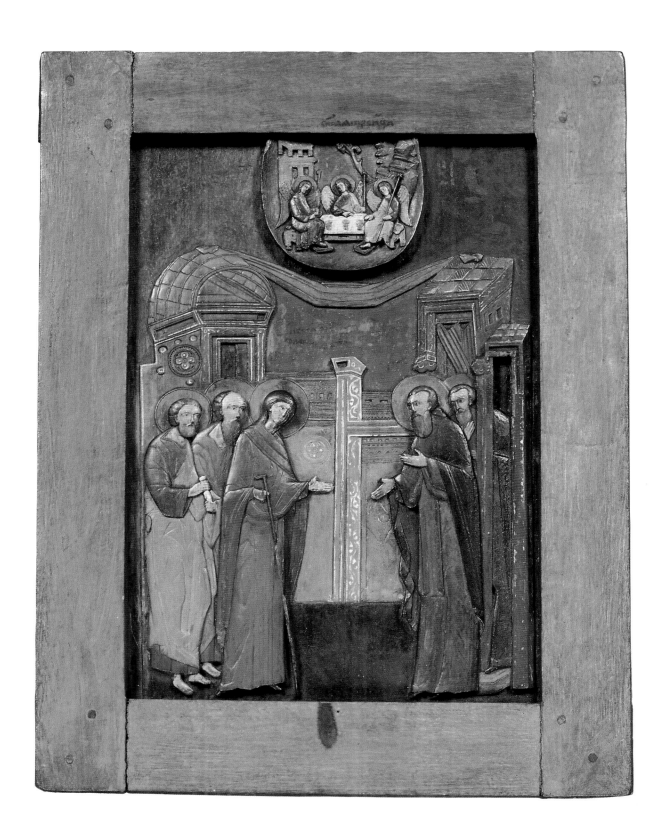

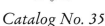

THE TRINITY

16th century

The icon is rectangular, with high borders made of a dark red wood, probably imported from southern Russia. The reverse and the edges of the icon show traces of thin cloth (*sorochka*). Parts of the oklad have also been preserved, in the form of simply decorated bands of silver-gilt. The icon depicts the Old Testament Trinity, and the inscription above the image reads: Holy Trinity. At the center of the icon is a semi-circular table with three cups, knives, spoons, and some vegetables. Near the table on high stools sit the three angels.

In the right foreground Abraham holds a cup, and in the left foreground Sarah is kneading dough. In the center, a young servant sacrifices a calf in front of the table. In the background are buildings; to the right is a rocky hill over a black cave. On the slope of the hill stands the oak of Mamre.

The icon is painted in egg tempera. The hill and earth are of ocher color with highlights; the garments of the angels combine blue, green, and cinnabar; and the table, the vessels, and the halos and wings of the angels are gilded.

The relief is low but carefully divided into separate planes. Due to the delicacy of the carving, the icon can be ranked among the best masterpieces of the 16th century monastic art of Vologda.

Izilla Pleshanova

20 cm x 13.5 cm x 1.5 cm
Carved wood, tempera, with engraved, silver-gilt *oklad*.

Donated by I. A. Shliapkin in 1918. Formerly in the Sianskaia Hermitage in the province of Vologda.

Inventory No.
ДРД 12

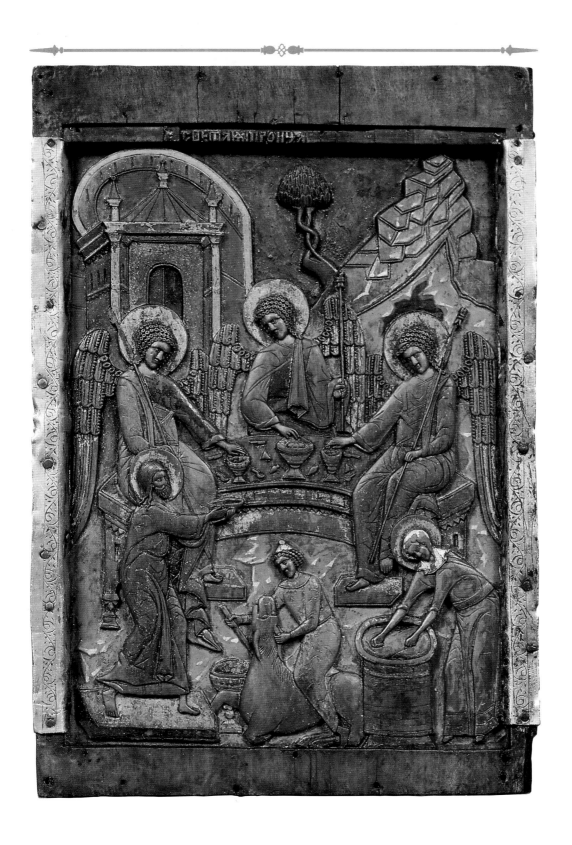

THE MOTHER OF GOD ENTHRONED AND St. CYRIL OF THE WHITE LAKE

The Monastery of St. Cyril of the White Lake
Icon – first half of the 16th century
Frame – late 18th century

The icon is carved in dark wood of a red hue, and has been set into a new icon panel. The wide borders are covered with a silver frame, chased and engraved in a delicate floral ornament with winding stalks, open flowers, and leaves. The silver is stamped with three marks: the first indicating its quality; the second indicating the year 1794, or possibly 1774; and the third indicating the coat of arms of Moscow.

Icons of this type represent the founder of a monastery praying to the Mother of God, asking that she protect it. Such images became popular in the 16th century when a number of Russian saints were canonized.

The prototype for this kind of image is known to have been a 13th century icon of the Mother of God called *Svensko-Pecherskaia*, originating in Svensk and, at least according to legend, at the Monastery of the Caves in Kiev. This icon is now in the Tretiakov Galley, and shows the enthroned Mother of God and Child faced by St. Anthony and St. Feodosii, the founders of the Monastery of the Caves, and therefore of Russian monasticism.

Another icon thought to be from the Makhrishchskii Monastery near Moscow represents an enthroned Mother of God and Child faced by a supplicant St. Sergei of Radonezh. This work was probably created at the Trinity-St. Sergei Monastery, and was placed over the sepulcher of the saint. It is now housed in the Historical Museum in Moscow. Similar compositions were painted in memory of other monks or church dignitaries including Nikon of Radonezh and the metropolitan Philip.

According to the inventory of the Monastery of St. Cyril for 1601, there were several paintings representing the Mother of God and St. Cyril in the local tier of the iconostasis in the Church of St. Cyril. As it was customary for wood carvings and small icons to be copied from highly venerated icons, often as gifts for pilgrims, the present icon may have followed such a model.

Judging from the inventories, the churches of the Monastery of St. Cyril had a large number of triptychs, crosses, and other carvings in wood or bone which were placed in the iconostasis above the local tier. Because of the small size of these objects, the tier was called *piadnichnii*, from *piad*, the palm of the hand.

Our icon is carved in a dark exotic wood, evidently imported. It shows no traces of paint. The relief is deeply cut and grooved to create a three-dimensional effect. The volumes are softly modelled and the different planes of the group are finely distinguished. Some of the geometrical ornaments are repeated in other wood and bone carvings from the same monastery. These details point to a date in the first third or first half of the 16th century.

Izilla Pleshanova

25 cm x 19.5 cm x 3 cm
Central panel : 17.5 cm x 12.0 cm
Carved wood with silver frame, chased , and engraved.

Acquired from the Old Believers' chapel in the Kolomenskoe Cemetery.

Inventory No.
БК 3467

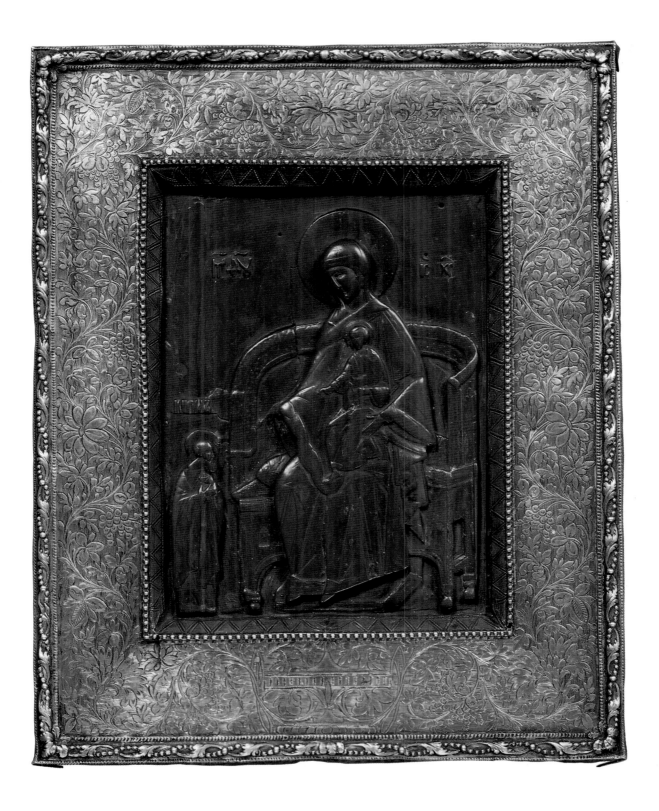

145

St. Cyril of the White Lake

Moscow
1514

St. Cyril was the founder of one of the largest northern monasteries of medieval Russia, a monastery that was to become a center of literary and spiritual culture. He is represented here full-length, his right hand raised in blessing, his left hand holding a scroll. He wears a monastic cloak with a light blue cowl and four crimson Calvary crosses. The pall was donated to the Monastery of St. Cyril by the

by the grand prince Vasilii III and his wife Solomoniia Saburova. They made donations to different churches and monasteries, praying to God for a child.

In 1585 a church was built over the tomb of St. Cyril, and in 1643 Prince F. I. Sheremetev donated a silver shrine to the monastery, the cover and silver details of which are now in the Museums of the Moscow Kremlin. Many palls were put on the tomb at different times, and the oldest and most important of these are now in the Russian Museum. The pall of 1514 is one of the earliest.

The embroidery shows signs of influence from the late 15th century painter Dionysii. It is mounted on taffeta, with silk, silver, and silver-gilt threads. The pall originally had a background of black taffeta. The embroidery was laid on new backgrounds several times. The monastic inventory of 1773 calls the ground of the pall 'some green taffeta with a play of colors.' The Department of Drawings of the Russian Museum preserves a representation of the pall (Inv. No. 26862) by the artist N. A. Martynov who prepared drawings of the architectural monuments, utensils, and embroidery of the Monastery of St. Cyril in 1860. At that time the ground

of the pall was of green taffeta. When it first entered the museum, the ground was red. It was laid on a new ground for a second time to celebrate the 500th anniversary of the monastery in 1897.

Under the *poziem*, the conventional depiction of the earth, the donation inscription reads: *The present pall was made in 7022 [1514 AD] by the order of Vasilii, by the Grace of God the Sovereign of All Russia and Grand Prince of Vladimir and Moscow and Novgorod and Tver and Pskov and other principalities, the 9th year of his rule and Smolensk.* The words 'and Smolensk' were added to the end of the inscription in small letters, as the town of Smolensk was joined to Moscow in 1514, the year when the pall was embroidered. In addition to the donation inscription, prayers were embroidered along the margin, but these are now lost. On both sides of the head of St. Cyril there was an inscription in Russian: *St. Cyril the Wonder-Worker.*

The pall was acquired by the Russian Museum in 1923 from the Monastery of St. Cyril. It was restored and put on canvas in 1925, and was laid on to linen in 1963-64.

Liudmila Likhacheva

Pall (*Pokrov*)

198.5 cm x 84 cm
Taffeta, embroidered with silk, silver, and gilt threads.

Inventory No.
ДРТ 306

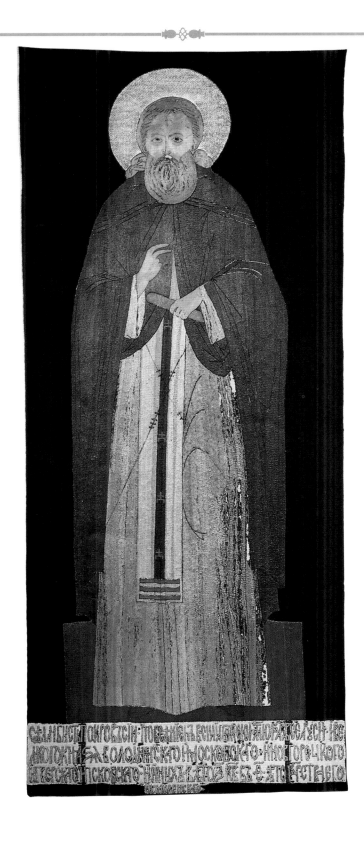

ST. CYRIL OF THE WHITE LAKE

Moscow
1555

The pall was a gift of Ivan the Terrible and his wife Anastasiia Romanovna to the Monastery of St. Cyril of the White Lake. It was received by the Russian Museum in 1923 from the monastery. The pall was restored in 1925 and the background was lined with canvas. After further restoration in 1979-80, the remains of the black damask background were mounted on black silk. Made for the tomb of St. Cyril, this pall represents one of the most expressive and spiritual images in medieval Russian art. The saint is represented full-length, with his right hand raised in blessing and his left holding a furled scroll. He is dressed in monastic robes with a light blue stole bearing a Golgotha cross embroidered in gold and with crimson stripes at the bottom edge.

The book of donations to the Monastery of Cyril of the White Lake for 1622 states: 'In the year 7063 [1555 AD] Tsar and Lord Grand Prince Ivan Vasilevich of All Russia, Tsaritsa and Grand Princess Anastasia, and their son the true believer Tsarevich Ivan dedicated a cloth to the All-Pure Mother of God and with her to Cyril the Wonder-Worker, the cloth sewn with pearls, and this pall was laid upon the Wonder-Worker on St. Symeon's day.' The cloth was highly prized at the Monastery of St. Cyril, as were all the gifts of Ivan the Terrible. The tsar believed that he owed his birth to St. Cyril and patronized the monastery as a result. A detailed description of the pall appears in a number of inventories, including that of 1601: 'Pall representing St. Cyril embroidered with gold, silver, and silks on black damask, nimbus, inscription, and cross studded with pearls. In the nimbus, three precious stones, one red and two blue, *troparion* and *kontakion* embroidered around the borders. Lined with crimson damask. Donated by the Sovereign Tsaritsa and Grand Princess Anastasia of blessed memory. The edges of the shroud are torn.'

From this detailed description it can be seen that the background of black damask had already deteriorated at the beginning of the 17th century. In the course of that century, the embroidery was transferred to a new piece of damask, again black, but the words of the dedicatory inscription were disturbed during the process. A record of the inscription with the correct date appears in 18th century monastic inventories. When it was received at the Museum, the pall bore no inscriptions or jeweled ornaments, although the inventory description mentions three precious stones, one red and two blue.

As with all the products of the workshops of the tsar, the shroud is remarkable for the excellence of its embroidery technique.

Liudmila Likhacheva

Pall (*Pokrov*)

186.0 cm x 86.0 cm
Damask, embroidered with silk, silver, and gilt thread.

Inventory No.
ДРТ 293

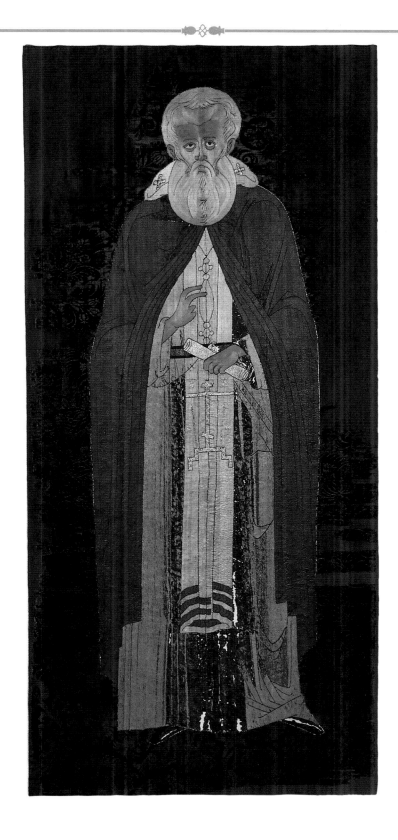

ST. CYRIL OF THE WHITE LAKE

Moscow
1548

This small embroidered icon with a full-length representation of St. Cyril of the White Lake is an embroidered replica of the famous icon of 1424 traditionally believed to have been painted by St. Dionysii of Glushitsa (1363-1437), the founder of two monasteries, one of them on the River Glushitsa. St. Cyril is represented here as a stocky old man and an attempt has clearly been made to convey a visual

likeness. It is known that St. Dionysii may well have been acquainted with St. Cyril, and this icon differs from the idealized image of the saint which appears on the pall of 1514 (Cat. No. 37).

The background in the center of the cloth is completely covered with embroidery in gold thread. The border of faded velvet is decorated with settings for pearls and retains traces of silver.

Ivan the Terrible and Anastasiia Romanovna commissioned embroidered cloths to be suspended under particularly venerated icons in the Monastery of St. Cyril, including THE MOTHER OF GOD OF THE SIGN which St. Cyril brought to the White Lake, and the icon of St. Cyril by St. Dionysii of Glushitsa mentioned above. Some believe that the cloth was created in the workshops presided over by Anastasiia Romanovna.

In 1548 Ivan the Terrible and his wife took the icon of St. Cyril to Moscow, and then returned it with a cloth. The book of donations for 1622 records that: 'In the year 7056 [1548 AD] the Tsar, Lord and Great Prince Ivan Vasilevich of All Russia and the Tsaritsa and Great Princess Anastasiia sent the image of the Wonder-Worker, and then the Lord Tsar and the Lady Tsaritsa hung under the miraculous icon a cloth sewn with pearls.'

G. I. Vzdornov believes that the present cloth is the one with which the Tsar and Tsaritsa returned the miraculous icon from Moscow.

The icon was received in 1923 from the Monastery of St. Cyril of the White Lake. It was restored in 1924 and again in 1975.

Liudmila Likhacheva

Embroidered icon (*Ikona*)

43.8 cm x 34.5 cm
Silk , velvet, embroidered with silk, silver, and gilt thread.

Inventory No.
ДРТ 7

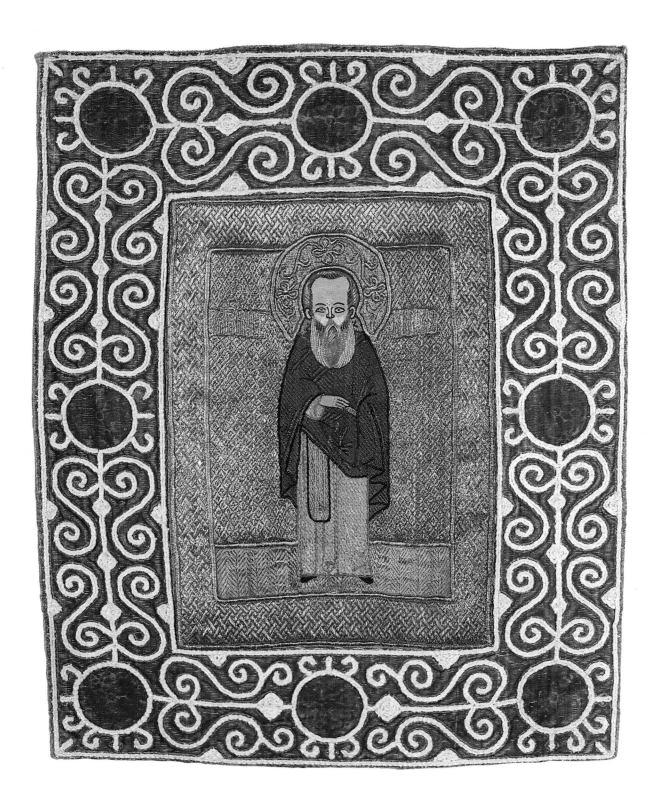

St. Alexander Svirskii

Moscow
1644

On the occasion of the completion of the stone Cathedral of the Transfiguration and the discovery of the holy relics of St. Alexander Svirskii, Mikhail Fedorovich, the first tsar of the Romanov dynasty, and his wife Evdokiia presented a silver tomb decorated with pearls and precious stones, the lid bearing a chased and engraved representation of the saint. The tomb was

Pall (*pokrov*)

204.0 cm x 84.5 cm
Satin, embroidered with silk, silver, and gilt thread, and pearls.

Inventory No.
ДРТ 263

accompanied by a pall embroidered in the workshop of the tsaritsa in silk, gold, and silver threads on a lilac and green satin, and then decorated with pearls. Like the lid of the tomb which is also preserved in the Russian Museum, the pall bears six medallions with half-length images of saints after whom members of the family of the tsar were named: St. Michael Maleinos, St. Evdokiia, St. Alexei the Man of God, St. Anna, and the martyrs Irina and Tatiana.

St. Alexander is represented as a full-length figure, wearing a mantle and an alb with perforated stripes. One hand is raised in blessing, and the other holds an unfurled scroll inscribed with precepts for the monks. An inscription around the head of the saint reads: *Our Holy Father Abbot Alexander Svirskii the Wonder-Worker.* St. Alexander Svirskii, who took his vows at the Monastery of Valaam, was abbot of the monastery he founded by the River Svir. He died in 1533 and his *Life* was com-

piled in 1545 by his successor, the abbot Irodion, at the order of the archbishop of Novgorod. The saint is represented in accordance with the iconographic model: 'Old and grey in appearance, hair straight, beard white and broad, about the length of St Sergei's, robes clerical, one hand blessing, the other holding a scroll.' The image of the Trinity above the head of the saint is explained by the fact that the main church of the monastery is dedicated to the Trinity.

The pall is meticulously embroidered, with a great virtuosity. This is especially evident in the treatment of the face, on which the contrasting shading forms the so-called 'eyelets' characteristic of 17th century embroidery. The clothing is executed in neat couching stitch typical of embroidery in gilt thread.

The shroud was acquired from the Monastery in 1925, and was restored in 1937, 1964, and 1978.

Liudmila Likhacheva

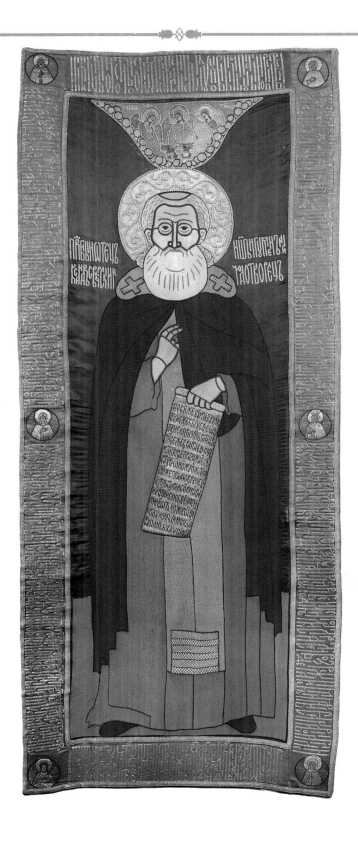

ALTAR CROSS

Monastery of St. Alexander Svirskii
1576

The silver reliquary cross is executed in a multi–colored champlevé enameling technique rarely found in the 16th century and is a magnificent example of the jeweller's art. The obverse surface is edged with running ornament on a light blue background. The row of pearls along the border has been lost. The open metal surfaces are covered with intricate incisions. The inscriptions and decoration are executed in high relief, which was also used to prepare the surface for covering with enamel. Some of the enamel is missing and the screws holding the sections of the cross together are new.

The Crucifixion is shown in the center of the cross, with medallions containing images of a cherub, the Mother of God, St. John, and St. Alexander Svirskii. Characteristic features are the proportionality and clarity of the design, and the elegant and gentle manner of the figures. The obverse is decorated with enamel in black, dark blue, light blue, emerald green, and white. The pale yellow shading on the body of Christ is applied by a painting rather than enamel technique, as are the trees on the green hill of Golgotha. The images are accompanied by the inscriptions: *Cherub, Crucifixion of our Lord Jesus Christ, Jesus Christ, Alexander.*

The upright bears the following historical inscription: *This cross was made in the Monastery of the Life-Giving Trinity and of Saint Alexander Svirskii the Wonder-Worker in the reign of the God-fearing Tsar Grand Duke Ivan Vasilevich of All Russia and under Metropolitan Anthony at the order of the servant of God Abbot Benjamin and his brotherhood in the month of March, the year 7084 [1576 AD].*

The inscription and images on the reverse side of the cross are in black enamel. Along the centerpiece there is a row of miniature figures, including St. Gregory the Theologian, the prophet Moses, King David, the prophet Zacharias, St. John the Baptist, St. Demetrios, St. James, St. Niketas, St. Zosima, the empress Helena, and St. Barbara.

Twelve inscriptions indicate the nature of the relics preserved in the cross, while a wooden case for the cross bears another inscription indicating that it was produced by Greek craftsmen exiled to the Monastery of St. Alexander Svirskii in the reign of Ivan IV.

Izilla Pleshanova

44.3 cm x 22.2 cm x 2 cm
Silver; forged, engraved, enamelled, gilt.

Received from the State Hermitage in 1924.

Inventory No.
БК 2889

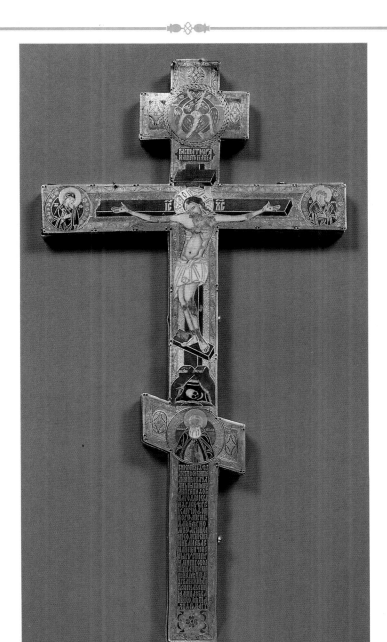

ST. ANTHONY THE ROMAN

Master Evtropii Stepanov
Novgorod
1573

The relief figure of the saint, taken from the cover of his shrine, is carved from a wooden plank, with two flanges at the sides. The gilding, applied by the glutinous size method, is worn. The soles of the feet are missing. The saint is depicted in monastic garb with a habit, cloak, and belted stole. The face is emaciated, with sunken cheeks, wide cheekbones, and sharply outlined eye sockets. He wears a pointed *schema* cap with three Golgotha crosses. The carving is intricate; the strands of the long beard are traced and the hands carefully moulded. An unusual feature is the gesture of the right hand, with the open palm turned towards the breast, while the left hand holds an unfurled scroll. The text, carved in interconnected letters, is a last word from the founder of the monastery to his monks: *Grieve not, my brothers, but think upon this, that if the purpose of my work is pleasing to God, this monastery will not fall into decline, but will only flourish further.*

The iconography of the relief along with the individual features in the appearance of the saint indicate that the image depicts St. Anthony the Roman. This assumption is confirmed by the accurate copy of the carved figure on the embroidered pall covering his tomb, dated between the 1630 and 1650 and preserved in the Novgorod Museum.

The relief is not high, and the impression of volume is created by the incisive outline of the figure and the depth of the shadows surrounding it. The characteristically linear treatment of the folds is in the tradition of Novgorod plastic art.

Anthony the Roman was the founder of the Monastery of the Mother of God of the Nativity, one of the largest monasteries in Novgorod. He died in 1147, and the first version of his *Life* was apparently written soon afterward by Father Superior Andrei, his pupil and successor.

The veneration of St. Anthony was established much later. The Makarian Councils of 1547-49 did not number him among the Russian saints, and the exhumation and examination of his relics did not take place until 1597, when official recognition began. His canonization was achieved through the efforts of two monks from his monastery, the archimandrite Cyril Zavidov and the monk Nifont, who wrote a later version of his *Life*.

On the basis of the date of canonization, it may be supposed that the relief was executed no earlier than the end of the 16th or the beginning of the 17th century, but information has been preserved which makes a more accurate dating possible.

It is known that in the 17th century the shrine of St. Anthony was situated by the south wall of the cathedral. The shrine was made of wood, overlaid with fine silver-gilt, and the interior was lined with gold-embroidered velvet. Texts dedicated to St. Anthony were inscribed on silver discs decorating the structure. The cover with its relief representation of the saint was carved from wood, which means that the top and bottom parts of the reliquary were produced by different techniques.

159 cm x 43 cm x 15 cm
Carved wood, gilt.

Transferred to the Russian Museum in 1898 from the Museum of the Academy of Arts.

Inventory No.
ДРД 494

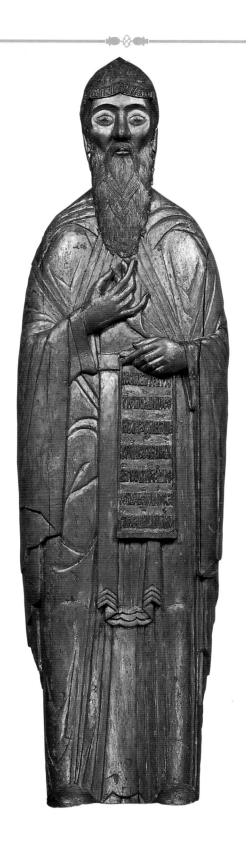

Ancient shrines have either been entirely lost, or have only survived in part. The reason for the loss of chased metal structures was the value of the materials, particularly the gold, silver, pearls, and precious stones with which they were decorated. A great blow to ecclesiastical monuments was dealt by the decree of the Holy Synod issued in 1722, which reflected the new interest in the achievements of European art and the increased enthusiasm for realism. In these new conditions, the traditional approach of medieval sculpture with its generalized forms, low relief, and linear working was considered to be unskilled and antiquated. The decree required reliefs on shrines to be replaced by painted representations. In adherence to the decree, carved figures were removed from shrine covers, and replaced with paintings. Several such reliefs were preserved in the repositories of the Cathedral of St. Sophia and the covers of old shrines often later served as icons. One of the icons in the iconostasis of the Cathedral of St. Sophia in Novgorod, for example, is the cover of the shrine of Archbishop Ioann from 1599.

In 1731 the shrine of St. Anthony was replaced by another, carved from cypress wood. This may be why the cover with a painted icon of the saint was moved to the Church of Elijah in the commercial district, where it was still located in the early part of the 20th century. Archimandrite Makarii described it thus: 'In the Elijah Church . . . there is a full-length icon of St. Anthony the Roman, formerly part of his shrine. The right hand of the saint, holding a rosary, is turned to his breast, and in his left hand he holds a scroll.' An inscription is carved around the edges of the icon., and the author renders it as follows: *In the year 7080 from the creation* [1573 AD], *on the 19th day of the month of August, this reliquary was estab-lished, in the reign of the devout defender of the faith, Tsar and Lord, Grand Prince Ivan Vasilevich, Autocrat of All Russia . . . and under Archbishop Leonid . . . in honour of the God-fearing superior and founder of this holy monastery, Anthony the Roman.* The base of the icon bears the further inscription: . . . *Master Evtropii Stepanov.*

This means that the shrine, or at least the cover, was executed under Archbishop Leonid in 1573. It would seem that preparations for the canonization of Anthony had been started under Archbishops Pimen and Leonid but had not yet been consummated. The reason for this may have been that the 1570s in Novgorod were a period of political repression which extended even to the clergy. Both archbishops ended their days in disfavor.

The name of the carver Evtropii is connected with another monument of ecclesiastical culture, the Oratory of Archbishop Pimen established in 1560 in the Cathedral of St. Sophia in Novgorod.

The figure of St. Anthony, with its characteristically voluminous proportions and plasticity, its clear-cut and somewhat rigid formal representation, resembles the figurative carving of the Oratory of Pimen. There are also many similarities between these monuments and the carving on the shrine of St. Zosima of Solovki from 1566, now in the Tretiakov Gallery.

The carving of 16th century Novgorod, especially the figures on the covers of shrines, enables us to trace the gradual departure from traditional bas-relief methods and the mastery of the three-dimensional shaping of forms. This representation of Saint Anthony, chronologically the last such monument of the 16th century, reflects those developments.

Izilla Pleshanova

THE METROPOLITAN PHILIP

Moscow
1590s

Than pall, representing one of the most outstanding figures in Russian history, is among the finest embroidered works in the collection of the Russian Museum. It might well have been executed in the workshops of Irina Fedorovna Godunova; it bears no dedicatory inscription, although prayers consisting of the *kontakion* and *troparion* of the saint are embroidered around the borders. The

Pall (*Pokrov*)

199.5 cm x 111 cm
Satin, embroidered
with silk, silver,
and, gilt thread.

Acquired in 1923 from the
Monastery of Solovki.

Inventory No.
ДРТ 308

harmonious coloring and the beautiful design are most striking. The skill of the draftsman and the embroiderers is evident in the treatment of the face, with its fine shading, as well as in the embroidery technique of couching, which employs gilt thread in many types of stitch to form a variety of patterns.

The metropolitan Philip was born in 1507 into the noble Kolychev family, and was given the name of Fedor. In 1546 he became abbot of the Monastery of Solovki, and on July 25, 1566, he was appointed to the theological faculty of Moscow. He rebuked the tsar Ivan the Terrible for what he regarded his misdeeds, and in 1569, at the command of the tsar, he was strangled by Maliuta Skuratov in the

Otroche Monastery in Tver. His relics were transferred to Solovki on August 11, 1591, and the shroud was most probably made at that time in the workshop of the tsaritsa Irina Fedorovna Godunova. The body of the metropolitan was laid to rest in the narthex of the Church of St. Zosima and St. Savvatii. His relics were transferred again to Moscow on July 3, 1652.

The original background has been preserved, although its color has faded considerably. The lower part contains a large damask insertion of a later date, a consequence of damaged by fire. The shroud was restored in 1933 and in 1963.

Liudmila Likhacheva

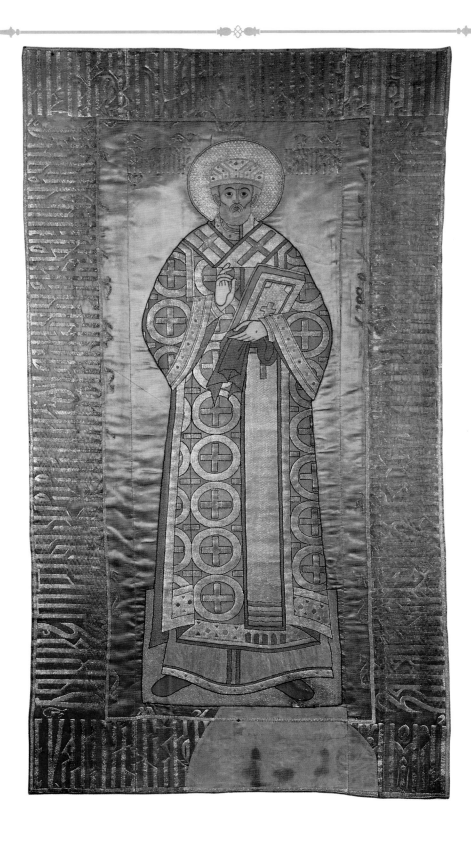

THE ASSEMBLY OF THE ARCHANGELS MICHAEL AND GABRIEL

Second half of the 13th – early 14th century

The icon of the Assembly of the Archangels Michael and Gabriel is one of the oldest and most important examples of medieval Russian painting. The austere spirituality and the intense colors are appropriate to its role as the dedicatory icon on the local tier of the iconostasis in the cathedral of the Monastery of the Archangel Michael in Velikii Ustiug. The monastery was founded in 1212 by

the monk Cyprian, who was close to the grand prince Konstantin Vsevolodovich Rostovskii, and the church for which the icon was painted was consecrated in 1216. It was replaced by a second church in 1653, and the icon was again placed in the local tier of the iconostasis.

The archangels are dressed in Byzantine imperial robes and the constrast between the dark shades of green, brown, and blue and the brighter yellow, ocher, and vermilion emphasized and symbolized the fiery nature of the angels. The painter paid special attention to the effect created by the use of vermilion, and it is remarkable that he employed vermilion instead of white for the highlights on the angels' robes.

The blue background of the icon is similar to icons painted in Vologda during the 14th and 15th centuries, and it is later seen in icons from almost all parts of northern Russia.

The composition is based on the principle of verticality, and is determined by the elongated figures of the angels, their lowered wings, and the folds of the robes hanging beneath the medallion of Christ Emmanuel.

The medallion occupies the center of the composition, and indeed could be said to provide the central theme of the composi-

tion. Together with the nimbuses of the angels, it forms a triangular pattern carefully placed within the vertical arrangement.

The icon has no close stylistic analogies, but some elements are similar to other icons from the early period. The most interesting in terms of chronological proximity are the icon of the Archangel Michael painted in Iaroslavl around 1300, now in the Tretiakov Gallery, and the 14th century icon of St. Boris and St. Gleb in the Russian Museum.

The Iaroslavl St. Michael is similar in terms of coloring, especially the use of a dark brown with contrasting vermilion. It is also similar in terms of composition. The figures of both icons completely fill the available surface, and their pronounced verticality is enlivened by the diagonal arrangement of the robes.

The Russian Museum icon of St. Boris and St. Gleb also displays a similar composition, with two large figures whose clothing is arranged in almost identical patterns. The eye is also drawn to the center of the panel, in this case to the handle of the sword of St. Boris. However, the icon of St. Boris and St. Gleb lacks an equivalent to the diagonal patterns of the robes of the archangels, which help to unite the composition from opposite

165 cm x 118 cm x 3.3 cm
Panel of four boards with four struts.

Inventory No.
ДРЖ 3103

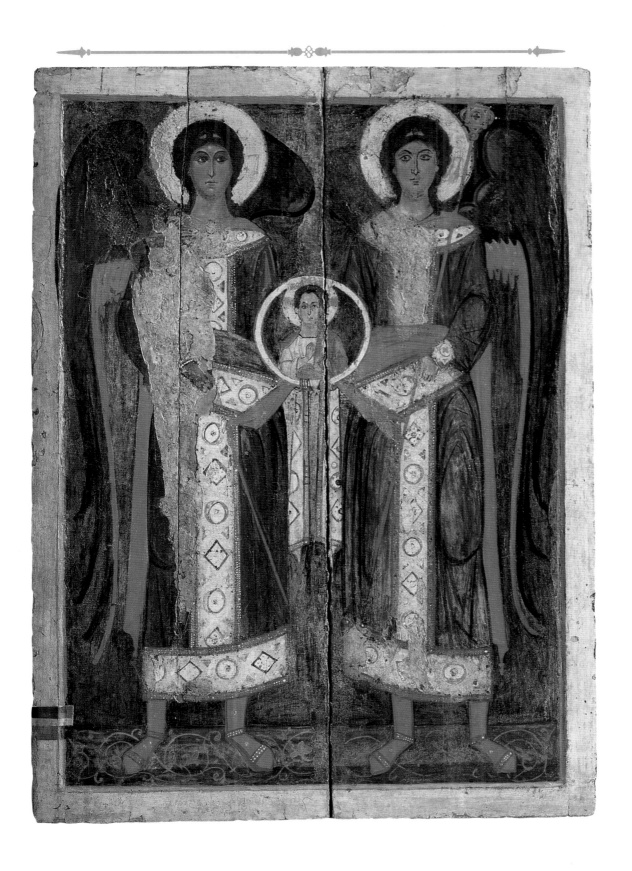

directions. By placing the hand of St. Boris on his sword, the artist has also emphasized the difference in status of the two brothers, St. Boris being the elder.

The symbolism of the Assembly of the archangels is obscure, and has been given a variety of interpretations by modern scholars. According to N.P. Kondakov, the iconography represented the Triumph of Orthodoxy over iconoclasm. A.N. Grabar believed that it expressed the role of the archangels during the Incarnation, while G.I. Vzdornov maintains that such images illustrate the Old Testament prophecies of the future Christ Emmanuel.

Recent examination has indicated that the icon was renovated in the 18th century, and that part of the gesso had been removed. In 1931, T.T. Tiulin began exploratory work at the Museum of Velikii Ustiug, where the icon was completely cleaned between 1959 and 1968 by A.N. Baranova.

A small section of the painting left as a record by Baranova indicates that the icon had been reprimed at least twice. Substantial damage has occurred over the surface of the icon, especially where the panels are joined. The hand of the Archangel Michael has been repainted, and the faces of both the Archangel Gabriel and of Christ Emmanuel have been retouched.

Until the work of G.I. Vzdornov, it was assumed by all specialists that the icon was painted by a Russian master during the 13th century. Vzdornov has suggested that it is the work of a local master in Velikii Ustiug, influenced by the traditions of Rostov, and active in the late 13th or early 14th century.

Irina Soloveva

ST. NICHOLAS WITH SCENES FROM HIS LIFE

Novgorod
Early 14th century

S T. NICHOLAS WITH SCENES FROM HIS LIFE was discovered in the local tier of the iconostasis in the wooden Church of St. Nicholas in Ozerevo by an expedition sent from the Russian Museum in 1966. However, the size of the icon and the scenes on its borders indicate that it was originally the dedicatory icon of an earlier and larger church. The removal of the borders and the loss of struts from the upper and lower butts

confirm it has been moved more than once. Ozerevo is in what used to be the province of Bezhetsk, one of five provinces controlled by Novgorod in the medieval period. A census taken in 1581–83 mentions a wooden church of St. George and a monastery of St. Nicholas not far from the village.

This icon is one of a large number that depict the famous bishop of Myra in Lycia, St. Nicholas the Wonder-Worker. The cult of St. Nicholas was brought to Russia soon after the conversion to Orthodoxy in 988 and spread rapidly. St. Nicholas was venerated more than any other saint in Russia, and was believed to intercede for the people before God, to defend them against injustice, and to help them in every kind of trouble, especially when traveling. His cult embraced every social stratum of medieval Russia. The respect shown to him, especially on his festivals (December 6 and May 9), was almost equal to that given to Christ and the Mother of God. Foreign visitors to Russia between the 16th and the 18th centuries invariably remarked on the special veneration shown to St. Nicholas and his icons, and in the 17th century they often described any Russian icon as 'a Nicholas' regardless of its subject.

The most intense devotion to St.

Nicholas was found in Novgorod and its northern regions, where a great many churches were consecrated to him, and where more of his icons have survived than anywhere else. St. Nicholas superseded the Slavic pagan deity Veles, the keeper of cattle, and was therefore credited in northern tradition with protecting livestock, helping farmers, and ensuring fertility and good crops. He was regarded as a source of wealth, a healer of diseases, a guardian against flood or fire, and a patron of bee-keeping. This belief is reflected in many proverbs which express faith in his power: 'Pray to St. Nicholas in all need'; 'Christ is risen, St. Nicholas help us'; 'St. Nicholas preserve us when traveling, Christ bless us.'

The most important iconographic types of St. Nicholas were inherited from Byzantium, where they had developed between the 11th and the 13th century. The *orans* posture in the centerpiece of the present icon is a version known as ST. NICHOLAS OF ZARAZSK, after the miracle-working icon in Zarazsk, near Riazan, which was originally brought from the Greek colony of Cherson in 1225. Before its arrival in Zarazsk, the icon had been kept in Novgorod, where it was renowned for the miracles it performed. *The Tale of St Nicholas of Zarazsk* describes how the icon resisted the

107.5 cm x 75 cm x 2.6 cm
Panel of three boards
with two inset struts.

Inventory No.
ДРЖ 3032

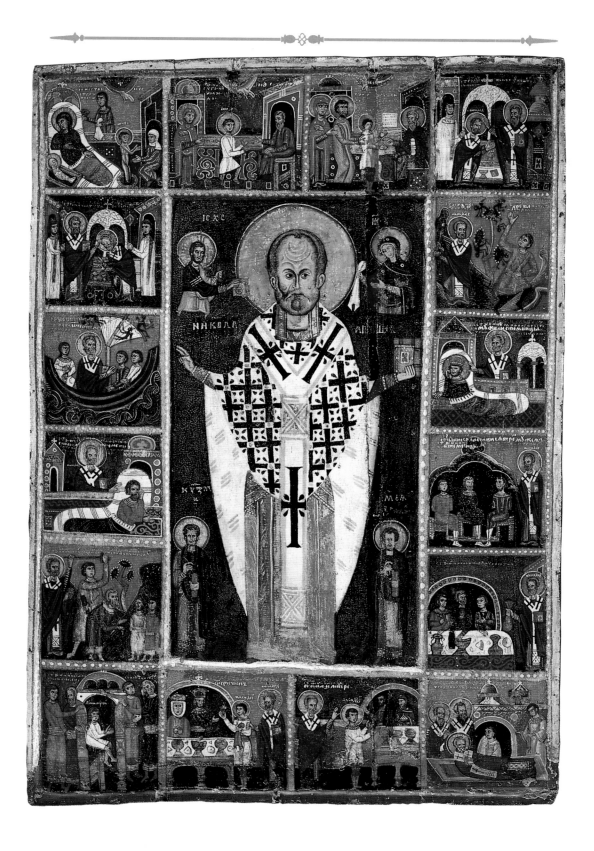

Tartar invaders during the 13th century, and the type was seen as worthy of special veneration because it possessed the power to defend cities from attack.

In the center of the icon, on either side of the head of the saint, the artist has included half-length figures of Christ and the Mother of God to represent the Miracle at Nicaea. During the first Ecumenical Council held at Nicaea in 325, St. Nicholas opposed Arius for his heretical denial of the divinity of Christ. The emperor and the bishops attending the council were about to deprive St. Nicholas of his bishopric, but Christ and the Mother of God appeared before them to intercede for the saint and return his Gospel book and his *omophorion*. The earliest representation of this scene is found in the Novgorodian icon of St. Nicholas with selected saints painted by Aleksa Petrov in 1292 (Novgorod Museum). In that icon, Christ and the Mother of God are painted full-length in the centerpiece. As in the present icon, the Gospel book and the *omophorion* held in their hands touch the halo of the saint to represent the divine patronage bestowed on him. In later icons, half-length figures of Christ and the Mother of God were placed in medallions closer to the upper corners of the centerpiece.

Below Christ and the Mother of God are the brothers Kosmas and Damian, who were venerated as healers and as patrons of blacksmiths and goldsmiths. Their cult was also widespread in Novgorod and the northern regions. The three saints in the centerpiece may have corresponded to the altars of a church consecrated to them, or may have been chosen as patrons of the family that commissioned the icon.

The border scenes are as follows:

1 The birth of St. Nicholas and the miracle in the bath.
 St. Nicholas was born in Myra to Theophanes and Nona, who had long been childless. Their prayers for children were answered, and their first and only child began to perform miracles immediately after his birth, rising to his feet in the bath where he was being washed and standing for two hours.

2 St. Nicholas chooses his teacher.
 Although his parents wanted to send the boy 'for book learning,' they were unable to choose a teacher, and so the boy named a teacher himself.

3 St. Nicholas is brought to school.

4 St. Nicholas is made a deacon.
 St. Nicholas was made a deacon by his uncle, Bishop Nicholas of Myra, the founder of the monastery of New Sion.

5 St. Nicholas is ordained into the priesthood.

6 Cutting down the tree.
 Near the village of Plaskomidia, an evil spirit lived in a tree which was worshiped by pagans, and it used to harm the people and their crops. A villager who tried to cut down the tree was mysteriously killed by his own ax. When the peasants turned to St. Nicholas for help, he struck the first blow with an ax and banished the evil spirit through the power of prayer. As the spirit fled, it tried to cause the tree to fall on the people, but St. Nicholas prevented a disaster and the miracle made his name famous throughout Lycia.

7 The miracle of the ship.
 The *Life* of the saint included several miracles performed at sea: calming the waves, exorcising evil spirits from the rigging, and helping the sailors to pray.

8 St. Nicholas appears to the emperor Constantine in a dream.

9 St. Nicholas appears to the governor Eulavius in a dream.

10 St. Nicholas appears to three men in prison.

11 St. Nicholas rescues three men from execution.
 Scenes 8–11 depict the miracle of three generals sent by the emperor Constantine with an army to suppress a rebellion during a famine in Phrygia. The

generals carried out their mission, but were wrongly accused of treason by the governor of Constantinople, Eulav ius. Convicted and imprisoned, the generals prayed to St. Nicholas, who appeared to Constantine and Eulavius in their dreams and told them to free the innocent men. This miracle was central in the *Life* and played a greater role than any other in spreading the cult of St. Nicholas throughout the Byzantine world.

12 The miracle of the loaves.
 The *Life* tells of several occasions when he 'fed everyone with a single loaf' at the Monastery of the New Sion or in the city of Myra.

13 The rescue of Demetris.
 Demetris, a citizen of Constantinople, was making a pilgrimage by sea, when the ship on which he was traveling began to sink in a storm. In answer to his prayer, St. Nicholas appeared to him and saved him by bringing him, home still wet from the waves. The iconography of Demetris 'back in his home' is extremely rare and is only preserved on one other icon, painted in Kolomna during the 14th century (Tretiakov Gallery). The composition is not known in later works. The usual version of the subject depicts a ship capsized at sea, and Demetris being rescued by St. Nicholas, who holds him by the hand.

14 Delivering Basil, the son of Agrig, from the Saracens.

15 Returning Basil to his parents.
 Scenes 14–15 represent the miracle of the youth Basil, whose pious father Agrig of Antioch would give a feast for the poor every year on St. Nicholas' day. One year, while he was worshipping at the Church of St. Nicholas, his only son Basil was abducted by Saracens, who took him to Crete and made him the royal cup-bearer. His parents searched in vain, but exactly one year later, as the feast was being laid in Agrig's garden, the dogs began to bark

and Basil appeared with a wine-cup in his hands. St. Nicholas had transported him from the table of the Saracen king.

16 The Dormition of St. Nicholas.
 St. Nicholas was buried at the Monastery of Holy Sion.

The present icon is one of the earliest to depict the cycle of scenes from the *Life* of the saint around the border. The detailed cycle represented both here and in the Novgorod icon from the village of Liubon (Russian Museum) and the Kolomna icon (Tretiakov Gallery) points to a mature tradition of painting the *Life*, which had been circulating in written form since the late 11th century.

While the present icon is of moderate size, it displays a power and energy that express the quality of steadfast protection which the people of Novgorod ascribed to their saints. However, there are considerable differences between the styles used to create this impression in the main theme at the center and in the border scenes. The central figure of St. Nicholas is flattened and symmetrical, hieratic and immobile, with a concentrated expression on the face. The figure occupies almost all the space in the centerpiece and in its outline resembles a cross. It is balanced by the figures of Christ, the Mother of God, and Kosmas and Damian, symmetrically placed in a composition that is highly organized and carefully considered.

The border scenes are nearly square in proportion. They are framed and separated from each other by bright-yellow ornamental strips studded with decorations resembling white pearls. The alternating blue and red grounds in the borders and the blue ground in the center produce an ordered composition. Unlike the solemn and immobile figures of the center, the border scenes are filled with characters in energetic motion, with tense faces and expressive gestures. They are surrounded by architectural settings with a variety of details and different kinds of ornamental designs, both geometric and

organic, which are similar to the titles and capitals of illuminated manuscripts from the 13th century. The inscriptions on the icon display flourishes at the beginning and the end of the line which are related to the same manuscript sources, while the stylized folds of the garments have been arranged in stiff lines to increase the decorative element.

The palette is exceptionally rich and employs almost the entire range of pigments available to the painters of the time: various ochers, cinnabar, azure, indigo, soot, white lead, and gold. The faces have been painted without the usual flesh undercoat, but are built up over an even layer of whitened ocher, and modeled with strokes of rouge and fine highlights in white. Tinted lacquers have been applied both as a finishing layer of paint and as a way of including detail, a technique that was rarely used in this early period of icon painting.

The icon appears to belong to a provincial branch of Novgorodian painting. All the stylistic features and the paleography of its inscriptions are close to the style of the 13th century, while the versatile palette, the delicate treatment of the faces, and the emotional scenes of the borders may point to the beginning of the following century. Few works have been preserved from this period, and each surviving example offers valuable evidence for analyzing developments in different cultural centers of medieval Russia.

The icon consists of a limewood panel in three pieces. It has two inset cross struts from a later date, as well as later insertions of gesso and paint over the losses along the joint on the right, and over the crack between border scenes 3 and 4. There are abrasions in the lower part of the center. The figure of the Mother of God has been largely repainted and traces of late overpainting can be seen in her robes. The original white inscriptions have faded. The border scenes 2, 6, 7, 8, 9, 10, 14, and 15 have remnants of white inscriptions from the 16th and 17th centuries, which have not been removed in conservation. The borders have been cut away in part.

Irina Soloveva

THE MOTHER OF GOD HODEGETRIA

Late 14th or early 15th century

The icon comes from the Church of the Protection of the Veil (*Pokrov*) at the Convent of the Protection at Suzdal. Founded in the 1360s, this convent acquired a special fame during the 16th century, when Solomonia Saburova, the wife of the grand prince Vasilii III, was forced to take the veil because of her failure to produce children. Thereafter, many of the women entering the convent were members of noble families who had fallen into disfavor. In addition to the Church of the Protection, the convent also contained churches of the Conception of St. Anna, the Discovery of the Holy Cross, and the Annunciation. A large number of works of art were preserved there, and through the personal intervention and support of the emperor Nicholas II in 1914, the convent presented the Russian Museum with 46 icons in precious metal covers, mainly from the sacristy of the Church of the Protection. These included the icon under consideration, which was found to be the oldest of the group.

The icon was restored several times before it reached the Russian Museum, where it was cleaned in 1915 by N. I. Briagin. During this restoration, losses of gesso were filled with wax and tinted with green tempera. The painting is very worn, with small losses of paint over the entire surface.

The icon has been variously ascribed to Moscow, Suzdal, or Byzantium. A study conducted in 1986 by S. I. Golubev confirmed that the technique used in painting the icon differs from that of Russian masters, although it seems likely that it was painted in Russia. The faces are executed on a base of rather dark olive green paint, on which the shape is constructed with clearly separated brush strokes of a differ-

ent color, creating a complex texture. The whole surface is covered with a very thin layer of the palest ocher, which serves to integrate the separate components of the forms into a single whole. White patches are further applied on this semi-transparent layer, to emphasise the most convex parts of the faces, but the sharp contrast of these highlights is muted by the delicacy and transparency of the overpainting. The outlines sometimes have no clear limits, being traced with thin, semi-transparent, brownish-red paint. The light blue patterns on the *omophorion*, like the highlights, seem to be fused with the painted surface.

The iconography of the work is unusual, the distinguishing feature being the position of the blessing hand of Christ, which seems to be folded into the hand of his Mother. Other distinctive features are the lyrical attitude of the figures, characteristic of Palaiologan painting, and the harmonious coordination of all the elements of the composition by means of rhythmic repetition. The color scheme is based on the juxtaposition of the muted shades of the *maphorion*, as if threaded with blue reflections, and the radiant gold shafts on the clothing of Christ. The figurative structure is intimate in character. The youthful, tender attitude of the Mother of God as she turns to the Infant, her narrow face

32.5 cm x 26.7 cm x 2.7 cm
Single panel with chased
silver- gilt *oklad*.

Inventory No.
ДРЖ 2059

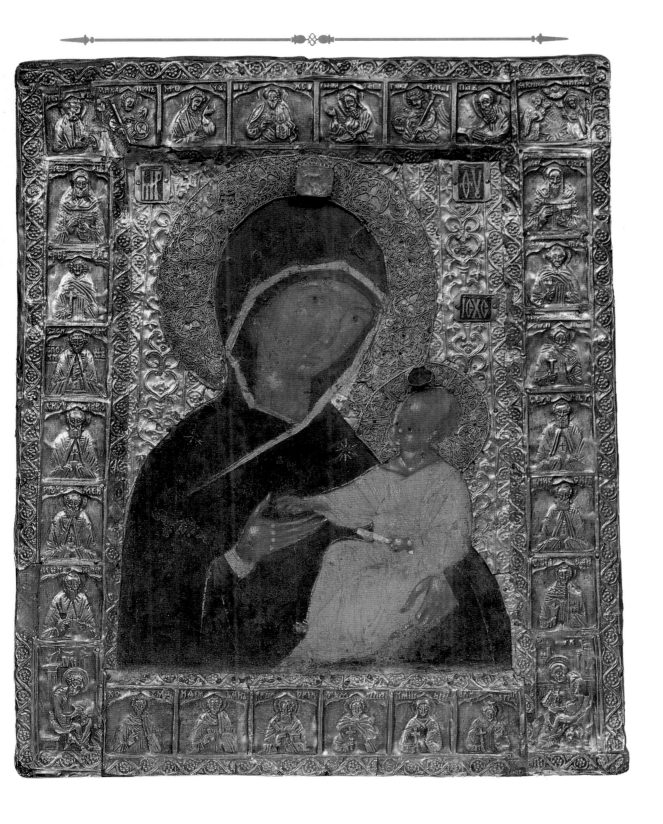

with its thin line of crimson lips, and the childlike features of the Infant evoke profound emotions.

The skill of the painter is marked by a vivid individuality akin to that of Theophanes the Greek. Like the work of the great master, it belongs to the artistic trends of Byzantine painting of the last quarter of the 14th and the early 15th century. Without any direct analogies, it nevertheless displays the same distinctive characteristics.

It is not impossible that the artistic idiosyncrasy of the icon is due to the fact that it was painted by a Greek master, but in Russia, most probably in Moscow. The hypothesis that the work was executed in Russia is indirectly confirmed by the history of its provenance.

The chased crowns surmounting the halos are the oldest parts of the icon cover, which is probably original. The manner of their execution is similar to the ornamentation on the gold cover of the Gospels in the Cathedral of the Dormition in the Moscow Kremlin dating from the first third of the 15th century. It may warrant their association with the group of Muscovite silversmiths who worked at the court of Metropolitan Photios.

The silver cover on the borders is of a later date. The upper border contains a Deesis, each figure of which appears in a three lobed arch with a keel-shaped top and bears an inscription identifying the person depicted. The Deesis comprises images of Christ, his Mother, St. John the Baptist, the Archangels Michael and Gabriel, and the Apostles Peter and Paul. In the upper right corner are representations of St. Joachim and St. Anna in prayer.

The paired images on the side borders are of the metropolitans Peter and Alexei, the martyrs George and Demetrios, St. Basil the Confessor and St. Niketas, St. Cyril of the White Lake and St. Sergei of Radonezh, St. German and St. Nikon, St. Leontii of Rostov and the archdeacon Stephen.

The lower border contains half-length representations of the martyrs Kosmas and Damian, Gregory, Menas, Paraskeve, and Catherine. The bottom corners contain images of the evangelists Luke and Mark. The Deesis in the upper border probably also reproduces similar images which appeared on the original cover. The placing of selected saints around the borders and the composition with the evangelists are usual in icon painting, but seldom found in icon covers.

The inclusion of the two metropolitans and of St. Sergei of Radonezh and his disciples German and Nikon, gives adequate grounds for ascribing the conception and execution of this part of the cover to Moscow. Since St. German died in 1492, the cover cannot have been made before the early 16th century, a fact which is confirmed by stylistic characteristics. The reason for isolating the images of St. Joachim and St. Anna from the general composition may be explained by the consecration of one of the churches in the Convent of the Protection to the Conception of St. Anna. This church was founded by Vasilii III in the hope of an heir to the throne. If we assume that the representation on the cover is also connected with prayers for an heir, the icon might have belonged to Solomonia Saburova, the wife of the grand prince. This hypothesis might also be connected with the inclusion of the image of St. Basil the Confessor, Bishop of Paros, the patron saint of Vasilii III.

Tatiana Vilinbakhova

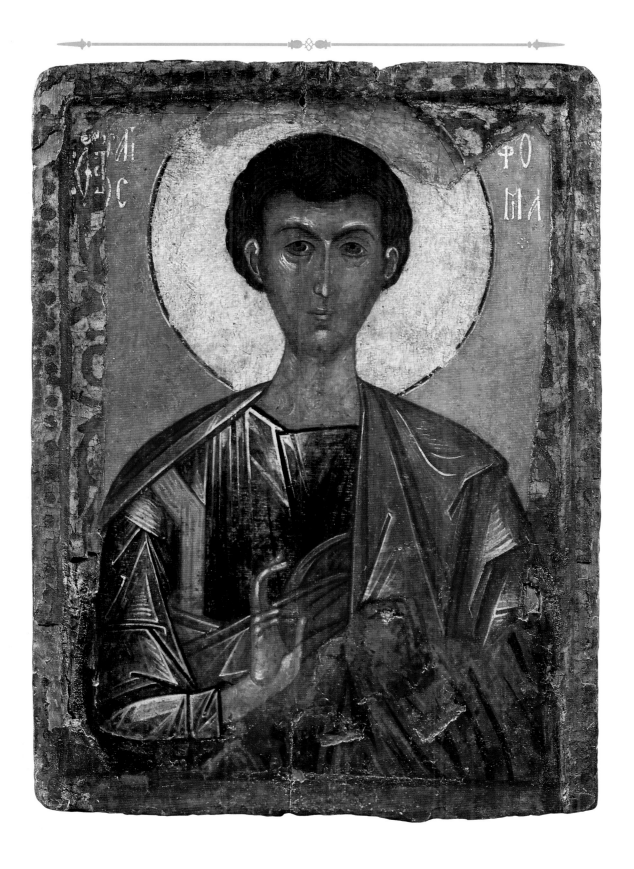

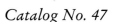

THE APOSTLE THOMAS

Novgorod
15th century

The apostle is depicted wearing the traditional *chiton* and *himation*, with his right hand raised in blessing. The edges of the nimbus bear the remains of the inscription *St. Thomas*. The half-length representation of the Apostle Thomas in an attitude of blessing has no analogy among surviving Russian iconographical works. In the opinion of N. P. Kondakov, the icon originally formed part of a half-length Deesis group with apostles. E. S. Smirnova conjectures that it might have been intended for a church or chapel dedicated to St. Thomas, or that it might have been commissioned by someone named after the saint.

Those who first studied the icon dated it to the 13th or 14th century, but subsequent experts have mostly ascribed it to the first third of the 15th century. The latest studies of the technique and state of preservation of the icon, conducted at the Russian Museum by O. V. Golubeva and D. E. Maltseva, established the partial preservation of the original painting, which makes any accurate determination of the date of the icon problematic. It should probably be dated broadly within the 15th century.

The icon has been frequently renovated. The earliest restorations date back to the 15th and 16th centuries, and the latest were carried out in the 20th century. There are many traces of overpainting on the background, the inscription, the hair, and the clothing. The painting of the face is severely damaged and is covered with thick layers of overpainting which greatly distort the original appearance of the saint. The icon was cleaned before it was received at the museum.

The origin of the icon is unknown. It was in the collection of N. P. Likhachev and was acquired by the Russian Museum in 1913.

Tatiana Vilinbakhova

52.7 cm x 39 cm x 2.6 cm
Single panel.

Inventory No.
ДРЖ 2064

St. Paraskeve and St. Anastasia

Novgorod
Second half of 15th century

This icon is a characteristic example of classical Novgorod icon painting during the second half of the 15th century. Typical of this period is an active, graphic modeling with bright highlights and dark shadow. The color scheme is based on the contrasts between cinnabar-red, bluish-green, and violet-brown. Two other features are also characteristic of 15th century Novgorod: austere, even severe,

expressions on the faces, which are modeled through many superimposed layers of rich reddish ocher; a ground consisting of two tiers enlivened with a geometrical ornamentation known as *kovrik,* since it resembles a small carpet.

St. Paraskeve is depicted wearing a red *maphorion* and holding a cross in her hand, whereas Anastasia is depicted in a violet-brown *maphorion* with a cross and vessel in her hands. Both saints were widely venerated in Russia. The cult of St. Paraskeve is very complex. Four martyrs were venerated in the Byzantine-Slavic countries under the same name. The most popular in Russia were Paraskeve from Ikonion who lived during the 4th century, and Paraskeve from Rome who lived in the 2nd century. In the popular mind the lives of both saints were merged together. According to legend, Paraskeve was born on a Friday and was given the epithet *Piatnitsa,* meaning Friday. This name is associated in the tradition of the church with Good Friday and with the sacrifice of Christ on the Cross. Thus St. Paraskeve was believed to personify Good Friday. The cross in her hand is a symbol of devotion to the crucified Savior and the red *maphorion* symbolizes sacrificial blood, martyrdom, and the love of God for his chosen ones. Her festival is October 28, but the Orthodox also

commemorate St. Paraskeve each Friday. In the merchant city of Novgorod, St. Paraskeve was worshiped as a patron of trade, and Friday became the day of the most intense commercial activity. A church dedicated to St. Paraskeve was built at the Novgorod market place. Like St. Paraskeve, St. Nicholas was considered by the people to be a defense and a help in times of trouble. It is not fortuitous that she was often depicted next to St. Nicholas in icons of selected saints. St. Paraskeve was considered a patron of the hearth and of women's work, and also a healer of mental and physical ailments. She was venerated as a patron of fields and cattle, and is often mentioned in popular poetry and charms together with the Intercession or Protection of the Mother of God. Both the Mother of God of the Intercession and St. Paraskeve were considered patrons of brides.

Depictions of St. Paraskeve are very often found in the art of Novgorod and its provinces. Normally she is depicted in icons of selected saints, the most popular from of icon in Novgorod. The earliest of the extant depictions of St. Paraskeve in icons of this type are ascribed to the 13th century. One example shows her as a figure on the lower border of an icon of St. Nicholas (Tretiakov Gallery).

75 cm x 58 cm x 3 cm
Panel of two boards with two struts.

Inventory No.
ДРЖ 2069

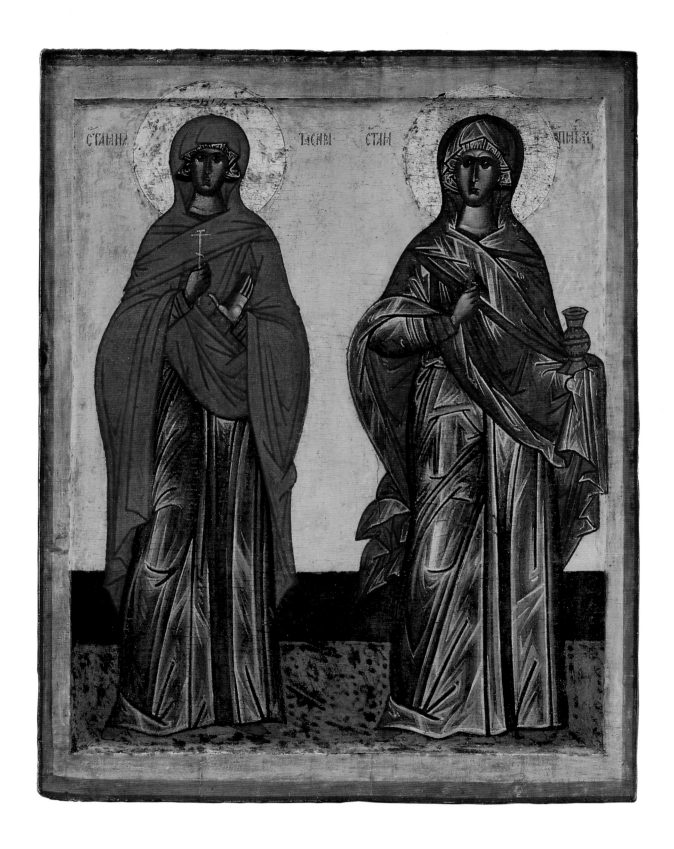

In the illustrated icon, St. Paraskeve is depicted together with the martyr St. Anastasia. The figure of Anastasia combines two martyrs venerated by the Orthodox Church: one of them suffered in Sirmium in 304, the other was called 'The Roman' and legends about her arose in the 5th and 6th centuries. A vessel in the hand of the martyr evokes her role as a healer. She was also called *Uzoreshitelnitsa* (One who Sets Captives Free) because, according to her *Life*, she dedicated herself to assisting those who were imprisoned for the sake of Christ. The cult of Anastasia was spread in Novgorod as widely as the veneration of St. Paraskeve and depictions of her are frequently found in Novgorodian art. In the icons of the Novgorodian provinces she is quite often depicted together with saints who were patrons of agriculture, since she was also venerated as a patron of sheep. In these icons of selected saints St. Anastasia is often portrayed next to St. Paraskeve. They are united both through the similarity of their roles and the proximity of their festivals: St. Anastasia is commemorated one day after St. Paraskeve, on October 29.

Common features in the cult of both martyrs are reflected in specific iconographic patterns. The red *maphorion* in which St. Paraskeve is usually clothed may also be seen in the depiction of St. Anastasia. Their images are very similar, and in the present case the name *Piatnitsa* is inscribed near the martyr in the violet *maphorion*, while *Anastasia* is inscribed next to the saint in red.

Taking into account certain iconographic features of both martyrs, one might suggest that contrary to accepted opinion the saint depicted on the left is Anastasia, and the saint on the right Paraskeve. As was noted above, St. Anastasia is often portrayed in a red *maphorion*. St. Paraskeve can be linked with the saint depicted on the right side for a number of reasons. The color violet is associated with the commemoration of the Cross and Crucifixion, with the remembrance of the death of Christ. The violet color of the garments of St. Paraskeve might therefore recall her association with Good Friday and the Passion. Regarding the vessel held by the martyr, which is the attribute of a healer, it is sometimes depicted in the hands of St. Paraskeve as well. Such an example is the icon of St. Paraskeve dated to the second half of the 15th century, now in the Vologda Museum. According to tradition, the relics of St. Paraskeve are invested with healing powers.

N. P. Likhachev (1862-1936) was a scholar, historian, and academician. He was known as a prominent expert in palaeography, numismatics, and the history of Russian art. He devoted more than 20 years to compiling a collection of Byzantine and Russian icons as a systematic presentation of panel painting from the 14th to the beginning of the 20th century. Regrettably, the collection as a whole existed in the Russian Museum only for a short period. After 1923, and especially during the 1930s, over 250 pieces of Byzantine and early Italian painting were transferred to the Hermitage. More than 200 other icons were transferred to Antikvariat for sale abroad as well as to various museums throughout the country. Nevertheless some 1,000 icons are still among the holdings of the Russian Museum. N. P. Likhachev himself suffered at the hands of the Soviet authorities. His work and scholarship were widely acknowledged before 1930, but he was arrested on charges of anti-Soviet activity in 1931 and was exiled to Astrakhan. His work and his name were suppressed, and he died discredited in Leningrad in 1936. He was not rehabilitated until 1967, and it was only after the end of the Soviet era, in 1991, that the Russian Museum was able to mount the first major exhibition based on his collection.

The exhibited icon is generally in a good state of preservation, except for the gold of the halos which is considerably effaced. The background was probably repainted during restoration. The provenance of this icon prior to its acquisition by Likhachev is unknown. It was acquired by the Russian Museum in 1913 as part of his collection.

Tatiana Vilinbakhova

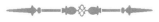

177

St. Floros, St. James of Jerusalem, and St. Lauros

Novgorod
Late 15th century

The origin of the icon is unknown. It was acquired by the Russian Museum along with the collection of N. P. Likhachev in 1913. It was cleaned prior to its acquisition by the Museum, and an additional cleaning was performed at the Museum by F. A. Kalikin in 1913. There are traces of later overpainting in the background and over the inscriptions. A considerable loss of ground can be seen in the lower border. The icon belongs to a type widespread in Novgorod. The saints stand facing those praying to them. St. Floros and St. Lauros are each dressed in a *chiton* and *himation*, holding martyr's crosses in their right hands and with their left hands covered. Their representations are nearly identical, suggesting their resemblance as brothers and the similarity of their fate. Floros wears the blue *chiton* and the red *himation*, and Lauros the red *chiton* and blue *himation*. The color red was considered suitable for martyrs, while blue was the color of the Holy Spirit or its influence.

The twin brothers lived in the 2nd century, in Byzantium and then in Illyria. They were martyred by being buried alive in a well, and many years later their bodies were recovered in a state of perfect preservation and transferred to Constantinople. Their cult was widespread in Russia. In the early period they were represented full-length or half-length. Beginning in the late 15th century there appeared a composition called THE MIRACLE OF ST. FLOROS AND ST. LAUROS, linked with their reputation as patrons of horses. They were also venerated as healers, a role which was probably shared with the third saint in the icon, James of Jerusalem, the son of Joseph the Betrothed. He was chosen as the first bishop of Jerusalem and presided over the Council of the Apostles described in Acts 15. In the 30 years of his service as a bishop, he is said to have converted many Jews to Christianity, and to have created a liturgy which served as a source for the liturgies of St. Basil the Great and St. John Chrysostom. James was stoned to death around 63 AD. His images were popular in Byzantium and Russia, and his cult is recorded in Novgorod as early as the 12th century. Among the sacred objects at Novgorod was a cross with his relics, and according to the records of the Cathedral of St. Sophia, people prayed to him for deliverance from festering ulcers. While the three saints in our icon may have been chosen for their healing powers, they may also symbolize the idea that the church draws its strength from its martyrs. As a prominent hierarch, James may personify the church, and the two martyrs turning to him on either side may signify its support and protection.

Tatiana Vilinbakhova

62.5 cm x 50 cm x 3 cm
Panel of three boards
with two struts.

Inventory No.
ДРЖ 1444

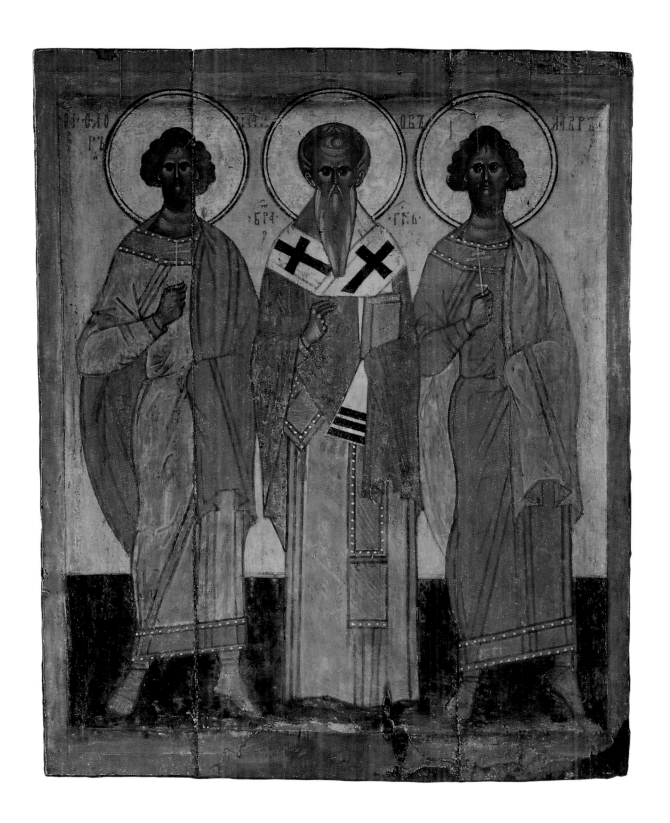

179

ST. GEORGE AND THE DRAGON

Novgorod
Second half of the 15th century

This icon of St. George and the Dragon is one of the most renowned of all Russian icons. It is the most famous object in the medieval collection of the Russian Museum, a masterpiece of medieval Russian painting. It comes from a church in the village of Manikhino, near the estuary of the Pasha River in the Volkhov district of St. Petersburg, and was purchased by the Russian Museum from

the Regional Museum Fund in 1937. St. George is one of the most venerated saints in Russia. A number of literary sources survive, giving details of his life. According to one of them, St. George was a warrior from Cappadocia. He publicly proclaimed himself a Christian before the pagan emperor Diocletian (d. 316), who ordered him to be tortured and killed. According to another version, his tormentor was the Persian king Dadian. The veneration of St. George the martyr began in the 5th century, particularly in Cappadocia. Cycles of his miracles were most probably elaborated in Eastern monasteries during the 11th century.

The cult of St. George increased during the reign of Iaroslav the Wise in the 11th century. Iaroslav Vladimirovich, whose Christian name was George, founded the city of Iuriev in 1032 and named it after his patron saint. He also built a church with a monastery dedicated to St. George in Kiev, and after its consecration by Metropolitan Ilarion on November 26, commanded that a feast day for St. George be celebrated throughout Russia.

St. George was a patron saint of Russia and of the grand princes. His image played a great part in old Russian political life; it appeared on the state coat of arms and was minted on coins of Moscow. He was equally venerated among the com-

mon people, not only as a courageous warrior, 'Egorii the Brave,' but also as a patron saint of those who tilled the land and bred cattle. Numerous customs and rites are connected with his commemoration days in the Russian calendar (November 26 and April 23). According to popular legends and religious verses, Egorii was the first man to set foot on Russian soil, before it was inhabited. He is said to have taken the country under his direct patronage, to have brought order to it, and to have established the baptized faith there.

Russian icon painting assimilated several different Byzantine iconographic types of St. George. In the pre-Mongolian period, the saint was depicted in a ceremonial and representative manner, in military attire with lance and sword. Also widespread was an image of the saint clad as a martyr with cloak and cross. The most popular image, however, was of St. George and the Dragon. The earliest known use of this iconography in Russia is a fresco of the 12th century in the diakonikon of the Church of St. George in Staraia Lagoda. In icon painting, it first appears in the central panel of a 14th century icon *ST. GEORGE WITH SCENES FROM HIS LIFE* from the collection of M. P. Pogodin, and now in the Russian Museum.

The 14th century icon from the Russian Museum mentioned above presents a con-

58.5 cm x 42 cm x 3 cm
Panel of two boards
with two struts.

Inventory No.
ДРЖ 2123

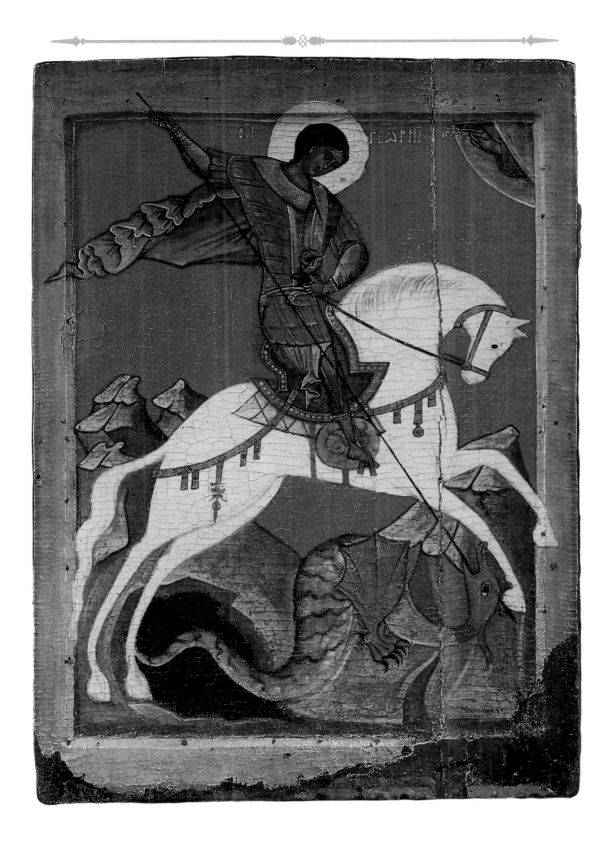

cise version of the scene. There is an opinion that it is based on a literary source that differed from the more conventional version. Yet, as was correctly noted by E. S. Smirnova, it was not uncommon for icons to illustrate different episodes from a single story. The scene in this icon is more in keeping with the climax of the story: 'The saint crossed himself and rushed towards the monster crying: "O Lord, my God, destroy this terrible dragon so that these unbelievers may believe." Having said this, with the help of God and the prayer of the martyr, the dragon fell at the feet of St. George.'

Combat with a dragon or serpent is a classic image in mythology throughout the world and is traditionally associated with the conquest of good over evil. In the Christian tradition, the dragon or serpent is the most universal symbol of the devil. The image of St. George and the Dragon was also associated with his triumph over a pagan king by the power of faith. Certain episodes from the *Life* of the saint coincide exactly with details from the *Life of St. Niketas the Martyr*, who was known for fighting demons and devils. The names of both saints were frequently used in Russia as a magical formula against evil spirits.

The icon is of the highest quality. Its composition is so balanced and its color scheme so strikingly harmonious that it seems to have absorbed the very best qualities from the entire tradition of Russian icon painting throughout the centuries. Its pictorial language is utterly expressive, precise, and clear. Its symbolic meaning is immediate and intelligible to everyone in a most direct way. There are no superfluous details; each one is so well conceived and constructed, and at the same time so natural, that if we were to remove a single detail the entire design would collapse. In the combination of the bright cinnabar background and the dazzling white painting of the horse, in the halo of the saint and the fathomless black grotto, in the simple but bold juxtaposition of red, white, and black, there is so much power and grandeur that the icon seems to embody the very essence of ancient Rus.

It has never been doubted that this icon is a classic example of the Novgorodian style. As to the time of its execution, however, there are considerable differences of opinion. In most works, the icon is dated to the late 14th century or to the turn of the 14th and 15th centuries. V. N. Lazarev at first dated it to the end of the 14th century, but in his later works, ascribed it to the beginning of the 15th century. G. I. Vzdornov ascribed it to the 15th century and E. S. Smirnova to the first half of the 15th century. In the catalog of the exhibition PAINTING OF EARLY NOVGOROD, the icon is dated to the second half of the 15th century. V. K. Laurina attributes it, even more precisely, to the last quarter of the 15th century.

The latter date seems most probable, since it was in the second half of the 15th century that a clear artistic style first appeared in Novgorodian art, characterised by an exceptional integrity in its perception of the world, a harmony in its graphic order, a perfection of forms and lines, and a flawless system of painterly devices. These qualities are epitomised by the present icon.

The icon is in good condition, with insets of later canvas and painting to the lower left and right sides. The inscriptions are in white lead and are partly effaced. It was last restored by N. E. Davydov and Ia. V. Sosin in 1937-38.

Irina Shalina

THE ARCHANGEL MICHAEL

Novgorod
Second half of the 15th century

This icon of the Archangel Michael came from the Murom Monastery of the Dormition, one of the oldest northern monasteries situated on the eastern bank of Lake Onega, an area which in ancient times was a domain of Novgorod. According to *The Tale of Lazaros of Murom*, the monastery was founded in the second half of the 14th century by a Roman monk from the holy mountain,

Mt. Athos, sent to Novgorod by the patriarch of Constantinople. Lazaros lived in Novgorod for nine years at the court of Vasilii, archbishop of Novgorod from 1331 to 1352. After Vasilii died, Lazaros moved to the remote northern region where he founded a monastery.

In the Murom peninsula, Lazaros received a vision of the Mother of God. He then marked the site of the vision with a wooden cross, and built a cabin for himself. During the following years other monks flocked to him, and churches were built and consecrated to Lazaros the Friend of God and to the miraculous icon of the Dormition of the Mother of God from the Monastery of the Caves. When Lazaros travelled to Novgorod to visit Moses, archbishop of Novgorod between 1352 and 1359, he was given a consecrated altar cloth, sacred vessels, and a sum of money for alms. The sheriff of Novgorod, Ivan Zakharev, also gave him a charter for the land of the monastery, and the right to hunt in the forests and fish in Lake Onega. Another monk from Mt. Athos, whose name was Theodosios, joined Lazaros and built a refectory at his own expense. When Lazaros died in 1391 at the age of 105, Theodosios succeeded him as abbot. Theodosios is considered the author of a biography of Lazaros, who was venerated as the father of this ancient northern shrine and

as the enlightener of the local Finnish tribes.

The icon of the Archangel Michael was part of a Deesis which unfortunately is not fully preserved. The Russian Museum has two more icons from it, the ARCHANGEL GABRIEL and the APOSTLE PETER. The Deesis must also have included icons of the Savior, the Mother of God, St. John the Baptist, and the Apostle Paul. It is difficult to know which of the churches in the monastery would have contained it. In 1886 an attempt was made to preserve the ancient Church of St. Lazaros by building a wooden structure around it. This was also used to store the oldest icons of the monastery, including a Deesis from the second half of the 15th century. E. S. Smirnova suggests that it was painted for the main Church of the Dormition in the monastery.

In its iconography the icon of Archangel Michael follows an example in the Deesis of the Cathedral of St. Sophia in Novgorod, painted by the master Aaron in 1438. The same iconography is found in other Deesis rows from Novgorodian churches dating from the second half of the 15th century, including the Church of St. Blasios (now in the Novgorod Museum) and the Church of St. Nicholas in the village of Gostinopolie (now in the Tretiakov Gallery). This suggests that the Novgorodian painters were

132.3 cm x 50.5 cm x 3.0 cm
Panel of two boards
with two inset struts

Inventory No.
ДРЖ 3106

all using the same drawing patterns.

The Deesis from the Monastery of Murom was created in one of the best Novgorodian workshops in the classical period of Novgorodian painting. The Archangel Michael, who leads the heavenly host against Satan and weighs souls for the Last Judgment, sending them to heaven or hell, is represented in our icon interceding before Christ. His vestments are an emerald-green *chiton* decorated around the shoulders and along the hem, and a pinkish-red *himation*. He holds a staff and a transparent sphere with a mirror reflecting the monogram of Christ, his attributes at the Last Judgment. His silhouette is carefully placed at the center of the icon and his figure is well proportioned. His face is marked with a concentrated inner harmony, and is turned toward the center of the Deesis. It is modeled with layers of opaque ocher and bold rouge over the olive underpaint. The figure is modeled with whitened main tones for the garments, providing an almost sculptured effect. The outline and the folds of the robes are painted with a darker shade of the same color, in bold and sure lines. The color scheme stresses a contrast of intensity, employing a subtle combination of shades which shine over the gold ground. Special Novgorodian features of the period are the halo with incised ornament, and the base painted in two shades which represents the Earth. The work has been unanimously dated to the second half of the 15th century.

The icon has suffered some damage. There is a crevice along the joint between the boards, and losses of gesso in the upper, lower, and right borders. There has also been a later insertion of gesso at the center near the lower border. Most of the gold of the background and the borders has been lost, along with the inscription.

As noted earlier, the icon came from the Monastery of Murom of the Dormition, in the Pudozh region of Karelia, and was brought to the Russian Museum in 1957 by an expedition sent to examine and collect works of medieval Russian art. It was cleaned at the Russian Museum in 1957-58 by N.V. Pertsev.

Catalog No. 52

THE PROTECTING VEIL
(*POKROV*)

Novgorod
Mid-16th century

The background of the composition is a church with three domes represented in cross-section. The Mother of God is depicted in prayer, standing on a cloud in the central apse. Two archangels, Michael and Gabriel, are soaring above her and holding her veil. Above the veil, Christ sits in an almond-shaped mandorla, supported by the seraphim. The saints representing the church militant

stand beside the Mother of God and face her. They are depicted in strict order as her heavenly retinue. The prophets and apostles are the closest to her, with the prelates and clergy behind them, followed by male and female martyrs. Under the Mother of God in the lower register is St. Romanos the Melode, standing on an ambo against the background of the Royal Gates. The Byzantine patriarch Tarasios and the emperor Leo the Wise are shown on the ambos to the right and left. St. Andrew the Holy Fool and his disciple Epiphanios, the witnesses of the miracle, are standing next to the ambo of the patriarch. Most of the images are accompanied by explanatory inscriptions on the sides of the central dome.

All the inscriptions were corrected during restoration. The icon has been known in research literature for some time and it has repeatedly been reproduced and described in detail. A. N. Nekrasov made the suggestion in 1937 that the icon belongs to the Moscow school, while others disagree and attribute it to Novgorod. The question of dating is also uncertain, but it would appear to belong to the 16th century. Specialists have repeatedly commented on its miniature style. The artist used line as his chief means of expression and the figures of his characters are emphatically elongated and graceful, with small but thoroughly delin-

eated strokes. The folds of their clothing curve in intricate patterns, and are painted in a graphic style. A similar approach to form can be found in the miniatures of *THE LIFE OF NIFONT* from the 1530s. The treatment of faces is close to that of the 1531 icon *THE MOTHER OF GOD OF THE SIGN* and *ST. NICHOLAS*. Several of the tablets from the Cathedral of St. Sophia, which are usually thought to date from a later period, form a close stylistic group with the icon. These are *THE HEALING OF THE BLIND* and *THE ECUMENICAL COUNCIL OF NICAEA*, dating from the middle or second half of the 16th century. Some depictions of saints in the icon can help make the dating more specific. There are reasons to believe that the icon contains images of the Holy Prince Peter of Murom and of St. Alexander Svirskii placed next to each other among the zealots. As both of them were canonized at the Makarian Councils for the canonization of Russian saints, held in 1547-49, the icon may have been painted shortly afterward.

The icon is devoted to one of the most significant festivals in Russia, the Protecting Veil of the Mother of God, celebrated on October 1. Since the time of Prince Andrei Bogoliubskii in the 12th century, the Mother of God was considered as the patron of the Vladimir-Suzdal principality, and the festival of the Protecting Veil instituted by the

118.5 cm x 69 cm x 3 cm
Panel of two boards with inset struts, now lost.

Inventory No.
ДРЖ 2142

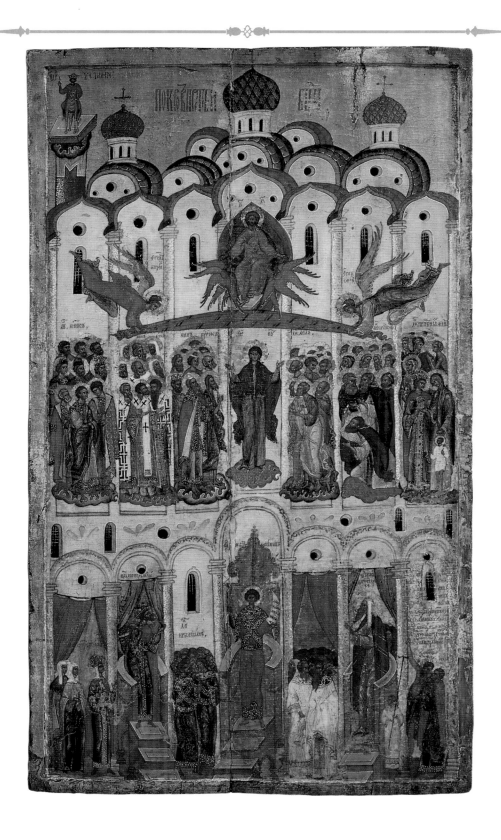

prince was associated with the idea of a united Russia. The painted composition *THE PROTECTING VEIL* reflects an episode from the life of St. Andrew the Holy Fool, in which the Mother of God appears before him and his disciple Epiphanios in the Church of Blachernai, her veil extended to offer shelter and protection. By the 16th century, Russian iconography included several versions of this event. These fall into two major groups, one widespread in Suzdal and Moscow, the other in Novgorod and Pskov.

The basic design of this composition adheres to the traditional Novgorodian style, with the scene positioned against the background of a temple and the hierarchic tiers quite clearly identified. Also following tradition, St. Andrew the Holy Fool is shown to the right of the Royal Gates, and the Protecting Veil is supported by angels above the head of the Mother of God. This is the main distinctive feature of the Novgorodian versions. However, the composition also has some fundamentally new characteristics. These are the images of the Emperor Leo the Wise and the Patriarch Tarasios. Their heads have halos, and their ambos are only one step lower than St. Romanos the Melode. The Emperor is surrounded by laymen and the patriarch by clergy, and together they are the supreme representatives of the people before God. In Russia, the name of the Patriarch Tarasios was associated with the fight against heresy. As patriarch from 784 to 806, he was the initiator of the Seventh Ecumenical Council, which restored the veneration of icons and condemned the iconoclasts. Leo VI is probably shown because the miracle of the Protecting Veil occurred during his reign. In Russia during the 16th century, his name was almost as famous as that of Justinian, whose statue is also depicted in the upper left corner of the icon. Veneration of Justinian in Russia was largely due to the fact that the Byzantine emperor was seen by the Russian grand princes as their predecessor, and was associated with the construction of the Cathedral of St. Sophia in Constantinople, the central shrine of the Orthodox world. Justinian also presided over the Ecumenical Council, and was therefore the scourge of heretics and the protector of both church and state.

These three individuals all represent the union of the spiritual and secular authorities, their equality and harmony. These issues were among the most important in 16th century Russian political treatises, and were alluded to by the followers of St. Joseph of Volotsk and by Maxim the Greek, the most eminent writer of the first half of the 16th century. We can assume that these issues were indirectly reflected in the design of the icon. It reveals a certain historicity, a feature that became particularly prominent in mid-16th century iconography, and was due to a new understanding of the role and significance of iconic imagery. There is a noticeable appeal to the authority of Byzantium, whose political and spiritual traditions were considered to have been inherited by Russia since the time of Ivan III.

The origin of this icon is unknown. It came to the Russian Museum as part of the N. P. Likhachev collection in 1913. It was restored before coming to the Museum, and again at the Museum in 1913, probably by N. I. Briagin.

Tatiana Vilibakhova

THE ENTOMBMENT

Novgorod
Mid-15th century

In the mid-15th century, Novgorod was under the authority of Archbishop Evfimii II (1429-58). His name is associated with the creation of many works of art, including architectural commissions as well as paintings and carved and embroidered objects. The St. Sophia workshop in Novgorod flourished under Archbishop Evfimii and it was at his orders that outstanding works of pictorial embroidery were

created: the famous Puchezh shroud of 1441, named after the town where it was found in 1939; the Khutyn shroud; the much reproduced Deesis of the Trinity-St. Sergei Monastery; and the shroud from Tikhvin, now in the Russian Museum.

Shroud (*Plashchanitsa*)
72.5 cm x 114.5 cm
Satin, embroidered in silk
and silver thread

Inventory No.
ДРТ 195

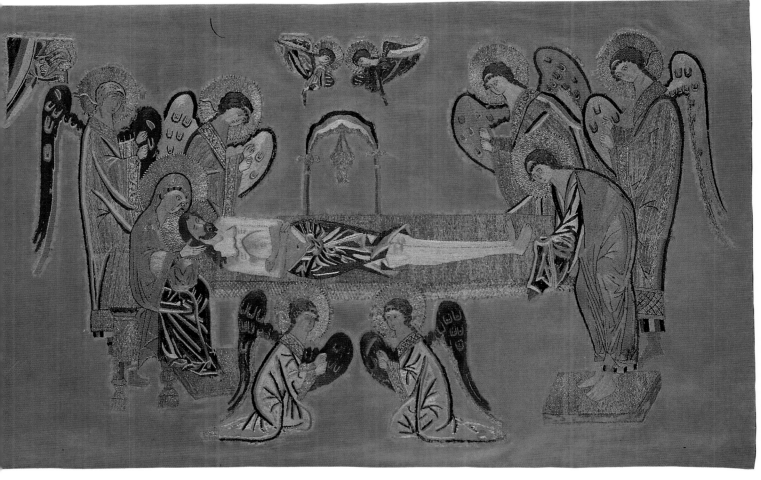

All these works are characterized by the specific individual features of so-called 'pictorial' embroidery: bright multi-colored silks with long split stitches; harmonious shading from dark to light; the use of white silk to represent highlights; individual styles of draftsmanship; and such details as peacocktail eyes in the wings of the angels.

These Novgorodian shrouds belong to a group in which liturgical significance is successfully combined with historical narrative. As in earlier Muscovite shrouds, the present example contains a small inset bearing the images of the Mother of God and St. John the Divine.

Not all the details of this shroud have survived. Of the four symbols of the evangelists at the corners of the central section, three have been lost. The candle between the two kneeling angels in the foreground and the representations of the sun and moon with human faces are also missing. The inscriptions around the borders and in the center have been lost.

The original yellow satin background has survived only under the stitching and at the edges of the shroud. The shroud was restored for the first time after its reception at the Russian Museum in 1933, when the embroidery was transferred to canvas. In 1964 the embroidery and the remains of the background were lined with silk of a color close to the original.

Liudmila Likhacheva

ST. SOPHIA THE DIVINE WISDOM AND ST. NICHOLAS, THE GREAT MARTYR NIKETAS, ST. ANTHONY AND ST. FEODOSII OF THE CAVES

Novgorod
Second half of the 16th century

The two sides of a church banner usually represent episodes that are specifically connected with the church in question. In his account of the antiquities of Novgorod, Archbishop Makarii mentions the Church of St.Niketas situated on the merchants' side of the city. The two parts of the present banner are mentioned among the relics there. On one side of the banner we see the saints that were especially revered in the Church of St. Niketas. There was a side-chapel named after St. Nicholas as well as one named after Anthony and Feodosii of the Caves. There were three altars: one dedicated to the Great Martyr Niketas, one to St. Nicholas the Wonder-Worker, and one to St. Anthony. The saints are represented in full-length: St. Nicholas in a *phelonion* with an *omophorion*, his right hand giving a blessing; St. Niketas the Warrior in a long cloak with a cross in his right hand and a sword in a sheath in his lowered left hand; St. Anthony of the Caves in a monastic habit with a cowl on his head, his right hand raised in blessing, and his left hand holding a scroll; St. Feodosii of the Caves in a monastic habit with a cowl, holding a scroll in both his hands at the breast. There are inscriptions near the images to identify them.

On the other side of the banner, there was a Novgorodian composition ST. SOPHIA THE DIVINE WISDOM. This image illustrates the episode in the Bible known as the Judgement of Solomon. The iconography of St. Sophia as an angel came into existence in Novgorod, independently of the Byzantine tradition. The importance of St. Sophia in Novgorod is generally known; she was seen as a personification of the Novgorodian republic. In the center of the composition, there is a winged maiden with a fiery face, on a throne supported by seven pillars. She wears a dalmatic, with a crown on her head, a wand in her right hand, and a scroll in her left. She is surrounded by a mandorla. To one side of her is the Mother of God with Christ Emmanuel; on the other side is John the Baptist with a scroll in his left hand. They are represented standing on rectangular platforms facing St. Sophia. Above the head of St. Sophia, we see a half-length figure of the Savior in Glory. There is an inscription with a prayer on the margins.

The embroidery is worked over an Italian blue damask, much altered in color, with silver and gilt threads. It was restored the first time in 1940 and a second time in 1976-78. It was acquired in 1938 from the Museum of Baron A.L. Stieglitz through the Hermitage.

Liudmila Likhacheva

Double-sided banner
(*khorugv*)
Damask embroidered with silk, silver, and gilt thread.

St. Sophia
48.5 cm x 53 cm

Inventory Nos.
ДРТ 30

St. Nicholas, St. Niketas, St. Anthony, St. Feodosii
49.5 cm x 53.4 cm

Inventory Nos.
ДРТ 20

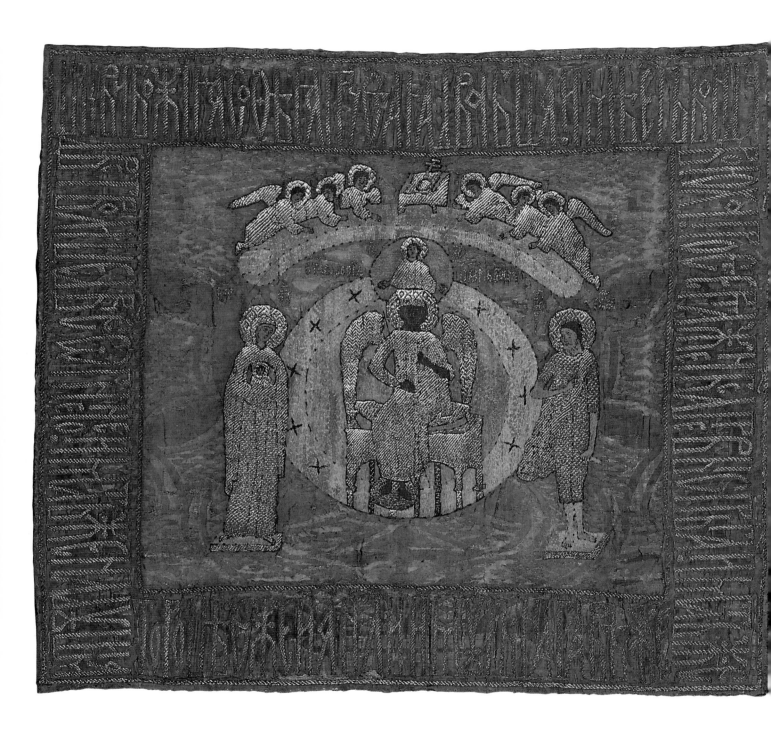

193

THE APOSTLE PETER

Novgorod
Second half of the 15th century

The workshops of medieval Russia produced embroidered replicas of especially venerated or miraculous icons, iconostases entirely executed in embroidery, and individual embroidered icons of considerable size, such as the image of the Apostle Peter from the Monastery of St. Alexander Svirskii. The icon was received at the Russian Museum in 1923 from the monastery of St. Alexander Svirskii,

and was followed two years later by a companion piece, the Archangel Michael.

Both icons are embroidered on canvas, which is very unusual. Most such icons were embroidered on precious imported silk fabrics. The backgrounds are entirely covered with split stitch embroidery in silk threads. The thread has worn away in many places, and the loss of silk on the faces reveals the basic design, drawn by a talented draftsman. This is particularly noticeable in the face of the Apostle Peter. To judge from the pictorial structure of the icons, and their similarity to Novgorodian icons of the period in terms of draftsmanship, coloring, and composition, they must have been embroidered in Novgorod.

The icons have been restored twice, in 1932 and 1963-64. It may be seen from the inventories of the Monastery of St Alexander Svirskii for 1660 and 1665 that the icons were brought there from Poland

between those two dates. In 1612-13 the monastery was gutted by the Poles and Lithuanians. It was later restored and replenished with icons and church plate, and the two embroidered icons were brought there during this process.

The icons were hung in the Church of the Trinity, by the midday or southern doors. As the monastic inventory for 1674 reports: 'By the midday doors are embroideries of the Archangel Michael and the Apostle Peter, in gold and different colored silks, worn standing upright.' The works were subsequently transferred from one church to another, as often occurred in monasteries. The icon of the Archangel Michael, for example, was nailed to a door panel and placed on the north door of the Peter and Paul chapel of the Church of the Trinity.

Liudmila Likhacheva

Embroidered icon (*ikona*)

158 cm x 80 cm
Canvas, embroidered with
silk and gilt thread.

Inventory No.
ДРТ 264

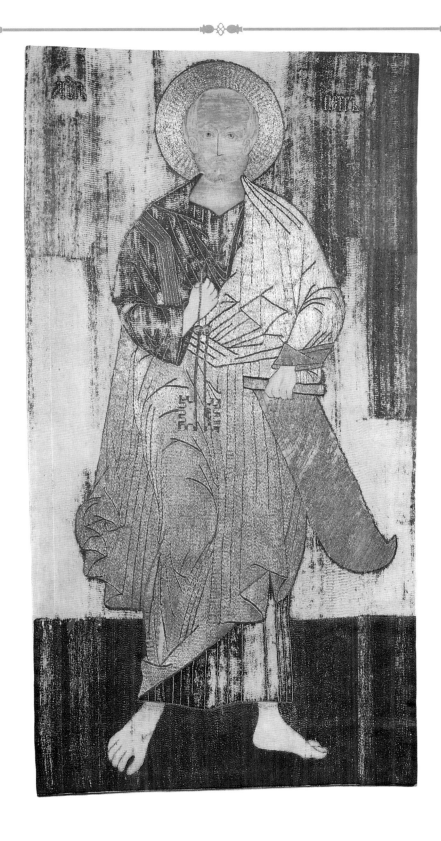

ST. GEORGE AND THE DRAGON

Novgorod
Early 16th century

St. George was one of the most popular saints in medieval Russia. His cult was widespread in Moscow, where he was the patron saint, but it was in Novgorod that the representation of the episode of St. George fighting the dragon was most common. The image tells the story of the rescue of a princess, the daughter of a pagan king, from a dragon that settled near the town and demanded human sacrifices.

The *pelena* represents a detailed version of the story. The central image depicts St. George on horseback piercing the dragon with a spear. On the right is a town represented by a tower. The king and queen and the people stand on the tower watching the miracle. In the corners of the *pelena* are six-winged seraphim. The left border is missing.

The inscription on the upper and side borders is completely preserved. It is a *troparion* and prayer to St. George: *The Liberator of Prisoners, the Helper of the Needy, and the Healer of the Sick; Accomplice of the Tsar, Conqueror, and Great Martyr! St. George, pray to Christ and to God to save our souls . . .*

The *pelena* belongs to the group of early 16th century Novgorodian embroideries that was created in the same workshop as another well-known cloth THE GREAT MAR-TYR ST. CATHERINE WITH SCENES FROM HER LIFE (Novgorod Museum).

The technique of the embroidery is interesting in that it combines satin stitches with split stitches. It is made of silk damask embroidered with gilt and silver threads. At a later period, the background was wholly embroidered with red silk threads. The *pelena* was restored in 1930. The lost border was reconstructed and the red threads removed; only traces of it remain. The evidence suggests that the *pelena* came from Konevets to the Derevianitskii Monastery. According to tradition, the Monastery of Konevets on Lake Ladoga, with its Cathedral of the Nativity of the Mother of God, was founded in 1398. In 1577 the cloister was destroyed by the Swedes, whereupon the monks moved to the Derevianitskii Monastery. After its destruction, the monastery was reconstructed in 1594 and seized by the Swedes again in 1610. In 1718 the Konevskii Monastery was given to the Derevianitskii Monastery. The latter sits on the left bank of the River Volkhov not far from Novgorod. The first record of the monastery in the chronicle refers to 1335.

When the monks moved from Konevets to the Derevianitskii Monastery they took all the utensils with them and also the cloth depicting St. George. I.A. Shliapkin was a famous historian who worked for a long period of time in Novgorod, where he acquired the cloth. He lived in Beloostrov, not far from St. Petersburg, and his collection joined the Russian Museum after his death in 1918.

Liudmila Likhacheva

Icon cloth (*pelena*)

53 cm x 50 cm
Damask, embroidered with silk, silver, and,gilt thread.

Inventory No.
ДРТ 41

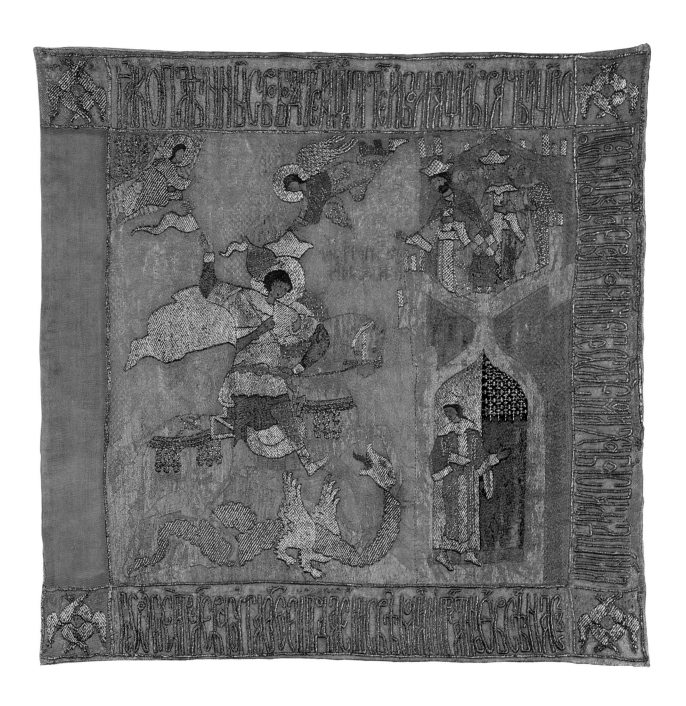

THE VISION OF THE HEAVENLY LADDER AND THE VISION OF EVLOGII

Novgorod
Mid 16th century

In the Russian Museum there are three icons, *THE PARABLE OF THE BLIND MAN AND THE LAME MAN*, *THE VISION OF THE HEAVENLY LADDER* and *THE VISION OF EVLOGII* which may once have formed part a of single ensemble whose origin is unknown. They were bought in the 1890s by N. P. Likhachev from N. D. Tiulin, a restorer who specialized in collecting, restoring, and selling icons to collectors at the end of the last century. N. P. Likhachev was one of his regular customers.

The related conception, style, materials, and dimensions prove that these three icons were previously part of a single ensemble. According to researchers, this had been a large scale four-part or six-part icon. Such a work is known as a 'parable-icon,' but this is not a wholly accurate term. Only one of the images can be called a parable in the true sense of the word, *THE PARABLE OF THE BLIND MAN AND THE LAME MAN*, which illustrates a parable written by Cyril, Bishop of Turov (1130-82). In the parable, Christ planted a vineyard and hired a blind man and a lame man to guard it, but then drove them away after they entered the garden and robbed it. The icon also depicts the punishment of the blind man and the lame man. They symbolize the soul and body of man separated from one another and arguing at the Last Judgement over who is to blame for any crimes commited during life. The icon reflects the artist's conception of the role of the spiritual and the bodily in man, the heavenly and the earthly elements in his life.

The icon *THE VISION OF EVLOGII* illustrates one of the stories from the *Skit Paterik*, a collection of short stories about famous saints. Copies of this text were known in Russia as early as the 13th century and were often to be found in monastic libraries. Some parts of the *Paterik* were included in the church service and also provided suitable subjects for icon compositions. There are several editions of this collection, each differing in content. One of them has a short didactic story telling how a wise monk named Evlogii stopped a group of monks who wished to approach the sanctuary. He called on them to repent, as only when their sins were forgiven would they become worthy of the presence of God. A different version of this text is published in the *Prolog*, a medieval Russian collection of *Lives* of saints and didactic stories arranged according to the calendar and written in an abbreviated form. Evlogii is not named in the story, as it is told from the point of view of an old monk who teaches that there are three things monks should approach with fear and trepidation: the divine liturgy, eating, and bathing. He told them a parable of a monk who saw a vision of three groups of monks, some eat-

64.2 cm x 44.0 cm x 4.2 cm
Panel of two boards
with a single strut.

Inventory No.
ДРЖ 2139

63 cm x 44 cm x 4 cm
Panel of two boards with a
single strut.

Inventory No.
ДРЖ 2141

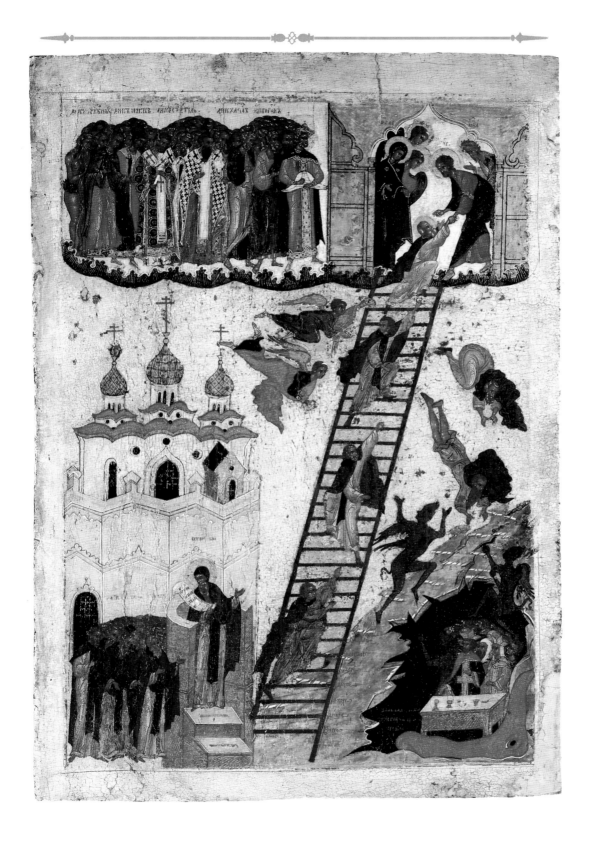

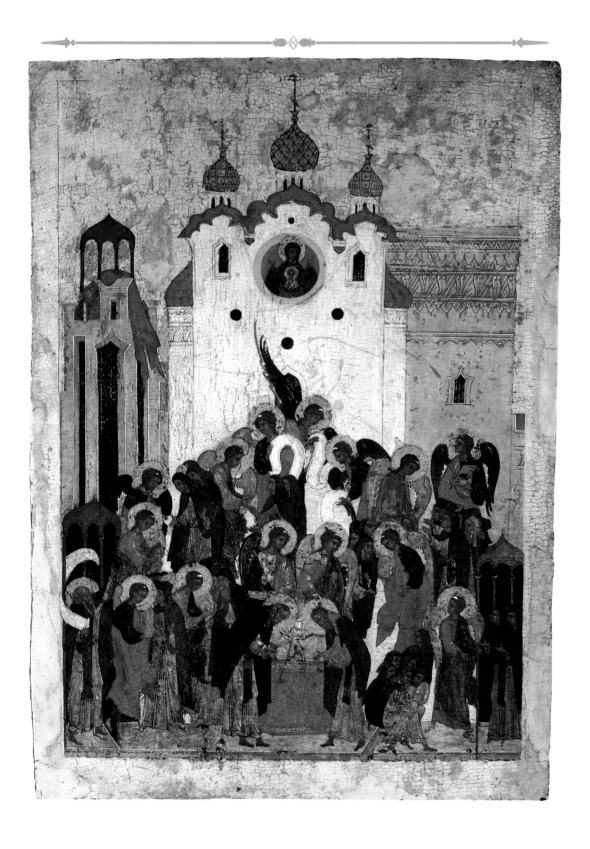

ing bread, others eating honey, and others eating scraps. The old monk was surprised and asked God to explain this mystery. He then heard a voice from above telling him that the honey was for those who ate with fear and trepidation, who prayed to God with a spiritual joy so that their prayers succeeded in reaching him. The bread was for those who praised the food sent by God, while the scraps were for those who were ungrateful, picking and choosing at what was given. That is why, the old man concluded, 'we should not judge, but praise God and glorify Him in our chants.'

These texts differ from what is shown on the icon, which in all likelihood was based on still another version of the story. The closest is the text written on the border of a 17th century icon of the same name, which used to belong to the Cathedral of the Dormition in the Tikhvin Monastery (Tretiakov Gallery). The holy father Evlogii had a vision when he was at the vigil service with the monks, singing the Psalms; the church was filled with light and he saw angels singing together with the brethren. When the service was over, the angels descended from the sanctuary and baskets full of gold, silver, and copper coins appeared in front of them. There was eucharistic bread, both whole and in crumbs, and a golden vessel with the chrism, as well as a golden censer. When the brethren came to adore the Cross, the angels presented their gifts: to some a gold coin with the image of Christ; to others a silver coin; and to others a copper coin without any image. Some received whole loaves of bread, others only crumbs, while others were anointed from the golden vessel. There were some who got nothing at all. Seeing this, Evlogii asked in his prayers why the monks who ate and prayed together received different gifts, and received the answer that a gold coin was for those who were at vigil services on Wednesday, Friday, and the rest of the week, and on all the feasts from Vespers till Matins; a silver coin was for those who were at vigil services from midnight

until Matins; and copper coins were for those who attended only the singing. A whole loaf of bread was for those who were diligent in reading, and the crumbs were for those who had just recently joined the monastery. Nothing was given to those who did not think of salvation, did not resist desires, or did not cleanse their hearts from impure thoughts, but indulged in gluttony and other vices.

The icon THE VISION OF THE HEAVENLY LADDER illustrates a well known text by St. John Klimakos of Sinai, *The Heavenly Ladder*. Most of his life was spent as a monk at the Monastery of St. Catherine on Sinai during the 6th century. At the age of 75, after many years as a hermit, he was selected as the abbot of the monastery, but towards the end of his life he returned to the life of a hermit. At the request of Abbot John of the neighbouring monastery at Rhaithou he wrote a treatise on the spiritual perfection of monks. His epithet *Klimakos* meaning 'of the Ladder' derives from the title of the treatise. He was canonized in the 9th century.

The image of a Heavenly Ladder is of ancient origin. The Egyptians believed that by such a ladder the souls of the dead ascended to heaven, and in Genesis 23: 10-12 a vision of a ladder was sent to Jacob, who saw angels ascending and descending between heaven and earth, promising him the protection and blessing of God.

The iconography of THE VISION OF THE HEAVENLY LADDER has a long and established tradition. As a rule, manuscripts of *The Heavenly Ladder* were illustrated on the frontispiece. The earliest such paintings to survive date from the 11th century. In Russia, illustrated copies of *The Heavenly Ladder* date from the early 15th century. The composition of the icon was fixed later and derived from such miniatures.

In the lower left corner of the icon we see St. John on an ambo, holding a scroll and reading his composition to the monks who listen with humility and respect. Behind them we see a massive wall that seems to echo the silhouette of St. John,

who is standing in prayer like an immobile pillar. Behind the wall is paradise. The image of the the ladder shows the 30 chapters of the book represented in 30 steps. Monks are slowly climbing the steps, each figure giving the impression of movement and of a desire to ascend. Christ appears to give his hand to the monk who has mounted the final step, helping him to enter the open gate of paradise. The Mother of God, St. John the Baptist, and the archangels meet him, and a golden nimbus appears above his head. Paradise is painted in white, symbolising the brilliance of the immaterial light, spiritual purity, and attained perfection. Near the entrance to paradise, groups of saints and martyrs on clouds inhabit the Heavenly Jerusalem and praise the Creator. At the forefront, King David plays the lute and sings his psalms, many of which were used by Klimakos in his treatise. Not all the aspirants reach paradise, however. Many of them fall, taken by the mischief and artifice of demons. In the lower right corner, the icon depicts a bare rock under which we see the abyss, the darkness of passions, where a red monster symbolizes death and hell.

According to Klimakos, the constant memory of death assists and supports people in their spiritual ascent. Among the figures in the underworld are two dressed in royal clothes. These are the rulers of the Kingdom of Shadows, Pluto (Hades) and Proserpine (Persephone), who reign over monsters of hell and break the last ties of the dying with the living. Such references to classical mythology are frequent in the 16th century.

Despite their different sources, the symbolic and artistic language of all three icons reflects the medieval interest in parables. All the books of the Old and the New Testaments contain parables. Many of these served as subjects for other writings, becoming symbols or aphorisms. A parable is a means to comprehend the wisdom of God: 'Shall I open my lips in parables, uttering the wisdom of the Creator'

(Luke 6: 20). The symbolic character of parables was the reason for their extensive use in painting. The parable style became especially popular in Russia in the mid-16th century and was even discussed at Church Councils in 1551-54. The 16th century striving for the visible, the didactic, and the edifying was reflected in the themes.

Most probably, the parable-icons from the Russian Museum were once part of the northern and the southern doors of an iconostasis, but its origin remains unknown. Judging by their size, each door probably had two compositions, perhaps with a Deesis tier above. Such an arrangement is found in the Church of the Nativity of the Mother of God in the Monastery of St. Anthony, where above the image of the Heavenly Ladder a Deesis appears on the door. It seems that in the 19th century such doors were sawn into individual compositions. Unfortunately, it is impossible to reconstruct the original ensemble, as the other parts of it are lost. It is known that N. P. Likhachev possessed only these three icons in his collection.

The icons published by Likhachev attracted the attention of many specialists. Due to the rarity of the subject and the excellent painting of the icons, V. T. Georgievskii concluded that the Vision of Evlogii belonged to the school of Dionysii. N. P. Sychev thought that the icons were painted by a miniaturist who worked in Novgorod in the 15th century. M. V. Alpatov states that the style of the works proves that they were painted in the 20s and 30s of the 16th century, and can be attributed to the workshop of the metropolitan Makarii. N. E. Mneva dated the icons to the 1530s-40s, while G. D. Petrova thought them to be Muscovite work of the mid-16th century.

The icons are indeed characteristic of the mid-16th century. The subject, the treatment of the literary source, the symbolism, and the technique have numerous links to the painting of the time. The images are still full of harmony and grandeur. Later,

in the second half of the century there would be less brilliance and color.

All three icons have a clear composition and well balanced proportions. Thus, in the THE VISION OF EVLOGII the pyramidal composition is completed by the raised wing of the upper angel. This movement upwards is also seen in the refined outline of the white church and the raised arms of the Mother of God of the Sign in the medallion. All the icons exhibit good draftsmanship. They are characterised by a smooth rounded line silhouetting the wings, nimbuses, and scrolls, the gentle curve of which emphasises the refinement and grace of the figures. Combinations of white and bright cinnabar create the impression of festivity and harmony.

We should therefore attribute the parable-icons to artists from Novgorod, whose painting in the mid-16th century was still bright and colorful. At the same time, the icons do reflect the influence of Pskov and Moscow. Possibly, such a merging of artistic traditions occured after 1547, when masters from Novgorod, Pskov, and Moscow worked together in the Kremlin Cathedrals. The parable-icons might have been painted in a large icon workshop in Moscow or Novgorod where artists from different centers were employed. In this case it would not be correct to attribute them to any specific church in Moscow or Novgorod. The presence of THE HEAVENLY LADDER on the side door of the iconostasis of the Church of the Nativity of the Mother of God in the Novgorod Monastery of St. Anthony as well as the presence of the Novgorodian palladium, THE MOTHER OF GOD OF THE SIGN, on the icon of THE VISION OF EVLOGII may serve as indirect proof of Novgorodian origin.

Losses of the paint layer and gesso across the whole surface of THE VISION OF THE HEAVENLY LADDER have been partly treated with mastic. The paint layer has abrasions and the gold from the background and borders has been removed. Cleaning of later layers of paint was undertaken by N. I. Briagin in 1913-14. Judging by the state of the surface, an entire layer of overpainting was removed. The restorer reconstructed the church cupola with the crosses and renewed many contours, as well as the inscription above St. John Klimakos.

The gold of the background of THE VISION OF EVLOGII is lost. Losses of primer on the edges and the central panel have been repaired. The original painting is in a poor condition. There are abrasions and renovations from various periods. Cleaned of later layers of paint before its acquisition, it was cleaned again in the Russian Museum in 1913-14 by N. I. Briagin. Most probably Ia. V. Sosnin also took part in the restoration. The numerous losses to the original painting were reconstructed during restoration. The faces were renewed in some places, craquelures added, and the church domes painted again.

Irina Shalina

DESCENT INTO HELL
(*ANASTASIS*)

Vologda
First half of the 16th century

This icon is from the Church of St. George on the River Svid south of Lake Lache in the Vologda region. It was acquired from the church in 1925 by the Vologda Museum and was obtained by the Russian Museum in 1933, after the exhibition of 1929-32, through the export company Antikvariat. The icon was cleaned at the Vologda Museum in 1927-27 by A. I. Briagin. There is some late painting

on the lower border, and a sample of the layers of later overpaint has been left by the restorers. The icon has a traditional composition common in 16th century painting. Its sources can be traced to the Palaiologan styles of the later Byzantine period. Characteristic of this iconography is the stance of Christ, turning to Adam and raising him by the hand. Eve is represented opposite Adam, her hands covered with the *maphorion*. Groups of the righteous dead look at the figures and gesture towards them. The upper part of the scene has analogies in both Byzantine and Russian icons, such as the 14th century DESCENT INTO HELL from Tikhvin, even though the Tikhvin icon displays an almond-shaped mandorla with Christ holding a cross.

In the present icon, Christ is represented in luminous clothing against a large round mandorla. The symbolism of the shining robes points to his bringing light and salvation to those who have died. According to the apocryphal *Gospel of Nikodemos*, Christ 'dispelled the gloom of death with his shining Godhead,' and in the present icon the divine rays stream from Christ to those who are resurrected from the underworld. The round mandorla is a symbol of glory and truth, and the circular form was believed to signify the perfection of the eternal and the divine. Dionysii also

painted a mandorla of this shape in his DESCENT INTO HELL from the cathedral of the Monastery of St. Ferapont and this iconography was frequently repeated throughout the 16th century.

Christ is shown holding a scroll in his hand. Its meaning is suggested by later icons which represent the scroll unfolded and bearing the inscription: *The record of Adam is torn up, the power of darkness is denounced and destroyed.* The scroll therefore represents the sins of Adam and the human race as a whole, which Christ has torn up. The detail derives from the Russian apocryphal tradition. Adam is depicted in the present icon rising from the shadow of death, extending his arms to the Savior just as it is written in the text of the *Gospel of Nikodemos*, where Adam expresses his gratitude to Christ in the words of Psalm 29:2), 'Give unto the Lord the glory due unto his name.'

The iconographic version of the Descent into Hell chosen by the artist stresses the link between two events, the historical crucifixion and the symbolic descent into hell. There is a belief that the grave of Adam was located under Golgotha where Christ was crucified, so that the blood of the Son of Man cleansed the sin of the first man, and death conquered death. In the icon, the intensity of the suffering and

125 cm x 71 cm x 3 cm
Panel of two boards with two struts.

Inventory No.
ДРЖ 2747

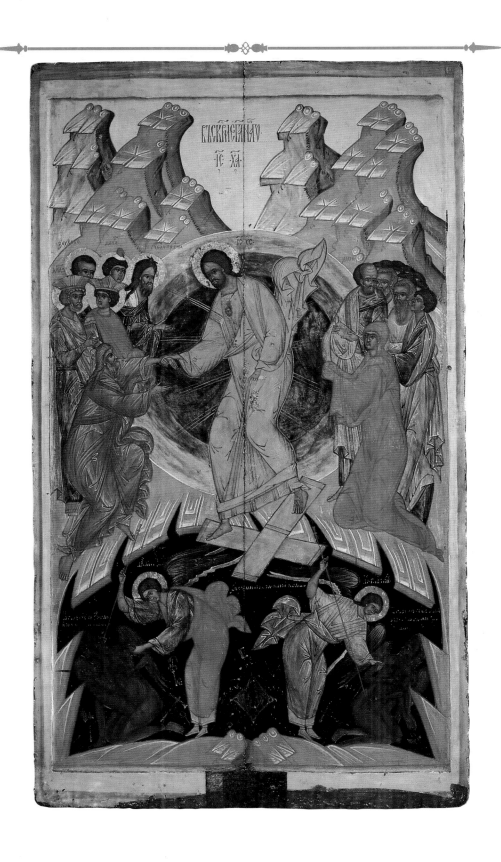

death of Christ is suggested by the sharp fissures in the earth and the sight of his wounds. Emphasis on the stigmata was usual in early paintings. The theme of the Descent into Hell and the Resurrection became a prominent theological issue during the lengthy controversies over the relationship of the human and the divine natures of Christ. The bloody wounds were seen as proof of his bodily death, a reminder of his humanity at the moment when his spirit descended into hell: 'his flesh in the tomb, his soul, Godlike, in hell' (*troparion* for Easter). Around the central figures of Christ and Adam are Old Testament Prophets and the righteous dead. On the left are David, Solomon, Zechariah, Daniel, and John the Baptist, all represented with halos. On the right, Moses leads a group of righteous men talking among themselves about the events before them. Moses is holding the Tablets of the Law, and the men are depicted without halos. Eve is kneeling, her hands are covered with her *maphorion*, and she is looking up at the Savior, 'delivered from fetters, Eve calls in her joy' (*kontakion* for Sunday). Angels attack the two-headed Satan and Beelzebub. At the center of the abyss of hell we see a large key-hole, with an angel on the left and a key hanging from his hand. This is the Archangel Michael, the keeper of the keys to Paradise, now open to those who have been saved.

Konrad Onasch has dated this DESCENT INTO HELL to the late 15th century, arguing that it ranks among the best of Vologda icons. The early 16th century was favoured by the compilers of the catalog for the foreign exhibition of 1929-32. Other specialists share that opinion, and attribute the icon to the provinces of Novgorod, sometimes naming Vologda.

It is difficult to ascribe the technique employed on this DESCENT INTO HELL to any known center. It has an unusual color scheme with contrasting, somewhat jarring combinations of intense and whitened red, watery green, and pink. These suggest Novgorod rather than Vologda, but the faces are more like the style expected of the latter. It is unlikely that the icon comes from the northern Novgorodian province, since the style, composition, concepts, and technique reveal an expert hand, and a good school rather than a provincial origin. It may have been painted in Vologda, or by a master from Vologda who had been influenced by Novgorod. The painting of Vologda is known to have been influenced by several other centers at the same time, Novgorod primarily, but also Moscow and the Rostov-Suzdal area, and many of its works are stylistically diverse as a result.

Irina Shalina

St. George and the Dragon

Vologda
First half of 16th century

This icon is from the Church of St. Theodore Teron in the village of Berezhok, near the town of Kadnikov in the district of Vologda. It was moved to the Vologda Museum in 1926 and was acquired by the Russian Museum in 1933 following the exhibition tour of 1929-32. There are cracks in the gesso, later overpainting and abrasions over the entire surface. Small losses have been filled and spots

touched up during restoration. It was cleaned at the Vologda Museum in 1926 by A. I. Briagin.

Little is known of conservation work in those years, so it is particularly interesting to find it mentioned in the correspondence of I. V. Fedyshin, a restorer and collector of icons from Vologda, and E. N. Sokolova of the Vologda Museum. Fedyshin wrote on September 30, 1926: 'How are you getting on with cleaning St. George? I love and value that icon more than ever before...I wish I could have another glimpse of it now. In my mind I see all our treasures with more clarity against the background of our drab Vologda reality... .'

Sokolova replies on October 2, 1926: 'I've been to Briagin's shop. St. George has been cleaned. It's wonderful. The dragon, it transpires, is coming out of the lake, the princess is standing by a latticed window and holding the dragon on a leash'

Another letter from her to Fedyshin of October 8, 1926: 'St. George is up on the wall. I have examined it inch by inch – cleaned well but not too much, as far as I can see. The overpainting, except in the right hand, is left intact...'.

Apart from the episode with the dragon in the *Life of St. George*, a separate account of the same subject was known in medieval Russia under the title *The Miracle of St. George with the Dragon and the Maiden.*

Judging by the number of copies preserved, it was even more popular than the *Life* of the saint. Five different editions of the story are known.

The events related in it are set during the reign of the pagan king of Laosia, although the name of the city can vary according to the version of the legend. A dragon had claimed a toll of the children of the town, and when it was the turn of the king to give up his younger daughter, St. George appeared. Calling on the maiden to turn to Christ, he overpowered the dragon with prayer. The citizens of the town were greatly impressed by the miracle, and were all converted to the Christian faith.

The text of the *Miracle* first appeared in Russia during the 11th century and was later included in the *Palaea*, a historical encyclopedia.

The earliest representations of the miracle are from Cappadocia, where it appears in a developed form during the 10th-11th century. The earliest representation in Russia is the 12th century mural in the Church of St. George in Staraia Ladoga.

Our icon follows the usual iconographic version, including the princess and the townspeople as well as the saint fighting the dragon. The text reports St. George as crying out: 'Oh Lord, strike down the fearsome dragon so that these infidels might

94.5 cm x 60 cm x 3.8 cm
Single panel without struts.

Inventory No.
ДРЖ 2750

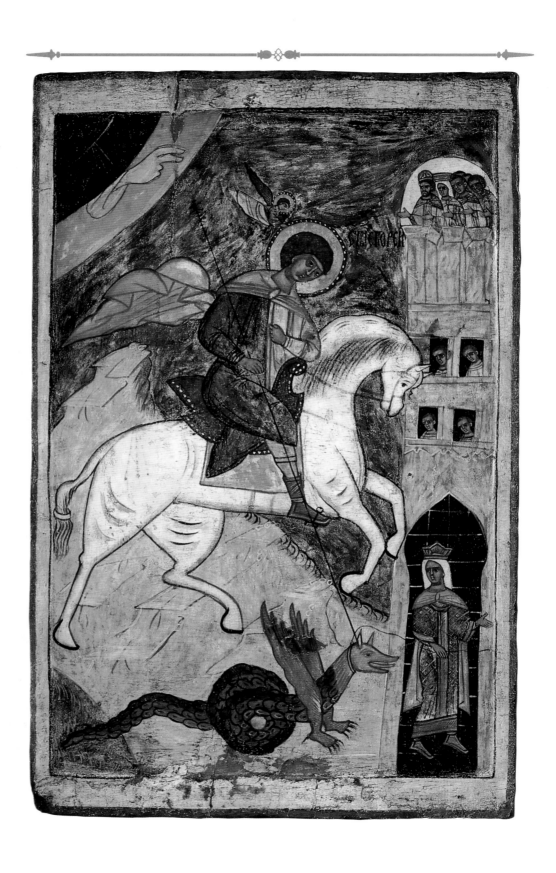

find faith.' As he spoke, the dragon fell at his feet. He then told the maiden: 'Take your belt and my reigns and hand them to me.' Once he had tied the dragon, he gave the leash to the maiden saying: 'Let us lead it to the city'. As they approached, the people fled in horror, but St. George stopped them by calling out: 'Have no fear, see the glory of the Almighty, and believe in the true God and our Lord Jesus Christ. I slay the beast.' The king and the people then said: 'We believe in the Father and the Son and the Holy Ghost, the One and Indivisible Trinity.'

The picture assumes a knowledge of the literary source. It makes no attempt to illustrate or narrate the story, but rather to remind the spectator of it. All the details, figures and actions are signs blended into symbolic associations through pictorial means.

St. George is shown in combat. His steed seems suspended in the air, with no sense of effort or motion, as if the action were brought about solely by the will of God. 'Send a good sign through me,' St. George prays to God, 'smite the terrible monster at my feet so the people will know that You are always with me.' The hand of God blessing the saint from the top left corner indicates the theological significance of the composition.

The tall tower symbolizing the city follows the proportions of the panel and suggests a slender burning candle which forms a white halo over the king and his retinue. The pagan infidels are overwhelmed with fear and awe at the miracle. This is reflected in the flowing outline of the group ending in a curve reminiscent of a nimbus. As the *Life* tells us, 'the whole city believed in Christ.' White is a symbol of enlightenment, purification, and faith, while the halo stands for holiness. The city towering to the sky may have been prompted by the words of St. John the Divine about the vision of 'a new city' on a high mountain 'shining with the glory of God.' A burning candle symbolizes the light of divine truth. The white halo over the people echoes the colour of the white steed, asserting the triumph of good over evil.

The people peering out of the windows at the miracle had assembled to see the princess torn up by the dragon. 'The whole town, young and old, had come to look at the maiden.' The princess with the tamed dragon on a leash stands by the city gate. Behind her is the gaping darkness, the pagan city still immersed 'in the gloom of disbelief.' As usual in pagan rites of human sacrifice, the princess is dressed in her finest clothes: 'The king turned out his daughter in purple and ermine, hung with gold and gems and pearls, he kissed and embraced her with love and lamented over her as for one dead. . . .'

The icon is characteristic of Vologda works of the 16th century with a blue background painted in wide liquid strokes, simplified and expressive drawing, immediacy of image, and a specific technique of facial painting in olive-brown ochre.

In the 16th century, Vologda emerged as a cultural and artistic centre. There were masters working in various styles and the influence of Moscow and Novgorod was strongly felt. This mixture of different traditions ripened with time into a unique phenomenon known as the Vologda school.

Irina Shalina

THE IGOREV MOTHER OF GOD OF TENDERNESS

Northern province (Vologda)
Early 16th century

From the Church of St. Floros and St. Lauros on the River Svid in the Kargopol district, the icon was acquired by the Vologda Museum in 1925. After the foreign exhibition of 1929-32 it entered the Russian Museum in 1933 through Antikvariat. It was cleaned at the Vologda Museum in 1926 by A. I. Briagin. The icon has suffered damage. There is loss of gesso over the cracks on the left side and

along the upper and lower border. The paint and chrysography is rubbed, and there is evidence of later insertions of gesso and traces of darkened varnish.

The iconography of this work can be traced to the famous *VLADIMIR MOTHER OF GOD* which was brought to Russia from Byzantium in the 12th century, and become the palladium of the Russian state. The first icon known as *Igorevskaia* was owned by Prince Igor Olgovich of Chernigov. He was involved in political intrigue and was captured and incarcerated in the Monastery of St. Theodore in Kiev. He was then forcibly made a monk and murdered in 1147.

The peculiarities of this iconographic type are the bust-length representation of the Mother of God, the high cap under her *maphorion*, and the covering of her right hand. The left arm of Christ is also invisible.

The central figure of the Mother of God is surrounded by half-length figures of saints on the borders, painted on alternating yellow and blue grounds. The saints form a Deesis. In the centre of the upper border is the Mandylion, an image of Christ also known as 'Not Made with Hands,' since the original was believed to have been an imprint taken directly from his face. This iconographic type was wide-

spread in northern Russia, and was often placed in the center of the Deesis or at the top of the iconostasis. Next to it on both sides we find the heavenly host, represented by the seraphim and cherubim, and the Archangel Michael. Next are the prophets, John the Baptist, and Elijah. Among the Church Fathers are Pope Clement, St. Nicholas of Myra in Lycia, and John the Merciful. Among the clergy is St. Varlaam, particularly venerated in Novgorod for founding the nearby Monastery of Khutyn in the late 12th century. Also included are martyrs and holy women: St. Menas, St. Niketas, St. Paraskeve, St. Anastasia, St. Catherine, and St. Barbara. The choice of saints was probably made by the client who commissioned the icon, following the names of his family members. All these saints were popular in Novgorod and its northern territories. At the same time they are all represented in supplication to the Mother of God, whose cult was more influential in Moscow than in Novgorod.

Varlaam of Khutyn was revered in Novgorod as a model of the monastic life, and was believed capable of sending good crops and fine weather. From the second half of the 15th century he was venerated throughout Russia. St. Clement was linked with the idea of baptism and con-

70 cm x 48 cm x 2.8 cm
Panel of two boards
with two inset struts.

Inventory No.
ДРЖ 2783

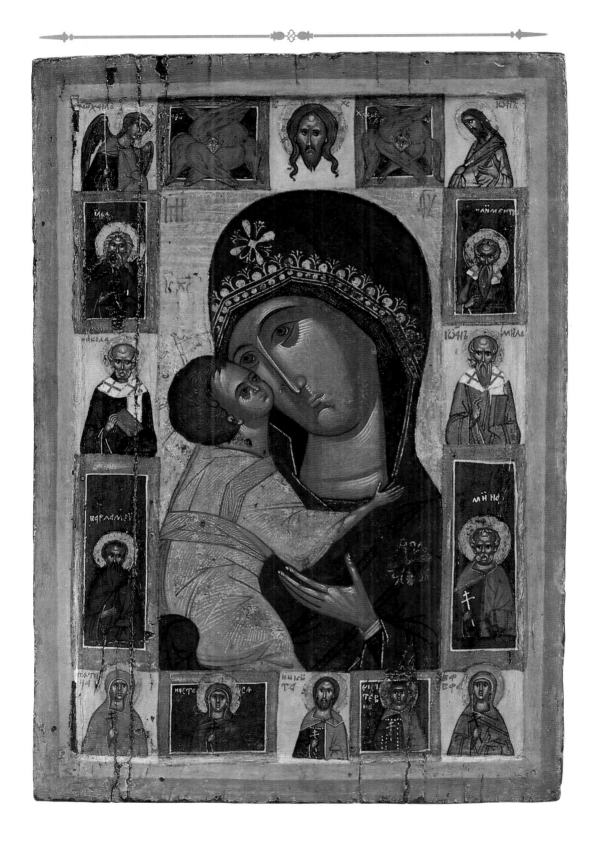

version; he was also considered the protector of sailors and travelers in general. The patriarch John of Alexandria was a symbol of mercy. The holy women were much venerated in Novgorod, especially in the 12th and 13th centuries. The female martyrs represented here were often found in the icons of Novgorod and Pskov, especially St. Paraskeve and St. Anastasia, who had special abilities as healers and cared for women in labor. They were also associated with the Passion and the Resurrection. The warrior saints Menas and Niketas were praised for their resolute faith and for the protection they offered from demons.

Scholars have recognised Novgorodian features in the present icon and attribute it to the local northern style of Vologda. Its origin largely explains its iconographic type. It was found in the area of Kargopol, a northern town at the crossroads of trade routes which emerged in the 14th century on Novgorodian territory. By the mid-15th century, when the town was first mentioned in the chronicles, the lands were already under Muscovite control. The region was then ruled by the archbishop of Novgorod, and the town was twice placed within the diocese of Vologda (1571-84 and 1613-17). The region had also felt the cultural influence of Rostov.

The *IGOREV MOTHER OF GOD* is comparable to many northern works including *ST. NICHOLAS WITH SELECTED SAINTS*, late 15th century (Vladimir-Suzdal Museum); *ST. NICHOLAS WITH SELECTED SAINTS*, first half of 16th century, from the village of Esino on Lake Onega (Russian Museum); *THE SMOLENSK MOTHER OF GOD WITH SELECTED SAINTS*, 1565 (Russian Museum); *THE DEPOSITION OF THE ROBE OF THE MOTHER OF GOD WITH SELECTED SAINTS*, mid-16th century (Vologda Museum).

They have a common principle of composition: the central subject is surrounded on four sides by small half-length figures of selected saints forming a Deesis. The central figures are only of bust-length, but nevertheless of large size, occupying nearly all the center of the panel and leaving only small areas of the ground and narrow bands for halos. The faces are executed over dense brown underpaint with darkish ocher in indistinct strokes and small bright highlights in parallel lines. A similarity can also be seen in the selection of saints and their iconography. While the central figures are suggestive of central Russia, particularly Rostov, the side figures are closer to Novgorod. The cultural processes developed unevenly in different regions of the North and they have not been studied thoroughly. Attributions for these works must therefore remain conjectural.

Irina Soloveva

ST. NICHOLAS WITH SCENES FROM HIS LIFE

Vologda
Late 15th - early 16th century

Half-length portrayals of St. Nicholas surrounded by scenes from his *Life* were a popular subject. This example is one of a group of related icons painted in the second half of the 15th century and first half of the 16th century. They have a similar number of border scenes with a similar choice of subject matter. The existence of such related groups of icons, produced in Novgorod or in Moscow, suggests that painters in different artistic centers had similar sets of patterns from which to work. It is difficult, however, to find two icons with absolutely identical life cycles; the scenes might follow a different order, or have some peculiarities in the treatment of subject and composition.

The icon was acquired by the Russian Museum in 1956 from the Kirillov Museum. It is said to have come from the Convent of the Resurrection at Goritsk, on the Sheksna River near the Monastery of St. Cyril.

It was cleaned at the Russian Museum in 1956-57 by N. V. Pertsev. There are a number of signs of restoration on the surface of the icon, especially the image of the saint and the scenes on the borders at the bottom and right side of the icon. The sides of the panel have been cut, and the surface indicates an earlier revetment.

The border scenes are as follows:

1 The Birth of St. Nicholas and the Miracle in the Bath.
2 The Baptism of St. Nicholas.
3 The infant Nicholas refuses to drink milk on days designated for fasting.
4 St. Nicholas is brought to school.
5 St. Nicholas is made deacon.
6 St. Nicholas is consecrated bishop.
7 The Miracle of the Ship.
8 St. Nicholas appears to the emperor Constantine in a dream.
9 St. Nicholas appears to three men in prison.
10 St. Nicholas saves three just men from execution.
11 St. Nicholas buys a carpet from an old man.
12 St. Nicholas gives the carpet back to the old man's wife.

Scenes 11 and 12 illustrate the Miracle of the Carpet, one of the so-called 'Russian miracles' invented in Russia during the 11th century. The other two are the Child of Kiev and the Epiphany. The miracle describes how an old man of Constantinople, whose name was Nicholas, wished to honour his patron saint by selling his finest carpet, and giving the proceeds to charity. St. Nicholas appeared in disguise at the market, and having bought the carpet, he returned it to the old man's wife, telling her that her husband had changed his mind about selling it.

13 The saint rescues Demetris.
14 St. Nicholas restores Basil, the son of Agrig, to his parents.
15 The Dormition of St. Nicholas.
16 The transfer of the remains of St. Nicholas from Myra in Lycia to Bari in Italy around 1087.

133.5 cm x 87.5 cm x 3 cm
Panel of three boards with two inset struts.

Inventory No.
ДРЖ 3086

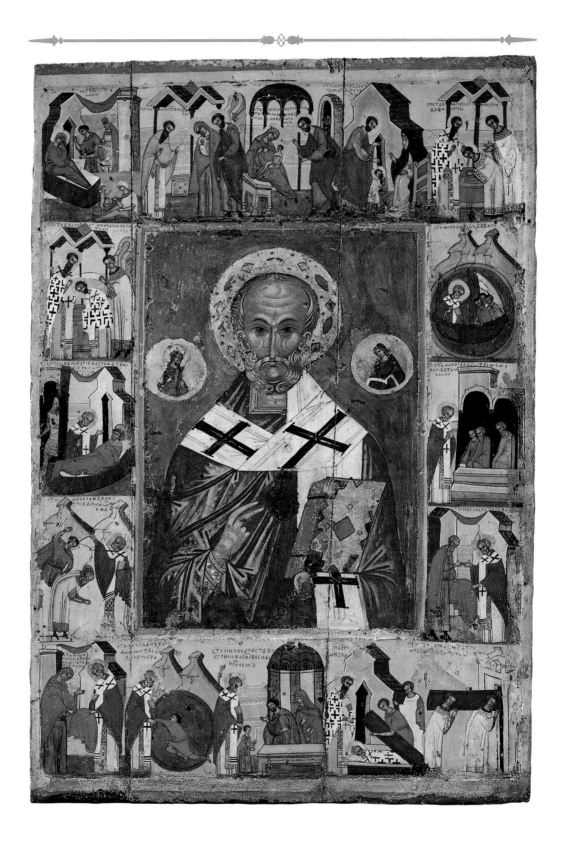

The present icon has the stylistic features of a Vologda icon, marked by a linear approach to the development of forms. The central image is treated in a different manner to the surrounding scenes from the life of the saint. The face of the saint is modelled in ocher over brown underpaint. The outlines are blurred and the underpaint is left exposed to suggest shadow. The features are carefully drawn with thin brown lines. Framing the face are carefully painted symmetrical strands of hair and beard. The gilded halo is in relief and set with large, bright gems, a similar technique being used on the Gospel cover held by the saint. The slender figure of the saint is in proportion with the elongated dimensions of the central field. He is clad in a red and brown *phelonion* with bright blue highlights reflecting the blue background.

The border scenes are painted in a more flat and simplified manner. The outline of hills, buildings, and figures are all traced with thick brown lines standing out against the pale-yellow ground. Within the outlines, unmixed local tones are applied without any attempt at light-and-shade modeling of faces or garments. The compositions are flat, and the smooth surfaces of buildings and rocky hills have no depth. The colors employed are characteristic of Vologda, relying on combinations of the prevalent intensive blue and pale-yellow, brown, pink, and red, along with white, and whitened shades of the principal colors.

Iconographic parallels can be drawn with the icon St. Nicholas with Scenes From His Life which was painted in the early 16th century at Velikii Ustiug. They have similar compositions in the border scenes, including such a rare detail as the bare breast of Nona in the suckling scene.

The simplified style and uncomplicated drawing, the use of local tones in the coloring, and the archaic treatment of the architecture and the rocky hills indicate a northern provincial origin for the icon. That being said, the absence of a rigid separation of scenes in the upper and lower borders, the elongated proportions of the figures, the laconic architectural forms, and the light palette suggest that the artist was familiar with the painterly traditions of central Russia, and indicate that the icon was produced at the time when Dionysii was active. That we should find a Vologda icon in the region of Beloozersk is not surprising, given that the vast region of Vologda lay just across the White Lake. Moscow was also a powerful influence in the area during the 15th and 16th centuries.

Irina Soloveva

ST. DEMETRIOS OF THESSALONIKE

Pskov
Late second quarter of the 15th century

St. Demetrios was venerated in Russia as the patron of the grand princes. The Riurikid dynasty christened sons after him, and built churches and monasteries consecrated to him, including the cathedral in Vladimir and the monastery in Kiev which has become known as St. Michael of the Golden Roofs. A wooden panel from the tomb of the saint in Thessalonike was brought to Vladimir in 1197, and

was used to make an icon. This is one of the earliest surviving icons of St. Demetrios, and is preserved in the Museums of the Moscow Kremlin. The first stone church in Moscow was dedicated to St. Demetrios, and was replaced by the Cathedral of the Dormition in 1326.

The present icon has suffered some damage, with losses of paint down to the panel or canvas on the lower border, and insertions of new gesso in the background, the borders, and the halo of the saint. There are abrasions to the original painting, particularly in the hair and the right sleeve, and traces of later repainting and oil over the entire surface. During restoration, the background, halo, and inscriptions have been painted over. The black ornament in the halo is also of a later date. The vermillion inscriptions in the background are of an early date, but not original. The icon was cleaned at the Central Restoration Workshop in 1926-27.

It comes from the Church of St. Barbara in Pskov. The wooden church in the Petrov quarter was originally built in the Convent of St. Barbara in 1688 to replace an older church. In the disastrous fire of 1561 the convent had burned down.

The icon of St. Demetrios described here was mentioned by N. F. Okulich-Kazarin early in this century. Among the local icons of the Church of St. Barbara he named 'the image of the myrrh-shedding Demetrios in an antique silver case.' The dimensions he gave are the same as quoted here.

The Russian Museum acquired the icon through Antikvariat in 1933 following the exhibition tour of 1929-32. Prior to 1926 the icon was at the Pskov Museum, and in 1926 it was handed over to the Central Restoration Workshop.

St. Demetrios of Thessalonike is among the most venerated Byzantine saints. His *Life* tells us that he ruled Thessalonike in the late 3rd and early 4th centuries. He suffered under the emperors Diocletian and Maximian for his Christian faith. Under Constantine, a church was built over his remains, which were exuding myrrh (hence his appellation 'the myrrh-shedding'). The saint was deemed the patron and defender of Thessalonike, and an army of pagan Slavs attacking the city was said to be petrified by the vision of a radiant young warrior walking upon the city walls.

In Russia, St. Demetrios always stood for martial valor, for the defence of motherland. This aspect of his cult was particularly emphasized in the late 14th century after the victory over the Mongol Horde. The chronicle of the battle of Kulikov men-

88 cm x 67 cm x 3.5 cm
Panel of two boards
with two inset struts.

Inventory No.
ДРЖ 2729

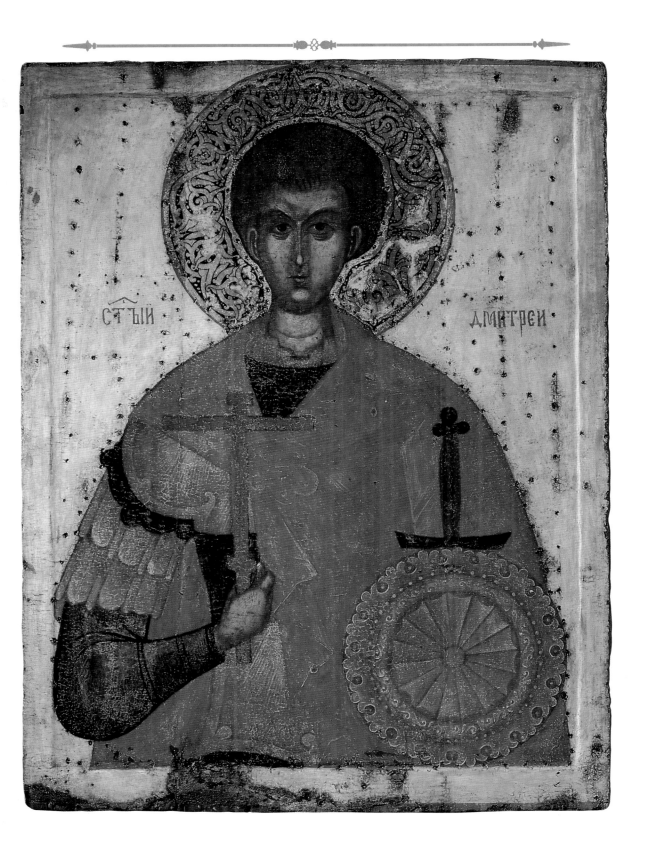

СТЫИ ДМИТРЕИ

tions the martyr and other saints helping the Russian army on the battlefield. The idea of St. Demetrios fighting the Mongols is reflected in icons depicting him striking the Mongol khan with his spear. Prince Dmitrii Donskoi greatly venerated his patron saint, and shortly before the battle of Kulikov, he moved the famous icon painted on the panel from the tomb to Moscow from Vladimir, and installed it in a special chapel in the Cathedral of the Dormition. After the victory at Kulikov, the Saturday before the saint's day was dedicated to the memory of those who had given their lives. The day came to be known as 'Demetrios' Saturday,' and churches built in cemeteries were often dedicated to him.

The image of the Christian martyr, of a warrior defending the walls of his city in times of danger, was particularly dear to the people of Pskov. Living under constant threat of attack by the Livonian knights, or by Lithuanian or Polish armies, they chose a patron saint to protect them. They built a stone church of St. Demetrios within the city walls as early as the 12th century, and brought his icons out to the ramparts when they were besieged. Near the city was the Monastery of St. Demetrios with a church dedicated to him in the cemetery. Memorial services for the fallen were also central in the foundation of the Convent of St. Barbara where the present icon was placed.

Representations of St. Demetrios of Thessalonike were widespread in the art of the Byzantine world. Most often he was linked with St. George in Deesis tiers or among selected saints. There were several iconographic types: St. Demetrios as a warrior clad in armor and carrying weapons, on horseback striking the enemy, or as a martyr in *himation* and *chiton* holding a cross in his hand.

The iconographic type of the present icon has no close analogies in Russian art. It was derived most probably from the Byzantine half-length representations of warrior saints. However, the Pskov icon accentuates the martyrdom of the saint, the cross in his hand being especially large. At the same time, he is depicted as a warrior in armour with a sword and a shield.

In the first half of the 15th century, new qualities appeared in representations of holy warriors in Byzantine and Russian art: a sense of meditation and self-absorption. The figures and the faces of the warriors become more delicate. Compared to this, the image of St. Demetrios from Pskov resembles a mighty fortress, a pillar of faith inspiring confidence and hope. His bright vermilion cloak symbolizes suffering, martyrdom, and death. The large cross resembles his sword, which is partly concealed behind his shield. The sword is lowered and hidden behind the shield to show that the saint prevails through the power of the cross, the spiritual sword. The result is a symbolic parallel between the warrior as martyr and as protector.

The refined and aristocratic image has much in common with many works of the early 15th century, while a certain psychological tension in the face recalls Pskovian paintings of the previous century. The Pskovian origin of the icon is beyond doubt, and is borne out by the characteristic manner of painting the face with dark grayish-olive underpaint, followed by whitened ocher, without rouge. The color scheme of cinnabar, green, and mineral pigments, and the gold *assist* in the robes are also characteristic of Pskov. The information on the provenance of the icon confirms the attribution.

Although the dating is controversial, Iu. N. Dmitriev assigned the icon to the 14th century, while E. S. Smirnova dated it to the first half of the 15th century, V.N. Lazarev to the mid-15th century, and N.B. Laurina to the second half of the 15th century.

Irina Shalina

THE DESCENT INTO HELL (*ANASTASIS*) WITH SAINTS

Pskov
Mid-16th century

The icon represents the most important event in the Christian history of salvation, the Resurrection of Christ. Its subject matter, however, is not the Resurrection itself but the Descent of Christ into Hell (Greek *Anastasis*), an event believed to have taken place after the Crucifixion but before the Resurrection. Christ is shown rescuing Adam and Eve from hell, the gates of which lie broken beneath his feet. The

theological meaning of the icon is that through the sacrifice of Christ the righteous are redeemed. The lower border of the icon contains a row of standing saints.

The *Anastasis* is mentioned in various biblical and patristic texts from the second century onward, including the works of St. John Chrysostom, St. Gregory the Theologian, St. Ephrem the Syrian, and St. John of Damascus. The most important source is the apocryphal *Gospel of Nikodemos*, which includes details relating to the life of Christ but not contained in the canonical Gospels. Many Slavonic manuscripts of the text survive, the earliest of which can be dated to the 13th century. Although the episode is not mentioned by the four canonical evangelists, it is nevertheless prefigured by a number of passages in the Old Testament: Daniel 12: 1–3; Isaiah 9:3; Psalms 16: 10-23; 7: 9; 82: 8, 107: 13–20. There are also several references in the New Testament, e.g. Acts 2: 23–28; I Peter 3: 18–19; II Peter 2. 4; I Thessalonians 4:1 3–18; Hebrews 2: 4; Ephesians 4: 8–10; Romans 10: 7; Revelation 20: 1–3, 10–15. Two further texts, the *Oration on the Burial of Jesus Christ* by Epiphanios of Cyprus and the *Oration on the Descent into Hell of John the Baptist* by Eusebios of Alexandria, are based on the apocryphal Gospel.

The iconography of the *Anastasis* was formed between the 6th and 10th centuries, and was originally most common in the eastern regions of the Byzantine empire: Syria, Cappadocia, and Mt. Sinai. Further developments occurred with the tradition of illustrating the Psalms. The earliest example of the theme in medieval Russian painting is an 11th century fresco in the Cathedral of St. Sophia in Kiev. It also appeared at Pskov in the Church of the Savior on the Mirozha of 1156.

Although the basic iconography of the *Anastasis* was fully established long before the 14-15th century, it was always subject to regional variations, of which the Pskovian tradition provides many fine examples. The earliest surviving Pskovian *Anastasis* is thought to be the 14th century icon from the collection of N.P. Likhachev. A 15th century icon can be seen in the Pskov Museum and three examples from the 16th century exist, among them a four-part icon from the collection of the Vorobev family in Moscow, another example from Ostrov, and a late 16th century example now in the Tretiakov Gallery. Each of these icons is based on the traditional prototype, with minor variations such as the number of participants, the treatment of hell, and the additional figures in the lower border. This particular iconographic type is more associated with individual icons of the *Anastasis*

157 cm x 92 cm x 3.8 cm
Panel of three boards
with two inset struts.

Inventory No.
ДРЖ 3140

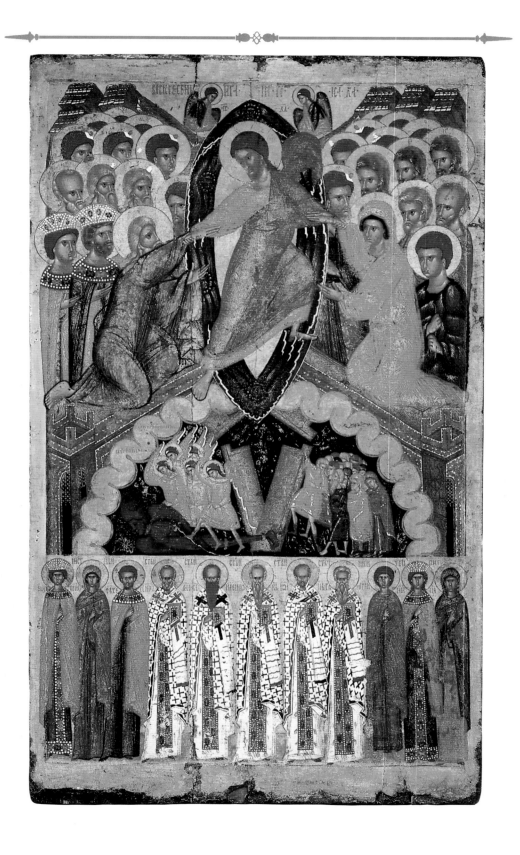

than with panels from the festival tier of an iconostasis.

The meaning of the icon revolves around the image of Christ, whose *chiton* and *himation* are painted in different shades of red. This is the color of martyrdom and redemptive sacrifice, and Byzantine emperors used to wear it at Easter. The mandorla against which he is placed is typically Pskovian, differing from the more usual type which is constructed of many dark rings and radiates golden light. Its sharply pointed form echoes the overall shape of the icon. This type of mandorla does appear in Byzantine and Russian painting, and examples include a mosaic in the Church of the Twelve Apostles in Thessalonike dated 1312, a 14th century fresco in the Chora, and a 15th century fresco at the Monastery of St. Ferapont. However, the translucent center of this icon is unique to Pskovian art, and this distinctive feature appears in each of the Pskovian icons of the *Anastasis* cited above. The absence of golden rays is also typical of Pskov. The monochrome figures in the dark ring of the mandorla are cherubim, after the seraphim the highest order of angels in the celestial hierarchy.

Christ is flanked by the kneeling figures of Adam and Eve, whom he led to freedom and eternal life from the black pit of hell. An unusual feature here is the fact the Christ holds the hand of both figures; it is more common for him to be shown holding the hand of Adam in one hand and a scroll in the other. Although the present iconography does have precedents in Byzantine art, such as the 14th century Chora and the Church of the Mother of God in Studenica from 1314, this feature is particularly associated with Pskov and is present in all the Pskovian icons of the *Anastasis* mentioned here.

According to the *Gospel of Nikodemos*, when Christ took Adam by the hand, Adam thanked him with the words: 'I will extol thee, O Lord, for thou hast drawn me up from Sheol . . .' (Psalms 29: 1–5). This moment is the culmination of the mission of Christ in the world, the redemption of the first man and therefore of humanity as a whole by God Incarnate through his own death. The theological message is that if the first Adam doomed humanity to death by falling into sin, the new Adam will purify humanity of sin and grant eternal life: 'The old Adam is put away and the new Adam is being accomplished' (*Easter Synaxarion*).

The earthy dark green mantle of Adam contrasts with that of Christ. The color green is symbolic of hope, salvation, and renewal. The fine web of gold hatching (*assist*) is a reflection of Adam's divine destiny. The figure of Eve is represented opposite Adam. Just as the sins of the old Adam were redeemed by the complementary figure of the new Adam, so Eve, as perpetrator of the fall, was associated with the image of the Mother of God, the vehicle of redemption.

Christ is shown standing triumphantly over the broken gates of hell. Also visible are broken keys and locks, the evidence of his victory; these details were included in the iconography of the *Anastasis* from the 11th century. Hell is depicted as a walled town with a dark abyss at its center. The vision of hell as a stronghold with doors is familiar from the Old Testament: Job 17:13, 38:17; Psalms 107:16. This image is repeated in a traditional Russian incantation against the 12 sins and 12 rash acts: 'I adjure you with the seven doors of earth . . . with the seven bolts of the earth.'

Also surrounding the abyss is a wavy motif probably related to the 'worm that shall not die' which devours the bodies of sinners in hell (Isaiah 66: 24; Mark 9: 48). The image of the snake in hell was traditionally associated with the serpent in paradise, and the golden color in the present icon serves to associate it with another realm.

In ancient Russian cosmology an important place was given to the fiery river which had its source at the place where Satan fell. At the command of God, this river fell through the Earth to its nether-

most parts where it is destined to flow forever. This is the place of death. To the right of the doors can been seen a group of the righteous, led by an old man who points to Christ. This group is a characteristic feature of Pskovian icons of the *Anastasis*, and in the present icon it closely resembles an earlier icon of the same subject in the Pskov Museum. The composition illustrates a detail included in the *Gospel of Nikodemos*: 'Many holy people said to the prince of hell: "Open your gates to let the King of Glory come in."' To the left of the gates, Satan is taken captive by angels. According to Revelation, an angel 'seized Satan, bound him for a thousand years and threw him into a pit' (20: 1–13). In the *Gospel of Nikodemos*, Christ is said to have taken Satan and to have handed him over to the angels, saying: 'Bind his hands, feet, neck, and mouth with the fetters of iron . . . take him and hold him tightly until my Second Coming.' The detail of taking Satan captive instead of trampling on him was represented in Byzantine painting from the 11th century. The triumph of Christ over death is also symbolized by the penetration of light into darkness. The gold of his garment extends throughout the icon, representing his influence in all parts of the world.

The impact of the spectacle is reflected in the faces of the Old Testament kings, prophets, and righteous people that have gathered around Christ. The large number of figures grouped together in this way is typical of Pskov. Also typical of Pskov is the fact that all the figures have halos, an attribute usually reserved for David, Solomon, and John the Baptist, whose face can be seen in the present icon immediately in front of Adam. The *Gospel of Nikodemos* records in detail the content of a sermon given by John the Baptist in hell; certainly in this icon he is turned toward the other righteous people as if addressing them. Abel is also represented, wearing an animal skin, as the first martyr for the truth (Matthew 23: 35).

The group of saints at the bottom of the icon is typical of Pskovian icons. Whereas most icons represent a single scene or group of saints, the two-part composition of the present icon is similar to the kind of iconographic programme more commonly found in frescoes. One of the sanctuaries in the Chora, for instance, has the hierarchs St. Basil, St. John Chrysostom, and St. Gregory the Theologian standing in the apex beneath.

The moral rectitude and fellowship of the saints is fittingly conveyed through their representation here as an impregnable spiritual wall. In liturgical texts the saints are variously described as 'the unshakeable foundation that Christ has made for his church,' 'chosen vessels, pillars, foundations of the church,' and so on. Five Holy Fathers stand at the center of the group, distinguished by their clerical vestments. The two flanking groups of martyrs represent a different aspect of the church, the extension of Christian sacrifice into the world. Their significance in the context of the Descent into Hell is to demonstrate that self-sacrifice conquers death.

The following saints are depicted, from left to right: the martyrs St. Catherine and St. Anastasia, the martyr St. Photios, St. Nicholas, St. Basil the Great, St. John the Merciful, St. John Chrysostom, St. Gregory the Theologian, the martyr St. Niketas, and the martyrs St. Barbara and St. Paraskeve.

According to legend, St. Catherine was the daughter of the emperor Constans and was martyred in the time of Maxentius (306-12). She is well-known for her 'mystical marriage' to Christ, which was commonly represented in Renaissance painting, and for her great learning. Her special attributes are a crown denoting her royal background, a cross, a palm frond, and the instruments of her martyrdom, a sword and wheel. Another Pskovian festival icon in which St. Catherine features as a pendant figure is in the collection of P.D.

Korin; it belongs to the Deesis row of an iconostasis and can be dated to the 15th century. The festival of St. Catherine is November 24.

The name *Anastasia* means 'Resurrection' and St. Anastasia is commonly associated with this event. She is sometimes represented next to the Last Judgment, a theme closely related to the Descent into Hell, as in the Church of the Savior in Nereditsa of 1198. Here the saint is shown with a martyr's cross. Her festival is October 29.

It is unclear which Photios is depicted, since representations of any of the four possibilities are extremely rare in icons: Photios of Constantinople, Photios of Nikomedia, a second Photios of Constantinople, or Photios of Thessaly.

In Russian tradition, St. Nicholas is sometimes so highly revered that he is believed to hold the keys to the Heavenly Kingdom and is invoked as a conqueror of demons. The significance of the saint in relation to the Resurrection of Christ is indicated in two Pskovian icons of the *Anastasis* in which Christ is replaced by St. Nicholas at the center of the Deesis group in the upper border (Pskov Museum, Russian Museum).

St. Basil the Great (330-79), St. Gregory the Theologian (329-89), and St. John Chrysostom (347-407) are known throughout the Orthodox world as the 'Three Holy Hierarchs,' the pillars of Orthodox theology. St. Basil was the Archbishop of Caesarea in Cappadocia (370-79) and is revered as the author of the liturgy; his festival is on January 1. St. Gregory the Theologian was Patriarch of Constantinople (379-89) and was also a prolific author; his festival is January 25. St. John Chrysostom was Patriarch of Constantinople (397-404) and so eloquent a preacher that he was given the epithet 'golden-mouthed'; his festivals are January 27 and November 13. In the 11th century, there were debates as to which of the three saints should be held in the highest honor,

and in 1084 a common festival, distinct from their individual festivals, was established on January 30. Although individual representations of the saints are known from the 11th century, the specific iconography of the Three Holy Hierarchs evolved later.

The popularity of the three saints in Pskov may relate to their defense of the Holy Trinity, which was particularly revered in Pskov. Not only do they form a trinity in themselves, but they are remembered as having defended the true trinitarian nature of God against the heretic Arius at the Council of Nicaea, and this naturally led to their being invoked in defense of Orthodoxy at all periods of Russian history. The figures are in keeping with the iconographic peculiarities of early Pskovian frescoes and icons in which they hold closed Gospel books. In Novgorodian icons, they are shown blessing the people while holding unfurled scrolls of their works.

Between the figures of St. Basil and St. John Chrysostom stands a further elder of the church, inscribed *St. John*. Some iconographic details suggest that this is St. John the Merciful, a patriarch of Constantinople in the 7th century. He was remembered for combating the Monophysites, who opposed the definition of the dual nature of Christ adopted at the Council of Chalcedon in 451. St. John the Merciful is traditionally placed among the Fathers of the Church. He was especially popular in Novgorod, where a church was dedicated to him. His festival is November 12. Many icons of the saint in the northern style survive, but while there was also a church dedicated to him in Pskov, few icons from this region depict him. The only other known image of the saint from Pskov appears in the borders of an early 16th century icon of the Mother of God ('IN THEE REJOICETH') in the Russian Museum. He may have been included in the present icon either because of his defence of the faith or because of his writing on the

departure of the soul, which formed the basis of the *Oration on the Departure of the Soul and its Ascent to Heaven after Death.* This was included in the church calendar for October 29, the festival of St. Anastasia, who is directly associated with the *Anastasis.*

The martyr St. Niketas was, by descent, a Goth. After baptism he dedicated himself to spreading Christianity in the region of the Danube. According to tradition he was involved in the struggle against the Arian heresy, and was executed for his faith in 379. In Russian legend this image of St. Niketas is combined with another image based on the text of his *Life* in which he is especially esteemed for conquering demons. His very name echoes the word *Nika*, which means 'victory.' Liturgical texts confirm this connection by describing St. Niketas as 'the one named Victorious.' Images of the saint were sometimes worn under clothes in the manner in which people wore a baptismal cross or amulet. The *Life* of St. Niketas describes how he used the cross to overcome demons, and his festival (September 15) is celebrated the day after the Festival of the Exaltation of the Cross. The proximity of the two festivals, along with the various associations of the Cross with victory, has resulted in a number of icons in which St. Niketas is shown crucified on the cross with Christ, or sometimes instead of Christ.

St. Barbara was a martyr of noble birth, executed under the Emperor Galerius in 306. Her cult became popular in Constantinople during the 9th-10th century, and in Russia from the 12th century, when her relics were taken to Kiev. A church consecrated in her name existed in Pskov from the earliest times, and her popularity there may be associated with her enthusiasm for the Trinity. The earliest known representation of St. Barbara in Russia is in the 12th century Church of the Savior in Nereditsa, but she did not become popular in Pskovian icons until the end of the 15th century. Examples include the works of the so-called Master of St. Barbara. Her reputation in Russia consisted in her ability to save people from the dangers of sudden death, thus conferring the opportunity to repent and take final communion.

St. Paraskeve *Piatnitsa* is especially associated with the events of the Passion. Her epithet means 'Friday,' the day on which she is said to have been born, and she is regarded as a personification of the events of Good Friday. In a well-known 15th century Pskovian icon of four saints, St. Paraskeve is shown together with the three Holy Hierarchs. She is interpreted in this context as being the symbol of the eucharistic sacrifice which was described by St. Gregory, and to which John Chrysostom and Basil dedicated their liturgies. Her name also means preparation, a reference to the fact that the Crucifixion was the necessary 'preparation' for the redemptive event of the Resurrection.

The dating and attribution of the icon involves a number of fascinating questions. Stylistically, it epitomises the Pskovian school. A bold and firm style of drawing is combined with a lightness of touch that imbues the figures of Christ and the angels with a real sense of motion. The colors are typically Pskovian: blood-red cinnabar, mellow brownish ocher, and green. Also characteristic are the highlights, applied in dense brush strokes, and the deep triangular eye sockets.

Comparison with earlier Pskovian icon painting reveals significant changes. Most noticeable are the more geometrical composition of the icon, the more voluminous modeling of the faces, and the drier and more schematic treatment of the highlights on the faces and the folds of drapery. The *assist* has become a thin web of gold, veiling the form. The overall impression is that a more measured approach is replacing the impulsiveness and inner emotional tension of the older style.

An archaic quality in the style of the icon has led some specialists to assign an early date. M.V. Alpatov attributes it to the 15th century, while N.G. Porfiridov, E.

S. Smirnova, and M.M. Krasilin date it to the beginning of the 16th century. It seems likely, however, that the icon is a replica of an earlier prototype. The copying of earlier icons was a practice not at all uncommon in the monasteries of the 16th century. The elongated figures of the saints with their smoothly outlined silhouettes are more reminiscent of the middle of the 16th century, as are the dazzling vestments of the Holy Hierarchs and the alternation of red and brown crosses on the *phelonia* and *omophoria*, each richly decorated with gems and pearls.

The icon is painted on a pine panel. It consists of three parts, roughly hewn and fastened together with two struts. The icon has narrow borders and a characteristic *kovcheg*. The surface is slightly flaked, the canvas is coarse-grained, and the gesso is carefully levelled and polished.

There is some retouching on the *himation* of Christ, on the halos of the prophets and in the lower border of the icon. Various areas of the original paintwork are lost and have been replaced, notably in the garments of Christ, Adam, and Eve. The icon was cleaned of overpaint at the Russian Museum in 1958-60 by N.V. Pertsev and I.V. Iarygina. The original paint has been covered by two later layers, the uppermost having been applied at the turn of this century.

The icon was discovered in 1958 at the Cathedral the Holy Trinity of Ostrov in the Pskov region and was taken to St. Petersburg by the expedition of the Russian Museum. The Cathedral of the Holy Trinity was built in 1790 on the order of the empress Catherine II on the bank of the Velokaia River. According to the inventory reports, the icons and the iconostasis in the church were painted by local painters at the end of the 18th or beginning of the 19th century. It is documented, however, that in the middle of the 20th century there were three large local icons in the church dating from the 16th century. In all likelihood, these may have been the icons brought there from the Church of St. Nicholas, another church in Ostrov, after that church was suppressed in the 1930s. An inventory report covering the icons of the iconostasis, mentions an ancient icon THE RESURRECTION OF CHRIST, but as it does not specify the size or iconography, it would be difficult to identify it with our icon.

On the back of the panel, two inscriptions have been added in green oil paint: *The Descent into Hell* and *No. 508–35*. Such marks appear on a number of Pskovian icons because they were used by the staff at the Pskov Art Museum when they prepared an inventory of the functioning churches in the town in 1935. Just as the 16th century icon of the SMOLENSK MOTHER OF GOD WITH SELECTED SAINTS (Russian Museum) was originally the property of the Church of St. Varlaam of Khutyn in Pskov but came to appear in the iconostasis of the Ostrov Cathedral of the Trinity, the present icon of the *Anastasis* may originally have belonged to a church in Pskov.

Irina Shalina

THE NATIVITY OF THE MOTHER OF GOD

Tver
Early 16th century

The icon depicts one of the 12 great festivals, THE NATIVITY OF THE MOTHER OF GOD, which is celebrated on September 8. The Orthodox Church marks it as a day of universal joy for it signifies the renewal of human life which took place at the juncture of the Old and New Testaments. The festival was established in the 5th century, and the canons which celebrate it were composed during in the

8th century by St. John of Damascus and St. Andrew of Crete. According to the latter, the Nativity of the Mother of God brings the era of the Law and of 'proto-history' to an end, opening the door to Grace and Truth.

The main source for the iconography of the Nativity of the Mother of God is the apocryphal *Protoevangelion of St. James*, composed in the 2nd or 3rd century.

The subject was well known in Byzantium from the 11th century, and the basic elements of the iconography were established by the end of the 13th century. In Russia, the theme was particularly popular in 'prayer-icons,' which were traditionally brought to church to pray for the birth of a child or to give thanks for the birth of a daughter. There are a significant number of churches dedicated to this festival, one of the most ancient erected during the 12th century in the Monastery of St. Anthony in Novgorod.

The composition of the Nativity of the Mother of God has taken its place as part of the festival tier of the Russian iconostasis since the 15th century. An icon of this theme from the iconostasis of the Cathedral of the Dormition in Vladimir attributed to 1408, is perhaps the earliest example. Another version from the Cathedral of the Dormition in the Monastery of St.

Cyril of the White Lake dates from the end of the 15th century.

From the size and proportions of the icon it is clear that it was made to take its place in the festival tier of an iconostasis, although the church in which it was originally placed remains unknown. The icon depicts Anna, the mother of the Mother of God, her father Joachim, women with gifts for the new mother, and midwives preparing to wash the infant, as well as the scene at the cradle.

The horizontal lines of the walls in the composition of the icon divide it into three sections. In the lower sections there are scenes with the infant Mary and the visiting women with their gifts, while the upper section contains architecture and the figure of Joachim against a gold background. As was usual with Russian icons of this type, Anna is placed on the left. The diagonal line of the couch, with the figure of Anna echoing its outline, visually unites the two lower sections, while the vertical line of the building above her head connects her with Joachim. As a result, the couch becomes the center of the composition. Joachim is inclined toward his wife. His open palm signals his acceptance of the will of God and is similar to the gesture Mary makes toward the Archangel Gabriel in the Annunciation.

62.2 cm x 53.4 cm x 2.7 cm
Panel of two boards
with two inset struts.

Inventory No.
ДРЖ 1208

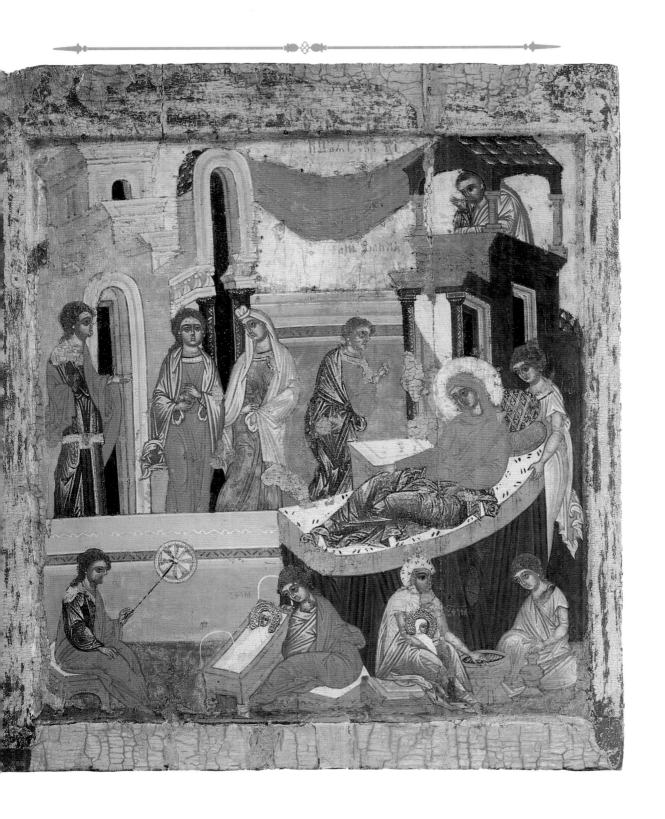

Women bearing gifts are approaching Anna, and it is possible that the scene echoes the Wise Men bringing gifts to the infant Christ. In Byzantine art this scene is usually depicted in terms of imperial court ceremony, and it would seem that this tradition laid the foundation for the iconography subsequently adopted in Russia, in which the mother and her baby are given vessels of precious metals or goblets filled with coins. This motive, invariably present in Russian icon painting over a period of several centuries, probably arose from the vision of the Mother of God as the Heavenly Queen. The washing of the baby, a scene which Byzantine art received from antiquity and which was often reproduced in the icons of the Nativity of the Mother of God, has a close analogy with icons of the Nativity of Christ. In the latter case, it is interpreted as a prototype for the baptism of Christ and of humanity as a whole. It seems that the same interpretation is possible here as well. The cradle, with the infant Mary in white swaddling cloths nearby, is also suggestive of the future Nativity of Christ. This idea is confirmed by liturgical texts for the feast of the Nativity of the Mother of God which variously repeat the message that the Mother of the Savior of the world, the source of the future purification of humanity, has come into the world. It is noteworthy that the Orthodox Church glorifies Mary above all as the Mother of God: in the words of St. John of Damascus, 'Rejoice, Joachim, the Son shall be born of the Daughter!' It is this theme which is reflected in the iconography.

The icon has long been known to specialists. When it was first published by N. P. Likhachev in 1906, he dated it to the 14th-15th century. The next and most recent publication of the icon is that of N. P. Kondakov, who attributed it to the early 15th century, suggesting that it was copied from a 14th century original. Kondakov emphasized the complex iconography and placed it among works of the Novgorod school. It should be mentioned, however,

that both scholars saw the icon under darkened varnish. As a result, the blue color which plays an active part in the color scheme of the icon and gives it a peculiar individuality has turned green, the color which from that time onwards was identified as typical of Novgorodian icons. The voluminous rendering of form is also close to that of Novgorodian painting; the three-dimensional character never violates the general flat structure of the composition but remains fully within the norms of the medieval understanding of pictorial space. The clear-cut chambers with columns and arched bays convey a notion of depth and space.

After restoration, the appearance of the icon changed so much that it became possible for V. K. Laurina of the Russian Museum to suggest that it had its origin in the painting of Tver. The results of her research are still unpublished but seem to be beyond doubt. The combination of red with blue is more characteristic of icons from Tver than from Novgorod, where a contrast between red and green was preferred. A similar composition on a wing of a triptych from Monastery of St. Cyril of the White Lake now in the Kirillov Museum and an image from a double-sided icon from the Cathedral of St. Sophia in Novgorod can serve as examples. The numerous folds in the garments underline the form and are of two types: the first is a dark linear drawing, while the second is strongly bleached, an effect achieved by mixing white with the pigment. The folds in the present icon are similar to those of Novgorodian painting, but are more complex and less dynamic, following the manner of Tver. However, what makes this icon markedly Tverian is the treatment of the faces: rounded shapes with sharply outlined features rest upon a contrasting ocher ground, which can be clearly seen around the eyes and near the temples and nose, and are highlighted with a vivid white on the more prominent areas, especially the forehead and cheeks. On top of these thin washes of white, a bright red-

dish hue has been laid, and some features have been further enlivened by a more dense and pure white pigment. This abundance of white in the treatment of the face is not found in Novgorodian icons, but it is typical of many examples of painting from Tver. The expression of the faces, with delicate and scrupulously outlined features, is also more characteristic of Tverian painters. The depiction of finger-joints as stylized circles, which was characteristic of Novgorodian style, is also not in evidence here. When one considers the general elements of the style of masters from Tver, it is important to remember that the painting of this center is still insufficiently studied, and that the examples available are scarce and fragmentary. It is therefore difficult to find close parallels to the icon under consideration. Nevertheless, it seems quite plausible to establish a connection between this icon and an analogous composition on a double-sided icon from Tver in the Andrei Rublev Museum, attributed to the first half of the 15th century. Both these icons include the features mentioned above and seem to come from a common source. However, the icon under discussion seems to be of a later date than the icon in the Rublev Museum, judging from the more complicated stylistic method and the more sophisticated iconography. A certain similarity with the present example is also evident in a detail from a pair of Royal Doors in the Russian Museum, also attributed to Tver. G. V.

Popov, the author of the most complete work dedicated to the icon-painting of Tver, identifies both Novgorodian and Tverian characteristics in this icon.

The closest iconographic parallel to the present icon is a late 15th or early 16th century *NATIVITY OF THE MOTHER OF GOD* from the Riazan Museum. Another comparison can be made with the central composition of an embroidered *NATIVITY OF THE MOTHER OF GOD*, donated to the Cathedral of the Resurrection in Volotsk by a local princess named Anna in 1510 and now in the Russian Museum. The composition of the embroidery is based on an example painted by Dionysii in 1502 above the portal of the Cathedral of the Nativity of the Mother of God in the Monastery of St. Ferapont. It seems probable that the composition of the present icon was executed under the influence of this famous fresco.

The painting on the border is substantially worn. There is a vertical fissure in the upper margin on the right and along the joint of the panels, and numerous insertions of gesso have been made at different times. The largest areas of renewed gesso are in the upper and lower borders and in the center. The inscriptions, executed in red, are poorly preserved.

The provenance of this icon is uncertain. It was acquired by the Russian Museum in 1913 from the collection of N.P. Likhachev.

Tatiana Vilinbakhova

THE PROPHET ZEPHANIAH

Andrei Rublev or Studio
Moscow
ca. 1408

The prophet Zephaniah is rarely represented in Russian iconography. He is the ninth of the 12 minor prophets of the Old Testament, the word 'minor' referring to the brevity of their books in comparison with 'major' prophets like Isaiah or Jeremiah. Little is known of his life; he was the son of Cushi, from a noble family, and he had quarters at the royal palace. He prophesied during the reign of

the Judaean king Josiah, between 624 and 611 BC. He followed in the footsteps of Isaiah, denouncing iniquity and warning of the Last Judgment on the one hand, and urging repentance and predicting the future liberation of Israel from sin and misery on the other. His prophecy of the deliverance of Israel (3: 8–15) was read by the Orthodox during the vespers on Good Saturday.

Icons of Zephaniah were sometimes placed in the prophets tiers of the iconostasis, as in the Cathedral of the Dormition in the Monastery of St. Cyril of the White Lake (1497), and in the Cathedral of the Nativity of the Mother of God at the Monastery of St. Ferapont (first half of the 16th century). Our icon from the Cathedral of the Dormition in Vladimir is the earliest surviving example from a prophets tier.

The figure is represented with a scroll in his right hand. He is inclined to the left, showing the bent back of an old man. The edge of his cloak is raised behind his back, but not in a sharp movement. The mass of his cloak is balanced by the gesture of the arm holding the scroll. His hands are in harmonious positions, the largest folds of his cloak are arranged to direct the gaze toward his head. The outline of his head is rhythmically repeated by that of his back

and the billowing edge of his cloak. The face of the prophet is marked with concentration, similar to St. Paul and the others included in the Deesis tier.

The position of their extended hands is also similar. Such a gesture, drawn from the Deesis, suggests that the prophets tier converged on an icon of the Mother of God, as was the case in most later prophets tiers. A close look at the technique of the painting reveals that the colors here are more dense than those of the Deesis. The ocher in the face is also more heavily applied and the contrasts of light and shade are sharper. The bold white streaks in the hair resemble the treatment of 16th century icons, as do the graphic folds of drapery. Both in the Deesis and in the present icon, the preliminary drawing scratched into the gesso has not been followed exactly by the painted outline. The greater part of the painted surface most probably belongs to an early overpainting, judging by its character from the first half of the 16th century. The original painting was largely rubbed off and survives only in small patches. The same is true of the icons of the Deesis which have also greatly suffered from repeated restorations. Nevertheless, for all the later distortions, these works have their basis in the excellent mastery of early 15th century artists.

157 cm x 149.5 cm x 3.5 cm
Panel of five boards
with two inset struts.

Inventory No.
ДРЖ 2136

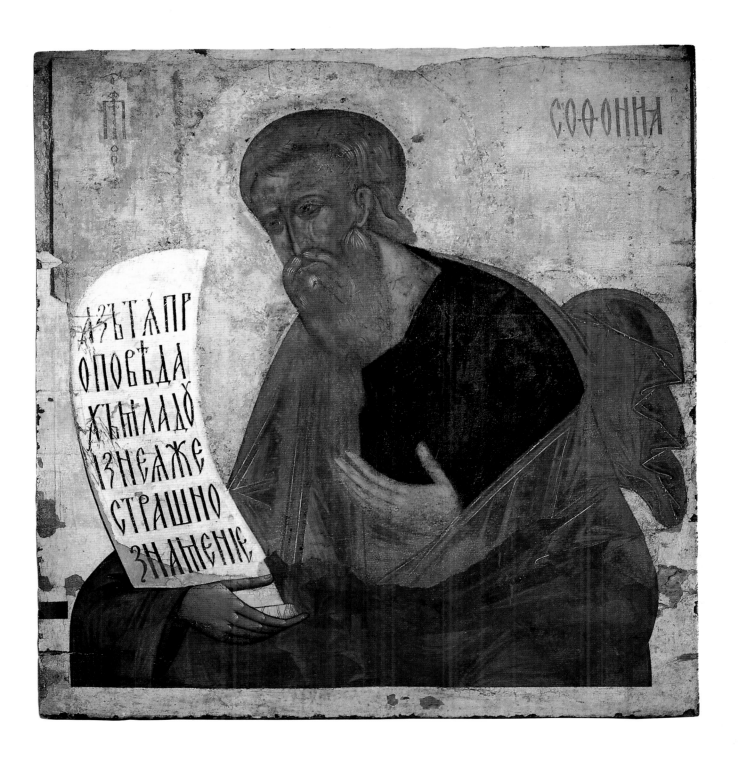

СОФОНИА

АЗЪ ТА ПР
ОПОВѢДА
ХЪ И ЛА ДО
ИЗ НЕ А ЖЕ
СТРАШНО
ЗНАМЕНІЕ

When creating the iconostasis, the masters took account of the vast proportions of the cathedral, where the icons must be clearly visible from a distance by the congregation. For this reason they gave special attention to the silhouette, applying color in large planes and aiming at a truly monumental impression.

It is known from the chronicles that the iconostasis of the Cathedral of the Dormition in Vladimir was created around 1408 by Andrei Rublev and his companion Daniil Chernii, together with assistants working simultaneously on the frescoes. At the time of I.E. Grabar's expedition in 1923, only 27 icons remained from the early iconostasis, with original painting preserved on 19 of them. The inventory of 1708 listed 83 icons. Eleven of the surviving icons were given to the Tretiakov Gallery and eight to the Russian Museum. The latter number contained the present icon of the Prophet Zephaniah. The iconostasis of the Cathedral of the Dormition has been of interest to every scholar studying Andrei Rublev. Many publications are devoted to its composition and peculiarities, and to the attribution of the icons included in it. This iconostasis was the greatest of all iconostases made in medieval Russia. Judging by the documentary sources and the surviving icons, it was also the first iconostasis to contain a prophets tier. Apparently it was Andrei Rublev and his assistants who first created a grandiose multi-tier iconostasis. Of this prophets tier, which contained 15 icons, only two survive, Zephaniah and Zechariah, and both are in the Russian Museum. On the latter icon only a few spots of original painting survive; the rest is overpainting from the 18th and 19th centuries.

In 1774 the iconostasis was replaced, and the icon of Zephaniah was sold along with a number of other icons to the village of Vasilevskoe. In 1923 the icon was discovered at the Trinity Church in the village by one of the expeditions sent by the Central Restoration Workshop, then headed by I. E. Grabar. In 1934 it was given to the Russian Museum.

The panel consists of five boards with two inset struts, canvas, gesso and tempera. The right border has been cut off. Later gesso has been applied along the upper and left border. Traces of the nails in the silver revetment are also evident. The gilt in the background and halos is badly rubbed. The icon was cleaned at the Russian Museum by N. E. Davydov (1940-41) and I. Ia. Chelnokov (1948-49). While cleaning the icon, Davydov noted traces of three separate attempts at restoration in the 19th century. His observations confirmed the reports of N.N. Ushakov in 1708 and N. I. Podkliuchinikov in 1855-56.

Tatiana Vilinbakhova

THE MOTHER OF GOD OF TENDERNESS AND THE ANNUNCIATION

Moscow
First half of the 15th century

Characteristic of the MOTHER OF GOD OF TENDERNESS is the intricate movement of the infant Christ. The figure of the child, standing out against the *maphorion* of his Mother, is turned toward the viewer; his legs are crossed and his head is thrown back. His cheek is touching his Mother's face, and his right hand touches her chin. In his left hand he holds a scroll. In Russia, this type of image received the

name 'Rejoicing.' The iconography of the image has been studied by many specialists including V.N. Lazarev, who proved that its origins lie in the art of Byzantium and the Christian Orient. The miniature from the Syriac Psalter of 1203, now in the British Library, is cited by Lazarev as being the earliest known version of the 'Rejoicing' type. Other representations of the type are known under such different names as *Pelagonitissa* or *Eleousa*. Most of these types are associated with Serbia and go back to the 14th and 15th centuries. Among Russian icons, the earliest example of this iconography is the icon from the Cathedral of the Annunciation in the Moscow Kremlin, belonging to the last quarter of the 14th century. The icon from the Russian Museum is the second earliest example. The Iakroma icon of the Mother of God, dating from 1482, is a later version of the same iconographic type as it spread throughout Russia. The type represented by the Iaroslavl Mother of God of Tenderness, however, was far more common in Russia, and it provides a close parallel to the version presented here.

The icon comes from the post-Rublev period of Moscow icon painting. Works from this period are very rare and it is thus of particular interest that such an outstanding example should have survived. The inspired face of the Mother of God, softened with a half-smile, resembles an icon of THE MOTHER OF GOD OF THE DON in the Tretiakov Gallery. There is also a hint of influence from Byzantine icon painting in the outline of the face of the Mother of God, especially the aquiline nose and the emphasized line of the chin. The color scheme of the icon is condensed, deep, and saturated. Against the background of the subdued shimmering colors, the faces stand out over a layer of light olive *sankir* with subsequent thin layers of light ocher. The use of pure white is restricted and is usually laid over the lighter parts of the form, such as around the eyes, in fan-shaped brush strokes which evoke the methods of the Byzantine masters of the second half of the 14th century. These techniques were used to communicate the inner luminosity of transfigured flesh. However, what we see in this icon is essentially an interpretation of the Byzantine tradition by a Russian master. The technique is softened here. The sharp edge between contrasting shades and high-

39.6 cm x 32.4 cm x 2.5 cm
Single panel without struts.

Inventory No.
ДРЖ 3072

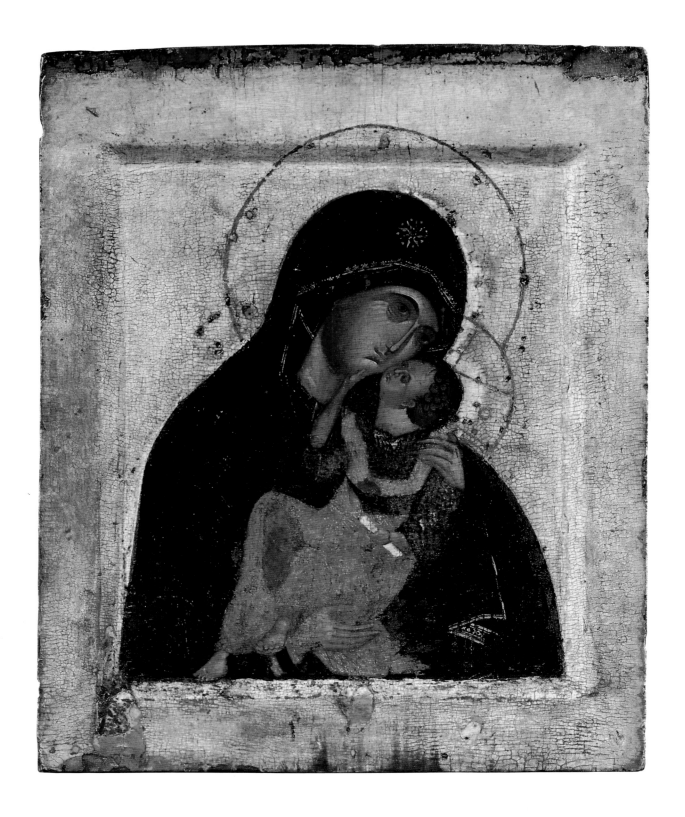

234

lights is smoothed over and the forms are flatter and less modeled. The intrinsically Russian feature in this case is the quality of lyrical intonation, and it is a characteristic of all Russian versions of the Mother of God of Tenderness. Although the icon is small, it is monumental in character, an impression conveyed primarily by the silhouette, which is traced with a sure unbroken line. The dark *maphorion* of the Mother of God, filling the lower part of the icon, gives her a roundness and fullness which recall the dome of a church. Her silhouette can be compared to a temple in which a precious treasure is enshrined, the infant Christ.

The icon consists of a panel without struts carved from a single piece of wood. In the lower border there are remains of clamps and struts with a handle used when carrying the icon in procession. There are holes left by nails from an *oklad*

and from a crown now missing. The depiction on the reverse is fragmentarily preserved and is covered by overpaint. The surface of the icon is substantially damaged, including the lines of the folds in the *maphorion* of the Mother of God and in the garments of her Child. Insertions of gesso covered with overpainting date from different periods. The largest sections are on the lower border where the paint representing the garments of Christ has been burnt, and on the red strap of his shoulder. Where the original paint is missing, there are traces of overpaint. The line of the eyebrows, the outline of the nose, and the reddish hue on the cheeks of the Mother of God were slightly strengthened during restoration.

The icon was acquired in Leningrad from L. M. Bialik in 1968.

Tatiana Vilinbakhova

THE ARCHANGEL GABRIEL

Dionysii and Studio
1502

St. SYMEON THE STYLITE

Early 16th century

These icons come from the iconostasis of the Church of the Nativity of the Mother of God in the Monastery of St. Ferapont. The stone church dedicated to the Nativity of the Mother of God was built and consecrated in 1490. The iconostasis was painted by Dionysii and his team of artists, who also worked with him on frescoes. The iconostasis consisted of the usual local, Deesis, festival, and prophets tiers.

156 cm x 65.5 cm x 3.8 cm
Panel of two boards with
two inset struts.

Inventory No.
ДРЖ 3090

159 cm x 49 cm x 3 cm
Single panel with
two inset struts.

Inventory No.
ДРЖ 3093

The Monastery of St. Ferapont is located in the northern part of Russia in the Beloozersk region, part of the territory of Vologda. It was founded by Fedor Poskochin, a native of the town of Volotsk who took his monastic vows under the name of Ferapont at the Simonov Monastery in Moscow. In the 1390s, together with his teacher Cyril who was also a monk of the Simonov Monastery, he left for the White Lake, where he founded a monastery. Following the instructions of his spiritual teacher St. Sergei of Radonezh, Abbot Ferapont adopted communal statutes for his new foundation, which demanded the complete absence of all personal belongings from monastic cells, except for books and icons, permanent residence in the monastery, and common meals. Helpful to the rapid growth of the Monastery of St. Ferapont was the active support given to it by a son of the grand prince Dmitrii Ivanovich Donskoi of Moscow, Prince Andrei Dmitrievich of Mozhaisk (1382-1432), in whose lands Ferapont and Cyril settled.

A stone church dedicated to the Nativity of the Mother of God was built and consecrated in 1490 with money from the monastic treasury and donations provided by Archbishop Ioasaf of Rostov, whose secular name had been Prince Ivan Nikitich Obolenskii. The prince had taken monastic vows and retired to the Monastery of St. Ferapont in 1488. He died at the monastery in 1506. Most probably, Ioasaf also commissioned frescoes to be painted for the cathedral, together with icons for its iconostasis. For this purpose he invited a renowned icon painter, Dionysii, to come to the remote northern monastery from Moscow. The inscription above the northern door of the Church of the Nativity indicates that its walls and vaults were covered by frescoes painted by Dionysii with his sons Vladimir and Feodosii in 1502.

With the exception of the icons of the stylites, the Deesis tier painted by Dionysii repeats the Deesis tier of the Cathedral of the Trinity in the Trinity-St.Sergei Monastery painted by Andrei Rublev and his disciples in 1425-27. The fact that the latter was chosen as a pattern may be explained by the authority of Andrei Rublev and the deep respect in which his

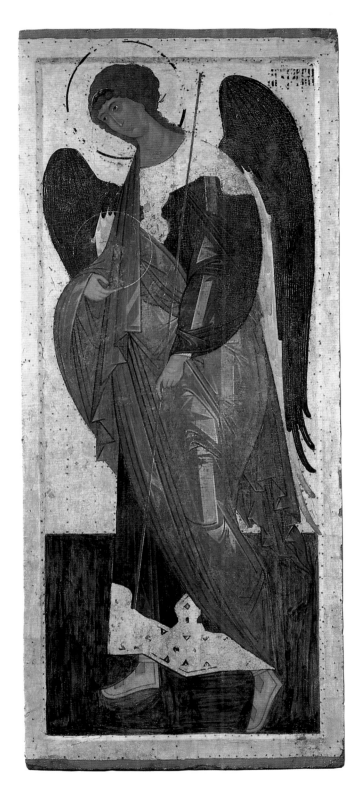

works were held. One should also remember that St. Sergei of Radonezh was a spiritual mentor of St. Ferapont, and that the monastery founded by St. Sergei served as the most authoritative example of monastic organization.

The Deesis tier of the iconostasis of the Church of the Nativity painted by Dionysii and his associates is a masterpiece, perfect and complete. Two symmetrically placed groups of saints incline toward Christ, who is seated at the center of the composition, and are presented in deep inner harmony with delicate color and rhythmical composure. The *Archangel Gabriel* is endowed with the characteristics typical of the art of Dionysii: an ideal sublimity, a spirituality rapt in contemplation of the divine, and a restrained melancholy. Having bowed his head, he is slowly advancing toward Christ, holding an orb and a thin staff. The figure of the archangel is inserted into the inner part of the icon with an ideal proportion. The silhouette of the figure is outlined by a smooth, rounded, and uninterrupted line. A three-dimensional effect is created by the fluid folds of his *himation*, modeled by means of precise drawing and an elusive overflowing of colors from dense to lighter hues. The highlights are subtly achieved by a whitening of the major tones. The color scheme of the icon is based on the combination of cool shades: green, blue, olive-brown, and lilac. The face of the archangel is gently modelled by several layers of reddish ocher on the brownish-olive *sankir*. An important part in the pictorial arrangement is played by the golden ground, the symbol of divine light, which pierces the figure of the archangel from within, falls on the wings with thin lines of *assist*, and is reflected in the edges of his *chiton*.

The icon of the Archangel Gabriel is formed from two wood boards joined together, with *kovcheg* and canvas. The reverse has two incised struts. Areas in the layer of pigment and gold are partly lost. There are losses of canvas on the lower

border. Small fragments of overpainting remain in the areas of loss and on the contours of the figures. The black outline of the halo and the inscriptions at the centre of the panel are of later origin and were retained in the process of restoration. There are holes and remains of nails from the *oklad* which is now missing. The original cinnabar inscriptions are not extant.

The icons of the stylites from the Deesis tier comprise a separate group and were included in the tier at a later time. This is attested by their iconographic peculiarities and the technique of their execution. They are three to four centimeters higher than other icons in the tier, their *kovcheg*s are more shallow, the side ends are treated differently and the line of the ground is lower. The rendering of the stylites is close to the style of the Dionysii icons, but the patches of dense color, the accentuated static postures of the figures, the massive proportions of the pillar, and a desire to fill the plane of the central panel to the maximum, prompt us to ascribe them to the first quarter of the 16th century.

According to Orthodox tradition, the stylites, like anchorites, ascetics, and monks, rank among the saints and serve as the foundation of the Christian faith. In fresco cycles, therefore, the stylites were placed in the lower register of paintings under the galleries and on pillars. Particularly revered in the countries of the Orthodox East, including ancient Rus, were two stylites named Symeon. St. Symeon the Elder is venerated as the founder of the practice. Longing for complete solitude, he built a pillar in Antioch in Syria and lived on top of it for 47 years in constant prayer and fasting. He died in 459. His ascetic exploit was repeated in the 6th century by St. Symeon the Younger, also called 'of the Wonderful Mountain,' since his pillar was built on the Wonderful Mountain near Antioch.

The old Russian *menologia*, like their Byzantine models, included images of both stylites. They were often thought to be one saint and their festivals were combined on September 1, even though the festival of the second St. Symeon was on May 24. The festival of St. Symeon the Elder also coincided with New Year in the old Russian calender, which gave an additional significance to the cult of the saint.

The exploits of the Syrian monks were emu-

lated by the Russian anchorites. The martyr St. Nikita committed himself to a pillar in a monastery near the town of Pereislavl-Zalesskii in the Vladimir-Suzdal Principality (died ca. 1186; commemorated on May 24). The first church in Russia dedicated to St. Symeon Stylites was built in Kiev in the second half of the 12th century. A church dedicated to St. Symeon of the Wonderful Mountain was built in Novgorod in 1206. The first known depiction of St. Symeon the Stylite is on a stone icon, together with St. Stavrokios. It was discovered in Novgorod and is dated to the first third of the 13th century. An image of St. Symeon in a manuscript illumination from the Novgorodian *Festivals* is ascribed to the same period. The figures of both Symeons are also present in the frescoes painted by Theophanes the Greek in 1378 for the Trinity side-chapel of the Church of the Savior of the Transfiguration in Novgorod, and one of them is depicted on the walls of the Church of St. Symeon the Receiver of God in the Zverin Monastery in Novgorod (ca. 1467).

Narrow icons of the stylites appeared at on both ends of the Deesis tier, bordering upon the southern and northern walls of the church and imparting a sense of completion and strength to the whole tier. Pictorial depiction of the pillar on which the stylites are seated naturally matches the real plane of the church wall. At the same time, it was traditional to place the icons of the stylites in the festival tier of iconostases. For example, they formed a part of the festival tiers of the churches of the Monastery of St. Cyril of the White Lake in the 16th-17th century. The icons of St. Symeon the Stylite from the Cathedral of the Dormition in the Monastery of St. Cyril of the White Lake (1497) and the Church of the Nativity of the Mother of God from the Monastery of St. Ferapont are the oldest among the extant depictions of the saint in the Deesis tiers of iconostases.

In conformity with the iconography of St. Symeon, he is depicted in the icon from the Monastery of St. Ferapont in a monastic cowl and mantle. He makes a gesture of benediction, and holds a closed scroll in his left hand, indicating his ministry as preacher and prophet. St. Symeon is seated at the open top of a platform on a hexahedron pillar with a door and windows. In the *Life* of the saint, which is ascribed to his disciple Athanasios, the pillar of St. Symeon is likened to the ladder of spiritual ascent. St. Symeon seated on a platform at the top of the pillar, which is separated from its plinth by the swirling clouds of heaven, the depiction of which helps to explain the following words from the *Life*: 'Always looking at heaven with his eyes, he sees beyond and over it with his mind.'

The icon of St. Symeon consists of a panel carved from a single board, with *kovcheg* and canvas. The reverse has two inset struts. There are some horizontal cracks in the canvas, and loss of canvas at the edge of the panel and on the lower border. In places, both pigment layer and gold are abraded. The black outline of the halo and the inscription are of later origin and were retained in the process of restoration. There are holes and remains of nails from the *oklad*, which is now missing. The original cinnabar inscriptions do not survive. Later inscriptions can be seen in black paint in the central panel.

Irina Soloveva

Catalog No. 71

ST. CYRIL OF THE WHITE LAKE WITH SCENES FROM HIS LIFE

Dionysii or Studio
Early 16th century

S t. Cyril of the White Lake was one of the greatest Russian saints and religious teachers. His activities were of particular importance for northern Russia where he is especially venerated. He was born in Moscow of noble parents in 1337. Originally named Kosmas, he was orphaned in his early youth and served as a treasurer in the house of his relative T.V. Veliaminov before retiring to live in a monastery.

After many years as a monk in the Simonov Monastery in Moscow, he departed at the age of 60 to become a hermit in the far north, and in 1397 he founded the monastery that came to be named after him. By the end of the next century it had grown into the largest monastery in northern Russia, and was a power house of spiritual life and enlightenment.

St. Cyril was the most famous disciple of St. Sergei of Radonezh. Both of them were exponents of hesychast teaching, both followed the monastic practice of the Palestinian tradition, both gave up their initially chosen ascetic solitude in favor of fraternity, and both were good counselors to the royal house, seeing this as duty to their native land.

Little more is known about the life of St. Cyril. He is supposed to have written three epistles to the sons of Prince Dmitrii Donskoi, a spiritual testament and several religious texts of a poetic nature. Twelve books that belonged to him are the earliest to survive from a personal library in Russia, and several are preserved in the Russian Museum. Cyril was canonized in Russia not later than 1447-48. He is commemorated on June 9.

The border scenes of the icon follow the course of his life as written by Pakhomii Logofet in the second half of the 15th cen-

tury, on the basis of information provided by his contemporaries.

1 The vows of St. Cyril at the Simonov Monastery. It was here that he often met St. Sergei of Radonezh.

2 St. Sergei converses with St. Cyril in the refectory. Having gained authority with the monks, after some years St. Cyril was made archimandrite.

3 St. Cyril is ordained into the priesthood.

4 St. Cyril seeks solitude and silence in the Simonov Monastery.

5–6 Obeying the voice and the vision he received while praying in his cell, St. Cyril departs in the direction of Beloozersk in company with Ferapont, who was to found another important monastery. After much wandering, the two of them stop by a lake, where they erect a cross on the site of the future monastery and excavate its first cell.

7–8 The further life of St. Cyril at the monastery abounds in miracles and signs of his holiness. He miraculously extinguishes a fire in his cell which threatens the whole monastery.

150.6 cm x 116.5 cm x 3.5 cm
Panel of two boards with two inset struts.

Inventory No.
ДРЖ 2741

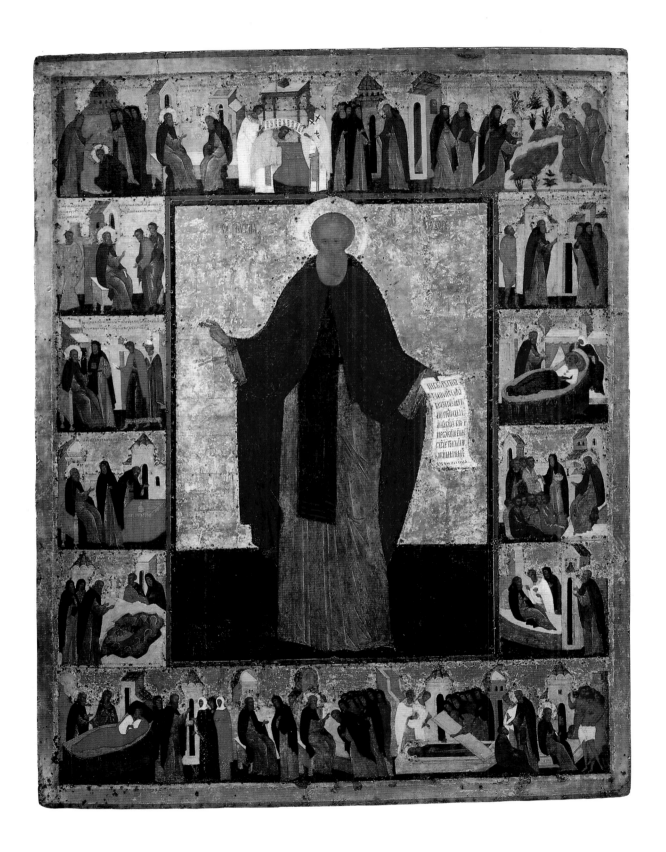

9 A messenger arrives from Prince Belevskii requesting that St. Cyril pray for an heir.

10 St. Cyril appears to Prince and Princess Belevskii in dreams announcing the conception of a child.

11–12 St. Cyril miraculously multiplies the wine and bread of the monastery.

13 St. Cyril delivers fishermen from drowning in the lake.

14 St. Cyril prays for a dead monk and restores him to life.

15 St. Cyril and the Mother of God appear to the boyar Roman in a dream.

16 St. Cyril heals the Princess Kargopolskaia of blindness.

17–18 Warned by St. Christopher of his death, St. Cyril calls the monks, tells them of his impending demise and blesses them. St. Cyril is buried in the monastery where he continues to perform miracles even after his death.

19–21 St. Cyril heals his servant Avksentii, and announces the arrival of Prince Mikhail to an old man.

In the center of the icon St.Cyril is represented in monastic habit, his right hand raised in blessing, his left holding a scroll with the parting words: *Do not grieve, brothers, but know that many more deeds here will be pleasing to God, and this place will not decline if you have love for one another.* The slim figure with a golden halo resembles a candle, a deliberate parallel emphasizing his character as a man of perfection, a lamp to enlighten the northern Russian lands. A contemporary of Dionysii, St. Joseph of Volotsk, remarked about St. Cyril that he was 'like a light on a stand shining in our time.' The image of St. Cyril epitomizes the ideal type of monk which had always been revered in Russia. During the medieval period the nation sought its spiritual and moral ideals in monastic life. The austere and modest appearance of the saint tells us of an ascetic life devoid of any external pomp, devoted to high service and constant self-perfection. His mild face radiates the Christian virtues of humility and love. The episodes of his life begin not with his birth, as in most cases, but with his monastic vows, the true birth of a monk.

The first scene depicts Cyril as young and beardless, but in the next scene he is already a bearded old man. According to his *Life*, he was not old when he with St. Sergei of Radonezh, but the artist probably intended to show that he was mature in spirit. His talks with St. Sergei were crucial in his life. St. Sergei was not famous for his writings, but rather for his spiritual discourse. Conversation with a holy elder, an old monk of saintly reputation, was always seen in Russia as a way of spiritual growth, a source of wisdom and a door to higher values: 'discourse for correcting and building souls.' St. Sergei of Radonezh was the holy elder of St. Cyril, teacher and father of the cause to which Cyril and other Russian hermits and ascetics gave their lives. Contemporary texts describe them as bound through their conversation in a common spiritual life. 'A teacher and disciple,' wrote St. Nil of Sora, 'are separate in body, but joined and united by spiritual love.'

The composition of the scene is laconic The two conversing figures are similar in appearance and attitude, indicating their spiritual kinship. The architectural shapes in the background echo their poses; everything is in harmony and clarity, in keeping with the inner world of the two saints.

The scene of St. Cyril ordained as priest is painted in the lightest palette of all the border scenes, delicate shades of pink and yellow, with white as the dominant color. Symbolizing purity and holiness, the color white expresses the profound significance of ordination, which confers divine powers on the priest, and the holiness of the sanctuary where the ceremony is conducted. The other scenes of the upper depict the life of the saint until the foundation of the new monastery.

Border scenes are always read from left to right, even if they happen to be interrupted by the main themes at the center. In this way the spectator following the story glances repeatedly at the central image of the saint in his perfect and eternal state, the crowning achievement of his earthly life. All the vertical scenes deal with the monastic life of the saint, and express the ideals of Russian monasticism. St. Cyril is shown raising the dead, healing diseases, relieving spiritual and physical pain, and constantly caring for his fraternity. The artist notes his particular veneration of the Mother of God. In border scene 14 he is praying to an icon of the Mother of God, and his *Life* tells us that he arrived in the region of the White Lake he brought this icon from the Simonov Monastery. It was the first icon in the monastery he founded. According to tradition, the icon was later placed in the local tier of the iconostasis in the Cathedral of the Dormition, and it is now at the Tretiakov Gallery. The Mother of God appears a second time in border scene 15, where she holds the saint by the hand.

All the scholars writing about the icon have linked it with Dionysii, but most of them incline to one of the master's pupils. It is well known, however, that the usual practice was for the master to paint the central theme and leave the border scenes to the apprentices. The custom was followed, for instance, when Dionysii worked at the Monastery of St. Joseph of Volotsk, where his son Feodosii painted the borders.

We have no documentary evidence concerning the icon in question, although it is known from tradition that it was greatly venerated at the monastery, and that a precious revetment was made for it in the mid-16th century. Whoever its artist might have been, the icon follows the spiritual ideals and artistic principles of Dionysii and his studio. It belongs to a group of icons by Dionysii and his circle devoted to Russian religious leaders, including the icons of St. Dmitrii of Prilutsk and St. Sergei of Radonezh, and of the metropolitans Peter and Alexei. These works reflected the epoch of great monastic activity which raised the spiritual life of Russia to an unprecedented level. The images of St. Dmitrii, St. Cyril, and St. Sergei are linked to each other through an idealized and elevated characterization, and a similar treatment of figures. All of them have a sense of slow movement, softly flowing outlines, and harmony of colour and line. The architectural setting is given clear and simple forms. The border scenes follow similar principles, one feature being the absence of lines dividing the scenes in the upper and lower horizontal rows. This omission encourages the viewer to link the events into a continuous story, and was a device introduced by Dionysii. In later times the method became widespread.

The icon consists of two pieces of pine glued together, with two inset cross struts. There are many small losses of paint, mostly in parts which were under the revetment. On the borders there are traces of later overpainting not removed in restoration; some patches are touched up. The inscriptions on gilded ground in the border scenes and in the scrolls have been strengthened. The icon was cleaned at the Central Restoration Workshop in 1928-29 by E.A. Dombrovskaia. It came originally from the local tier of the Cathedral of the Dormition in the Monastery of St. Cyril of the White Lake. After the dissolution of the monastery, the icon passed to the Central Restoration Workshop in Moscow, from which it was acquired by the Russian Museum in 1932.

Tatiana Vilinbakhova

ST. CYRIL OF THE WHITE LAKE WITH SCENES FROM HIS LIFE

Moscow
Early 16th century

The central field contains a full-face, full-length representation of St. Cyril of the White Lake in monastic garb with lowered hood. The saint is shown in an attitude of blessing and with a cross in his left hand. An inscription around his head reads: *The blessed St. Cyril the Wonder-Worker, Abbot of the White Lake.* The centerpiece is surrounded by scenes from the life of the saint. The composition of the scenes

is crowded, with lengthy inscriptions explaining the significance of each episode:

1 The birth of St. Cyril.
2 The monastic vows of St. Cyril, the blessed Wonder-Worker.
3 St. Cyril converses with St. Sergei the Wonder-Worker.
4 The appointment of St. Cyril as abbot
5 The Holy Mother of God appears to the blessed abbot Cyril.
6 St. Cyril consecrates the site of the monastery and blesses the people.
7 St. Cyril discovers Andrew setting fire to his cell. St. Cyril blesses the craftsman of the church.
8 St. Cyril puts out the fire with his prayers. St. Cyril makes obeisance to his spiritual father.
9 St. Cyril accepts gifts from Prince Mikhail Belevskii and blesses his emissaries. St. Cyril appears to the prince in a dream.
10 St. Cyril casts out a demon from a sick man and restores him to health.
11 A priest comes to St. Cyril about a shortage of wine, and the saint blesses him. St. Cyril fills some vessels with wine for rejoicing.
12 St. Cyril loads the table at the holy monastery with festive fare and blesses the food.

13 St. Cyril saves some fishermen from drowning in the lake.
14 St. Cyril raises a monk from the dead and blesses him.
15 With the Mother of God, St. Cyril cures the boyar Roman and blesses him.
16 St. Cyril heals the blind Princess Kargopolskaia and lets her go in gratitude into a convent.
17 St. Cyril instructs the brothers and the abbot on the administration of the monastery.
18 The burial of St. Cyril, Wonder-Worker of the White Lake.
19 St. Cyril appears to an elder by his tomb in the church.

This is one of the few cloths with scenes from the life of a saint that has survived. The background is of Italian damask, yellow in the center and violet at the borders. The embroidery is executed in split stitch with different colored silks, as well as in couching with gilt and silver thread, and filigree stitching in silk and gilt thread twisted together, characteristic of the 16th century. The cloth was hung under the icon situated in the lowest tier of the iconostasis of the Cathedral of the Dormition in the Monastery of St. Cyril of the White Lake. The icon was produced in the workshop of

Icon cloth (*pelena*)

99.5 cm x 118 cm
Damask, embroidered with silk, silver, and gilt thread.

Received in 1923 from the Monastery of St. Cyril of the White Lake.

Inventory No.
ДРТ 276

the famous painter Dionysii, and is preserved in the Russian Museum (cat. no. 71). It is quite obvious that the needlewomen who embroidered the cloth knew exactly where it would hang. This explains the greater width of the cloth which is uncharacteristic of icons depicting scenes from the life of a saint. The full-length representation of the saint usually dictates that length will exceed width.

The image of St. Cyril in the center of the cloth is embroidered with great skill. One is struck by the refined, spiritual expression on the face of the saint, his eyes turned upwards in prayer. The borders with scenes from his life are embroidered in brightly colored silks, the contours and individual details being outlined in gilt thread. The work was produced in Moscow, in the early 16th century. Its entire composition displays features characteristic of the work of Dionysii. M. A. Maiasova believes that the cloth may have been executed in the workshop of Solomoniia Saburova, wife of Grand Prince Vasilii III.

Liudmila Likhacheva

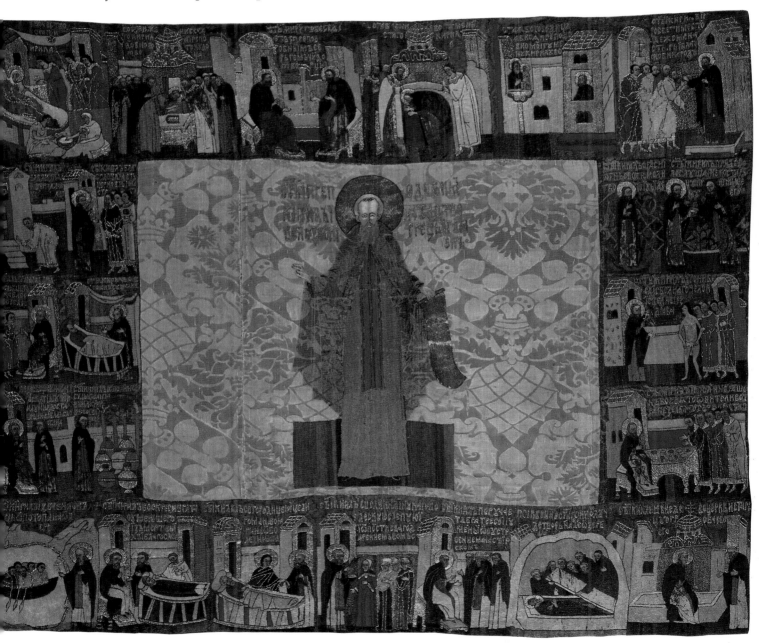

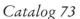

St. Andrew the Holy Fool with Scenes from His Life

(formerly attributed to Dionysii)
Mid-16th century

The iconography of St. Andrew the Holy Fool with Scenes from His Life is unique. There is no other surviving icon with such a complete cycle depicting the life of the saint. The subjects of the border scenes are based on the text of the *Life of St. Andrew.* According to this account, he lived in Constantinople during the 9th-10th centuries. Although he was born in Scythia, he was bought with other slaves by the Byzantine dignitary Theognostos, whose favorite servant he became. The first five scenes depict Andrew's education and his decision to devote himself to God as a 'holy fool.' When demons appear to him during his prayers at night, followed by youths in white clothes holding three crowns in their hands, St. John the Divine comes to his rescue. Christ then appears to him and encourages him to become a beggar for the sake of God. Scenes 6 and 7 are miracles which the saint performed in the streets of Constantinople, and in scene 8 he sees Christ again, and learns of a plague about to strike the city. Thanks to the prayers of Andrew and Daniel the Stylite, the disease attacks only a grave-yard thief who was going to steal the belongings of a dead girl. In spite of a warning, the thief crept into the sepulcher at night and removed the clothes from her body. The girl then rose from her coffin and struck the thief in his face, blinding him. In scene 11, Andrew exposes a demon who had assumed the appearance of a poor old woman sitting in the middle of the road, and in the next two scenes he saves a monk whose soul had been placed in danger through the love of money.

In scene 14 Andrew has another vision at the Cathedral of St. Sophia, in which King David is coming to meet him with all the prophets of the Old Testament, and in scene 15 Andrew appears before a woman as a column of fire.

Scene 16 depicts the main miracle of the saint: his vision of the Mother of God in the Church of Blachernai. One night as they prayed in the church, Andrew and his disciple Epiphanios saw the Mother of God standing with her servants on a cloud above the Royal Gate, with her protecting veil spread over her. This subject was used for individual icons and became wide-spread in Russia.

The penultimate scene tells of an aristo-crat who insulted the saint, and then fell ill, while the final scene is devoted to the death of the saint.

Holy fools who humbled themselves by feigning madness have played a major role in Russian spiritual life. The abundance of fools in the church calendar and the respect they enjoyed among the common people indicate that their way of life became central to the history of Russian spirituality. During the 16th century holy fools began to play a greater social and political role, using their position at the margins of society to denounce the injustice of those in positions of authority like boyars and tsars.

St. Andrew was held in special regard in

131 cm x 101 cm x 3 cm
Panel of three boards
with two inset struts.

Inventory No.
ДРЖ 2099

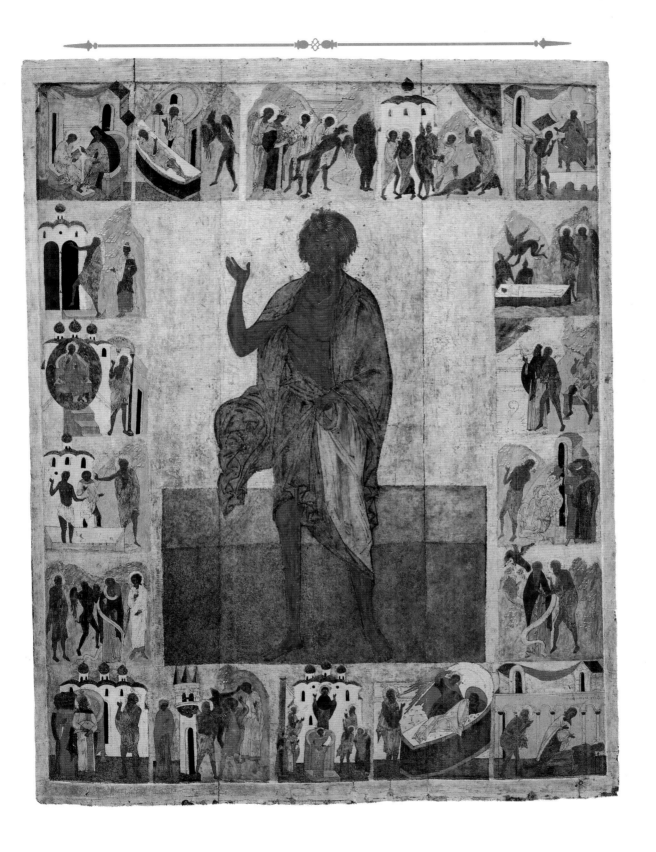

Russia, and his *Life* was considered to be a compendium of holiness. All other hagiographic writings were strongly influenced by this text. The veneration of St. Andrew began in the 12th century at the time of Andrei Bogoliubskii, the prince of Vladimir. In honor of his patron saint, Andrei instituted the festival of the Protecting Veil of the Mother of God, to which he built and dedicated a stone church. In the 14th century, the cult of the saint developed in Novgorod, and according to the third chronicle of Novgorod, a church in honour of Andrew of Constantinople was built in the Sitetskii Monastery in 1331. The large number of churches and icons of the Protecting Veil based upon the Novgorodian model also contributed to the cult. Interestingly enough, the Sitetskii Monastery possessed a large icon of St. Andrew the Holy Fool with 18 border scenes of his life, which may have been similar to the present icon.

In the *Life of St. Andrew*, miraculous visions are interspersed with scenes of temptation by demons and with philosophical discussions of the destiny of the world and humanity. Such eschatological themes must have been particularly interesting to the medieval reader, who lived at a time marked by the expectation of the end of the world and the Last Judgement. It is only in the context of this mentality that one can fully understand the language and imagery of the biography.

St. Andrew the Holy Fool is depicted at the center of the icon in the posture of a classical orator. His emphatically rugged body is that of an ascetic, his tousled hair and weathered face convey an air of internal concentration and spiritual power. The asceticism of his appearance is emphasized by the combination of dark-brown ocher and green in his garments, almost blending with the green ground. In medieval painting, the symbolism of green refers to the triumph of life over death, to the rebirth of the soul through suffering and humility. As the entire life of the saint was a struggle for the triumph of the spirit and light, the choice of colors is appropriate.

Almost all students of the icon date it to the beginning of the 16th century, and attribute it to the Muscovite style at the time of Dionysii. V. N. Lazarev considered the artist to be a follower of Dionysii. The icon was cited as a stylistic analogy by M. V. Alpatov when he studied the late 15th century icon THE APOCALYPSE (Moscow Kremlin). E. K. Guseva suggested that it was the work of a Muscovite artist who worked in Novgorod.

However, the style of the icon is consistent with the middle of the 16th century. The monumental figure takes up the whole length of the central field, and the double ground line brings the figure closer to the foreground. The closed composition of the border scenes is also indicative of a later date. Each scene can be considered a self-sufficient unit often divided from the others by the empty strips of the background, a feature which was typical of the middle or second half of the century. The figure of the saint is noticeably elongated, which is indeed reminiscent of Dionysii, but a similar technique was also used by later icon painters until the end of the 16th century. Figures in THE MENOLOGION of 1569 can serve as an example. The dating to the early 16th century had been largely based on technique. The light almost transparent colors of the preparatory drawing resemble watercolor. However, the most recent technical analysis has shown that the original layer of paint has been very poorly preserved, so that what now appears to be a special device is in fact only the preparatory coloring. Judging by the small fragments that have been preserved, the icon was originally painted in the traditional multi-layer technique with a very dense dark-green pigment, dense reddish ocher, and a thick network of whitened highlights. This kind of painting is at variance with the traditional attribution to Dionysii. It was, however, common in Novgorod and Pskov. For example, small white highlights which resem-

ble shading strokes are common in Novgorodian icons. Many researchers have noted the beauty of the drawing. Indeed, its light flexible lines and the quality of its draftsmanship make it an outstanding work of medieval Russian painting. The graphic treatment of the figures is comparable to miniature techniques. In this respect, the icon is closely akin to the miniatures in THE LIFE OF NIFONT which are often linked to the Novgorod workshop of Metropolitan Makarii in the 1530s-1540s. St. Andrew the Holy Fool stands apart from the icons of that time, but some stylistic parallels can be found between it and the border scenes of the icon ST. GEORGE WITH SCENES OF HIS LIFE (Russian Museum) dated to the 1540s, or the icon ST. PETER AND ST. PAUL (Novgorod Museum).

The icon is made from three lime boards; there is a *kovcheg*, and two struts sunk into the sides. The partial canvassing is in poor condition. The original painting is abraded over the entire surface. There are remains of background gold in the center panel, the scenes from the life, and the borders. Later renovations and repairs have been made to the inscriptions of the border scenes, the outlines of figures and halos, and the garments in the composition The Protecting Veil. There is a crack along the line of the panel joint. There are inscriptions in vermillion, of which only fragments have been preserved and not in all the border scenes. The origin of the icon is unknown; it entered the Russian Museum in 1913 from the collection of N. P. Likhachev.

The icon was cleaned of later layers of paint before coming to the Museum. During that restoration, the original painting was partly pumiced; the areas of losses and abrasions were renovated and covered with paints and glazes. Strong solvents have caused changes in some pigments, especially the blues. A second restoration was undertaken by N. I. Briagin and N. A. Okolovich at the Russian Museum in 1915. Dirty varnish, repairs, and overpaintings were removed, and the areas of loss were touched up. The poor condition of the original painting, with the first layers of color exposed, allows one to see the letters indicating the place for each color which were made by the icon painter or more probably by the colorist in the process of work. These marks were a sign of the emerging division of labor between icon painters and draftsmen and used to be made on panels which were created in large workshops. Similar marks can be found on THE MENOLOGION of 1569 or THE FOUR-PART ICON from 1547 in the Cathedral of the Annunciation in the Moscow Kremlin.

Irina Shalina

CRUCIFIXION

Moscow
First half of the 16th century

This icon probably originated as part of the festival tier found on the iconostasis of an unknown church. The scene of the Crucifixion was among the 12 festivals traditionally included in that tier, and its iconography evolved in Byzantine art by the 11th century. The earliest fully preserved row with all 12 feasts comes from the Cathedral of St. Sophia in Novgorod, and dates from 1341. This crucifixion

follows the traditional iconography. The cross with the figure of Christ is placed at the center of the panel, raised between two rocky hills representing Golgotha. In the cave below is the skull of Adam, for Christ is believed to have been crucified over the grave of Adam so that his blood could wash the skull of the first man and thus redeem his Fall. In the background are the walls of Jerusalem. Standing by the cross on the left are the Mother of God and the other Mary who accompanied her, and on the right, St. John the Divine and the centurion Longinus. The weeping angels flying down to the cross often appeared in such compositions.

This iconographic version is one of the most concise. It is derived from the festival icon of the iconostasis which is now in the Cathedral of the Annunciation in the Moscow Kremlin. Following that model, the painter created a harmonious and rhythmically refined composition. However, the style of the present icon differs from its prototype since it was painted a century later. The horizontal lines are more marked, the forms more massive. The heavier curve of the hanging body of Christ and the substantial cross cause the

crucifixion to dominate the scene and overpower the spectators. Even so, they still appear more bulky than in the prototype due to the different treatment of the folds in the robes, drawn in brittle lines with pointed ends. The walls of Jerusalem are tall, enclosing the scene and depriving it of depth. As in the earlier icon, the surface of the wall is modelled in detail.

The faces are modelled with dense dark ochers over brown underpaint. The icon is painted with dense pigments, its color scheme combining green and red in various shades. These stylistic characteristics suggest that the icon was produced in the first half of the 16th century by a Muscovite master.

The origin of the icon is unknown. It was acquired by the Russian Museum in 1898 from the collection of the Academy of Arts. Prior to this acquisition, the icon was cleaned and restored. It is slightly cut at the sides and has been extended at the top and bottom. Much of the surface paint has been lost and there have been attempts to reconstruct the original scheme. No inscription survives.

Irina Soloveva

75.2 cm x 53.4 cm x 2.5 cm
Panel of two boards with
two inset struts.

Inventory No.
ДРЖ 1219

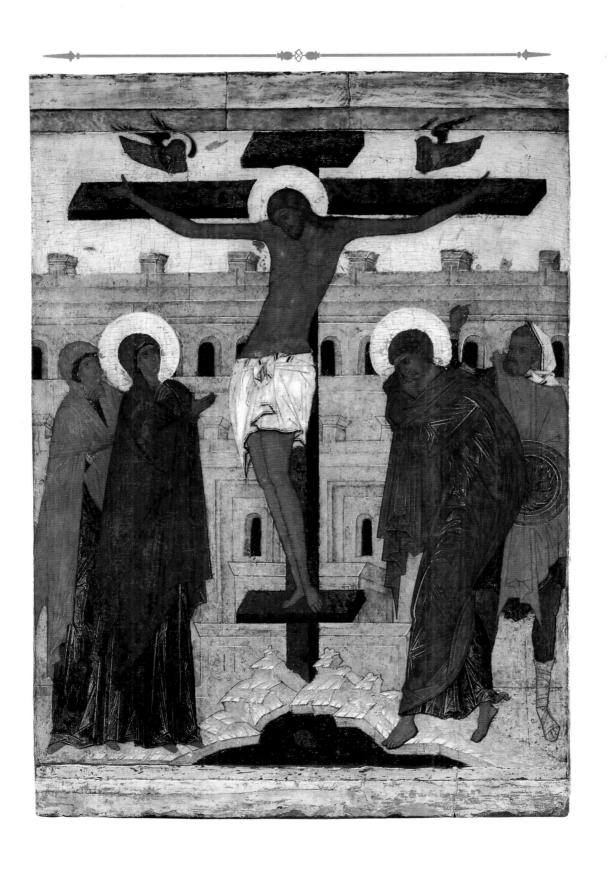

THE ENTOMBMENT

Moscow
Early 15th century

The shroud depicts the scene of the Entombment, and during Easter services it is placed on the altar to symbolize the winding-sheet of Christ. This embroidery, one of the most famous in the Russian Museum and one of the earliest donations to the Monastery of St. Cyril of the White Lake, belongs to a group of celebrated Muscovite shrouds of the early 15th century which includes

such works as the blue shroud in the Trinity-St. Sergei Monastery, the 1456 shroud donated by Grand Prince Vasilii II to the Cathedral of St. Sophia in Novgorod, and the mid-15th century shroud received in the Russian Museum from the Stieglitz Museum in 1938. These works are all based on the same prototypes found in examples of early Palaiologan art, and as a result the Muscovite shrouds have the same structure as their Byzantine models. The borders bear a liturgical inscription, most often *Let all earthly flesh be silent . . .*, and the central panel shows the Entombment, with the Mother of God seated by the head of her son and St. John embracing the legs of his master. In the foreground two kneeling angels hold liturgical fans. In the center stands a ciborium with a lamp, and in the upper part, angels fly beside a sun and a moon with human faces. The symbols of the evangelists appear at the corners of the centerpiece, with seraphim in each of the four corners. Crosses and stars are scattered over the background, and dedicatory and liturgical inscriptions are inserted between the figures of the kneeling angels. Some experts, including V. N. Lazarev and A. N. Svirin, believe that these shrouds originate from Novgorod.

The shroud from the Monastery of St. Cyril has not retained all its figurative details, many of which were lost when the embroidery was transferred from the original dark blue damask to a new background of the same color. This seems to have occurred in the 1830s, when a special effort was made to restore the embroideries of the monastery. Additional borders of green velvet were applied, along with an inscription embroidered in gold to record the donation in 1645 by Prince Ivan Andreevich Golitsyn of a cover for the tomb of his brother-in-law, Prince Fedor Andreevich Teliatevskii. This cover bore a Golgotha cross of silver appliqué. When the shroud was received at the Museum, the border with a dedicatory inscription was removed and preserved separately. The embroidery was transferred to blue denim.

The inventories of the Monastery of St. Cyril for 1773-74 and 1802 describe the shroud, and indicate that there used to be a dedicatory inscription between the figures of the kneeling angels. The inventories record the opening words: *This cloth was created by the true believer Grand Prince Vasilii . . .*, from which it may be presumed that the shroud was donated by Grand Prince Vasilii I, son of Dmitrii Donskoi, who together with his mother and brothers was a patron of the monastery.

Liudmila Likhacheva

Shroud (*Plashchanitsa*)

140 cm x 187 cm
Damask, embroidered with silk, silver, and gilt thread.

Gift of Grand Prince Vasilii I to the Monastery of St. Cyril of the White Lake. Received at the Russian Museum in 1923.

Inventory No.
ДРТ 281

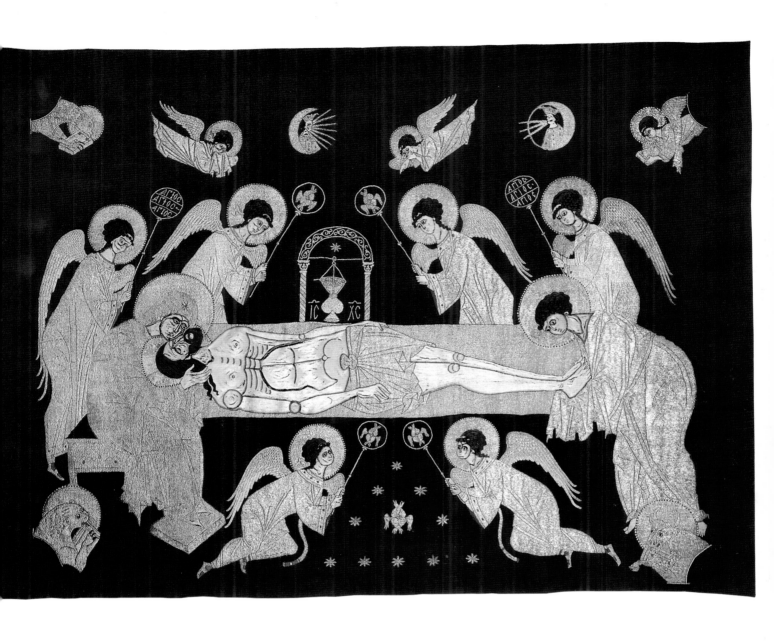

THE TRANSFIGURATION AND FESTIVALS

Moscow
Second half of the 16th century

I n the center of the icon cloth the scene of the Transfiguration of Christ on Mt. Tabor is represented. According to the Gospel accounts on which the image is based, the face of Christ 'shone like the sun and his raiment became as white as light.' The prophets Moses and Elijah, depicted to the left and right of Christ, are said to have miraculously appeared with him on the mountain top. The disciples Peter, James, and

John are astonished at the bottom of the image. The 12 great feasts of the Orthodox Church are represented on the borders of the cloth. These are: Annunciation, Nativity of Christ, Presentation of Christ in the Temple, Epiphany, Raising of Lazarus, Entry into Jerusalem, Crucifixion, Anastasis, Ascension, Pentecost, Trinity, and Dormition of the Mother of God.

On the border, *kontakia* and *troparia* to the Transfiguration are embroidered in a complex ligature: *Christ Our Lord has been transfigured on the mountain . . .*

The cloth can be compared to a second *podea* from the same workshop: The *TRINITY AND FESTIVALS* in the Trinity-St. Sergei Monastery. Certain features of style indicate that both were embroidered in a Muscovite workshop.

The cloth is well preserved. The contrasting backgrounds of the centerpiece and the margins play a significant role in its color scheme. The folds of the garments and a number of other details are outlined

with a doubled silver-gilt thread. The cloth was decorated with precious stones, lost before it arrived at the Russian Museum. The halo of Christ is outlined with pearls and three spaces in the halo are evident. The cloth is described in the monastic inventory for 1771: 'A small *podea* of green satin trimmed with red taffeta; in the center, a representation of the Transfiguration of Our Lord with apostles and prophets, and on the red border there is the Holy Trinity; around it there are scenes of the great festivals worked in various silks, silver, and silver-gilt thread. The halo of the Savior is oversewn with two strings of small pearls and that of the prophets with a single string; in the halo of the Savior there are three blue stones and another red stone. The *podea* is lined with pale green taffeta.'

The cloth was acquired in 1923 from the Monastery of St. Cyril of the White Lake.

Liudmila Likhacheva

Icon cloth (*podea*)

50 cm x 51 cm
Satin, embroidered with silk, silver, and gilt thread.

Inventory No.
ДРТ 19

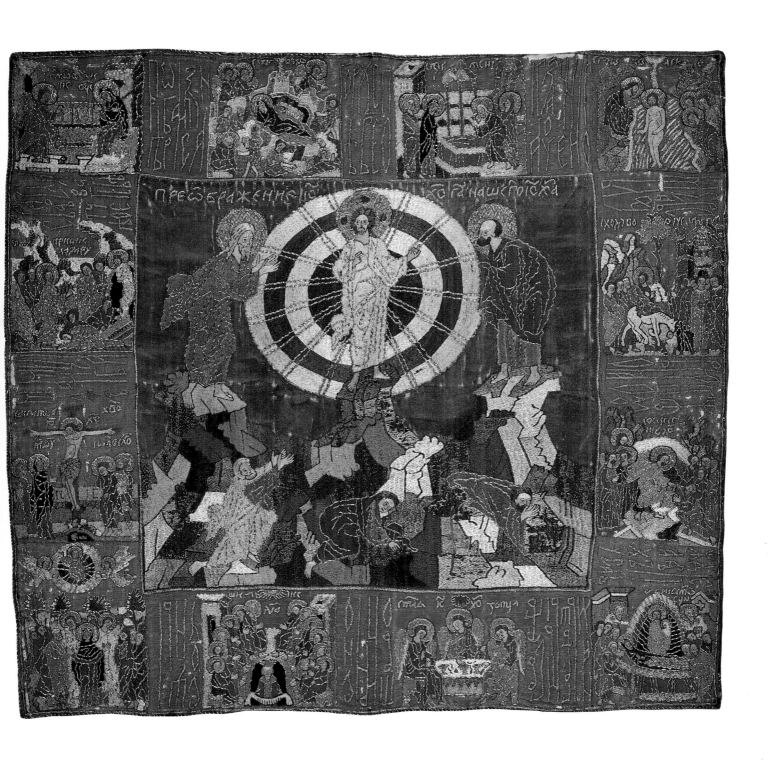

THE MOTHER OF GOD OF THE BURNING BUSH

Moscow
Late 15th - early 16th century

This cloth is one of the most exquisite examples of medieval Russian embroidery. In the center, the Mother of God with the Child in her arms is shown against the background of a brightly colored feathery bush surrounded by flames, the burning bush seen by the prophet Moses at the foot of Mount Sinai. The image of the Mother of God is flanked on one side by an angel flying down to her,

and on the other by Moses removing his sandals. At the bottom, Russian saints are depicted turning to the Mother of God in attitudes of prayer. On the left, in full length, are the metropolitan Peter, Leontii of Rostov, and St. Cyril of the White Lake; on the right are the metropolitan Alexei, St. Sergei of Radonezh, and St. Varlaam of Khutyn. All these saints were venerated in Moscow in the late 15th century. The borders contain half-length images in medallions. At the top the Mandylion, the image of the face of Christ 'Not Made with Hands,' is flanked by the Archangels Michael and Gabriel and the Apostles Peter and Paul. The other images represent a selection of saints who were also revered at that time in Russia, particularly in Moscow: St. John Chrysostom, St. Basil the Great, St. Nicholas, St. Gregory the Theologian, St. Anthony and St. Feodosii of the Caves, St. Evfimii the New, St. Savva the Consecrated, St. Varlaam the Anchorite, and St. Dmitrii of Prilutsk.

The Mother of God of the Burning Bush belongs to the group of themes relating to prophecies of the incarnation of Christ, such as 'It is Fitting,' 'In Thee rejoiceth'

and the Praise of the Mother of God.

The background of the center is bright yellow Italian raw silk and that of the borders is raw silk of a color which has changed greatly over the years and is now greyish brown. The embroidery is executed with brightly colored silks in the split stitch characteristic of the 15th century. The contours of the figures, the folds of the garments, and various other details are outlined with gold thread. The flesh-colored silk thread used for the faces has greatly darkened with time.

Several existing cloths resemble the one in the Russian Museum. Particularly close analogies may be observed with the cloth representing the Appearance of the Mother of God to St. Sergei of Radonezh, the center background of which is also of bright yellow Italian raw silk. A cloth of the same type representing The Dormition of the Mother of God with Saints is preserved in the Tretiakov Gallery.

The *pelena* was from the Monastery of St. Cyril of the White Lake in 1923, and was restored in 1924 and 1962.

Liudmila Likhacheva

Embroidered cloth (*pelena*)

55 cm x 52.5 cm
Silk, embroidered with silk, silver, and gilt thread.

Inventory No.
ДРТ 31

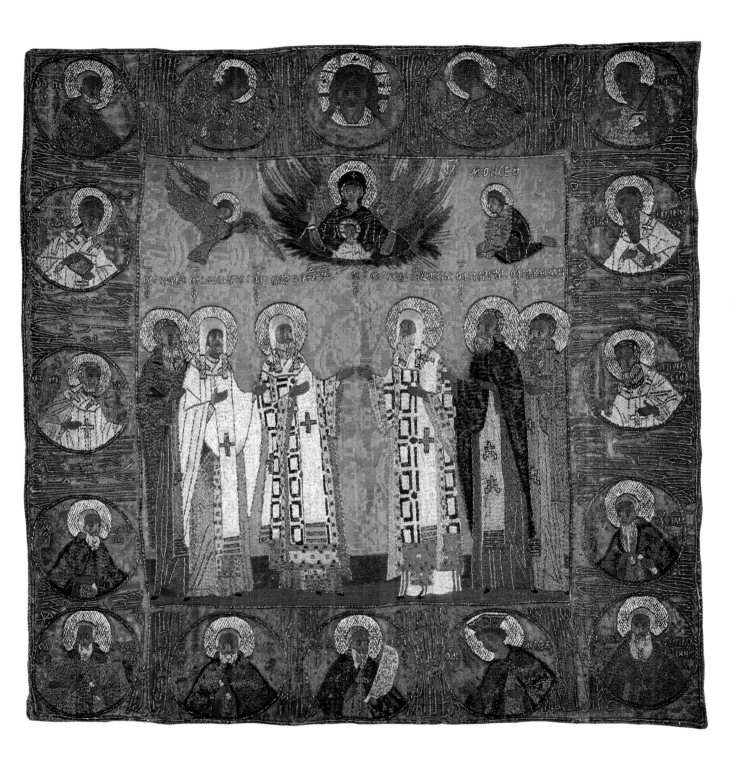

257

THE CRUCIFIXION WITH EVANGELISTS AND APOSTLES

Moscow
Mid-15th century

Eucharistic cloth (*pokrovets*)

51.5 cm x 53 cm
Taffeta, embroidered with
silk and gilt thread.

Inventory No.
ДРТ 42

The cloth was designed as a cover for the communion chalice, and is one of the finest examples of 15th century embroidery produced in Moscow. The representation of the apostles on the borders is similar to that on the blue borders of the cloth of *THE DORMITION OF THE MOTHER OF GOD* in the Russian Museum. The centerpiece shows Christ on the cross flanked by his Mother and St. John the Evangelist. Weeping angels fly down to him, and in the background are the walls of Jerusalem. The cross stands on Golgotha, traditionally held to be the burial place of Adam as well as the site of the Crucifixion. At the corners of the cloth, evangelists in the act of writing are shown against a background of the same color as the central field, which lends originality and harmony to the color scheme. The apostles are embroidered on red borders.

St. Peter and St. Paul are depicted on the upper border, St. Philip, St. Bartholomew, St. Andrew, and St. Thomas at the sides, and St. James and St. Symeon at the bottom. Each figure is identifiable by an accompanying inscription.

The icon was received in 1925 from the Russian Archaeological Society. It was restored in 1930 and again in 1962.

Liudmila Likhacheva

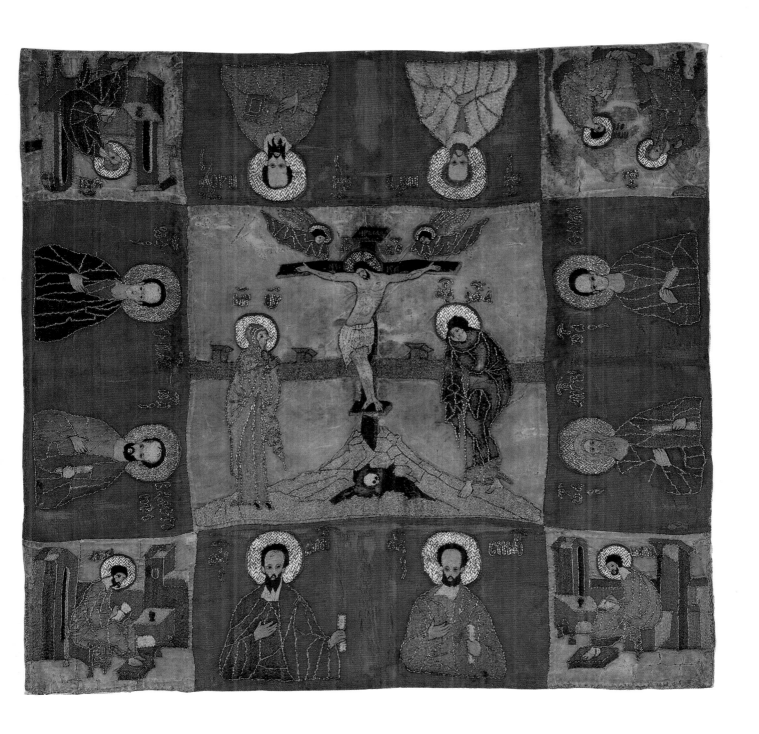

THE GREAT MARTYR IRINA

Monastery of St. Cyril of the White Lake
Late 16th – early 17th century

This icon cloth was a gift to the Monastery of St. Cyril of the White Lake Monastery from Irina Fedorovna Godunova. It entered the Russian Museum in 1923. The saint is represented full length, wearing a cloak, and a head-dress resembling a turban. She holds a cross and is crowned by two flying angels. On either side of her head are inscribed plaques. The cloth is skillfully embroidered on a cartoon showing features characteristic of the Godunov workshop.

The original background has been preserved only under the embroidery and the inscribed plaques. The figure of the saint now appears on the dark blue lining laid under the background for convenience while embroidering. The settings of the nimbuses and the crown would have contained pearls, and the points of the crown would have been surmounted by large pearls. The cloth was restored in 1928 and in 1976-79.

The work was originally kept in the Church of the Transfiguration in the Monastery of St. Cyril of the White Lake. There were two side chapels in this church, one dedicated to St. Nicholas and the other to the Great Martyr Irina. The iconostasis of this church also contained an icon of the martyr Irina.

The monastic inventory mentions the cloth among the contents of the sacristy in the 18th century: 'Cloth, damask, color dark pink, with image of the martyr Irina and two angels at the sides.'

Irina Fedorovna Godunova was the sister of Boris Godunov and the wife of Fedor Ivanovich, son of Ivan the Terrible by his first wife, Anastasiia Romanovna. Fedor Ivanovich became tsar after the death of his father in 1584, and died himself in 1598. Irina Fedorovna then took the veil at the Novodevichii Convent in Moscow under the name of Alexandra, and the cloth was probably embroidered during this period.

Liudmila Likhacheva

Icon cloth (*pelena*)

68 cm x 70.5 cm
Damask embroidered with silk, silver, and gilt threads

Inventory No.
ДРТ 36

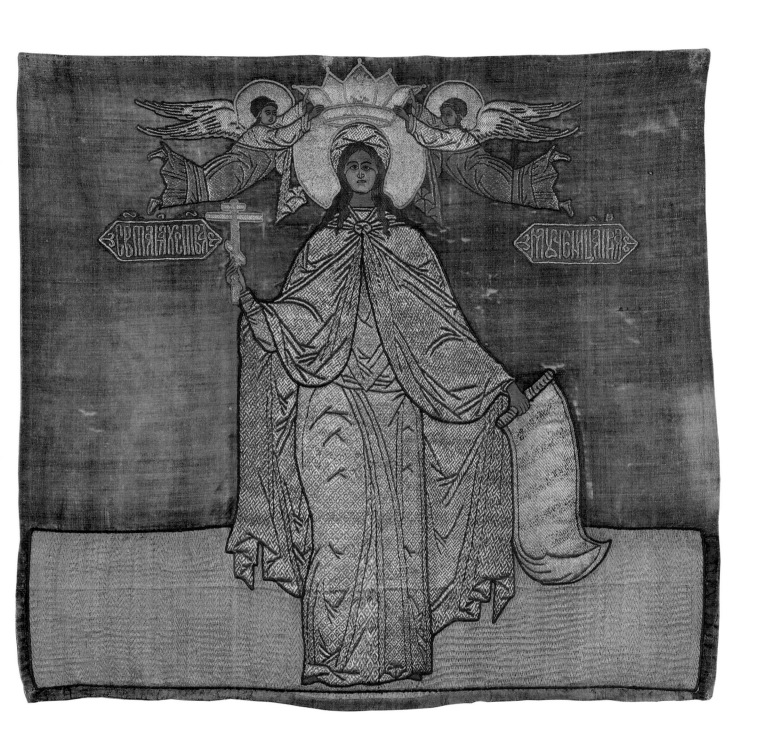

THE PRAISE OF THE MOTHER OF GOD

Moscow
1550–70

The centerpiece of *THE PRAISE OF THE MOTHER OF GOD* and the border scenes illustrating the hymn *Akathistos* form a single image filled with symbols. The Mother of God sits in the center on a high throne with a skein of purple yarn in her hand. As in the Annunciation, she is slightly turned to the right, raising her right hand to her breast with the palm outward, a gesture signifying acceptance, submission, and modesty. Around her are 11 prophets offering to her open scrolls with their prophesies of the coming of Christ, and the symbolic attributes ascribed to her from the Old Testament.

This icon was cleaned in the Russian Museum in 1961-64 by I. P. Iaroslavtsev. It is in a good state of preservation, although there are slight abrasions and traces of the nails from the lost silver revetments. There are also small insertions of gesso with later overpainting, particularly in the figure of Christ Emmanuel in the center.

The icon is from the local tier of the iconostasis in the Cathedral of Dormition in the Monastery of St. Cyril of the White Lake. It was the fourth image on the left of the sanctuary doors, between the icon *ST. CYRIL OF THE WHITE LAKE WITH SCENES FROM HIS LIFE* and the northern door to the sanctuary. Its position there is documented from 1601 to 1924, when along with other icons it was removed from the monastery and placed in the Central Restoration Workshop in Moscow. While *THE PRAISE OF THE MOTHER OF GOD* was undisturbed for centuries in the iconostasis, there is no documentary evidence of when it was acquired by the monastery. N. K. Nikolskii, who studied the monastery before the revolution of 1917, thought that the icon had been brought there in 1568 by Ivan the Terrible for his personal cell. He cited an entry in the register of donations, but this refers to an icon with a gilded background, while the present icon has a green background. In addition, this is a large icon for a church iconostasis, not for a small monastic cell. Its style and quality point to a major workshop in the capital, and it may well have been donated by the tsar or his family. In the 16th century the Monastery of St. Cyril was in close contact with Moscow. The register lists many donations including one from the tsar. The icon was among the most venerated in the monastery and was repeatedly adorned with rich revetments and precious decorations. The monastic inventory states: 'The local icon *PRAISE OF THE MOTHER OF GOD WITH SCENES* in a silver-gilt case with tooled halos, hung with 13 entwined silver-gilt pendants, with a silver cross of fine work set with sard and another cross carved in bone and set in silver-gilt thread. The same icon has an everyday cover of silk in green and yellow, with a red velvet cross enriched with gold embroidery. Another cover is of gold-embroidered velvet of green and red silk with a white calico cross.'

When the iconostasis was rebuilt in the 18th century the number of local icons was considerably reduced, but the *PRAISE OF THE MOTHER OF GOD* was restored to its former place.

146 cm x 112.7 cm x 3.5 cm
Panel of three boards with two inset struts.

Inventory No.
ДРЖ 1834

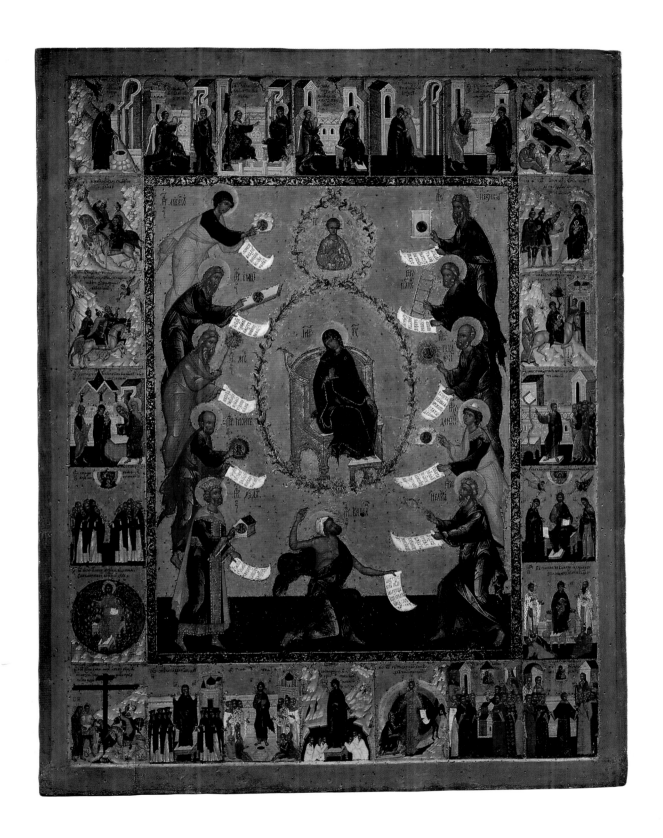

Judging by the traces of silver and nails found in the process of conservation, the icon must have had two different revetments in the 16th century. The first was probably made at the same time as the icon itself. The second, of late 16th century origin, may have been ordered by the monastery in Moscow. In the mid-17th century the icon was adorned with a new chiseled silver cover, one of the best in the iconostasis. The workmanship of the preserved revetment is close in style to those of the mid-17th century now kept in the Kremlin Armory. In the process of conservation it was removed from the icon and is preserved in the Russian Museum.

The composition THE PRAISE OF THE MOTHER OF GOD in all likelihood first appeared during the 14th century when a lively interest was shown in the subject of the cycle. The earliest icon of THE PRAISE OF THE MOTHER OF GOD WITH THE AKATHISTOS known in Russia is in the Cathedral of the Dormition in the Moscow Kremlin. Throughout the next century the theme appears frequently in Muscovite art. The iconographic version of the central theme in the present icon comes most probably from the mural in the side-chapel of the Cathedral of the Dormition in Moscow, from the early 1480s.

The center is separated from the borders by a narrow ornamental strip executed in silver on a black background, similar to the traditional decoration of manuscripts or the technique of niello. Around the center are 24 border scenes illustrating the text of the *Akathistos*, a solemn chant in praise of the Holy Mother of God. The Greek word *akathistos* means 'a hymn during which sitting is forbidden'('non-sitting one,' in Church Slavonic). It was first performed on August 7, 626 to commemorate the miraculous deliverance of Constantinople from the hordes of Avars, Slavs, and Persians. The hymn is ascribed to Romanos the Melode. The Orthodox Church includes the *Akathistos* in the liturgy sung on the Saturday of the fifth week of Lent, the Festival of the Praise of

the Mother of God.

The iconographic choice of the border scenes is derived from several sources. They largely follow the compositional scheme of the murals by Dionysii in the cathedral of the Monastery of St. Ferapont. Some of them are modeled on Russian icons of the 15th and 16th centuries. The closest analogies are THE TIKHVIN MOTHER OF GOD WITH THE AKATHISTOS from the Cathedral of the Trinity in Pskov (now in the Pskov Museum) and THE ANNUNCIATION, WITH AKATHISTOS from the Cathedral of the Savior in Iaroslavl (now in the Iaroslavl Museum). All these works may have a single prototype.

The figures in the upper row are, from left to right: Habakkuk, with a mountain; Ezekiel, with a closed gate; Jeremiah, with the stone tablets of the law; Jacob, with a ladder; Aaron, with a blooming staff; Gideon, with a fleece; Moses, with the burning bush; Daniel, with a mountain, David, with the Ark of the Covenant; and Isaiah, with tongs. Kneeling below is Balaam, the Chaldean magus, pointing to the star. All the symbols are represented with blue medallions encompasing half-length images of the Mother of God. The prophets praise her as the sacred 'pre-ordained altar,' as the 'animated temple.' Mary is depicted here without her Child, to emphasize her virginity. Her gesture is the same as that of the Annunciation and symbolizes the Incarnation, recalling images of a 'hall of immortality,' 'a tabernacle adorned,' 'a vessel of the uncircumscribed Godhead.' The half-length figure of Christ Emmanuel above her is a symbol of Christ eternally incarnate.

The young blue shoots springing up around the Mother of God and the Savior remind us of the tree of Jesse, ('There shall come forth a shoot out of the stock of Jesse and a branch out of his roots shall bear fruit.' Isaiah 11:1), as well as of the many comparisons of Christ with the Tree of Life and the Mother of God with a vine or a blossoming paradise.

Consensus of opinion links the icon

with the influence of Dionysii in Muscovite painting. E. S. Smirnova mentioned it as a work of the first half of the 16th century even prior to its cleaning. T. N. Mikhelson and T. V. Nikolaeva referred to it as analogous to the early 16th century work. G. V. Popov dated THE PRAISE OF THE MOTHER OF GOD to the same period, and attributed it to the region of Beloozersk. The mid-century was preferred by E.K. Guseva and the authors of the catalog *Dionysii and Moscow Art*. The monograph on the icon by O. V. Lelikova and G. D. Petrova favors the same period. In its imagery and plasticity THE PRAISE OF THE MOTHER OF GOD is certainly an example of Muscovite culture. Its mastery and deep symbolic conception indicate a metropolitan master. The compositional and painterly characteristics point to the middle or second half of the 16th century when the artists of Moscow were searching for a new style. The involved and tightly packed composition with its multitude of minuscule architectural details, the circumscribed space in some of the scenes, the increased external dynamism, and more extravagant gestures are all familiar from other works of the period. Characteristic of the time is the juxtaposition of a rather spacious centerpiece and densely filled border scenes which no longer form a single space as they did in the works of Dionysii and his circle. The separation is further emphasized by the ornamental strip around the main theme. Volume, depth, and elements of perspective are introduced in some of the scenes to render three-dimensional space in a manner which recalls Cretan icons of the mid-16th century. The painting of the faces and some iconographic variants also show an acquaintance with Balkan, particularly Serbian painting.

All this is evidence of the complex developments in Muscovite art during the middle and second half of the 16th century, when painters were searching for new and original stylistic possibilities within the traditional idiom of the icon.

Irina Shalina

Catalog No. 81

THE NICENE CREED

Moscow Armory School
1668-69

This icon comes from the church of St. Gregory the Neocaesarian in Polianka, Moscow. The icons in the Church were made in 1668-69 by the icon painters of the tsar, headed by Simon Ushakov. They normally began decorating a church with its iconostasis. Ushakov painted two icons for the lower tier: THE MOTHER OF GOD OF KYKKO, which bears the signature of the artist and the date 1668, and THE SAVIOR.

Georgii Terentev Zinovev painted icons for the Deesis, festival, prophets, and patriarchs tiers of the iconostasis, though the list made by A. I. Uspenskii does not specify which ones. Icons were also painted by artists from other centers, including Ivan Karpov and Fedor Popov from Iaroslavl. Uspenskii does not name the other painters, but says that the Church of Gregory the Neocaesarian 'is the only one in Moscow... where the best and most splendidly executed works of the painters of the tsar have survived in such abundance.' There is no doubt that the other images on the church walls and in the chapels were the work of the tsar's painters. For this reason THE NICENE CREED can be dated to 1668 or 1669. It was not part of the main iconostasis which was finished in 1668, following the date on the THE KYKKO MOTHER OF GOD. THE NICENE CREED was behind the right choir, while its paired icon OUR FATHER was behind the left choir. Apart from the traditional images on the iconostasis, a large number of icons were made to depict various complex subjects and illustrate the texts of psalms, hymns, and prayers. The following icons are now accessible for study and have been cleaned of overpainting: THE TEN COMMANDMENTS OF JOY (History Museum, Moscow); THE ONLY SON (Tretiakov Gallery); and two icons belonging to the Russian Museum, OUR FATHER and THE NICENE CREED.

The Nicene Creed is a brief statement of Orthodox religious dogma, approved by the First Council of Nicaea in 325 and the Second Council of Constantinople in 381. It consists of 12 parts, or clauses proclaiming belief in the triune God: the Father, who created the world; the Son, who descended to earth, was born of Mary, crucified, rose from the dead, and ascended to heaven, who shall come to earth a second time and judge all the living and the dead; and the Holy Spirit which emanates from God the Father. In a local church council held at Toledo in 589 an addition was made to the Creed stating that the Holy Spirit did not only come from God the Father, but also from God the Son. This addition, never accepted by the Orthodox Church, is the source of a major doctrinal dispute between Orthodoxy and the West.

The Nicene Creed is included in the divine liturgy, and is sung at the very beginning of the service by all those who have been baptized. Icons illustrating the Nicene Creed have been known since the 16th century, but were not common in Russian iconography until a century later. In his description of Novgorod antiquities, Archimandrite Makarii named two such icons, one in the Cathedral of St. Sophia and the other in the Church of Elijah in Slavna. In Moscow, the summer church of the Old Believers' cemetery at Rogozhskoe had an icon of the Creed with a striking miniature

130 cm x 77 cm x 2.5 cm
Panel of three boards with three inset struts.

Inventory No.
ДРЖ 2773

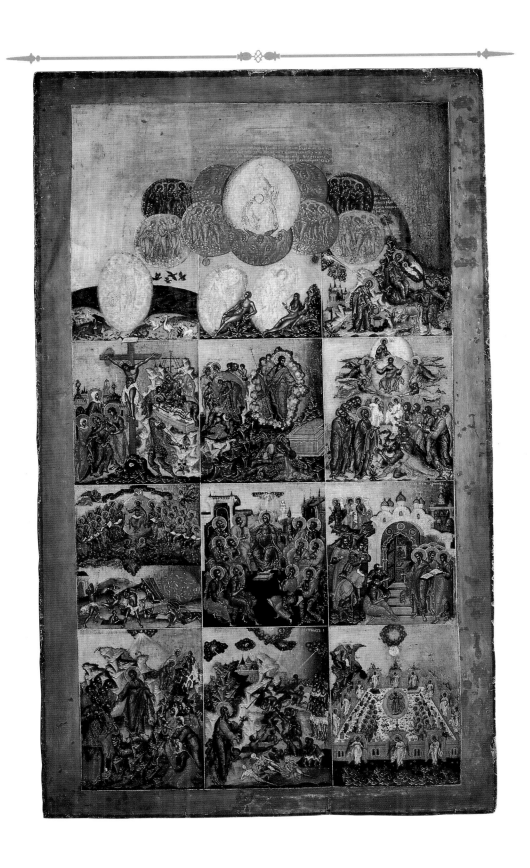

brushstroke and in splendid condition, the work of a 17th century court painter. There are two icons of that name at the Tretiakov Gallery, one of the Stroganov school of the late 16th century from the collection of A. V. Morozov and the other of the late 17th century Northern school. The Church of John the Baptist in Iaroslavl and the Cathedral of the Transfiguration in the Monastery of Solovki each had one such icon dating from the 1680s. In the 18th and 19th centuries, graphic works and icons devoted to the Nicene Creed became widespread.

The icon of the Nicene Creed is divided into three registers with three scenes in each. The upper three scenes are united by an image illustrating the first clause of the creed: 'I believe in one God the Father Almighty, the Creator of heaven and earth, and in all things visible and invisible.' Represented here is Sabaoth with a depiction of the infant Christ on his chest, and with the Holy Spirit depicted as a dove in a shining white mandorla surrounded by the nine small circles of the invisible heavenly powers. The celestial hierarchy is of nine orders and three ranks: the highest (seraphim, cherubim, and thrones), the middle (dominions, virtues, powers) and the lowest (principalities, archangels, and angels).

Below are three white ellipses showing God the Father as he created the world (Genesis 1: 1-12, 20), and Adam and Eve, the first man and woman (Genesis 2: 4, 21). These represent the second clause of the Creed.

The third clause is illustrated in a border scene which combines two subjects: the Annunciation and the Nativity of Christ. In the Annunciation, Mary stands by a well and turns to the Archangel Gabriel, who flies towards her tell her of the birth of her son. The Annunciation is a turning point in the Christian history of salvation, marking the transition from the Old Testament to the New Testament. In the Nativity of Christ, the Mother of God sits on a bed against a background of small mountains and a cave. She watches her swaddled son, who is lying in the manger with an ox and an ass leaning over him. Joseph sits to the right, and next to him is a shepherd in animal skins.

Two compositions illustrate the fourth clause of the Creed: the Crucifixion, and the Entombment. On the left is a long cross with the figure of Christ crucified. Further to the left, the Mother of God is supported by St. John the Divine and a holy woman, with another woman behind them. In the foreground, a soldier has pierced the side of Christ with a long spear, and blood and water are flowing from the wound. Above this scene, against a background of architectural structures and a thin cross, is the tomb where the body of Christ is laid by St. John and Joseph of Arimathea.

The fifth clause of the Creed is represented by the Resurrection and the Descent into Hell, while the sixth clause is represented by the Ascension. The seventh clause is illustrated by the Last Judgement and the Raising of the Dead, and the eighth clause by Pentecost, in which 12 apostles headed by the Mother of God are sitting in pairs on a semicircular bench. The architectural background is formed by two chambers connected by a white wall with peaked domes.

The ninth clause of the Creed is illustrated by the Ecumenical and Apostolic Church, followed by the tenth clause, 'I confess one baptism for the redemption of sins.' The eleventh clause of the Creed is represented by the vision of Ezekiel, and the final scene depicts the Heavenly Jerusalem and Life Everlasting.

The model for the icon of the Nicene Creed is the Piscator Bible which is illustrated with engravings by Dutch artists of the mid-16th and early 17th centuries. It was produced by the publisher Klaas Jans Vischer (Piscator) and published by his son in 1614. The editions of 1643, 1646, 1650, and 1674 were popular in Russia, where artists used the engravings as models. In many cases, the engravings were freely adapted, and in the first two scenes of the icon (the Creation of Heaven, Earth, and the Animal Kingdom; and the Creation of the First Peo-

ple) several engravings have been combined. The twelfth scene (the Heavenly Jerusalem) is among the closest to the original.

The icon of the Nicene Creed is a characteristic example of a certain type of icon painting from the second half of the 17th century, a complicated and controversial period. The iconography of that time became increasingly narrative, movement and feeling were mostly conveyed through gesture, and the illusion of depth and perspective was introduced largely by means of color. A timid attempt at rendering volume was made in depicting faces. Abundant use of gold and combinations of green, vermillion, and crimson were among the favorite devices of these painters.

The present icon of the Nicene Creed has repeatedly been mentioned and reproduced in literature, but no publication has been specifically devoted to it. V. G. Briusova, who compared the icon with the works of Gurii Nikitin has come to the conclusion that some border scenes of the icon were painted by him. Another paper by Briusova attributes the icon as a whole to Simon Ushakov, Gurii Nikitin, and their associates, and the detail of the Last Judgement perhaps to Simon Ushakov and Leontii Stefanov. No arguments are provided to support the attribution.

The icon was received by the Russian Museum after the exhibition tour of 1929-32, and had been restored and cleaned of later layers of paint before then. There is some loss of surface in the borders and the background, and there are insertions of gesso and numerous nail holes. An elliptical insertion of canvas with overpaint, differing from the original in color, can be seen on the right hand of Christ in the Crucifixion. Small bits of gesso on the edges of the icon have chipped off. A dent in the gesso is visible in the scene of the Last Judgement. The layer of varnish covering the icon is uneven and the reverse of the panel is painted an impure blue. There are two red wax church seals with a picture of a single-domed church under the upper and middle struts.

Alevtina Maltseva

'PRAISE THE LORD'

Vologda
Second half of 16th century

The framed rectangular icon is carved from walrus ivory. The composition *PRAISE THE LORD* illustrates the text of Psalm 149: 'Praise ye the Lord from the Heavens: praise him in the heights. Praise ye him, all his angels: praise ye him all his hosts. Praise ye him, sun and moon: praise him, all ye stars of light. Praise him, ye heavens of heavens, and ye waters that be above the heavens . . . Mountains and all the hills; fruitful trees and all cedars. Beasts and all cattle; creeping things, and flying fowl. Kings of the earth, and all people; princes, and all judges of the earth. Both young men and maidens; old men and children.'

The composition is surmounted by two unfurled scrolls, one of which bears the text of the psalm, while the other is the celestial scroll studded with stars and with lamps at its side.

In the upper part of the icon, Christ Emmanuel is depicted enthroned on a rainbow in the radiance of his glory. His right hand is raised in blessing and his left hand holds a scroll. His Mother, John the Baptist, and the angels turn to him in sup-plication. Prophets, apostles, and saints are shown in the lower tiers. The center of the icon depicts mountains, trees, the waters 'that are above the heavens,' plants, birds, and beasts. The entire natural world is shown praising the Lord.

The relief of the icon is quite low, the shapes being emphasized by grooved hatching. The clothing of the figures is decorated with 'eyelet' ornamentation.

The iconographical and stylistic features of the work warrant its attribution to northern Russia, most probably Vologda during the second half of the 16th century.

Izilla Pleshanova

10.4 cm x 8 cm x 0.7 cm
Carved ivory.

Received from the collection of the Archaeological Society in 1925.

Inventory No.
ДРК 40

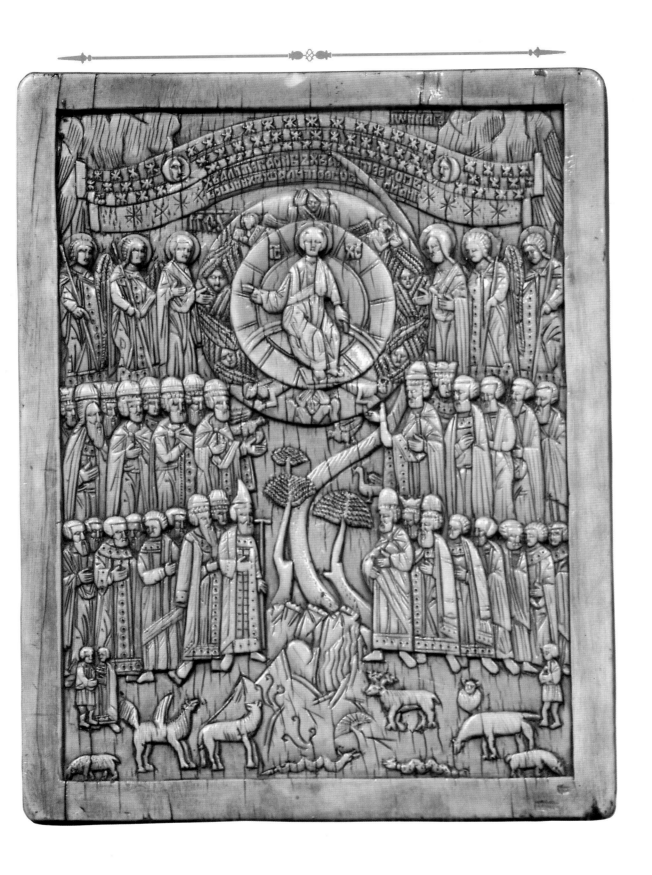

'IN THEE REJOICETH'

Vologda
Second half of the 16th century

The icon is carved from walrus ivory, and illustrates the text of a hymn addressed to the Mother of God: 'In Thee rejoiceth, Blessed One, all creation, the company of angels and humankind: Holy temple and earthly paradise, glory of virginity, from Her was incarnated our God... .' The literary basis of the composition is the hymn from the *Oktoechos* sung during the Liturgy of St. Basil the Great. The

Holy Mother is enthroned in radiant glory in the upper part of the icon. The aureole on which the words of the hymn are inscribed is surrounded by angels. The author of the hymn and of the entire *Oktoechos*, St, John of Damascus, is shown unfurling a scroll at the foot of the throne; he is followed by the New Testament prophet, St. John the Baptist. At the right are figures of nuns, with the inscription *glory of virginity*, while around the foot of a rocky hillock a crowd of people jostles together, representing the human race. The dome of heaven rises above the earthly paradise, the Garden of Eden, and amid the trees of the garden stands a building with five domes which represents the Church. The images therefore provide a literal illustration of the passage from the *Oktoechos*, and at the same time reflect the artist's conception of the cosmos and the role of virginity in restoring it to a state of paradise.

The iconography of the composition 'In Thee rejoiceth' emerged towards the end of the 15th century and became widespread during the 16th. A characteristic feature of miniature plastic works of the middle and second half of that century is a predilection for the themes of Psalm 149 (*Praise ye the Lord*), and the hymn *In Thee rejoiceth*. The two themes are often represented together in folding icons (*skladni*).

Certain features of this icon, including the proportions of the figures, the low but elaborately carved relief, and the ornamentation, justify ascribing the icon to the school of Vologdian carved miniatures of the second half of the 16th century.

Izilla Pleshanova

12 cm x 8.9 cm x 0.7 cm
Carved ivory.

From the collection of Bazilevskii, received from the State Hermitage in 1930.

Inventory No.
ДРК 41

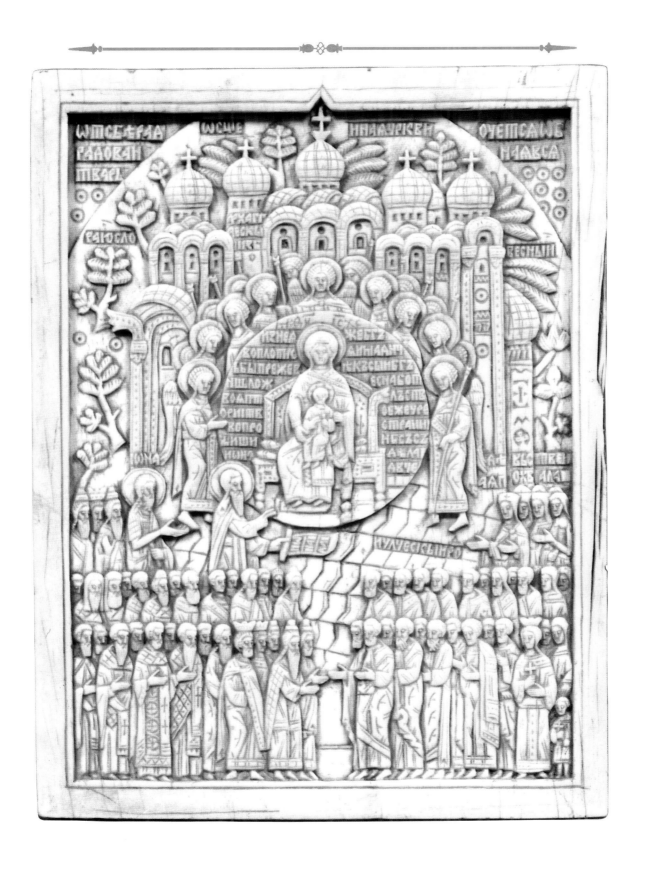

THE VLADIMIR MOTHER OF GOD

Simon Ushakov
Moscow Armory
1662

Simon Ushakov was a celebrated icon painter appointed by the tsar to the Armory of the Moscow Kremlin. His origins have not so far been accurately determined, but it would seem that he came from landed gentry. Inscriptions on the icon of THE SAVIOR painted in 1684 and now in the Cathedral of the Trinity-St.Sergei Monastery mention relatives of the artist, among them several monks and a merchant.

In an inscription which has survived on another icon, the painter is described as a nobleman. In the 17th century titles of nobility were granted as a reward for special distinction to other painters of the Armory like Ivan Bezmin and Ivan Saltanov.

From 1648 to 1664 Ushakov worked as a standard maker in the Silver Chamber, where he produced designs for the royal plate, jewelry, and various works of applied art. In 1664 he was transferred by the decree of the tsar to the Armory, where he directed icon painting for many years. His creative life was full and varied; he decorated and restored churches, and worked at miniature illuminations, engraving, and icon painting. He painted portraits of Tsar Alexei Mikhailovich. The tsar, the tsaritsa, and the patriarch were among his clients. He often painted for the boyar B. M. Khitrovo, who was for many years in charge of the Armory, and maintained a friendship with his relative Hieromonk Ilarion, the bishop of Suzdal and founder and abbot of the Florishchev Monastery, for whom he also painted several icons.

Ushakov was a gifted teacher and many of his pupils became famous icon painters, including Georgii Zinovev, Ivan Maksimov, and Mikhail Maliutin. The names of Simon Ushakov and the icon painters of the Armory are associated with the use of true perspective and three-dimensional modelling based on European models.

This icon has an inscription on the obverse bottom center, two lines written in white semi-uncials: *In the year 7170 [1662 AD] the painter and scribe Simon son of Fedor Ushakov at the Monastery of the Presentation of Christ painted this icon after the Wonder-Working Holy Mother of God of Vladimir, at the behest of Abbot Dionysii of that monastery.*

According to the inscription, the icon was ordered for the Monastery of the Presentation in Moscow. In the 19th century it was in the collection of N. M. Postnikov, and it came to the Russian Museum in 1913 from the collection of N. P. Likhachev.

The icon was restored and cleaned before it reached the Museum. The outlines of the eyebrows of the Mother of God have been altered several times, the robes of the saints have been repainted, and nearly all the supports are later additions. The outlines of the facial features and the girdle, cowl, and wristbands of the Mother of God have been renovated. A microscopic examination of a section of the inscription has revealed that the lettering was added later and cannot be attributed to the painter.

101 cm x 69 cm x 3 cm
Panel of three boards with two inset struts.

Inventory No.
ДРЖ 2100

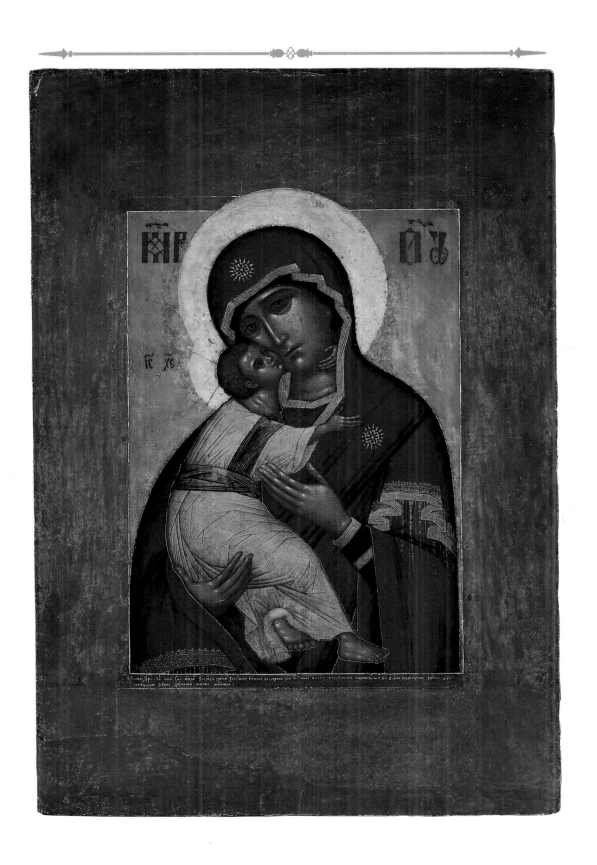

The icon was restored in the Russian Museum in 1913-16. A technical examination was carried out by O. V. Golubeva and R. A. Kesarev in 1990.

The background, borders, and halos contain holes from the nails which held the metal casing and the superimposed nimbuses, and these have been filled and painted. The ends and sides also bear traces of nails and an actual nail from the casing, which is missing. There is a large insertion of gesso in the lower background.

Iconographically, the Vladimir Mother of God is a variant of the Mother of God of Tenderness (*Eleousa*), which assumed its final form in Byzantine art during the 11th century. The present icon is a version of the famous 12th century icon of the same name which was preserved in the Cathedral of the Dormition in the Moscow Kremlin. According to tradition, this icon was painted by St. Luke the Evangelist. In the 1330s, it was brought to Russia and installed in Vyshgorod near Kiev, but in 1155 Prince Andrei Bogoliubskii transferred it to Vladimir on the Kliazma and installed it in the Cathedral of the Dormition, where it was consecrated, acquired special renown, and given the additional name of *Vladimirskaia*. The icon became the foremost object of veneration in the Vladimir-Suzdal region and later throughout Muscovite Russia.

The Russian Orthodox Church commemorates the icon of the Vladimir Mother of God three times a year, on June 23, May 21, and with particular solemnity on May 26, in memory of the miraculous deliverance of Moscow from the invasion of Tamerlane during the reign of the Grand Prince Vasilii I. As the enemy advanced on Moscow, the clergy were sent to Vladimir to bring the miraculous icon in the hope of obtaining its support and protection. According to tradition, at the moment the icon was greeted at Kuchkovoe, Tamerlane was dozing in his tent and saw a vision of a majestic woman clothed in radiant light who ordered him to leave Russian territory. When the diviners of his dream told him that 'the radiant woman was the Mother of God, the great protectress of Christians,' Tamerlane gave the order to retreat, much to the astonishment of the Russian armies. In commemoration of this event, the Monastery of the Presentation was founded at Kuchkovoe, and a festival of the Presentation was instituted with a special procession of the icon from the Kremlin to the monastery. Replicas of the icon were made, of the same size as the original or smaller, and one of the first was painted by Andrei Rublev. Simon Ushakov also painted versions of the original on several occasions, including 1652 for the Church of Archangel Michael in Ovchinnikii, and 1662 for the Monastery of the Presentation at the order of Abbot Dionysii.

The style used in this work is very close to the traditional iconography. The painting is severe, particularly in the treatment of the face of the Mother of God, although the painting of her fingers is softer and more three-dimensional.

The icon is frequently mentioned in specialist literature but no publication has been entirely devoted to it. All the researchers, including N. M. Postnikov, N. P. Likhachev, N. P. Kondakov, A. I. Nekrasov, M. K. Karger, and Iu. G. Malkov, accept the attribution to Simon Ushakov and the date given in the inscription.

Alevtina Maltseva

ST. GEORGE AND THE DRAGON

Nikifor Istomin Savin
Stroganov School
First half of 17th century

The provenance of the icon is unknown, but during the 19th century it was in the collection of Count S. C. Stroganov (1794-1882). It was restored prior to its acquisition by the Russian Museum. The painting and gesso were transferred to a new panel, and the gold *assist* and inscriptions retraced. The nail holes from the revetment and the cracks were filled and retouched. The reverse

has an inscription on the upper strut: *painted by Prokopii Chirin.* This must be a record of an earlier attribution made during a restoration carried out at the turn of this century. The icon was later attributed to Nikifor Savin, which still seems to be correct.

Sergei Grigorievich Stroganov was a prominent figure in Russian culture in the 19th century, a patron of arts and a connoisseur of Russian antiquities and numismatics. He was also chairman of the Moscow University Society for History and Russian Antiquities and founder and chairman of the Imperial Archaeological Commission. He sponsored the publication of Antiquities of the Russian State from 1839 to 1853 and wrote a book about the Cathedral of St. Demetrios in Vladimir. He founded the first drawing school in Moscow, and had an immense numismatic collection which is now in the Hermitage. He also increased the family collection of Western European art which adorned the Stroganov Palace in St. Petersburg.

As the trustee of the Moscow educational board, he began collecting icons. His collection became widely known and

was later moved to the Stroganov Palace in St. Petersburg. Of the greatest interest in the collection were the icons of the so-called Stroganov school dating from the late 16th and early 17th centuries. A feature of the group is that many of the icons are signed by the artists on the reverse, or display inscriptions mentioning the persons who commissioned them. Among the artists are Semen Borozdin, Istoma, Nazarii and Nikifor Savin, Semen the Lame, Emelin Moskvitin, Persha, and Pervusha. Most of these icons are of excellent quality and establish the reputation of the Stroganov school.

The present icon can be ascribed to Nikifor Savin. In its style it is close to the better known ST. THEODORE TERON AND THE DRAGON, although it is hardly inferior in quality. Both works have a fairy-tale character, with bright clear colors, and highly refined forms. They are also similar in the proportions of the figures, in the gestures, in the repetition of the same facial type with small features, in the outline of the heads with wide foreheads, and in the architectural details.

Under the hand of a Stroganov artist the traditional austere composition has lost its

35.4 cm x 30 cm x 2.6 cm
Single panel with two struts.

Inventory No.
ДРЖ 1039

277

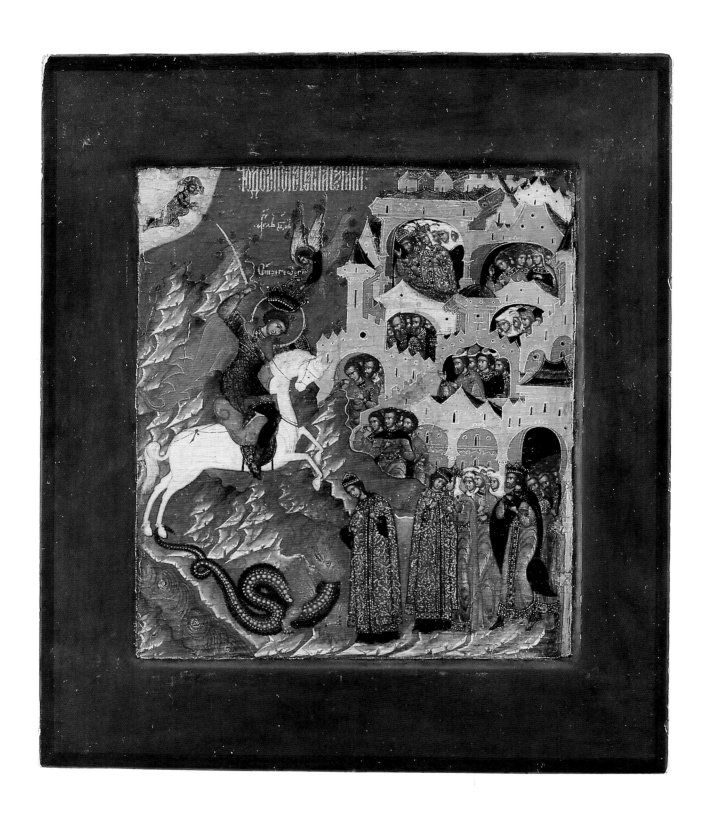

278

epic character. The triumph of the saint is witnessed by a multitude of onlookers. The crowded city, the king, the princess, and a throng of their courtiers take up a large part of the composition. The mounted figure of St. George has been ousted by them from the center and holds its own only through its size. An angel crowns the victor whose raised sword points to the upper corner of the icon where the hand of Christ can be seen.

The most recent cleaning was carried out at the Russian Museum in 1981-83 by S. I. Golubev.

Tatiana Vilinbakhova

THE TSAREVICH DMITRII AND PRINCE ROMAN OF UGLICH

Prokopii Chirin
Stroganov School
First half of the 17th century

Tsarevich Dmitrii (1583-91), was the youngest son of Ivan the Terrible by the tsaritsa Maria Fedorovna Nagaia. After the death of his father, Dmitrii was allotted the principality of Uglich as his domain, and he died there before the age of eight. As the last of the royal line of Riurik and heir to the throne, he was a real threat to the rule of Boris Godunov, and popular opinion accused Boris of

murdering the boy. At the present time, historians are inclined to assume that he died accidently in an epileptic fit. In 1606 the tsarevich was canonized as a martyr who suffered at the hands of hired assassins. His remains were moved from Uglich to Moscow and solemnly buried in the Cathedral of the Archangel in the Kremlin. When his coffin was opened by Soviet historians, his mummified body was still clad in royal robes of gold and purple, with a golden belt and red leather boots. This is precisely how he was represented in the portrait icon over the sepulcher.

After his canonization, his *Life* was written and a service composed to honour for the 'new Wonder-Worker.' The people of that age thought of the martyred tsarevich as the patron of the dynasty, the invincible protector of the Russian state. The *troparion* in his honor declares, ' . . . pray for the realm of your house to deserve God's grace and for the sons of Russia to obtain salvation.'

During the 17th century Tsarevich Dmitrii was among the most venerated Russian saints. He was the patron saint of Dmitrii Andreevich Stroganov (d. 1673), and this explains why the masters of the Stroganov school often painted his image.

His icon by Nazarii Istomin Savin, 1621-22, was in the local tier of the iconostasis in the Cathedral of the Annunciation in Solvychegodsk, which was the shrine of the Stroganov family. The icon is a very close replica of the icon over sepulcher of the tsarevich in the Cathedral of the Archangel in the Moscow Kremlin. This icon by Prokopii Chirin is drawn from the same source.

Prince Roman, who lived in the 13th century was the second son of the prince of Uglich, Vladimir Konstatinovich. Roman ruled the principality between 1261 and 1265. He devoted the last years of his life to building churches and monasteries and to charitable activities. According to popular belief, it was his prayer that saved Uglich from the Mongol invasion. He was buried in the Cathedral of the Transfiguration in Uglich. In 1605 his mummified relics were examined by the metropolitan Germogen of Kazan, his *Life* was written, and a service dedicated to him. The wise, humble, and merciful prince was remembered as a builder of churches and hostels for pilgrims.

In this icon the two saints pray to the image of THE MOTHER OF GOD OF THE SIGN, which was believed to have saved Nov-

29.8 cm x 23 cm x 3.4 cm
Single panel with two struts.

Inventory No.
ДРЖ 2053

gorod during a siege in the 12th century. Their faces are turned to the Mother of God, their upraised hands express supplication, humility, and acceptance of the will of God. Honoring the convention that an expression of feeling should be reserved, the artist avoids affectation of gesture, but seeks to depict the harmony between body and spirit.

The technique employed is refined and highly involved. A multitude of intricate ornamental patterns in the robes was executed with a thin brush. The paint was applied in many layers including gold, silver, and colored lacquers. A tinted ground under the gold and a niello pattern above it help to create a shimmering surface.

The first to attribute the icon to Prokopii Chirin was N. P. Kondakov. V. I. Antonova confirmed the attribution on the basis of its stylistic similarity to another signed work by Prokopii Chirin *St. Demetrios of Thessalonike and Tsarevich Dmitrii* in the collection of P. D. Korin. The icons are similar in both style and technique, having ocher grounds and borders intended to be overlaid by silver revetment. The difference is that St. Demetrios of Thessalonike was replaced in the pre-sent icon by a Russian saint, thereby emphasizing the idea of saints praying for their homeland. This concept was particularly important during the troubled times in which the icon was painted, one of the most dramatic periods in Russian history, with invasions from Poland and Sweden causing terrible devastation.

The icon was given to the Russian Museum by the emperor Nicholas II in 1912. Imperial donations to the Museum were frequent at that time, the emperor buying icons from well-known collectors or restorers and presenting them to the museum.

In this case the icon had been acquired. from the restorer and icon painter G. O. Chirikov, and it was cleaned and restored prior to being given to the Museum. The ornament in the robes and the inscriptions were retraced and the lost right hand of St. Roman was restored. The remaining overpainting and darkened varnish were removed in 1981 by R. A. Kesarev. In the spots where the original paint had been lost, the 19th century overpainting was preserved. The nail holes were filled.

Tatiana Vilinbakhova

ST. THEODORE TERON AND THE DRAGON

Nikifor Istomin Savin
Stroganov School
First half of the 17th century

Nikifor Savin ranks among the most renowned masters of the Stroganov school of painting. He was born into a family of icon painters who received commissions from the Stroganov family. The dates of his birth and death are unknown, but his name is inscribed on the reverse of many icons, including examples in the Tretiakov Gallery, the collection of P. D. Korin in Moscow, and the Perm Art

Gallery. There are six icons in the Russian Museum that can be ascribed to him. His work can be identified either from the inscriptions on the reverse or by a stylistic similarity to icons that have been signed by him. To judge by the inscriptions on the icons in the Perm Gallery, one of his patrons was Nikita Grigorievich Stroganov, whose name is associated with the largest number of icons of the Stroganov school.

The icon of ST. THEODORE TERON AND THE DRAGON belongs among the best known paintings by Nikifor Savin. As with all his other work, this icon is distinguished by its masterful execution, subtle graphic elaboration of forms, and sophisticated ornamentation. His images are notable for their accentuated refinement; graceful figures in light flowing garments tread the earth while seeming scarcely to touch it.

According to his *Life*, St. Theodore was a warrior in Alasia, in Asia Minor. He was tortured for his faith and sentenced to be burned alive. His body, undamaged by fire, was buried in Euchaita (ca. 306) and his relics were later transferred to Constantinople. The commemoration days of St. Theodore Teron are February 17 and the first Saturday of Lent. His *Life*, the original version of which is ascribed to St.

Gregory of Nyssa, has many features in common with the *Life* of another St. Theodore, St. Theodore Stratelates. A popular characteristic of both Lives is the account of single combat between a holy warrior and a dragon. A story of St Theodore Teron and the dragon appeared in the Russian *Prologue* in the 12th and 13th centuries. This same subject was later to lay the foundation for an apocryphal story that became widespread in the literature of the 16th and 17th centuries. According to the legend, the mother of St. Theodore descended into a well in search of a lost horse. She then fell into the clutches of the devil, who tempted her with the crown of the mistress of hell. St. Theodore went down to the dragon's lair and challenged it to a duel, which ended with the victory of good over evil and the release of his mother.

Several episodes from the legend are depicted in the present icon, but they do not adhere to the conventional sequence of events characteristic of the hagiographical genre. On the contrary, the order is dictated purely by artistic design. The most important events are arranged in the composition through the depiction of a hill, the top of which is placed in the center and the slopes in the lower part of the icon. This

35.8 cm x 30.5 cm x 2.5 cm
Single panel with
two struts.

Inventory No.
ДРЖ 2146

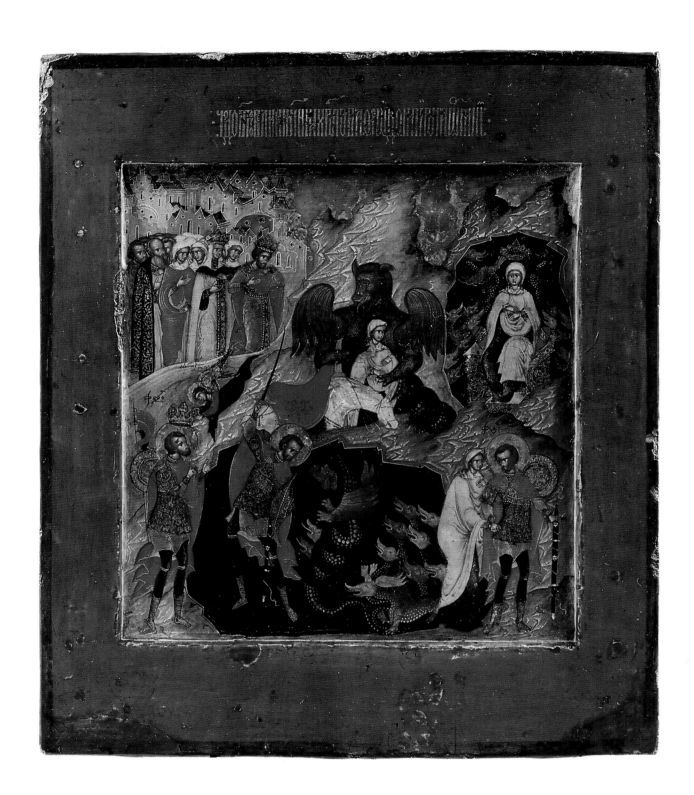

type of arrangement of the pictorial surface is frequently found in the manuscript illustrations of the 16th and 17th centuries.

The more important episodes are depicted in the lower part of the icon: St.Theodore's descent into the abode of dragons, his combat with them, and the rescue of his mother. The central part of the icon is occupied by a large dragon, in whose clutches the small figure of a woman appears weak and fragile. Clad in white garments, she symbolizes a pure soul fallen into the power of the devil. The use of contrast or correspondence plays an important part in the unfolding of the design. The story relates how, after he reached the dragon's lair, St. Theodore saw his mother seated on a throne and wearing the crown of the mistress of hell. This scene corresponds to another, set in the lower corner, where St. Theodore is standing with his arms raised in a gesture of prayer, while an angel descends from heaven to crown him. With divine assistance the saint rescues his mother and conquers the devil, but while the triumph of good over evil is clearly revealed in other icons from the very beginning, as with ST. GEORGE AND THE DRAGON, in this icon it is the moment of combat that is emphasized. The icon is obviously exhortative, and is intended to warn people against the temptations and snares of the devil.

Unlike St. Theodore Stratelates, St. Theodore Teron was a rare subject in Russian icon painting. He is usually depicted full-length, dressed in armor, and with other saints. The present icon is therefore especially striking. We know only one earlier icon of this theme, an early 16th century version now in the Russian Museum, and its iconography differs considerably from that employed by Nikifor Savin. It seems probable, therefore, that his icon of St. Theodore together with his icons THE SLAUGHTER THE HOLY FATHERS IN SINAI AND RHAITHOU and THE STORY OF JONAH, should be considered as original contributions made by an artist of the Stroganov school to the iconographical canon of medieval Russian painting.

The panel consists of tempera and gesso over a lime panel with two struts, inserted during the 19th century, and canvas. Inscriptions in ink on the reverse under the upper strut date from the 19th century. The Stroganov collector mark is also present. The icon was restored before its acquisition by the Museum, probably in the 19th century; the background and halos were re-gilded, the areas of losses touched up, the linear design on the gold and other details strengthened, the struts replaced, and the nail holes of the lost *oklad* filled. The icon was acquired from the Museum of Christian Antiquities of the Imperial Academy of Arts in St. Petersburg in 1898.

Tatiana Vilinbakhova

THE ACTS OF THE PROPHET JONAH

Stroganov School
First half of the 17th century

The prophet Jonah was commanded by God to deliver his message in the Assyrian capital of Nineveh, but he disobeyed and tried to escape by ship to Tarshish. God then sent a tempest which threatened to overwhelm the ship, and when the prophet told the sailors that the tempest had been sent on his account, he was cast overboard and swallowed by a great fish. For three days and nights he lay

inside the fish, praying for forgiveness, and was finally cast ashore near Nineveh. Although Jonah announced that the city would be destroyed in 40 days and called on the inhabitants to repent, he was angry when they actually did so and proved his prophecy to be false. Through the parable of the gourd (Jonah 4: 6–12), God explained how tragic the loss of such a great city would have been.

As with most Stroganov icons, the present icon displays a detailed narrative and a moralistic character inherited from the period of Ivan the Terrible. An explicit call to repentance was natural during the time of anarchy in which the icon was painted. The endless sufferings which the country endured in those years, including the famine, the struggle for the throne, and the Polish-Lithuanian invasion, were felt to be a punishment for sin and injustice, and reference was frequently made to the biblical story of Nineveh and its theme of repentance. An icon with the story of Prophet Jonah and the city pardoned by God was therefore very topical.

Earlier icons of Jonah were mostly painted for the prophets row of the iconostasis, as a prototype of the advent of Christ. The survival of the prophet in the

belly of the whale for three days was seen as prefiguring the Passion and Resurrection of Christ.

The icon is of unknown origin. In the 19th century it was in the collection of S. G. Stroganov and it was delivered to the Russian Museum from the Stroganov Palace in 1922.

It was cleaned and restored prior to its acquisition by the museum. The numerous small losses of the original painting were left under later overpaint. The rocks, clouds, architectural details, and borders were touched up. New gold was laid on the halos, the butts were painted red, and the traces of the nails from the revetment were filled. New struts were provided, probably at the same time. According to restorer Ia. V. Sosin, conservation work was performed early this century at Palekh, near Vladimir. The village later became famous by producing lacquer miniature, and its artists had a high opinion of the Strogonov school. They followed the Stroganov style in their own work, and often restored Stroganov icons. The present icon is an example of such restoration.

Tatiana Vilinbakhova

35.5 cm x 29 cm x 2.3 cm
Single panel with two struts added in the 19th century.

Inventory No.
ДРЖ 2054

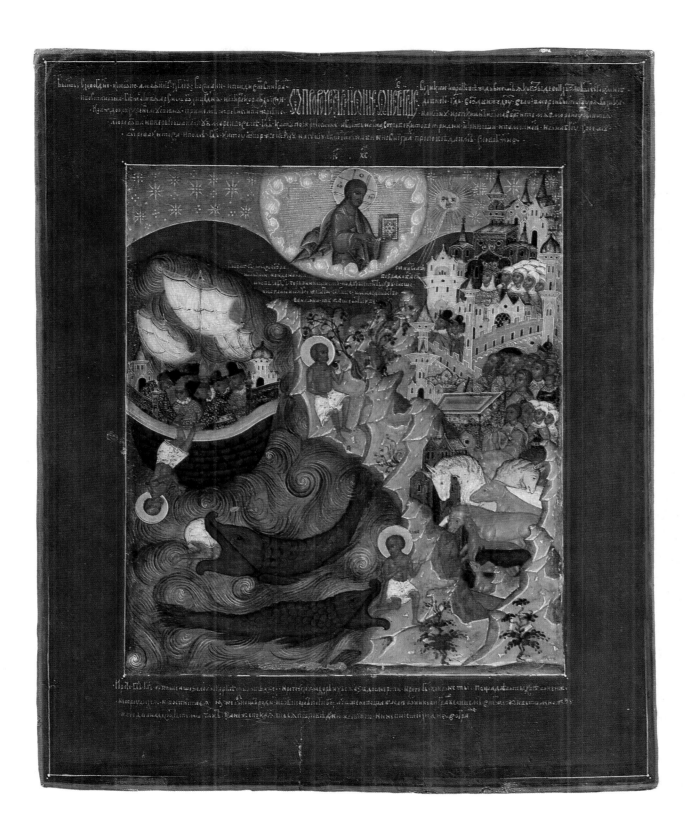

THE SLAUGHTER OF THE HOLY FATHERS IN SINAI AND RHAITHOU

Master Pervusha
Stroganov School
First half of the 17th century

The icon depicts an event commemorated on January 14: the slaughter of monks who lived in the monasteries and caves of Mt. Sinai, and in the desert of Rhaithou beside the Red Sea. The painter has depicted a number of scenes described by the Egyptian monk Ammonios, in which monks are being killed by nomadic barbarians who had arrived by ship from what was called 'the Ethiopian land.' An army was sent to rescue the monks from the city of Pharan and defeated the barbarians. As the barbarians fled to the shore, they discovered that their ship had been stolen by the helmsman in an attempt to escape, and was driven onto rocks by the wind and wrecked. The subject is rare in medieval Russian iconography. In the 16th century, icons depicting the topography of Mt. Sinai were not uncommon. The subject was depicted by the Cretan master George Klontzas and later by El Greco. There is no doubt that such works also found their way north to Russia. When comparing this icon with the views of Mt. Sinai by George Klontzas, one sees a definite similarity in the landscape, especially the rocky terraces crowned by three peaks.

The origin of the icon is unknown, although it was part of the collection of Count S. G. Stroganov. It came to the Russian Museum in 1922 from the Stroganov Palace and the reverse side bears the Stroganov collectors mark in ink under the upper strut. The name of the artist appears in an inscription on the reverse and for many years it was read as *Persha*. During an examination conducted in preparation for the exhibition THE ART OF THE STROGANOV MASTERS, the inscription was inspected in luminescent light and the name was seen to be *Pervusha*. The icon was restored and cleaned of later layers of paint before coming to the Museum. New gold was laid on the background and the halos, and the borders were covered with a thin layer of paint whose shade was close to the original, and then trimmed. The inscription in the top border was corrected, nail holes plugged, and the border painted red. It was apparently at this time that new struts were inserted. In 1940 the icon was again restored by Ia.V. Sosin, who removed the darkened varnish on the overpaint.

Tatiana Vilinbakhova

36 cm x 30 cm x 2.3 cm
Single panel with two struts
added in the 19th century.

Inventory No.
ДРЖ 2144

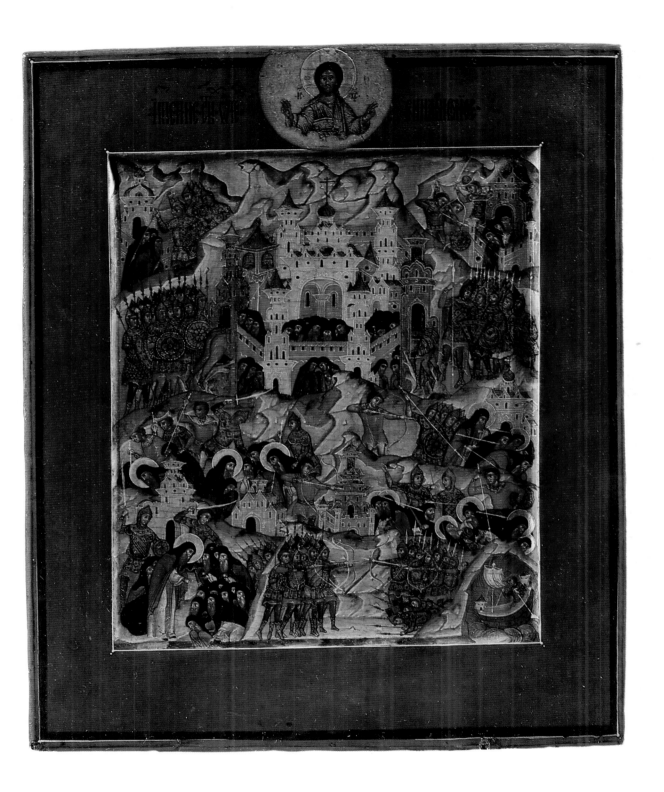

289

DEPOSITION OF THE SASH OF THE MOTHER OF GOD

Master Pervusha
Stroganov School
First half of the 17th century

The Orthodox Church commemorates the Deposition of the Sash of the Mother of God on August 31, a festival which is linked with several events involving the sash. Along with the robe and the veil, the sash of the Mother of God was venerated in Russia following Byzantine tradition as a sacred object which protected the city from enemy invasion. According to the Byzantine historian

Nikephoros Kallistos, the Byzantine emperor Theodosios II (408-50) made a Jewish synagogue in Chalkoprateia into a Christian church and moved the sash to the new foundation.

During the reign of the emperor Leo VI (886–911), the empress Zoe was healed by the sash, and the festival was instituted to commemorate both the miracle and the first and second depositions of the sash. The festival is believed to have been introduced in Russia before the Mongol invasion.

In the 13th century, the theme of the Deposition of the Sash was depicted on the gates of Suzdal. After the fall of Constantinople in 1453, Moscow began to be described as the 'Kingdom of the Mother of God,' and a special significance was attached to the veneration of her sash and robe. During the 'Time of Troubles' in the 17th century, it was believed that these objects would continue to provide protection against military threat.

The icon is considerably different in style from THE SLAUGHTER OF HOLY FATHERS IN SINAI AND RHAITHOU, an icon attributed to the same master (see Catalog No. 95). The shapes are less fragmented, while the fig-ures are more monumental. Attempts at attribution are further complicated by the fact that the icon has a significant amount of later overpainting.

The origin of this icon is unknown. It was found in the St. Nicholas Monastery of the Edinoverie Old Believers in Moscow and then preserved in the Central Restoration Workshop until the exhibition tour of 1929-32. After the tour, the icon came to the Russian Museum.

Under the upper strut, the reverse of the icon bears an inscription in a circular field made in the 17th century. A similar circular field can be found on the reverse of the icon THE TRANSLATION OF THE HOLY FACE. Palaeographic research has indicated that both inscriptions seem to have been added during restoration prior to the acquisition by the Museum. During this restoration a number of small losses of the original paint were retained under the later layers. The outlines of figures, small details of the original painting, architectural elements, and the inscription on the top border were repainted.

40.1 cm x 33.6 cm x 2.2 cm
Single panel with two struts.

Inventory No.
ДРЖ 2758

Tatiana Vilinbakhova

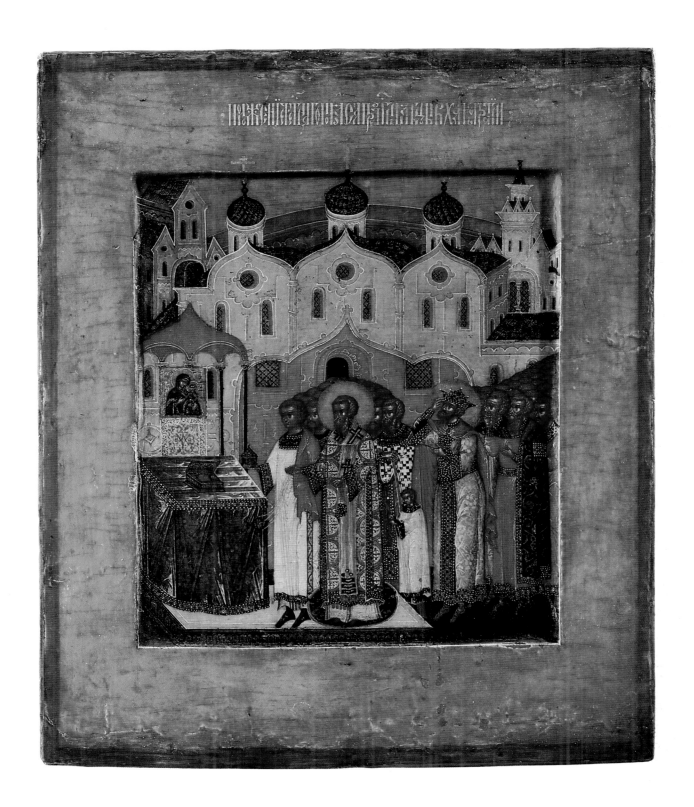

291

ST. SAVVATII AND
ST. ZOSIMA OF SOLOVKI

Stroganov workshops, Solvychegodsk
1660 and 1661

T he palls were produced at the famous workshops of the Stroganovs, wealthy industrialists and merchants who lived in Solvychegodsk. The Stroganov women not only created embroideries themselves, but instructed their daughters in the art and employed expert needlewomen to help them in their households. They also ran large-scale embroidery workshops, whose products are marked by the excellence of

of their technique. The high point of Stroganov embroidery came in the mid-17th century, when the workshops were supervised by Anna Ivanovna, the wife of Dmitrii Andreevich Stroganov, and it was under her administration that these two works of art were created.

Dedicatory inscriptions are placed in three rows on the right side of the lower border of each pall. The inscription on the pall of St. Savvatii reads: *In the year 7169 [1660 AD] on the 26th day of September this pall of the Holy Father Savvatii, Wonder-Worker of Solovki, was completed as ordered by Dmitrii Andreevich Stroganov and his children Grigorii Dmitrievich and Pelagiia Dmitrievna.* The inscription on the pall of St. Zosima reads: *In the year 7169 [1661 AD] on the 16th day of April this pall of the Holy Father Zosima, Wonder-Worker of Solovki, was completed as ordered by Dmitrii Andreevich Stroganov and his children Grigorii Dmitrievich and Pelagiia Dmitrievna.*

The pall of St. Savvatii was embroidered first, in September, and the pall of St. Zosima in April. Since the Russian New Year began in September, the works are dated 1660 and 1661 respectively. They were donated to the monastery in 1662, a year after their completion. Their arrangement is traditional; they are vertically

stretched pieces of fabric on which full-length figures are represented. Around the edges, *troparia* and *kontakia* to the saints are inscribed in the complex cursive lettering characteristic of the time. The central figures are surrounded by floral motifs. Like many of the embroideries from the Stroganov workshops, these shrouds imitate icons with rich gold settings, a feature emphasized by the rigid gold mantles of the saints. The contours and folds of the clothing are outlined in silk thread and the faces are densely embroidered in grey silk twist, with narrow lines of contrasting shading arranged in the traditional manner. Especially characteristic is the representation of the eyes, with large dark pupils, highly arched eyebrows, and narrow lines of contrasting shading from the corners of the eyes to the temples. The facial expressions of both saints are calm, and the individual details and folds of the monastic garb are almost identical in the two palls.

St. Zosima and St. Savvatii founded the Monastery of Solovki on the islands of the White Sea in the 15th century. The Stroganovs especially revered these holy fathers and made a large number of donations to the monastery.

Liudmila Likhacheva

Pall (*Pokrov*)

196 cm x 113 cm
Satin, embroidered with silk, silver, and gilt thread.

Inventory No.
ДРТ 301

Pall (*Pokrov*)

195 cm x 113 cm
Satin, embroidered with silk, silver, and gilt thread.

Inventory No.
ДРТ 300

THE VLADIMIR MOTHER OF GOD OF TENDERNESS WITH FESTIVALS AND SAINTS

Prokopii Chirin
Early 17th century

The icon is overlaid with a patterned revetment of chased silver. The edges of the wings are covered by a frame of repoussé silver with a floral pattern. The halos and stylized crown are lined with pearls and decorated with stones and pastes. The central image is also lined with pearls. The triptych was probably commissioned by Nikita Grigorievich Stroganov who died in 1618. Nikita Grigorievich was

the principal patron of icons for the Cathedral of the Annunciation in Solvychegodsk, and the inventories also mention a carved cross contributed by him. The collection of the Russian Museum includes a reliquary cross made from the coffins of Princes Vasilii Vsevolodovich and Konstantin Vsevolodovich, the saints of Iaroslavl, produced in his workshops. The present triptych was apparently painted by Prokopii Chirin in Moscow and a splendid silver revetment was made for it at the Stroganov workshop by the silversmiths of Solvychegodsk. I. I. Pleshanova has pointed to the existence of identical revetment decorations on icons in the Cathedral of the Annunciation. They resemble those of the triptych in ornamental design, chasing, and even in the thickness of the silver. They also possess the same shape of halo studded with pearls and stones. A particularly close similarity can be seen between the ornaments of the triptych and the patterns on a chased wine-bowl (*bratina*) donated by Nikita Stroganov to the cathedral sacristy in 1607. It appears that the triptych was also intended for the cathedral sacristy.

The image of the Mother of God in the central panel is unusual. She is depicted turning to the Child, who is placed on her left rather than the more customary right. The iconography of THE MOTHER OF GOD OF TENDERNESS (*Eleousa*) took shape in Byzantium and became widespread in the 11th and 12th centuries. One particularly revered early 12th century Byzantine icon became very popular in Russia from the middle of the 12th century as THE VLADIMIR MOTHER OF GOD, the most sacred object of veneration first in the principality of Vladimir-Suzdal and then also in Moscow. This miraculous image was considered the palladium of the Russian state, and it was credited with the preservation of the city of Moscow during the invasion of Tamerlane in 1395. As a result, a large number of replicas were produced around 1400. The present image of the Vladimir Mother of God was produced at the end of the 16th century as part of a triptych with festivals and saints.

There are 22 border scenes around the central image, from left to right:
1 The Trinity.
2 Nativity of the Mother of God.
3 Presentation in the Temple.
4 Praise of the Mother of God.
5 Annunciation.
6 Nativity of Christ.
7 Purification of the Mother of God.
8 Mid-Pentecost.

Wings:
39.9 cm x 16.5 cm x 2 cm
Central panel:
39.9 cm x 33.6 cm x 2 cm
Triptych of three single panels each with two struts; oklad of chased and repoussé silver.

Inventory No.
ДРЖ 2559

9 Baptism.

10 Raising of Lazarus.

11 Entry into Jerusalem.

12 Transfiguration.

13 Crucifixion.

14 Deposition from the Cross and Entombment.

15 Descent into Hell.

16 Holy Women at the Sepulchre.

17 Doubting Thomas.

18 Ascension.

19 Pentecost.

20 Dormition of the Mother of God.

21 Exaltation of the Cross.

22 Protecting Veil (*Pokrov*).

There are 12 pictures in each of the wings, positioned in six horizontal rows. On the left wing these are, from the top: patriarchs, apostles, prelates, princes, holy women. On the right wing: prophets, male martyrs, holy fathers, hermits, female martyrs.

There are many Russian saints depicted on the wings among the prelates, princes, holy fathers, and hermits. Among the prelates are the leading hierarchs of Moscow: Peter, Alexei, and Jonas. Peter was the metropolitan of Russia in 1308-1326, and it was under him that the seat of the metropolitan was moved from Vladimir to Moscow, marking the beginning of the rise of Moscow as the center of the nation. He initiated the construction of the Cathedral of Dormition in the Moscow Kremlin, and was later buried there. Alexei was metropolitan from 1354-1378. In the 1360s he was *de facto* head of the Russian state as regent during the minority of the grand prince Dmitrii Ivanovich. Jonas was the metropolitan of Russia from 1449 to 1461. He was the first Russian metropolitan to be independently elected by the council of bishops of the Russian Church, rather than appointed by the

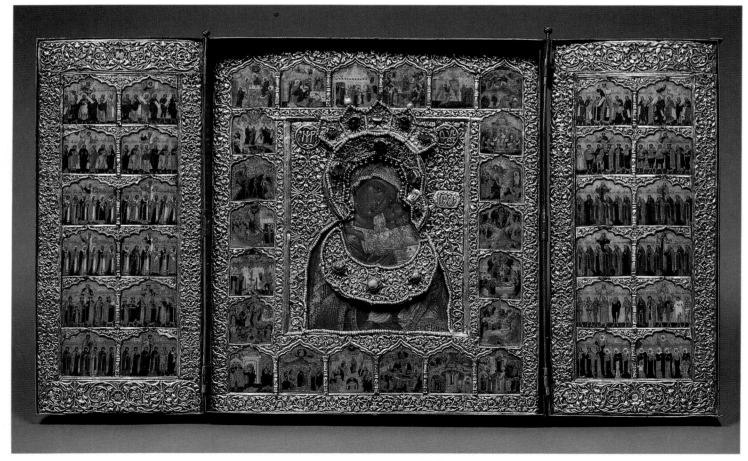

patriarch of Constantinople. Under the metropolitan Jonas, the Russian Church became autocephalous. The three Russian prelates Peter, Alexei, and Jonas are probably depicted together because the Patriarch Job instituted their commemoration on a single day, October 5, 1596.

Among the martyrs right on the wing are the princes Boris (d. August 6, 1015) and Gleb (d. September 18, 1015), the sons of Grand Prince Vladimir and the first saints to be canonized by the Russian Church. They were murdered by their step-brother Sviatopolk, nicknamed 'the Cursed' for the crime.

The left wing depicts Prince Fedor and his sons Konstantin and David. Prince Fedor of Smolensk and Iaroslavl died as a monk in 1299. He is depicted in monastic garments along with his young sons; all three were canonized in 1463. The adjoining image is that of Prince Mikhail of Tver, who was Grand Prince of Tver in 1305 and was executed by the Mongols in 1319.

Among the hermits on the right wing, the first Russian holy fool Prokopii of Ustiug is depicted holding three pokers in his hands. Next to him is another fool, John of Ustiug. They are normally depicted together in icons. Prokopii of Ustiug was a Hanseatic merchant engaged in trade with Novgorod. He adopted Orthodoxy and became a monk in the Monastery of Khutyn, assuming the name of Varlaam. From there he went to Velikii Ustiug where he devoted himself to a rigorous asceticism until his death in 1303. The three pokers he carried in his left hand were attributes of his life as a holy fool.

The figures in these pictures are small and elongated, and they stand in relaxed poses. The drawing is refined and precise. Ocher is superimposed over brown paint in the central panel, and soft white highlights are applied to the eyes, nose, and chin. The highlights in the border pictures and on the wings are made in thicker strokes of white. The background in the border pictures and on the wings is rendered in gentle silver tones. The inscriptions are in red and white. Those on scrolls are in black. In general, the colors are somewhat muted tones of red, yellow, brown, and green, and there is a large amount of gold.

The icon came to the Russian Museum in 1917 from the collection of M. S. Oliv. It had been restored by G. O. Chirikov in 1913 before it entered the Museum. It appears that the original painting was slightly strengthened during that restoration. Missing parts of the revetment were replaced. An insertion of wood was made on the reverse of the central panel. Three struts were replaced by new ones. The reverse was coated with dark varnish. A restoration analysis was conducted at the Russian Museum by I. V. Iarygina and S. I. Golubev in 1982. The original painting is well preserved. There are insignificant abrasions and losses to the paint layer. The varnish from the restoration is slightly darkened.

Alevtina Maltseva

THE TSAREVICH DMITRII WITH SELECTED SAINTS

Workshop of Anna Ivanovna Stroganova,
wife of Dmitrii Andreevich Stroganov
Solvychegodsk
1656

The tsarevich is represented in a long robe with a crown on his head, a martyr's cross in his right hand, and a furled scroll in his left. The floral motifs surrounding the figure are typical of Stroganov embroideries of the time. The borders contain images of saints after whom members of the Stroganov family were named, along with other saints who were especially venerated by them. The

tsarevich Dmitrii, whose image appears twice, in the center and in the border, was not only the patron saint of Dmitrii Andreevich Stroganov, he was a favorite saint in Moscow and was widely revered during the 17th century.

A number of saints are represented in the border medallions. In the upper border, God the Father is surrounded by the Mother of God with her Child, the Archangel Gabriel, St. Nicholas, and St. John the Baptist. The medallions in the side borders contain full-length images of the metropolitans Peter and Alexei, St. Jonah and St. Philip, the tsarevich Dmitrii and St. Anna, St. Sergei of Radonezh, St. Cyril of the White Lake, and St. Zosima and St. Savvatii of Solovki; the medallions of the lower border contain St. Christopher, St. Prokopii, and St. John of Ustiug. The symbols of the evangelists appear in the four corners.

This cloth was created during the great period of Stroganov embroidery, when the workshop was supervised by the wife of Dmitrii Andreevich Stroganov, who

played an important role in production herself. This cloth is distinguished by the outstanding virtuosity of the embroidery technique. The faces are embroidered in a dense satin stitch with contrasts, and are delineated with repoussé silver lines added in running stitch.

The tsarevich Dmitrii was the son of Ivan the Terrible, and died on May 15, 1591 in the town of Uglich. In 1606 his relics were transferred to the Cathedral of the Archangel in the Moscow Kremlin.

The background is of crimson taffeta lined with crimson damask, bearing the following inscription on a tablet under a Golgotha cross: *In the year 7165* [1656 AD] *on the 19th day of October was completed this icon cloth of the blessed keeper of the faith, Tsarevich and Grand Prince Dmitrii, Wonder-Worker of Moscow and All Russia, to be borne in procession on the feast days of his birth, assassination, and canonization, in accordance with the promise of Dmitrii Andreevich Stroganov.*

Liudmila Likhacheva

Icon Cloth (*Pelena*)

144.6 cm x 93.3 cm
Taffeta and damask,
embroidered with silk,
silver, and gilt thread.

Restored in 1964.
Several rows of silk twist stitching were removed from the place on the neck of the tsarevich, where a rectangle of crimson background signifies the cutting of his throat.

Inventory No.
ДРТ 206

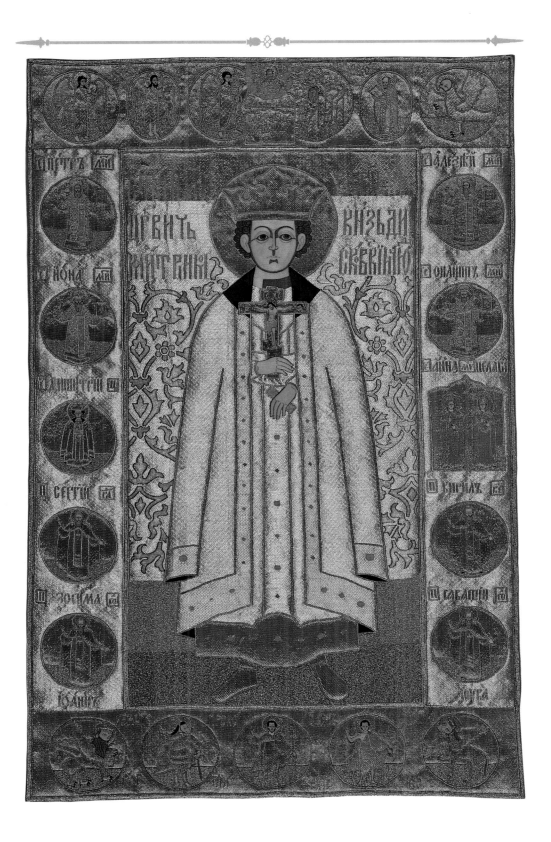

CHRIST PANTOKRATOR ENTHRONED

Semen Spiridonov Kholmogorets
ca. 1682

Icon painter, miniaturist, and master of monumental art, Kholmogorets was a follower of one direction of the Stroganov school which developed in the towns bordering the Dvina. Born in 1642, his works record a number of important events in Russian culture. Surviving information indicates that he was numbered among the icon painters of the town of Kholmogory throughout his working life, but his activity is

also connected with other artistic centers of northern and central Russia, including the Solovki Monastery, Iaroslavl, and Moscow. Kholmogorets was twice invited to serve as court icon painter, in 1666 and 1677. He died in 1694/5.

The icon is from the Church of St. John Chrysostom of the Cowsheds in Iaroslavl. The icon was placed in the local tier of the main iconostasis, to the right of the Royal Doors. There is reason to believe that the icon was ordered by the land-owning Nezhdanovskii family, who for no less than 80 years were patrons of the Church of St. John Chrysosotom

Around 1924 the icon was transferred to the Iaroslavl Museum, and then in 1929 to Antikvariat. In 1933, after being shown at the exhibition of 1929-32, it was sent to the Russian Museum.

The icon was restored at Iaroslavl. M. I. Tiulin performed a partial cleaning, and N. I. Briagin a complete cleaning in 1925-26.

Parts of the painting are worn, with slight losses of pigment layer. Some traces remain of 18th and 19th century overpainting. The icon probably bore the signature of the artist, to judge from three incised lines at the foot of the throne in the centerpiece. Nail holes indicate that silver nimbuses were applied around the heads

of the Savior and the Mother of God.

The icon is one of the best and most complex works by Semen Spiridonov, painted at a mature stage of his creative activity. It reflects all the typical features that he used throughout his working life, in its general structure, its rhythmic arrangement, and its color scheme. The palette is based on three main colors, vermillion, dark green, and raspberry. In this icon the artist often mixes the pigments, especially with white, and frequently overlays one color with another, white with pink, for example, or gold with a green or raspberry glaze. The gold background and colored enamels of the border scenes give the impression of a somewhat two-dimensional mosaic of precious stones, and their complex color scheme contrasts with simple cruciform distribution of colors in the main theme.

The iconographical version of Christ Pantokrator presented at the center was widely followed in the mid-17th century. Its particular feature is the incorporation of a number of details reflecting various iconographical schemes earlier than the scheme under consideration, such as kneeling saints and archangels bearing the instruments of the Passion. The text shown on the pages of the Gospel is seldom to be found in analogous composi-

156 cm x 108 cm x 4 cm
Panel of two boards
with two struts.

Inventory No.
ДРЖ 2772

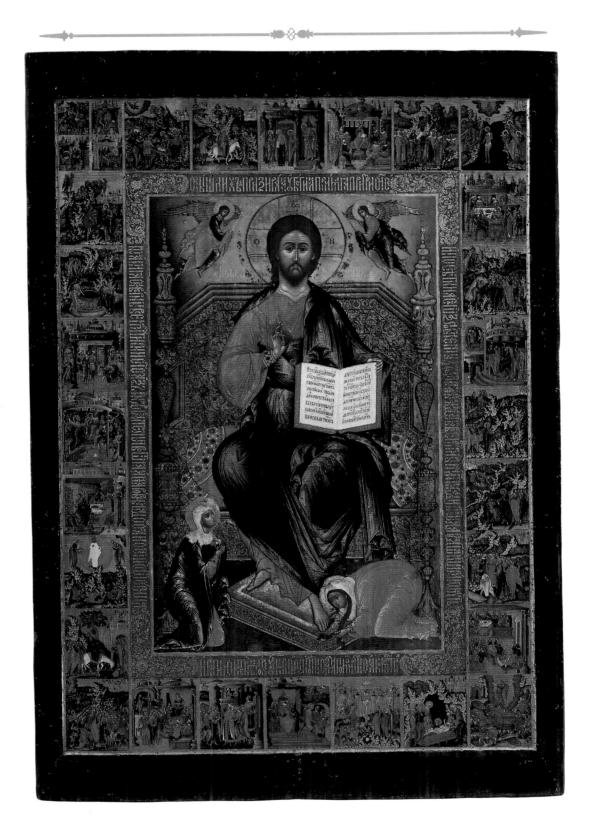

tions: *Thus spake the Lord: When the Son of man shall come in his glory, and all the holy angels with him, then shall he sit upon the throne of his glory: And before him shall be gathered all nations; and he shall separate them from one another, as shepherd divideth his sheep from the goats: And he shall set the sheep on his right hand, but the goats on the left. Then shall the King say unto them on his right hand, Come ye blessed.*

The artist was paraphrasing Matthew 25: 31–34. White it was customary for Russian icon painters referring to this chapter to quote either verse 34 or verses 34–36, the passage above also conforms to the traditional structure of the composition, which represents Christ as the Judge of mankind. This image of Christ belongs to the iconography of Christ in Glory, and is adorned with a nimbus inscribed with a cross. Rather than a simple nimbus, Kholmogorets has painted a cloud illuminating the head and body of Christ. This shining cloud is represented not in the traditional form of an oval or circle with golden rays, but by an irregular lightening of the color around the contours of the figure of Christ, a method that became widespread in Muscovite icon painting in the second half of the 17th century. In the belief that this new iconographical version of Christ in Glory needed some explanation, the artist inscribed the verses from the Gospel.

The border scenes are as follows:

1 The Four Evangelists.
2 The Nativity of Christ.
3 The Flight into Egypt.
4 The Presentation of Christ in the Temple.
5 Mid-Pentecost.
6 The Prophecy of St. John the Baptist concerning Christ.
7 The Baptism of Christ.
8 The Temptation of Christ.
9 The Marriage of Cana.
10 The Woman of Samaria.
11 The Healing of the Blind and the Lame.
12 Christ and the Adulteress.
13 The Poor Widow's Mite.
14 The Expulsion from the Temple.
15 The Healing of the Demoniac and the Woman with an Issue of Blood.
16 The Feast in the House of Simon the Pharisee.
17 The Healing of the Ten Lepers.
18 The Transfiguration.
19 The Raising of Lazarus.
20 The Entry into Jerusalem.
21 The Last Supper.
22 The Kiss of Judas.
23 Christ before Caiaphas.
24 Christ before Pilate.
25 Pilate washes his hands.
26 The Crucifixion.
27 The Entombment.
28 The Resurrection.

The cycle of border scenes includes a number of rare themes, or unusual treatments of more common themes.

The first category comprises the following images: The Prophecy of St. John the Baptist concerning Christ; The Temptation of Christ; and Christ and the Adulteress.

The second includes: the Four Evangelists, represented together according to early Byzantine tradition and Russian illuminations of the 14th and 15th centuries; the Nativity of Christ, in which the Mother of God is represented seated, in accordance with Western European iconographical traditions; and the Raising of Lazarus, who is represented not as a man resurrected from the dead, but rather as a prisoner liberated from hell, a concept found in Russian manuscripts since the 13th century and based on the apocryphal *Story of the Raising of Lazarus.*

The uniqueness of this work of Semen Kholmogorets lies not only in the excellence of its execution and the inclusion of rare subject matter, but also in the fact that the artist attempted to create an object of veneration with a traditional interpretation, at the same time as he represented an actual event, the deliverance of the city of Iaroslavl from the epidemic of 1654. In medieval Russia, Christ was revered more as the judge of mankind than as a healer. In Iaroslavl, one of the icons dedicated to the Savior was consecrated in 1612, and

thereafter became an object of supplication for protection from infectious diseases. The Church of St John Chrysostom of the Cowsheds, for which Semen Spiridonov painted the present icon, was consecrated in 1654, the year of the epidemic. This explains the emphasis in the icon on the healing powers of Christ, indicated by the choice of special prayers in the inscriptions and the unusual placing of the subjects in the series of border themes. Of the eight scenes depicting miracles performed by Christ, seven relate to healing. All these compositions are combinations of two miracles, as in border scenes 11, 15, and 17, and this indicates their special significance. The Raising of Lazarus must also be included among these scenes, since this miracle of resurrection is the only healing miracle mentioned in the prayers for deliverance from deadly infection. The artist placed all seven scenes together, in a vertical series on the right side of the icon, thereby breaking the rule of Russian iconography that the chronological sequence of events should be maintained in the order of border scenes.

The texts on the frame of the icon are the *kontakion* and *troparion* to the Savior which are sung on August 1, the Festival of the Origins of the Holy Trees of the Life-Giving Cross. This festival had been instituted to avert the epidemics which often broke out in late summer. It was originally celebrated in Constantinople, where it became customary to carry the Holy Cross in procession along roads and streets in order to bless various sites and avert disease.

The inscribed *troparion* reads: *Looking down from on high upon Thy humble servants, O Savior, forgive us our sins in our dire plight, All-Merciful Lord, and for the sake of Thy Holy Mother grant to our souls Thy great compassion.*

The *kontakion* reads: *All merciful Savior, I have perpetrated all kinds of evil-doing and have fallen into the abyss of despair; but I groan from my heart and cry unto Thee in Thy strength: grant us Thy great gifts and come to our help, in Thy compassion.*

The upper part of the centerpiece contains figures of archangels holding a cross, a lance, and a rod with a sponge at its end. The theme of the Life-Giving Cross is closely connected with the instruments of the Passion. In the present icon, the fact that the prayers inscribed round the borders of the icons relate to the Cross as a means of deliverance from disease seems to indicate the simultaneous veneration of the Life-Giving Cross and Christ the Healer. The lower part of the centerpiece shows two women worshipping at the feet of the Savior, Martha and Mary, the sisters of Lazarus. The presence of their figures in the composition may symbolize prayer for the resurrection of the dead, which may also be identified with prayer for deliverance from deadly pestilence.

Although the events of 1654 are described in various documents, they have never been compiled in any single literary source authorized by the church, a fact that precluded them from being represented in an icon. Furthermore, no analogies could be found in any religious text. These circumstances led the artist to resort to the complicated principle of reflection, well known in the baroque literature of the Eastern Slavs. Its basic premise is a close relationship between all the elements of the world, and the possibility that every object or event has a counterpart which is outwardly dissimilar, but which nevertheless reflects its essence. Kholmogorets does not directly name any event depicted in the icon, but merely indicates its individual properties, and in the general context, this elicits associations with the story of the deliverance of the city from the epidemic of 1654.

The work under discussion is the earliest example of the use of the principle of reflection in Russian iconography.

Nina Turtsova

THE MOTHER OF GOD ENTHRONED

Semen Spiridonov Kholmogorets
1687

There are good grounds for believing this icon to be a late work of Semen Spiridonov. Practically all the elements that are characteristic of his last works are concentrated and completed in this icon. The most important is the combination of antiquarian style and iconographic innovation, and a subtle and accurate use of the baroque principle of reflection. The stylistic development of Semen

Spiridonov from 1685 to 1694 allows us to characterize his last years as a time in which he turned away from the experiments of his earlier work, including the use of perspective, naturalistic modeling, and a single source of light. The works of this period are distinguished by strong black contours and crisp drawing. These characteristics are clearly present here. We also see a further miniaturization of form, with a consequent intensification of the use of gold in the background of the border scenes. The amount of gold evidently led to a reduction in the use of colored varnish, which would detract from its smoothly polished appearance. There are some variations in the color scheme of the icon. In the border scenes this is seen either in the use of contrasting colors, as in scene 16 (*THE MOTHER OF GOD AS THE LIFE-BEARING FOUNT*), or in the use of numerous shades of just one or two colors, as in scene 5 (*ST. LUKE PAINTING THE ICON OF THE MOTHER OF GOD/THE MOTHER OF GOD BLESSING THE ICON*).

For the first time in his career, Kholmogorets does not represent light in the central panel with an indication of its source, but employs an indeterminate background as a symbol of light, just as it had been understood until the 17th century. It is significant that the background

he chose was dark-green, as this color was considered to be particularly authentic in the 17th century, due to its use in early Byzantine icons. The obligation to follow the example of such early icons was imposed on painters by the reforming patriarch Nikon. Kholmogorets' return to a more traditional style of icon painting may have been a response to the distortion of the traditional role of icons which occurred when painters began to imitate the world of natural appearances. It is clear that Western painting and icon painting were separate activities for Kholmogorets, and that in this respect his views were consonant with those of both Grecophiles and Old Believers. During this time the party of traditionalist Grecophiles had grown stronger at the court of Sophia Alexandrovna, who ruled the country from 1682 to 1689.

The depiction of the Mother of God *Hodegetria* in the central part of the icon does not correspond to any of the known iconographic variations. The image combines very ancient features known in the pre-Mongolian icons of the Mother of God with innovations such as the scepter, orb, and crown on her head. The orb in the left hand of the Christ is a symbol of his omnipotence and possession of the world. According to N.P. Kondakov, this detail is

168 cm x 136 cm x 5 cm
Panel of four boards
with two struts.

Inventory No.
ДРЖ 2894

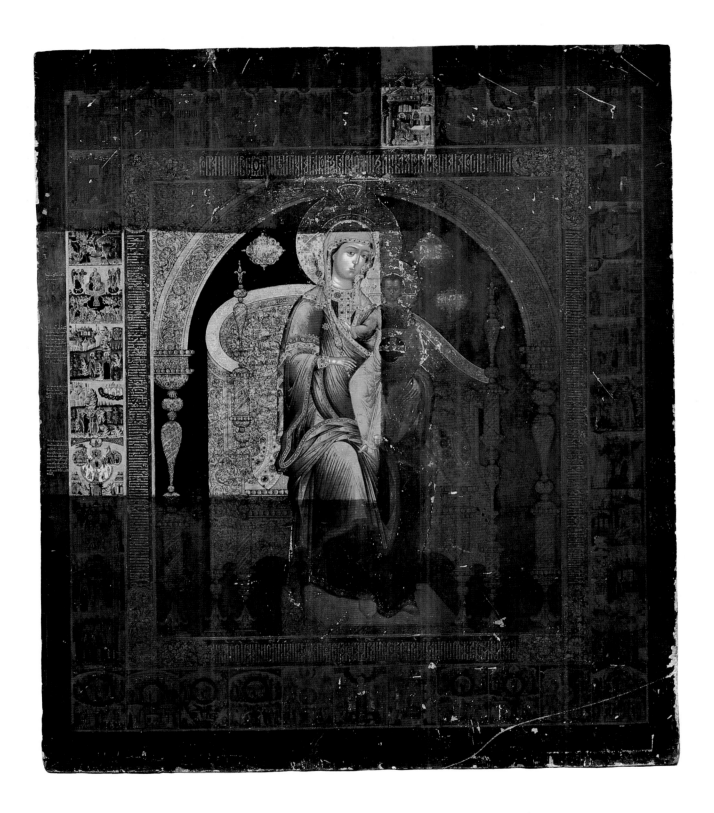

305

an attribute of many iconographic types of the Mother of God and is of Balkan origin. The depiction of the Mother of God with a crown and the infant Christ with a scepter was widespread in the 17th century, probably due to Western influence.

The subjects in the border scenes can be organized into three main themes: the life of Christ and the Mother of God; the miracles of the Mother of God; and the praise of the Mother of God. The life scenes are placed in the upper register (scenes 1–9), while the scenes of the miracles occupy part of the upper register and sides (scenes 10–21, 23–29). Scenes 19–21 and 23–24 draw on the *Paterikon* of the Monastery of the Caves composed at the beginning of the 13th century. The first printed editions of the *Paterikon* appeared in Kiev in 1666 and in 1678, and the engravings from these editions probably served as an iconographic source for the composition of the scenes. The rest of the border scenes (1–18, 25–29) are illustrations to a treatise entitled *The New Heaven Created with New Stars*, written by a contemporary of Semen Spiridonov, the Ukrainian Ioannikii Galiatovskii. This book was published in Russian and Polish in Lvov in 1665, in Chernigov in 1677, and in Mogilev in 1699, but a Russian manuscript version seems to have been used here. The border scenes of the third cycle, the praise of the Mother of God illustrate lines from a number of prayers. Scenes 30–33 are from the Liturgy of St. John Chrysostom, and 37–40 from the Liturgy of St. Basil the Great. The source of scenes 34–36 remains unknown. All border scenes of the praise cycle, except scene 22 (What Shall We Call Thee?) are in the lower register.

The scenes illustrating prayers have the same composition with only minor differences. They are clearly divided into two areas horizontally: in the upper part there is a depiction of the Mother of God in paradise surrounded by the heavenly host; in the lower part there are angels and human beings praising her.

Two historical events are represented in the present icon, the union of Kiev with Russia in 1686, and the Iconoclastic Controversy. Although the program is more complicated than that of the icon *THE SAVIOR PANTOKRATOR ENTHRONED*, the principle of the concealed parallel is also used here to great effect. The artist had no reservations about dispensing with the unnecessary formal foundations of the principle, and instead created an accurate ensemble of analogies to real events. The design is therefore easier to follow than in *THE SAVIOR PANTOKRATOR*. From a structural point of view, it is also revealing to compare this icon with *THE MOTHER OF GOD ENTHRONED WITH 32 BORDER SCENES* (Iaroslavl Museum). In the latter icon the artist keeps strictly to the chronological sequence of the events, and draws on subjects from Russian history to complete the side registers of border scenes, but in the present icon, events that would have been placed in the border scenes have been transferred to the center. Nevertheless, scene 29 which illustrates an event connected with Novgorod remains in its former place, and this indicates that the artist believed it necessary to accentuate Kievan subjects in particular. Their number was also increased: there are two Kievan themes in the icon from the Iaroslavl Museum, and five in the icon from the Russian Museum.

This disruption of the usual order of the scenes was not accidental, and is related to other noticeable features of the icon. While there is no scene actually dedicated to the Smolensk Mother of God *Hodegetria* the artist has used the type in a number of the scenes. This choice was not accidental either, as it is known that the Mother of God *Hodegetria* was a military palladium of Constantinople and of Moscow since the time of Ivan III.

In all works by Semen Spiridonov, the frames between the center panel and the cycle of border scenes contain the texts of a *troparion* and a *kontakion* set out toward each other. The *troparion* is placed in the

upper and right sides of the frame, while the *kontakion* is in the lower and left sides. The icon from the Russian Museum is the only known exception to this rule, and gives a particular emphasis to the *troparion* 'victorious Chieftan,' which is not the habitual eulogy of the Mother of God, but rather a thanksgiving prayer for deliverance from enemies: *We, thy servants, having been delivered from evils, do offer unto the, O Birth-giver of God, who as victorious Chieftan warrest for us, songs of triumph and thanksgiving; and as thou has might invincible, do thou free us from every calamity, that we may cry unto thee: 'Hail, O Bride unwedded!"*

It is important to note that Semen Spiridonov was a very consistent artist and deviated from his rules only for very particular reasons. In this case he seems to have a very precise agenda. He places the thanksgiving prayer to the Mother of God for the deliverance of enemies in the foreground. He depicts the Mother of God *Hodegetria* of Smolensk, the military palladium of Russia, in the border scenes. He makes a connection between the Kievan topics (border scenes 20 and 24) and the scene illustrating the eulogy to the Mother of God, who was venerated as a protector of the city of Kiev. He places subjects related to Kiev in the center of the icon. He uses the *Paterikon* from the Monastery of the Caves to elaborate the Kievan topics, although it would have been more convenient to use only the treatise by Galiatovskii in which the same events were described.

These features can be explained if we turn to the history of the Russian state in the 17th century, since events of great importance had taken place shortly before this icon was painted. In 1686 the Russian government succeeded in obtaining permission from the patriarch of Constantinople to have the metropolitan of Kiev placed under the jurisdiction of Moscow. Also in 1686, after the signing of a peace treaty with Poland, Russia received Kiev, the Ukraine, and other territories. Seen in this light, the icon by Semen Spiridonov

Kholmogorets is a unique record and interpretation of these historic events.

Comparison of certain aspects of the icon with other sources may result in more substantial explanations. For example, in the cycle of the miracles of the Mother of God there are episodes from the story about the icon of the Three-Handed Mother of God. This image relates to an episode in which St. John of Damascus was insulted and suffered the amputation of his hand. By the grace of the Mother of God, the severed hand grew back. St. John of Damascus then composed the thanksgiving prayer to the Mother of God: 'In Thee rejoiceth ... Thou full of Grace.' The third thematic cycle of the icon, praise to the Mother of God, begins with this prayer. It is also possible that in the theme of the hand growing back there is a reference to the return of old lands into the possession of Russia. The concept of the 'Kievan inheritance' had occupied a prominent place in the public mind since the end of the 15th century, and it became official government policy in the 16th century.

The denunciation of heresies of various kinds has always been a task of icon painting, and many subjects dedicated to the Iconoclastic Controversy appeared in the second half of the 17th century. Throughout the century iconoclasts had been troubling the church authorities, and the official publications of the time stress the importance of venerating icons and denounce iconoclasts from the 4th century to the 16th century.

There are several compositions dedicated to this particular theme in the icons by Semen Spiridonov, and in the present icon there are two more topics related to it, namely the Apparition of the Mother of God to St. Cyriac (scene 26) and The Miracle of the Icon of the Cyprus Mother of God (scene 28). The latter theme, which involves punishment for the desecration of relics, is closely related to the theme of iconoclasm, and its appearance in the icon is not surprising. However, the former

requires some explanation. It recounts how the Mother of God refuted the doctrine of Nestorius. Nestorian Christology was denounced as false at the Seventh Ecumenical Council in Nicaea (787), the same council at which the iconoclasts were defeated and the veneration of icons was restored. Having taken into account the fact that Semen Spiridonov painted his icon in 1687, exactly 900 years after the Council, we can surmise that his aim was not only to show the phenomenon of iconoclasm as such, but also to remind us of its defeat at the Seventh Ecumenical Council. The principle of the concealed parallel of baroque poetics is used here again in order to make an oblique reference to a concealed meaning. One of the most characteristic features of the culture of the second half of the 17th century, the duality of Grecophiles and Westernizers, has found a vivid expression in this icon of 1687. It shows itself not least in the contradiction between the archaizing style and the innovations of the program.

Almost the entire surface of the icon is covered by darkened varnish. There are scratches and minor losses of the pigment layer through to the canvas on the margins of the panel, especially in the lower part of the icon and on the *chiton* of Christ. The ornamentation painted in white lead on the back of the throne has been damaged. Some overpainting is left on the restored fragment of the icon. As the research of the restorer R.A. Kesarev has shown, the original background of the frame was a raspberry-colored varnish on silver ground, and the inscriptions were painted with white lead and then covered with gold. At a later date, the frame was completely overpainted in dark red, on which the text was painted again. On the contours of the halos and figures there are traces of nails.

The icon was partly freed of overpainting by the artist-restorer E.V. Pertsev in the Russian Museum. Border scene 7 (St. Luke Painting the icon of the Mother of God/The Mother of God Blessing the Icon) was cleaned in 1958; part of the center panel and four border scenes on the left side (16, 18, 20, and 22) were cleaned in 1959-66.

Nina Turtsova

The Medieval Collection of The State Russian Museum

Liudmila Likhacheva

The collection of medieval art in the State Russian Museum is of great size and importance. It includes more than 6,000 panel paintings and more than 20,000 objects of applied art, many of which are distinguished by their rarity and by their significance for the history of Russian culture. Many of them have been published extensively and have been reproduced in scientific journals, exhibition catalogues, and photographic albums for general readers. In addition to panel paintings, manuscripts, and copies of frescoes, the collection includes embroidered textiles, wooden sculptures, carved ivory and stone, cast metal icons, statuettes, liturgical vessels, ceramic tiles, and a large number of archaeological artefacts.

The State Russian Museum was established on April 13, 1895, when the senate passed a decree founding a museum of national art. The project was sponsored by the emperor Nicholas II in memory of his father, Alexander III, whose own plans for such a museum were left unfinished at his death in 1894. The original name of the museum was 'the Russian Museum in the name of the emperor Alexander III.' To display the collection of the museum, the City Treasury purchased the Mikhailovskii Palace, from the heir of Grand Duke Mikhail Petrovich. Designed by the Italian architect Carlo Rossi for the son of the emperor Paul I and completed in 1825, the palace is regarded as one of the most beautiful buildings in St. Petersburg. The State Russian Museum now also occupies a second building, designed for the Museum in 1916 by the architect Leontii Benois.

The Fine Arts Section of the Museum comprised the central collections of the museum, and was dived into smaller departments including the Department of Orthodox Antiqui-

ties. The collection of this Department was composed mainly of works drawn from the Museum of the Academy of Art, founded in 1856 on the initiative of Duke G. G. Gagarin. The early curators made important contributions to the collection, bringing many Old Russian objects from monasteries and storehouses in Novgorod that had fallen into disuse. In addition to the collection of the Museum of Old Russian Paintings, which numbered 1,616 panel paintings, 3,346 wooden objects of various sorts, and 141 liturgical objects, the new Museum received the private collections of M.P. Pogodin, P.F. Korobanov, and P.I. Sevastianov. In addition, the government bought and donated the collections of V.A. Prokhorov, who succeeded A. M. Gornostaev as curator of the Academy and A.M. Postnikov. From its earliest origins, the collections in the Museum were catalogued and published including N.P. Kondakov, N.P. Likhachev, A.I. Sobolevskii, and V. I. Uspenskii. They were assisted by M.P. Botkin and N.V. Pokrovskii, a professor of the St. Petersburg Theological Academy who served as the evaluation expert for new acquisitions.

Panel paintings, liturgical vessels, embroideries, and other objects were often brought to the Museum by icon painters and restorers who were working in churches and monasteries. Several complete collections were acquired by the Museum in 1901, including more than 1,500 objects from the estate of Duke A.A. Vasilchikov, the collection of architect and scientist V.V. Suslov, and the collection of the historical painter V.V. Vereshchagin, which also included the collection of the painter N.I. Podkliuchinikov. In 1909, the art historian and academician N.P. Kondakov donated his own collection to the Museum. Panel paintings from

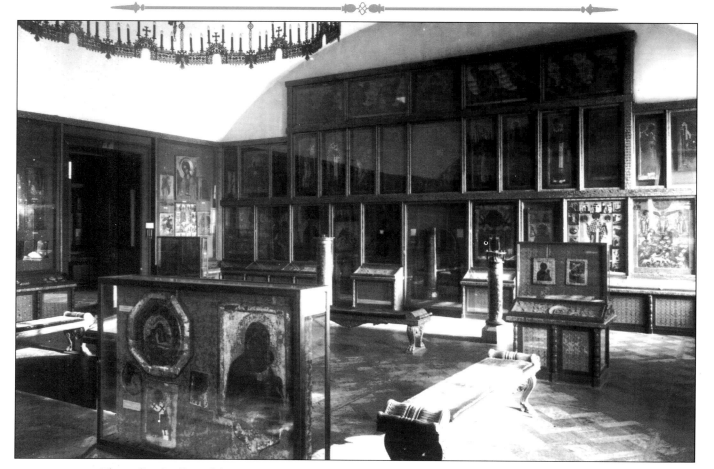

The medieval gallery of the Russian Museum, as designed by A. V. Shchusev in 1914.

these collections were displayed in special glass vitrines in the last hall of the Museum gallery, the entire display filling four halls on the ground floor of the Mikhailovskii Palace.

A new period in the history of the Department began in 1912, as a result of the enthusiasm for Old Russian art that arose when the process of restoration began to reveal evidence of early masterpieces beneath the paint and grime of later centuries. New funds were donated to the Museum to reorganise its facilities and significant contributions were made to the permanent collections by E.M. Tereshchenko, who was renowned for her patronage of the arts. The emperor Nicholas II himself donated 30,000 rubles in 1913, and the Kharitonenko family donated a further 25,000 rubles for the establishment of an 'Icon Chamber,' part of a permanent exhibition which now occupied five halls on the ground floor of the Mikhailovskii Palace.

The 'Novgorod Icon Chamber' was designed by the architect and academician A.V. Shchusev, with luxurious vitrines constructed of stained oak and decorated with silver *basma* based on old designs held by the Mishukov Co., and polished plate glass held in place by elaborate metal frames. The interiors of the vitrines were covered in silk produced according to an Italian design. A huge chandelier hung from the ceiling in the middle of the hall and an iconostasis was mounted near the eastern wall, flanked by candlesticks and embroideries hung from lanterns. In the center of the hall there was a round window above a display of icons.

Soon after the opening on March 23, 1914, the Department was renamed the 'Antique Depository of Monuments of Russian Icons and Church Antiquities in the name of Nicholas II.'

In the first decade of the 20th century, collecting became more systematic and intensive. In 1909, the painter P.I. Neradovskii was appointed curator of the Fine Arts Section, where he immediately began enlarging the collection by purchasing liturgical objects from the storehouses of churches and monasteries, by soliciting donations, and by organizing new exhibitions, research, and restoration. In 1910 workshops were established at the Museum under Neradovskii's direction, and were responsible for cleaning, restoring, conserving, and copying panel paintings. In the same year, the Moscow icon painter and collector G.O. Chirikov restored 40 panels, and after his departure for Moscow he was replaced by another famous restorer, N.I. Briagin.

It was also largely due to Neradovskii's efforts that a program of visits to old Russian cities was undertaken in search of new objects for the Museum collection. Neradovskii was also responsible for the purchase in August 1914 of several important works from the Cathedral of the Dormition in Murom.

The growing interest in Old Russian art was given an important boost by the collection of the academician N.P. Likhachev, which was purchased for the Department in 1913 and served to attract both new funds and new trustees to the Museum. As described in the yearly report for 1913, the collection included 1,431 panel paintings, among them some of the best icons currently in the Russian Museum, and 34 works of applied art. N.P. Likhachev was a remarkable figure, not only for his large collection and his extensive study of icons, but also for his concern about problems of conservation. He was convinced that the best icons should be stored away from the light, and only less important ones displayed on the walls of a museum.

As early as 1908 a famous collector in Pskov, F.M. Pliushkin, had decided to sell his large collection of Russian panel paintings and applied arts. Nevertheless, despite his death in 1911, questions about the purchase and distribution of his collection among the museums of St. Petersburg continued until 1914, with both the Hermitage and the Russian Museum negotiating for some of the 4,700 objects. When the distribution was finally made in 1914, the Russian Museum received 113 panel paintings and 984 objects, including cast copper icons, crosses, and liturgical vessels.

Nicholas II continued to play a central role in enlarging the collection of the Museum. In May 1916, while he was visiting the Convent of the Pokrov at Suzdal in the company of the art historian V.T. Georgievskii, the emperor paid special attention to the ancient and damaged icons from the chasuble chamber in the Cathedral of the Pokrov. Personal icons were stored there which had belonged to nuns from noble families, including the dukes of Suzdal. From a collection of more than 70 panels, 46 were selected and delivered to the Museum, some associated with famous historical figures and decorated with silver *okladi*.

In the early decades of the century, a large

number of icons were sold to the Museum by icon painters who were collectors in their own right. In the pre-Revolutionary period and even later, the Museum bought a significant number of works from the famous antiquarian N.M. Savostin, as well as from D.S. Bolshakov, N.N. Chernogubov, and other collectors. Immediately before the Revolution of 1917, the 'Depository of Antiquities' comprised 3,141 panel paintings and 6,100 objects, including liturgical vessels, cast metal icons, embroideries, enamels, and carved wood and bone icons.

After the Revolution of 1917, a new period in the life of the Russian Museum began. Although it remained part of the Fine Arts Section, the 'Depository of Antiquities' was renamed the 'Department of Old Russian Art.' This was obviously a period of radical change and the main task facing the new department was to organise its activities for the research and promotion of Old Russian art according to the interests of the new state. Museum curators traveled extensively, lectured, conducted seminars, and published widely on different aspects of the subject. Leading scholars such as D.V. Ainalov, N.P. Likhachev, V.N. Peretz, and V.V. Vinogradov were invited to participate in international conferences, seminars, and research councils, and until 1928, reports were published, collections of scientific articles were prepared, and seminars organized.

The years 1917–28 were difficult for the Russian Museum. In February 1917, the Provisional Government crated and shipped the Museum's most valuable objects to Moscow, where they were kept in storage in the Kremlin Palace along with objects taken from the Hermitage. As soon as these were returned to the Museum in 1920, the staff began to make plans for their exhibition, even though they could not be displayed immediately. Heating was not to be restored in the Museum until 1922.

The first exhibition of Old Russian art after the Revolution was installed in the same halls of the Mikhailovskii Palace which had been used before the Revolution. In 1935 a permanent exhibition of panel paintings and decorative art opened on the ground floor of Mikhailovskii Palace, in a design proposed by the archaeologist M.M. Karger.

The restoration workshops established before the Revolution continued to clean, conserve, stabilize, and restore panel paintings.

This work expanded during the years that followed the Revolution, and new methods were discovered as an intensive restoration program was undertaken under the direction of N.A. Okolovich. In 1924, due to the large number of new objects arriving at the Museum, restoration workshops were also established for textiles, wood, and jewelry. However, the process was made more difficult by the fact that the Soviet policy of closing churches, monasteries, palaces, and museums was conducted in a disorganized manner, and tens of thousands of objects arrived without any coordination. In 1921 the Museum Fund was established to undertake this task, and in 1928 responsibility for distribution passed to the Hermitage.

Even in 1917, icons and other objects continued to be donated by individuals. M.S. Oliv gave the Museum a famous painted triptych of the Stroganov school, while in 1918 the Museum purchased the panel paintings and embroideries in the collection of D. S. Bolshakov. In addition, 37 panels came from the Military Chamber of Tsarskoe Selo, and the collection of the historian I.A. Shliapkin was left to the Museum after his death in 1918. In 1919 many additional panels were purchased for the collection, and icons and other objects were delivered from the Department of the Preservation of Monuments of Art and Antiquity. Many further objects came from the Museum Fund in 1922. At the same time, panel paintings from the Winter Palace and from the Monastery of St.Alexander Nevskii were delivered to the Museum, the first of many acquisitions from these sources.

Especially important objects began to arrive at the Museum in 1923, when the Soviet authorities closed the great northern monasteries of Cyril of the White Lake, Alexander Svirskii, and Solovki. Many of the objects from these monasteries were transferred to the Russian Museum, where they were saved from destruction, including a large number of donations from tsars and grand dukes who had commissioned the leading painters, embroiderers, goldsmiths, and silversmiths of their time.

On March 7, 1924 the noted connoisseur N.F. Romanchenko gave the Museum a large collection of cast copper icons, which increased the Department's existing collection to approximately 4,000 objects. In 1925 the collections of the Museum Fund and other institutions were

transferred to the Russian Museum, including 2,707 objects from the Cabinet of Archaeology and Art of the Archaeological Society of Leningrad State University. This transfer was supplemented by panel paintings from the Palace of Peterhof and from the northern districts of Vytegorsk and Lodeinopolsk. At the end of the decade there were also additions from the Society of Arts Incentives, from the Theological Academy, and from the Society of Old Manuscripts.

Throughout the next decade there were exchanges of objects between different departments of the Museum and between the Museum and the Hermitage. Beginning in 1924, many smaller museums in St. Petersburg were gradually closed and their furniture and other treasures dispersed to the larger museums of the city. In 1930 the Old Russian Department received objects from the Sheremetev Palace and later in the same year it was given embroidery, silver gilt vessels, and other liturgical objects from the Cathedral of the Trinity in Pskov. Additional objects came to the Museum from the Dormition and Vvedensk Monasteries of Tikhvin.

When the Second World War began, the most valuable objects in the Museum were evacuated to Perm, and the remaining collection was maintained during the long siege of Leningrad by a small staff under the direction of Iu. N. Dmitriev.

Once the horror of the siege had passed, the objects were returned from temporary storage in Perm and the most urgent task was to reinstall the collection. The exhibition of Old Russian art was opened again on March 7, 1946, now occupying the first four halls of the upper floor of the Mikhailovskii Palace. By 1960 the four upper halls were devoted almost entirely to panel painting. This led to the opening of a permanent exhibition of Old Russian applied art in 1966, comprising 750 objects in the care of I.I. Pleshanova.

Curatorial work at the Museum continues the tradition of collecting, so fundamental to the Museum since its earliest days, and recent years have seen many exhibitions of new acquisitions. Since 1954, under the direction of N.G. Porfiridov, researchers and restorers from the Department traveled regularly throughout Russia, including the regions of Karelia, Archangelsk, Pskov, Novgorod, and Leningrad, to collect new objects for the Museum. Many excellent paintings and sculptures were discovered on these expeditions, and some of them have made valuable contributions to the study of Old Russian art. Private collections also continue to be valuable sources of purchases or donations.

By 1972 the Department had become so large and complex that it was reorganized into two separate departments, both of which are participating in the present exhibition: the Department of Old Russian Painting, directed by T.B. Vilinbakhova; and the Department of Old Russian Applied Art, directed by I. I. Pleshanova. In the challenging circumstances of the present time, the staff continues to display the same care it has shown throughout the previous decades: preserving and enlarging the collection, organizing exhibitions, and conducting research.

The Technique of Old Russian Painting

PROBLEMS OF RESEARCH AND RESTORATION

Dariia Maltseva

A knowledge of icon production and an acquaintance with the peculiarities of its painting technique may help explain the iconographic message, since all these elements are often closely interrelated.

The panel or foundation of the icon was prepared from dried wood, normally lime or oak, although in northern Russia spruce or pine were also used. For an icon of average size, the width of one plank would be sufficient; larger icons would often require several planks to be glued together, or joined with struts (*shponki*).

Attached or recessed struts were set into the rear of the panel to protect the wood against excessive warping. As the form of the struts and the method of fastening them onto the panel changed over the centuries, they are considered to be important evidence in the attribution and dating of icons. For example, the oldest icons were placed at the top and bottom of the panel rather than across the middle, and icons with struts fastened onto the surface of the panel are generally older than those whose struts are sunk into the surface.

On the obverse, side margins were left along the edges of the icon to frame the central area, which was then often hollowed out with an adz to form a slight recess know as the *kovcheg*. Although the *kovcheg* is typical of Russian icons, it is often missing from icons in the prophets and patriarchs tiers of the iconastasis, and from many icons painted in the 19th and 20th centuries. The raised border that results from the formation of the *kovcheg* has a specific function: being a replica of the Hellenistic niche, it gives a sense of condensed space peculiar to the icon, and addresses the transition between the two-dimensional world of the icon and the three-dimensional world inhabited by the viewer. On very early Russian icons, it was common practice to highlight the *luzga* between the margin and the depressed surface with a painted stripe, often of cinnabar.

When the panel was thoroughly prepared, a piece of linen known as a *pavoloka* was placed either across the whole of the obverse side of the panel, or over the borders and any joints or knots. The *pavoloka* further strengthened the adhesion of the primer to the panel.

The primer consisted of thin coats of white chalk pigment suspended in fish-glue (*levkas*). This was then polished and used for a preliminary contour drawing (*grafia*). So that it might not be lost under dense layers of paint, the drawing was frequently incised. However, masters of Russian icon painting such as Andrei Rublev incised the panel only when it was necessary to mark the contours of figures to be painted against a gold background, which was normally applied prior to the actual painting.

The medium was egg tempera, in which the colors were prepared from mineral or vegetable pigment, using yolk as the adhesive element. The main technique employed was the so-called *sankir* method. A portion of the image was first covered with a dark color, whose shade varied according to the date and the region where the icon was produced. Volume modeling was achieved by laying down thin patches of paint, every succeeding coat being lighter and covering a smaller area than its immediate predecessor. Details were outlined by highlights, often in pure white, and other parts of the composition, known by the generic term *dolichnye*, were added in the same way. The process of painting concluded with the addi-

Textile and painting specialists in the restoration workshop of the Russian Museum, in 1925.

tion of gilded details (*assist*) and inscriptions, after which the painting was covered with a thick coat of hot linseed oil varnish.

Since the 19th century, those who sought to understand the nature of Old Russian painting have examined every aspect of the icon. Aside from the investigation of iconography and of the various styles and schools, many historians have focused on the actual process of icon making, drawing information from Old Believers and from families of icon painters. In these circles, the icon was believed to have profound theological implications, and the very materials used in icon painting were often given a symbolic interpretation. Even the division of labor among the artists (*znamenshchiki* responsible for the drawing; *dolichniki* for the clothes, buildings and scenery; and *lichniki* for the faces, arms, hands, and feet) was believed to symbolise the element of communion and fellowship.

Despite the strict canonicity of the form of the icon, the choice of technique was always left to the painter. For example, during the reign of Ivan the Terrible there was a tendency to use dense dark paints with olive-green backgrounds, whereas the Stroganov masters of the late 16th century produced a miniature style using translucent layers of color. The use of gold ornament also changed over time. In the 17th century, colored polishes and ornaments were frequently used on gold and silver, while in the 19th century there is widespread use of *tvorenoe* gold applied with a brush, rather than gold leaf

A wide range of modern techniques has recently presented new possibilities for the study of medieval Russian art. In order to grasp fully the ideas implied in the icon, it is helpful to identify the precise technique used in every individual case, and to study these in the context of the composition of the icon. In the absence of such a study, a false impression may develop both of the object itself and of the general principles of icon painting.

The 13th century icon depicting The Mother of God Enthroned with St. Nicholas and St. Clement provides a useful example. This icon was acquired by the Russian Museum from Novgorod, and is now in the process of restoration. The faces of the Mother of God, of Christ, and of the saints are worked in a combined technique. First, a thin coat of yellow varnish was laid on the faces, then the model-

ing of volume was executed in tempera over the varnish. The translucence of the varnished ground, unlike the traditional tempera preparation, allows light to penetrate and be reflected by the white priming, and this produces an effect of transcendent luminosity.

A different technique can be seen in St. Nicholas with St. Kosmas and St. Damian, an icon of the first half of the 14th century. On top of a light ground, the form is constructed from translucent shades of gray and red, with modeling in white. The difference is that each of these elements stands in isolation, without shading into any of the other colors. To draw such a mosaic picture together, the painter introduces an additional layer of ocher in the primer. Unfortunately, because of the poor preservation of the painting, it can be difficult to determine the order of the painted layers on the icon, but the rendering of the neck of St. Nicholas demonstrates the point. The complicated system of painting seems to have been intended to enhance both the plastic quality of form and the decorative appeal of the style.

The vulnerability of the materials of the icon to climatic changes, especially temperature and humidity, often resulted in the destruction of both the primer and the painted layers. Moreover, linseed oil varnish quickly loses its transparency and obscures the image. For these reasons, icons were often renovated by removing the darkened linseed oil varnish, and then restoring the damaged areas of primer and paint.

Different methods were employed for removing the varnish. It could be scrubbed off using a rough pumice stone, or it could be dissolved in a corrosive medium and then washed away. After that, the damaged portions were primed again and the lines of the image on the icon were redrawn. Once all the details of the image were renewed, the edges of the insertions were smoothed. However, such measures frequently damaged the original painted layer.

Another method of renovation did not demand the total removal of the darkened linseed oil varnish. The surface was first gently washed so that the outlines of the image became visible, and the icon was then redrawn, either in part or in full. In many cases, perhaps because of the lack of skilled craftsmen, only the borders and the ground would be restored in this way.

The fact that some icons have six to eight painted layers, each of a different date, sug-

gests that restoration was a common practice in earlier centuries. Since many icons, have undergone a series of restorations in the course of their long history, the majority of them have come down to us as complex structures of different layers from different dates. It is obviously essential to decipher these, so that a program of restoration can be worked out correctly. The removal of later layers of paint from the original image usually consists of the following two stages: the linseed oil varnish is first softened by applying compresses of solvent, and then removed with a scalpel. At the restoration workshop in the Russian Museum, micro-instruments were used to free icons of overpaint as early as 1970. This produced a considerable improvement in the quality of restoration, and also offered a chance to conduct research into the techniques of painting. For example, it allowed the restorers to explore beneath thin layers of *lessirovochne*, and to conclude that the old masters had been using a mixed technique of colored varnishes and organic pigments. The use of solvents in restoration has therefore been restricted, as these not only affect the upper layers of paint, they also change the optical properties of the pigments, leading to a distortion of the image itself.

In this way, a relationship between the technique of painting and the symbolic content of the icon continues to be seen in current attitudes to restoration. It is now believed to be essential to undertake a complete examination of the icon, encompassing a technical review, and a detailed study of the iconography. The correlation of these two types of research will enhance our understanding of both the pictorial structure and the symbolic message of each particular icon. The general plan of restoration, especially the approach to individual elements within the image during the course of restoration and to the final state of the icon, depend ultimately upon how deeply the restorer has managed to penetrate the original intention of the artist.

The History of Embroidery Technique

Liudmila Likhacheva

Even secular life in medieval Russia was modeled on the monastery and the convent, and women in particular often spent much of their lives in seclusion. Women were mainly occupied with handicrafts, occupations regarded as their principal virtue. Embroidery served both to decorate the objects with which medieval Russians were surrounded in their everyday life and also to create figurative and ornamental works for religious purposes.

Embroidery is a true, original art form in its own right, and merits being ranked alongside other media. The art of ecclesiastical embroidery came to Russia from Byzantium after the conversion to Orthodoxy, and it developed in its own characteristic manner. Ecclesiastical embroideries include cloths suspended under icons, embroidered icons, iconostases entirely executed in embroidery, palls for the tombs of saints, altar cloths and covers to be placed over church vessels during services, and the ecclesiastical banners that were carried in church processions. Every embroidered article had a specific liturgical function that determined not only the subject of the work, but also its dimensions, shape, and artistic structure.

Ecclesiastical embroidery called for especially precious materials, and the costly fabrics on which the work was executed were imported from Western Europe, Italy, and the East. The needlewomen used silk thread in various techniques, including silver–gilt couching, whereby the threads laid on the fabric were sewn on to it in a specific order. The patterns formed in this way bore simple demotic names which have come down to us from the 18th century, but apparently date from even earlier times, including 'little coin,' 'little bug,' 'scallops,' 'grafting,' 'little fir tree.' Silver and gilt threads were produced by drawing a metal filament through a die, or by inserting spun silk thread into a fine metal tube. Silk threads were used in both twisted and untwisted form, the former giving the finished surface a matte appearance, while the latter produced a shiny surface closely imitating the sheen of flesh. Untwisted thread was therefore often employed to render the faces of human figures.

Early embroideries were often executed in silk threads, and this kind of embroidery was described as 'embroidery painting.' Another contemporary technique involved the use of gilt threads, with silk restricted to the face and hands.

When planning an embroidery, the needlewomen usually knew the church for which it was intended and the exact purpose to which it would be put. Embroideries often contain a larger number of liturgical inscriptions than panel paintings, as well as dedicatory and historical inscriptions which give the date, the name of the donor, and the place where the gift was received. Unfortunately, many of these inscriptions have not survived, the fabrics which served as backgrounds for the embroideries having deteriorated more quickly than the stitching itself.

When the background had deteriorated, the usual practice in monasteries was to cut around the contours of the embroidery and transfer it to a new backing fabric, in effect creating an entirely different work. This process led to the loss of the inscriptions on the background cloth. In the absence of any inscriptions, embroidered articles can be given a provisional date or attribution on the basis of the technique employed. The 'double-fastening' technique, for example, whereby the fastening stitch is doubled or tripled in order to give the impression of a silk pattern on the golden background, is characteristic of Godunov embroidery.

The finest works were created in the workshops of the great princes and tsars, where the most experienced and talented needlewomen were employed. In palaces or in the houses of boyars, the lightest and most spacious premises were allocated to embroidery workshops, which were known as *svetlitsa* (light rooms), with enough windows for 30 to 40 embroiders to work at their frames. In some workshops there were even larger numbers of needlewomen, as many as 80 -100, and in a few palaces separate wings were built for the purpose, connected by passages to the chambers of the head of the household, the tsaritsa.

Most of these royal works date back to the 17th century, including the objects connected with the Convent of the Ascension in the Moscow Kremlin. This entire complex was run by the mother of Mikhail Fedorovich, founder of the Romanov dynasty, and the embroideries were executed by her daughter-in-law, Evdokiia Lukianovna, and by the tsaritsa Maria Ilinichna, the wife of Alexei Mikhailovich.

When the Russian Museum was founded in 1898, its collection already contained masterworks of embroidery, some of them purchased from private individuals, mainly icon painters and restorers. In 1912 a splendid embroidery was brought from the Monastery of St. Joseph of Volotsk by the museum curator, the famous artist N.I. Neradovskii. From 1922 onward, a number of works including exquisite embroideries were received from the sacristies of the greatest northern monasteries. Embroidered objects were also received from Tikhvin, from the Cathedral of the Trinity at Pskov and from the Sheremetev Palace. In the late 1930s a large number of excellent embroidered icons, shrouds, altar cloths, and vestments were received from the Stieglitz Museum.

The 14th century Muscovite embroideries in the Russian Museum include some small cloths and vessel covers of beautiful composition, harmonious coloring, and masterly execution, the best of which were received from the Monastery of St. Cyril of the White Lake.

The collection also contains a group of Novgorodian embroideries. In the mid-15th century, works were created in Novgorod at the order of Archbishop Evfimii II (1429-58), who ordered several shrouds to be embroidered, including the Tikhvin shroud now in the Russian Museum.

After the union of Novgorod with Moscow in 1478, Muscovite features became more discernible in Novgorodian art. In 1489 Ivan III took harsh measures against Novgorod, expelling from the city over a thousand 'boyars, rich men, and merchants' and giving their lands in Novgorod to the boyars and merchants of Moscow. As a result, many renowned Novgorodian masters also moved to Moscow.

The first half of the 16th century witnessed a particularly close connection between Novgorodian and Muscovite art, a process in which an important part was played by Archbishop Makarii who became metropolitan of Moscow in 1542 and was steeped in both traditions.

Early 16th century embroidery shows the prevailing influence of the great icon painter Dionysii. The cloth of St. Cyril of the White Lake with scenes of his life, may well have been executed by an artist closely associated with the master.

By the mid-16th century greater interest was being shown in narrative embroidery, and in a multitude of detail. Colors became less bright and clear, a wider range of materials was used, and techniques became more complex. One of the most important palls is that of St. Cyril of the White Lake donated for his tomb by Ivan the Terrible and his wife Anastasiia Romanova. It was originally decorated with precious stones which, like the inscription, have been lost.

A masterpiece of the late 16th century is the shroud of the Entombment of 1592, donated to the Monastery of Solovki by Reverend Mother Feogniia of the Convent of St. Alexei in Moscow. The work is outstanding not only for the mastery of its execution but also for its excellent preservation.

In the 17th century, embroidered works became even more ornamental, magnificent, and variegated. Many different materials were used during this period, including a great deal of gold thread, precious stones, fringing, braid, and sequins. The most outstanding works of that century came from the workshops of the tsar. After Mikhail Fedorovich became tsar in 1613, his mother entered the Convent of the Ascension in the Moscow Kremlin. As the Reverend Mother Martha Ivanovna, she spent many years in the convent until her death in 1631. She administered the entire complex, restoring it after the 'Time of Troubles' and leaving the art of embroidery at a high level, not only in the convent

but also in the workshops of the tsar.

In the early and mid-17th century, a leading role at the Convent of the Ascension was also played by Reverend Mother Alexandra Golitsyna, who made a number of donations to various monasteries. The Russian Museum contains several covers donated by her to the Convent of the Ascension.

Throughout the 17th century, especially during the last 50 years, some splendid works of outstanding technical virtuosity were embroidered at Solvychegodsk, in workshops administered by the wives of the famous Stroganov family. Palls, icon cloths, vessel covers and altar cloths, icons and church vestments embroidered under the auspices of the Stroganovs are to be found in museums throughout the Russia. They were executed not only by the wives and daughters of the family, but also by the nuns of the convent situated near Solvychegodsk, many of whom were related to the family. Stroganov embroidery flourished particularly in the 1650s and 1660s, when the workshops were supervised by Anna Ivanovna, the wife of Dmitrii Andreevich Stroganov. The family made many donations to the Monastery of Solovki, and many of these are now preserved in the Russian Museum.

In conclusion, the Russian Museum contains one of the finest collections of medieval embroidery in Russia, enabling us to trace the development of this astonishing art from the earliest times to the period of Peter the Great. The works that have been handed down to us show us how talented, inspired, and industrious Russian women had been during the medieval period.

The Icon

PAST, PRESENT, AND FUTURE

Robin Cormack

The icon, you might think, is one form of art which can 'speak for itself.' It was, after all, often designed as a self-contained composition, usually for display in a church, and sometimes at home or as a travelling companion. But in actuality the icon is no more able to speak for itself than any other work of art. Even in the church, the silence of the icon is translated in different ways by different viewers, depending on their religiosity and current state of mind. It may be seen, for example, to act as a screen to conceal the holy of holies or as a window to eternity. It may appear as an intimate devotional help or as an overwhelming and unapproachable revelation of the divine. The icon screen has evocatively been described as 'on the boundary between earth and heaven.'

How has art history tried to speak for icons? To find a perspective requires a vista of at least a century; through sketching a selection of approaches over this period, we can begin to construct a mosaic with a pattern. This should help towards handling the question which is more perceptively explored today than it was a hundred years ago: how do we look at this particular kind of religious art?

The treatment of icons as a distinctive medium is commonplace today. This is partly a matter of changed definitions, partly the result of the discovery of so much new material. It is of course reasonable, and for some kinds of analysis very helpful, to employ the broad medieval definition of the word *eikon* as a pictorial image in any medium, including monumental mosaic as well as small ivories or wood productions. But in recent years it has become more common to conceive the icon as a panel painting, normally on wood (for which there was also a medieval term, *sanida* in Greek). This is the definition followed here. While this will help to focus the discussion and to appreciate the special character of icons, yet we need to remember that earlier this century icons were in-corporated into a broader art historical discourse, and analysed in the same framework as the other pictorial arts. It is a recent insight that the devotional image is in a special category, distinguished by its patronage across all classes of society, and viewed in special ways by individual members of the whole society. In comparison with the icon, monumental mosaic decoration was the product of the elite only, and was no doubt normally viewed communally in the church from a less personal and intimate viewpoint. We can return to this positive treatment of the medium later, but first let us look how historians of Orthodox art have handled the pictorial image.

Two episodes may be suggested as particularly important in the modern perception of the icon, although this is not to deny the potential significance of other factors, such as awareness of the medium which might have been gained through private collections and the rise of the modern museum. But two things effectively took the study of the icon out of the highly-charged atmosphere of the worshipping community in the church into the world of scholarship. Both took place in Egypt: one was the removal of icons from Sinai to Kiev by Archimandrite Porfirii Uspenskii in 1850, some later to be lost; the other was the excavation of considerable numbers of Late Antique mummy portraits from the Fayyum, which were soon widely dispersed in collections across Europe. Knowledge of this material was at the basis of the much repeated (but essentially superficial) idea that the icon was a 'continuation' of pagan art, and that the environment of Egypt was an essential element in the transition from pagan to Christian art. This 'orientalizing' interpretation of Christian art was in turn challenged from a more Greco-Roman standpoint which saw the beginnings of Christian art in Italy, even perhaps in the catacombs. All the seeds were laid early for the

The art historian and collector N. P. Likhachev at home ca. 1910, with the 14th century icon of St.Boris and St. Gleb now in the Russian Museum.

Orient oder Rom controversy over the genesis of Christian art.

The beginnings of the scientific study of Byzantine and Russian icons are necessarily linked together, another factor in the frameworks of interpretation being the 19th century 'Romantic' observation of Orthodox art. British travelers in Orthodox lands were less than attracted by the art they found: for Robert Curzon in 1849 the art of the Levant was 'very inferior to the admirable productions of the Italian schools'; and for J.Beavington Atkinson in Kiev in 1873, 'only in the most corrupt of Roman Catholic capitals does ecclesiastical art assume the childish forms common in Russia.' Yet other travelers were fascinated in different ways. Another 'Romantic' question was to ask how the Orthodox artist coped in a church-dominated society. In 1845 Didron introduced into the literature the idea that the Byzantine artist was programmed into uniformity by the imposed formulae and models of a controlling church. The evidence was the 'Painter's Manual' of Dionysios of Fourna, and the interpretation of this and other post-Byzantine and Russian codifications have had a profound, but unresolved, influence on the art history of the icon.

By the end of the 19th century, field research on Orthodox art, and particularly architecture, was ardently and systematically undertaken. This activity was essentially archaeological and antiquarian, and has turned out to be indispensable for its thorough record of material often now crumbling or destroyed. The foreign schools working in Greece and the Ottoman lands built up and published invaluable archives of photographs, descriptions, drawings and plans. Two key institutions were the Russian Archaeological Institute in Constantinople and the British School of Archaeology at Athens, and there were many extraordinarily energetic individuals, perhaps most notably Nikodim Kondakov, Gabriel Millet, and Josef Strzygowski.

At any time when primary material is collected on this massive scale, the intellectual problem that emerges is how to catalogue and present the data. The common solution is to follow and adapt (apparently) successful models from other more advanced areas of scholarship. Inevitably the model was to be Renaissance Italy, which up to 1880 was the main training ground and focus of attention of art

history. Inevitably the structures of interpretation which then emerged in the study of Orthodox art involved the perception of 'renaissance,' the creativity of 'regional schools,' and the role of the artist. Particular theories have dominated the subject ever since: was there a 'Macedonian Renaissance' in the 10th century? Was there a 'Palaiologan Renaissance' and period of 'humanism'? What was the relative importance of the 'school of Antioch' and the 'school of Alexandria' in the creation of the 'school of Constantinople'? Was there a 'Macedonian' school? How far was the development of Russian art decided by the relative creativity of the 'schools' of Moscow and Novgorod and other cities? How did artists' 'workshops' operate? How free was the individual artist? What 'influences' can be identified between artists or between schools? How far was Byzantine Iconoclasm a movement to control the power of artists? Many of these questions are still debated in the literature, although their interpretative value may no longer be maintained in their parent Italian Renaissance art history! It is hardly possible for us to keep speaking in these terms now, unless methodological justification is also given. Most of these questions involve a reductionism which, it may be felt, cannot do justice to all the conceptual and cognitive issues involved in the production and use of icons.

While the basic interpretative structures within which Orthodox art history long operated are identifiable, the individual scholarship is obviously far more complex. One can only admire, for example, the fantastic knowledge of Orthodox art which some specialists have managed to achieve, despite the fragmented and scattered nature of the material and the disparate sources of scholarship. The recent exploration of new approaches to the interpretation of the icon depend entirely on the energy of these scholars, and often on their personal insights within the overall frameworks in which they were to some extent straight-jacketed. It would be worthwhile exploring their individual contributions in some detail, but for the present my aim is to extract the more historiographic elements of their work which have duly influenced specific writings about the icon.

At the beginning of the century, the general perception seems often to have been that the icon, and the iconostasis, was a special devel-

opment of Russian Orthodox art. This was a medium which, in other words, characterized Russia, and which needed to be studied as a development or transformation of Byzantine art; for some critics it even appeared to be a degeneration of Byzantine art. This whole aesthetic panorama is now discredited, but it has some historical interest, both for the part it played in the development of modern art through the interest in icons shown by Matisse and other artists in the early 20th century, and in the stimulus towards collecting icons as part of Slavic national revival movements. These questions were reviewed by Labreque-Perrouchine in 1982, among others.

The foundation of the modern art historical study of icons is undoubtedly the work of N.P.Kondakov (1844-1925), whose approach was marked by a clear reaction against aestheticism, and is characterized by its thorough and dry analysis of the objects. His travels gave Kondakov a clearer picture of the importance of the icon in Byzantine and Russian art, and of the need to explore the chronological history of the medium, and the precise relations between the two cultural areas. After all he had been to Sinai in 1881, although the icons had not yet been collected together and made accessible in the monastery, and published in 1902 the icons brought from Sinai and Athos to Kiev. Fortunately the seminal nature of the work of Kondakov became easily accessible to international scholarship in the well-produced English translation of E.H.Minns of 1927 entitled *The Russian Icon*, which is based primarily on the collection of the Russian Museum of St. Petersburg. Kondakov here and elsewhere took a formalist approach to the subject, and was concerned through considerations of style to set out a structure of dates, schools, attributions, and influences. The discourse is similar to that of Gabriel Millet. One crucial issue for Kondakov was to explain the development of Russian art in the 14th century. He engaged in a debate with N.P.Likhachev and D.V.Ainalov on the relative importance of the Italian proto-renaissance over the Palaiologan art of Constantinople as an influence in the creation of the distinctive Russian icon. This long-lasting debate was vigorously continued by, among others, V.N.Lazarev, D.S.Likhachev, and M.V.Alpatov. The resolution of the debate must lie in dissolving too sharp a distinction between Byzantine and Italian art and so losing the idea of characteristic polarities from which to derive various elements and features of Russian art. The consequence would then be to point up connections between Russia and Byzantium, both in stylistic terms and also in their common religious interests, particularly the mystical movement of hesychasm, which undoubtedly influenced icon subject matter and perhaps style, although in ways yet to be satisfactorily documented.

The consequence of the groundwork of Kondakov and his successors is that the empirical study of the Russian icon has been well established throughout the century. The centralization of works of art in galleries and museums intensified after the Revolution of 1917, and the Russian expertise in icon restoration and technical study has built up a impressive repertory of information. A classic example of this expertise in action is the catalogue of the Tretiakov Gallery of 1963 by Antonova and Mneva. This basic work on one of the most important collections of icons has meant that whenever there are collections of Russian icons outside Russia, comparative information for cataloging them is available. Hence icons which left Russia after 1917 and entered museum collections have been dated and attributed along established lines; two examples of such groups are the important collection of Aschberg (245 icons) which entered the National Museum in Stockholm in 1933, and the much smaller collection of Allen in the National Gallery of Ireland, Dublin, purchased in 1968, but mostly acquired in Turkey in the 1920s.

But paradoxically the most striking demonstration of Russian skills was less obviously constructive. This was the attempted deconstruction of the authenticity of the Hahn collection of icons published by V.M.Teteriatnikov in 1981. This re-assessment of a 'collection of masterpieces' as a 'museum of phantom-icons' relied on a Russian training in connoisseurship, which attempted to dissolve the historical value of a collection that had been prominently appreciated since its appearance in the United States during the late 1930s. Teteriatnikov controversially attributed much of the production of the icons in the collection to expert Russian creator-copyists at the beginning of the 20th century. While he may have been too hasty to generalize, and a recent technical study by Havice of one of the icons of the Dormition does vindicate the antiquity of some of its sur-

face paint, our interest for the moment is in his account of his methods, a section of which can be revealingly quoted: 'There is the problem of the wood. The study of Russian icon painting begins with the study of the wood on which it is painted. The famous Russian specialist of the early twentieth century, I. E.Grabar, required his students to spend the first two years of their training studying the wood. This approach has been so well inculcated into Russian specialists that everyone has acquired an almost uncontrollable habit when confronting a new icon: instead of examining the painting itself, they habitually turn it over to look at the wood and the construction of the board.'

The main lines of the stylistic development of the Russian icon have therefore been painstakingly established, predominantly by the work of scholars in Moscow and St. Petersburg. We learn that in the period from the 11th to the 13th century the lines of communication between Byzantium and Russian production are reasonably simple, or in other words, the origins of the artists of icons are not always detectable. But from the 14th century onwards the pictorial dialogue between Byzantine and Russian art is increasingly sophisticated. The similarities between the mature work of the documented Byzantine artist Theophanes the Greek and the early work of the Russian painter Rublev would seem to be so close that a relationship of some sort is obvious; whether this was one of master and pupil or a less formal connection is less important an issue than that of analyzing the character of the contribution of Theophanes to the development of Rublev's career, although it is true that all attributions to Rublev at any point in his career might be challenged, and his personality is still far from any agreed characterization. Yet between them, Theophanes and Rublev might be seen as the pictorial 'architects' of a generation, profoundly influencing almost a century of Russian production. If we continue this interpretation of the development of icon painting in terms of personalities, it is clear that the next turning point is in the distinctive style and elongations of Dionysii, and that this stage was followed subsequently the exquisite innovations (and variations) of the 'Stroganov school' artists. But despite the ease with which we may feel we can set out a development of the Russian icon in terms of styles, this framework omits all sorts of fundamental questions of in-

terpretation. It hardly enables us to consider the medium in its historical social environment. The emphasis of Kondakov and his followers has been significantly (though not of course exclusively) on the circumstances of the production of icons; increasingly this has meant working in the terms of an anachronistic art historical methodology, and at the expense of a full consideration of the possible functions of such religious images in a traditional society. Herein may lie certain conceptual limitations which were inherited from the initial Italian Renaissance model. The most obvious problem in the approach is the highlighting of chronology and attribution as ends in themselves. By treating works of art in this sort of isolation, the danger is of an excessive teleological interpretation of the progress of style, without due attention to contextual and historical frames. It is this hermetic problem which 'new art history' has identified, and which it has attempted to renegotiate.

At this point we need to broaden our range and ask what other methods of approach need appraisal. On the question of the functions of icons in their society, there have been perhaps two main strategies: to look at the expressed policy of the church, or to seek to understand the motivations of patrons. The first has been easier to explore, partly because of the relative wealth of textual documentation. However the reading of that text requires the utmost care and consideration of method; it certainly cannot be treated as 'fact' at face value. The most sophisticated area of Byzantine historical research is currently the period of Byzantine Iconoclasm, when the church and state explicitly faced a dispute on the purposes and proper forms of Christian imagery. Although the Council of Nicaea in 787 was regarded in Byzantium as the final and authoritative statement on these issues, in Russia the debate on the proper forms and functions of icons was continued and later intensified. Among scholars, L. Uspenskii has in particular articulated an analysis of the social function of icons on the witness of Council and Church statements. In a synthetic coverage published in 1980, he has emphasized the importance of the Moscow Council of the Hundred Chapters (*Stoglav*) in 1551 as witnessing a major turning point in the awareness of the powers of the icon. Among the canons of this council are included stringent regulations on the content and production

of icons and even on the character and behaviour of artists. While it is always difficult to assess the relation to actual practice of official pronouncements, this kind of research has certainly not yet been sufficiently exploited.

The issues of patronage have of course been likewise explored; but despite the traditional art historical interest in 'patronage,' unless this research is carried out within some formulated sociological framework, there is a danger that little is discovered beyond a list of the names of patrons. In 1974 Grishin was right to point to the production of a new and distinctive form of icon specially connected with the far north-eastern estates of the Stroganov family around 1600 as an exemplary case for the study of changing patterns of patronage connected with the development of a 'bourgeoisie.' Recent work by Tatiana Vilinbakhova has opened up the question of stylistic origins of the Stroganov painters, who have been shown to have developed along the same lines as some post-Byzantine icon painters in the Venetian environment of Crete.

This directed focus so far on the character and context of the Russian contribution to the study of the icon is intended to emphasize that for decades scholarship saw the icon as a Russian domain. Only recently has the whole horizon radically changed, and art history recognized the icon as a major form of expression from the very beginning of Christian art in Byzantium, and to an extent in Western Europe too. Some hints of this situation had of course been visible to those who cared to look at icons, for example, in the South Slav countries of the Balkans, in Greece and Italy, and to the East in Georgia, Cyprus, and the Levant. But it needed the massive stimulus of the publication of the icons of St. Catherine's Monastery on Mt. Sinai to jolt the whole consciousness of the Byzantine art historian to appreciate a new perspective. The 'discovery' of icons at Sinai is without exaggeration one of the major events in world art history. The quality and importance of this substantial hoard has caused a total reappraisal of the icon, and this expansion of knowledge has enabled us to recognize new materials as part of the corpus. Only in the light of the publications of Sinai icons was it possible to see the small panel of St. George in the British Museum as one of a 13th-century group of panels.

The turning point in the realisation of the importance of the icons of Sinai came in the 1950s. George and Maria Soteriou brought out in 1956 an album of over 150 icons, which they had been preparing since a first visit in 1938; the descriptive text volume appeared in 1958. Meanwhile in 1956 Kurt Weitzmann of Princeton University had gone to the monastery to consider organizing an expedition there, but he was quite unprepared to learn of the enormous icon stores. He was shown the Soteriou album by the archbishop, which confirmed for him the outstanding importance of the material; and he subsequently helped to arrange the Michigan-Princeton-Alexandria joint campaigns of recording the Sinai material between 1958 and 1965. Weitzmann has since published the seminal studies of many of the icons, although not the complete 2048 items on his checklist. Weitzmann's publications of Sinai material and his cooperation in a number of 'block-busting' composite icon albums has achieved a revolution in the art historical consciousness of the medium. In 1990 Manafis edited the most lavish publication so far of the artistic riches of the monastery, which includes a major revisionist consideration of the dates and attributions of Weitzmann by the late Doula Mouriki.

The Sinai collection of icons posed the classic situation for the art historian: how does one study and publish a mass of new material? Since the formulation of a framework was made in 1938 and 1956, it is not surprising that the chronological catalogue was chosen, and indeed it might still be strongly argued that this should be the 'norm' for art historical presentation. Interestingly, however, in some of his preliminary publications, Weitzmann elected to publish groups of material which, though stylistically chosen, did represent types of patronage as much as artistic personalities. These treatments of 'Crusader' icons, which were suggested by Buchthal's pioneering construction of a category of 'Crusader' illuminated manuscripts, have been immensely provocative in re-examining the character of art during the period of the Crusades, including the whole issue of the artistic relations between both Eastern and Western Europe and between the various Orthodox and Eastern Christian communities. While this discussion has considerably sharpened our visual awareness of artistic personality and has usefully dissolved some of the stereotypes of East and

West, we still need to develop a conceptual framework which avoids apparently nationalistic arguments over the origins of the individual artists. In particular the relatively small groups of composite 'Crusader' icons need a more subtle analysis than in terms of regional attributions of the artists, who are in danger once again of returning to stereotypes of 'French,' 'Italian,' 'Byzantine,' 'Cypriot,' 'Syrian,' 'Coptic,' or other national constructions. While the architectural and sculptural enterprises of the Crusaders can show very clearly the existence of Frankish artists in the region, the more 'synthetic' styles of the icons are more difficult to explain.

The capital importance of the Sinai collection and the concomitant interest it has stimulated in the study of other panels has contributed the empirical information about the history of icon production which we now have. We need to integrate this work with the Russian tradition of scholarship to construct a new discourse. This integration is needed not only for the Crusader period, but also for the following centuries. The growing information about icon production in Greece after 1204 cannot be studied in isolation from the Russian material. But Sinai has already greatly increased our knowledge of the Byzantine icon, even if the study of the wood and technical aspects of the Sinai icons were given surprisingly little attention. The Sinai sequence begins in the 6th century, and, like the Fayyum mummy portraits from Egypt, the pigments were mixed in egg tempera or wax encaustic. The regular use of encaustic had dropped out use by the end of Iconoclasm (730-842), and so the great majority of icons are in the tempera technique. The Sinai corpus includes single panels, diptychs, triptychs, icons made up from jointed panels, and beams. It gives a repertory of types, and stimulates all sorts of very basic questions: how did the icons enter the collection? How many were painted on site and how many brought overland from outside? Who were the patrons and who were the artists? What were their functions in the churches and chapels of the Sinai desert? What is the connection between icons, manuscripts, and wallpaintings?

Of all the empirical questions which our new awareness of the long history of the icon has prompted, the most intense has been over the precise history and devotional implications of the 'icon screen.' Can we map the stages and implications of the development from the open chancel of the early church, through the higher templon barrier of the medieval Orthodox church, to the final iconstasis of the Orthodox church, of which the Russian *ikonostas* is often taken as the paradigm case? The controversy has been over the time (between the 11th and 13th centuries?) and the place (whether it was a regional development in the Orthodox world or in the monastery or cathedral?) of the transition from templon to iconstasis. The evidence is in the main either archaeological – the evidence of the icons themselves or of the fittings in churches or of representations in other media– or textual. It seems that the answer will most likely come from an interpretation of these texts, which may be archival, consisting of medieval inventories or descriptions in church charters (*typika*), or may be historical, literary, or theological. But unless historians of the iconstasis are as sophisticated in reading text as historians of *ekphrasis* like James and Webb, who have learnt to negotiate writings which are about the works of art they 'describe' in very elusive ways, both the development and meanings of the screen may be distorted. Texts which describe works of art are seldom merely descriptive–they need to be carefully negotiated.

The art history of the icon, like the discipline itself, has moved into post-modernism, and as discussed by Cormack in 1985, it has loosened its former primary concern with production or patronage. At its simplest, the approach focuses on viewing or the viewer; but this axis has opened out many questions and is particularly opportune for handling some of the other new materials which have become the subject of study in recent years. For example, in the study of the growing repertory of 'Cretan' or Venetian Renaissance icons, it can now be seen that there is no need to look exclusively at the chronology and attribution of these icons, although the redating of the painter Angelos Akotantos to the 15th century and the establishment of his oeuvre has been important. Questions of nature of late medieval piety and the reasons for the westernization of the Orthodox are better understood in terms of the responses of the viewers to the new forms and subjects. Similarly the study of the icons of the 'Old Believers' or of the 'modern' icon and of the whole issue of the status of 'copies' may be far more evocative in terms of the spirituality

of the religious viewer than of the expertise of the artist. Boris Uspenskii, despite his ambivalence in the treatment of formal composition between the eye of the artist and the eye of the viewer, was a perceptive contributor to the new debate. To understand the icon, it is now clearer, involves the understanding of how religious art at its broadest functions in the viewing society.

What is perhaps most evident from the historiography of icons is the gulf between the modern cataloger and the medieval consumer. Their icons almost without exception lack explicit indications of their date, place of production, and name of artist; this can hardly have been 'information' which the Orthodox Christian then required. This position changes in the course of the Cretan and Russian production, as the relation between communality and the individual in society changed. A reconstituted art history needs to be sensitive to the strengths and weaknesses of its influential predecessors in order to relate itself to the objects of its study.

BIBLIOGRAPHY

This is a highly selective and subjective bibliography chosen to illustrate the historiography of the icon. Some items are explicitly mentioned in the text, others implicitly. They are listed in chronological order. There is no attempt at any sort of completeness, and some titles are chosen for their own bibliographical rather than methodological value.

A. Didron, *Manuel d'iconographie chrétienne grecque et latine*, Paris, 1845.

R. Curzon, *Visits to Monasteries in the Levant*, London, 1849.

K.A. Uspenskii (Archimandrite Porfirii), **Второе путешествіе въ Синайскій Монастырь въ** 1850 **году** (Second Journey to the Sinai Monastery in the year 1850), Kiev, 1850.

J. Beavington Atkinson, *An Art Tour to Northern Capitals of Europe*, London, 1973.

N.P. Kondakov, **Путешествіе на Синай въ** **1881 году** (Journey to Sinai in the year 1881), Odessa, 1882.

E. von Dobschütz, *Christusbilder: Texte und Untersuchungen zur Geschichte der altchristlichen Literatur*, Leipzig, 1899.

D.V. Ainalov, **Эллинистическія основы византійскаго искусства** (The Hellenistic Origins of Byzantine Art), St. Petersburg, 1900-1 (English translation, New Brunswick, 1961).

N.P. Kondakov, **Иконы Синайской и А фонской коллекціи Преосв. Порфирія** (Icons from Sinai and Athos of the Collection of the Most Eminent Porfirii), St. Petersburg, 1902.

Dionysios of Fourna, *Manuel d'iconographie chrétienne*, ed. A. Papadopoulo-Kérameus, St. Petersburg, 1909.

G. Millet, *L' iconographie de l'évangile*, Paris, 1916.

N.P. Kondakov, *The Russian Icon*, tr. E.H. Minns, Oxford, 1927.

I. Grabar et al., **История русского искусства** (History of Russian Art), Moscow, 1940-.

L. Ouspensky and W. Lossky, *Der Sinn der Ikonen*, Bern, 1952 (English translation *The Meaning of Icons*, 1952, 2 ed. 1978).

G. Hamilton, *The Art and Architecture of Russia*, Harmondsworth, 1954, 2ed. 1975.

G. and M. Soteriou, *Icônes du Mont Sinaï*, Athens, 1956 (album), 1958 (text).

H. Buchthal, *Miniature Painting in the Latin Kingdom of Jerusalem*, Oxford, 1957.

A. Grabar, *L'iconoclasme byzantin*, Paris, 1957, 2ed. 1984.

V.N. Lazarev, **Феофан грек и его школа** (Theophanes the Greek and his School), Moscow, 1961.

V.J. Djuric, *Icônes de Yougoslavie*, Belgrade, 1961.

M. Chatzidakis, *Icônes de Saint-Georges des Grecs et de la collection de l'Institut*, Venice, 1962.

K. Weitzmann, 'Thirteenth-Century Crusader Icons on Mount Sinai,' *Art Bulletin* 45, 1963, pp. 179-203.

V.I. Antonova and N.E. Mneva, **Гос. Третьяковская галерея. Каталог древнерусской живописи** (State Tretiakov Gallery: Catalog of Early Russian Painting), 2 vols., Moscow, 1963.

K. Weitzmann et al., *Icons,* London, 1965.

J.H. Billington, *The Icon and the Axe: An Interpretative History of Russian Culture*, London, 1966.

V.N. Lazarev, **Андрей Рублев и его школа** (Andrei Rublev and his School), Moscow, 1966.

K. Weitzmann, 'Icon Painting in the Crusader Kingdom,' *Dumbarton Oaks Papers* 20, 1966, pp. 50-83.

D. Talbot Rice and T. Talbot Rice, *Icons: The Natasha Allen Collection*, Dublin, 1968.

A. Papageorgiou, *Icons of Cyprus*, Paris, 1969.

C. Walter, 'The Origin of the Iconostasis,' *Eastern Churches Review* 3, 1971, pp. 251-265.

D. and T. Talbot Rice, *Icons and their Dating*, London, 1974.

P. Hetherington, *The 'Painter's Manual' of Dionysius of Fourna*, London, 1974.

A.D. Grishin, *Stroganov Icon-Painting: A Study in Late 16th and early 17th century Russian Patronage*, unpublished MA thesis, University of Melbourne, 1974.

B. Uspensky, *The Semiotics of the Russian Icon*, ed. Stephen Rudy, Lisse, 1976.

K. Weitzmann, *The Monastery of Saint Catherine at Mount Sinai: The Icons from the sixth to the tenth century*, Princeton, 1976.

L. Ouspensky, *La Théologie de l'icône dans l'église orthodoxe*, Paris, 1980.

V.M. Teteriatnikov, *Icons and Fakes: Notes on the George R. Hann Collection*, 3 vols., New York, 1981.

N. Labreque-Pervouchine, *L'Iconostase: une évolution historique en Russie*, Montreal, 1982.

K. Weitzmann, *Studies in the Arts at Sinai*, Princeton, 1982.

K. Weitzmann et al., *The Icon*, London, 1982.

R. Cormack and S. Mihalarias, 'A Crusader Painting of St. George: *Maniera Greca* or *Lingua Franca*?,' *Burlington Magazine* 126, 1984, pp. 132-41.

R. Cormack, *Writing in Gold*, London, 1985.

D. Mouriki, 'Thirteenth-Century Icon Painting in Cyprus,' *Griffon* n.s. 1-2, 1985-6, pp. 9-80.

J. Børtnes, *Visions of Glory: Studies in Early Russian Hagiography*, Oslo, 1988.

G. Vikan, R. Cormack, W. Tronzo, T. Gouma-Peterson, *Icon*, Washington DC and Baltimore, 1988.

G. Babic, *Icons*, Belgrade, 1988.

R. Cormack, *The Byzantine Eye*, London, 1989.

E. Smirnova, *Moscow Icons: 14th - 17th centuries*, Oxford, 1989.

H. Belting, *Bild und Kult: Eine Geschichte des Bildes vor dem Zeitalter der Kunst*, Munich, 1990.

M. Cheremeteff, 'The Transformation of the Russian Sanctuary Barrier and the Role of Theophanes the Greek,' in *The Millenium: Christianity and Russia 988-1988*, ed. A. Leong, Crestwood NY, 1990, pp. 107-40.

K.A. Manafis, *Sinai: Treasures of the Monastery of Saint Catherine*, Athens, 1990.

L. James and R. Webb, 'To understand Ultimate Things and Enter Secret Places: Ekphrasis and Art in Byzantium,' *Art History* 14, 1991, pp. 1-17.

N. Teteriatnikov, 'The Role of the Devotional Image in the Religious Life of Pre-Mongolian Russia,' in *Christianity and the Arts in Russia*, ed. W.C. Brumfield and M.M. Velimirovic, Cambridge, 1991, pp. 30-45.

R. Cormack, 'Reading Icons,' *Valör: Konstvetenskapliga Studier* 4, 1991, pp. 1-28.

M. Barasch, *Icon: Studies in the History of an Idea*, New York, 1992.

C. Havice, 'The Dormition of the Virgin Icon,' in *Four Icons in the Menil Collection*, ed. B. Davezac, Houston, 1992, pp. 24-45.

Notes

Introduction
Roderick Grierson

1 E. Gibbon, *The History of the Decline and Fall of the Roman Empire*, ed. J.B. Bury, London, 1896, vol. 1, p. xxxvi.

2 D. Obolensky, *The Byzantine Commonwealth: Eastern Europe 500-1453*, London, 1971, esp. pp. 1-3.

3 **Повесть временных лет,** ed. D.S. Likhachev, Moscow and Leningrad, 1950, vol. 1, p. 75. (for an English version, see *The Russian Primary Chronicle*, tr. and ed. S.H. Cross and O.P. Sherbowitz-Wetzor, Cambridge, Mass., 1953, p.198.)

4 E.W. Said, *Orientalism: Western Conceptions of the Orient*, London, 1978.

5 A. Cameron, 'The Exotic Mirage,' *Times Higher Educational Supplement*, September 21, 1990, p. 13.

6 R. Byron, *The Byzantine Achievement: An Historical Perspective*, London, 1929, p. 200.

7 C. Sykes, *Evelyn Waugh: A Biography*, London, 1975, p. 343.

8 P. Brown, 'A Dark Age Crisis: Aspects of the Iconoclastic Controversy,' *English Historical Review* 88, 1973, pp. 1-34. (reprinted in *Society and the Holy in Late Antiquity*, London, 1982, pp. 251-301.

Visions of the Invisible
Sergei Averintsev

1 Kontakion of the Triumph of Orthodoxy, celebrated on the first Sunday of Lent to commemorate the victory over iconoclasm.

2 *Patrologia Graeca*, ed. J.-P. Migne, vol. 98, col. 157.

3 *Sanctorum Conciliorum . . . collectio nova*, ed. Mansi, vol. 13, p.344.

4 L. Ouspensky, **Богословие иконы православной**, Paris, 1978, pp. 132. (the translation is the author's own; an English version is forthcoming as vol. 2 of *The Theology of the Icon*, Crestwood, N.Y.)

5 ibid, pp. 149-50.

6 P.A. Florenskii, **У водоразделов мысли**, Moscow, 1990, p. 100.

The Death of Eternity
Roderick Grierson

1 *Corpus Scriptorum Historiae Byzantinae*, vol. 2, Bonn, 1828, pp. 101-2.

2 *Le Livre des Cérémonies*, ed. A. Vogt, Paris, 1935, vol. 1, p. 2.

3 *Istoria Turco-Bizantina*, ed. V. Grecu, Bucharest, 1958, p. 329.

4 *Acta et Diplomata graeca medii aevi sacra et profana*, ed. F. Miklosich and I. Müller, Vienna, 1862, vol. 2, pp. 188-92.

5 **Памятники дипломатическихъ сношений древней Россіи съ державами иностранными**, St. Petersburg, 1851, cols. 604 - 5

6 Quoted in Gordana Babic, *Icons,* Belgrade, 1988, p. 2.

7 *Nova Patrum Bibliotheca*, ed. A. Mai, Rome, 1844-54, vol. 6.2, p. 427.

8 *Patrologia Graeca*, ed. J.-P. Migne, vol. 100, col. 1113.

9 *The Life of Archpriest Avvakum by Himself*, tr. J. Harrison and H. Mirrlees, London, 1924, pp. 23-4.

10 C. Mango, 'Antique Statuary and the Byzantine Beholder,' *Dumbarton Oaks Papers* 17, 1963, pp. 65ff.

11 C. Mango, *The Art of the Byzantine Empire 312-1453: Sources and Documents*, Englewood Cliffs, N.J., 1972, pp. xiv-xv.

12 L. James and R. Webb, 'To Understand Ultimate Things and Enter Secret Places: Ekphrasis and Art in Byzantium,' *Art History* 14, 1991, pp. 1-17.

13 C. Mango, *Byzantium: The Empire of New Rome*, London, 1980, p. 260.

14 J. Trilling, 'Late Antique and Sub-Antique, or the "Decline of Form" Reconsidered,' *Dumbarton Oaks Papers* 41, 1987, pp. 469-76.

15 R. Cormack, 'Patronage and New Programs of Byzantine Iconography,' in *The 17th International Byzantine Congress: Major Papers*, New Rochelle, N.Y., 1986, pp. 608-38.

16 L. Ouspensky, 'The Meaning and Language of Icons,' in *The Meaning of Icons*, L. Ouspensky and V. Lossky, Crestwood, N.Y., 2ed. 1982, p. 40.

17 For example, H. Hibbard, *Bernini*, Harmondsworth, 1965, p. 138.

18 E. Panofsky, *Abbot Suger on the Abbey Church of St.-Denis and its Art Treasures*, Princeton, 2ed. 1979, p. 23.

19 *Patrologia Graeca*, ed. J.-P. Migne, vol. 155, col. 345.

20 K. McVey, 'The Domed Church as Microcosm: Literary Roots of an Architectural Symbol,' *Dumbarton Oaks Papers* 37, 1983, pp. 91-121.

21 C. Mango, *Byzantium: The Empire of New Rome*, London, 1980, p. 270.

22 M. Cheremeteff, 'The Transformation of the Russian Sanctuary Barrier and the Role of Theophanes the Greek,' in *The Millenium: Christianity and Russia 988-1988*, ed. A. Leong, Crestwood, N.Y., 1990, pp. 107-24.

23 For a valuable survey of Byzantine liturgical commentators see H. Wybrew, *The Orthodox Liturgy: The Development of the Eucharistic Liturgy in the Byzantine Rite*, London, 1989.

24 Nicholas Cabasilas, *The Divine Liturgy*, tr. J.M. Hussey and P.A. McNulty, London, 1960.

25 J.F. White, 'Durandus and the Interpretation of *Christian Worship*,' in *Contemporary Reflections on Medieval Christian Traditions*, ed. G.H. Shriver, Durham, N.C., 1974, pp. 41-52.

26 For example, *The Study of Liturgy*, ed. C. Jones, G. Wainright, E. Yarnold, London, 1978.

27 quoted by J. Meyendorff, 'The Mediterranean World in the Thirteenth Century, Theology: East and West,' in *The 17th International Byzantine Congress: Major Papers*, New Rochelle, N.Y., 1986, p. 671, from Etienne Gilson, *La philosophie au Moyen-Age des origines patristiques à la fin du XIVe siècle*, Paris, 1952, p. 396.

28 see J. Meyendorff, *A Study of Gregory Palamas*, London, 1964; idem, *St. Gregory Palamas and Orthodox Spirituality*, Crestwood, N.Y., 1974.

29 P. Brown, *The Body and Society: Men, Women and Sexual Renunciation in Early Christianity*, London, 1989, pp. 77-82.

30 For example, Diego de Estella (Diego de San Cristobal) nephew of St. Francis Xavier and theological adviser to Philip II, who employs the terms *deificado* and *endiosado*. A helpful summary of a very complex issue is provided by R. Williams in *A Dictionary of Christian Spirituality*, ed. G.S. Wakefield, London, 1983, s.v.

31 *New York Times*, March 23, 1972, p. 6.

32 R. Cormack, *Writing in Gold: Byzantine Society and its Icons*, London, 1985, esp. pp. 141ff.

THE ORIGINS OF RUSSIA AND ITS CULTURE

Simon Franklin

1 On this sporadically controversial issue see *Varangian Problems* (=*Scando-Slavica*, suppl. 1, 1970); on the name see G. Schramm, 'Die Herkunft des Namens Rus: Kritik des Forschungsstandes,' *Forschugen zur Osteuropaischen Geschichte* 30, 1982, pp. 7-44; also **Константин Багрянородный, Об управлении империей**, ed. G.G. Litavrin and A.P Novoseltsev, Moscow, 1989, pp. 293-307. General histories of Kievan Rus are scarce in English, see G. Vernadsky, *Kievan Russia*, New Haven, 1943; also now in translation the 'textbook' Soviet account by B.A. Rybakov, *Kievan Rus*, Moscow, 1989.

2 **Повесть временных лет,** ed. D.S. Likhachev, Moscow and Leningrad, 1950, vol. 1, p. 18; here and subsequently translations are the author's own, but for the full chronicle text in English see *The Russian Primary Chronicle*, tr. and ed. S. H. Cross and O.P. Sherbowitz-Wetzor, Cambridge, Mass., 1953.

3 Constantine Porphyrogenitus, *De administrando imperio*, vol. 1, ed. G. Moravcsik, tr. R.J.H. Jenkins, Washington D.C., 1971, pp. 56-63; vol. 2, Commentary, ed. R.J.H. Jenkins, London, 1962, pp. 16-61 (commentary by D. Obolensky); see also the commentary in **Константин Багрянородный**, pp. 291-332. For a broader context see H.R. Ellis Davidson, *The Viking Road to Byzantium*, London, 1976.

4 **Повесть временных лет,** p. 56. For the story of the conversion see Cross, *Chronicle*, pp. 96-119.

5 See esp. Ilarion's *Sermon on Law and Grace*: L. Müller, *Des Metropoliten Ilarion Lobrede auf Vladimir den Heiligen und Glaubensbekenntnis*, Wiesbaden, 1962; English translation in S. Franklin, *Sermons and Rhetoric of Kievan Rus'*, Cambridge, Mass., 1991, pp. 1-29; also **Повесть временных лет**, p. 81.

6 On threats and force see **Повесть временных лет**, p. 80 (=Cross, *Primary Chronicle*, p. 116); Müller, *Ilarion*, p. 105; Franklin, *Sermons and Rhetoric*, p. 19.

7 See A. Pope, *The Rise of Christian Russia*, London, 1982, IV.

8 Müller, *Ilarion*, p. 126; Franklin, *Sermons and Rhetoric*, p. 25.

9 *Das Paterikon des Kiever Höhenklosters, nach der Ausgabe von D. Abramovic*, ed. D. Tschizewskij, Munich, 1963; English translation by M. Heppell, *The 'Paterik' of the Kievan Caves Monastery*, Cambridge, Mass., 1989.

10 **Русская историческая библиотека** 6, p. 18.

11 On the range of Slavonic translations and their provenance, and on the sources of native writing, see the series of studies by F. J. Thomson in *Slavica Gandensia* 5, 1978, pp. 107-39; 10, 1983, pp. 65-102; 15, 1988, pp. 63-91.

12 On native writing see G. Podskalsky, *Christentum und theologische Literatur in der Kiever Rus (988-1237)*, Munich, 1982.

13 See C. Mango, *Byzantium: The Empire of New Rome*, London, 1980, pp. 147-8, 233-40.

14 See note 12 above; also D. S. Likhachev, 'The type and Character of the Byzantine Influence on Old Russian Literature,' *Oxford Slavonic Papers* n.s. 13, 1967, pp. 16-32; S. Franklin, 'The

Reception of Byzantine Culture by the Slavs,' *The 17th International Byzantine Congress: Major Papers*, New Rochelle, N.Y., 1986, pp. 382-97; I. Sevcenko, *Byzantium and the Slavs in Letters and Culture*, Cambridge, Mass. and Naples, 1991, pp. 107-150.

15 For a succinct survey see C. Mango, *Byzantine Architecture*, London, 2ed. 1986, pp. 180-91; in more detail A.I. Komech, **Древнерусское зодчество конца X-нацала XII в.: византийское наследие и становление самостоятельной традиции**, Moscow, 1987; A.L. Iakobson, **Закономерности в развитии средневековой архитектуры** IX - XV **вв.**, Leningrad, 1987, pp. 126-53.

16 On the 13th century see G. Vernadsky, *The Mongols and Russia*, New Haven, 1953; J. Fennell, *The Crisis of Medieval Russia, 1200-1304*, London, 1983. On Russian responses to the Mongols see C. Halperin, *The Tatar Yoke*, Columbus, Ohio, 1986. See also idem, *Russia and the Golden Horde: The Mongol Impact on Medieval Russian History*, Bloomington, Ind., 1985.

17 On Constantinopolitan diplomacy regarding the metropolitanate see J. Meyendorff, *Byzantium and the Rise of Russia*, Cambridge, 1981.

18 D.S. Likhachev, **Галицкая литературная традиция в Житии Александра Невского // Труды отдела древнерусской итературы** 5, 1947, pp. 36-56.

19 On the early versions see G. Lenhoff, *The Martyred Princes Boris and Gleb: A Socio-Cultural Study of the Cult and the Texts*, Columbus, Ohio, 1989; P. Hollingsworth, *The Hagiography of Kievan Rus'*, Cambridge, Mass., 1992, pp. 3-32, 97-134.

20 **Памятники литературы Древней Руси.** XIII

век, Moscow, 1981, p. 430.

The Legacy of Beauty
J. Meyendorff

1 **Повесть временных лет**, ed. D. S. Likhachev, Moscow and Leningrad, 1950, vol. 1, p. 75; trans. in S.H. Cross and O.P. Sherbowitz-Wetzor, *The Russian Primary Chronicle*, Cambridge, Mass., 1953, p. 198.

2 Osip Mandelshtam, **О поезии**, Leningrad, 1928, p. 32, 38; quoted in S.S. Averintsev, 'Die byzantinische Erbe der Rus' und seine Wirkung auf das russische Sprachfuhl,' in *Tausend Jahre Christentum in Russland*, ed. Wolfgang Heller, Göttingen, 1988, p. 107-8.

3 See A. Chekhov's short story **Святою ночью** (Easter Night), commented by S.S. Averintsev, op. cit., p. 105.

4 Reprinted Paris, 1965; English translation *Icons: Theology in Color*, with an introduction by G. M.A. Hanfmann, Crestwood, N.Y., 1973.

5 Jaroslav Pelikan, *Imagio Dei: The Byzantine Apologia for Icons* (The A. W. Mellon Lectures in the Fine Arts, 1987), Princeton, 1990, p. 11.

The Schools of Medieval Russian Painting
Engelina Smirnova

1 V.N. Lazarev, **Русская средиевековая живопись**, Moscow, 1970, p. 300.

Note
In transliterating Russian names and terms, the Library of Congress system has been followed, except for soft and hard signs and the diaeresis on ё, which are omitted. Specialists will be familiar with the original, while general readers are not likely to be helped by the presence of diacritical markings. In an effort to avoid confusion, names are often given in a form already familiar in English, even if this leads to some inconsistency.

Glossary

Akathistos (Gk. lit. 'not-sitting') a *kontakion* sung in honor of the Mother of God while the congregation stands.

archimandrite a monk with authority over a monastery or a group of monasteries.

assist golden highlights applied to a painted panel after the tempera.

basma strips of metal, usually silver or silver-gilt, applied to the surface of an icon.

boyar a member of the higher aristocracy in medieval Russia.

chiton a tunic, the basic garment during the Byzantine period.

ciborium dome supported by four or six columns symbolizing the tomb of Christ.

Deesis an image of intercession in which the Mother of God and St. John the Baptist stand on either side of Christ, often with additional saints and archangels.

Dormition the 'falling asleep' of the Mother of God, known in the West as 'the Assumption'.

Eleousa (Gk. 'merciful') an image of the Mother of God bending her cheek to touch the cheek of the infant Christ.

Emmanuel an image of Christ depicted as the pre-existent Word of God, represented as a beardless youth with a high forehead and curly hair.

enkolpion (Gk. lit. 'on the breast') an object worn about the neck.

Haghia Sophia (Gk. 'the Divine Wisdom') St. Sophia, the name of numerous churches in the Byzantine world, including Constantinople, Kiev, and Novgorod.

hesychasm (from Gk. *hesychia* 'silence') a method of contemplative mysticism involving physical techniques of posture and breath control.

hieromonk a monk who has been ordained as priest.

himation an outer garment worn over the chiton.

Hodegetria (Gk. 'showing the way') an image of the Mother of God holding the infant Christ on her left arm and gesturing toward him with her right hand, indicating that he is the way of salvation.

icon (Gk. 'image') a term often applied to panel paintings, but in fact indicating an image of sacred persons or events in any medium.

iconoclast (Gk. 'destroyer of images') one opposed to the veneration of icons, especially during the Iconoclastic Controversy of the 8th-9th centuries.

iconodule, iconophile (Gk. 'servant of images,' 'lover of images') one who venerates icons, an opponent of the iconoclasts.

iconostasis a screen separating the sanctuary from the nave, and displaying tiers of icons.

kiot a niche for icons.

Komnenian Byzantine dynasty (1081-1185).

kontakion a sermon in verse consisting of an introduction followed by a number of stanza connected by a refrain.

kovcheg (lit. 'ark') the recessed central area of a panel painting.

kremlin the fortified citadel at the center of most medieval Russian cities.

kukol a hood worn as part of the monastic habit

loros a heavy stole decorated with precious stones and worn by Byzantine emperors and empresses.

Macedonian Byzantine dynasty (867-1056).

mandorla (Ital. 'almond') the conventional term for an aureole, often almond-shaped, which was placed around a figure to symbolize the presence of God.

mandylion an image of Christ 'not made with hands' originally taken on cloth as an impression of his features.

maphorion a cloak covering the head and shoulders, traditional attire of the Mother of God.

metropolitan the title given to the bishop of a capital, or the head of a church which was not self-governing (autocephalous).

oktoechos a set of hymns for each of the seven days of the week in eight musical modes, taking eight weeks to complete.

oklad a metal cover or revetment for an icon or book.

omophorion a band of cloth decorated with crosses and worn about the neck, characteristic garment of bishops.

orans (Lat. 'praying') a depiction of the early Christian posture for prayer, with the body upright, and the hands open and raised to shoulder height.

Palaiologan Byzantine dynasty (1259-1453).

Pantokrator (Gk. 'the all-sovereign') an image of Christ as a severe dark-bearded figure, holding a Gospel book in one hand and blessing with the other.

phelonion a vestment worn primarily by priests and bishops.

rhipidion a ceremonial fan carried during the liturgy.

sakkos a tunic worn by emperors and patriarchs, and later by metropolitans and bishops.

schema the habit worn by monks and nuns.

stylite an ascetic living on top of a pillar (Gk. *stylos*).

synaxarion a church calendar of fixed festivals with appropriate readings for each.

troparion the earliest form of Byzantine hymn; later used to refer to any stanza of a hymn.

tsar (from Lat. *Caesar*) the Russian term for the Byzantine emperor, and then for the Mongol khan; Ivan IV was the first of the Russian grand princes to be crowned formally as tsar, and the title was abolished by Peter the Great in favor of 'emperor'.

tsaritsa the consort of the tsar.

tsarevich the heir of the tsar.

Index

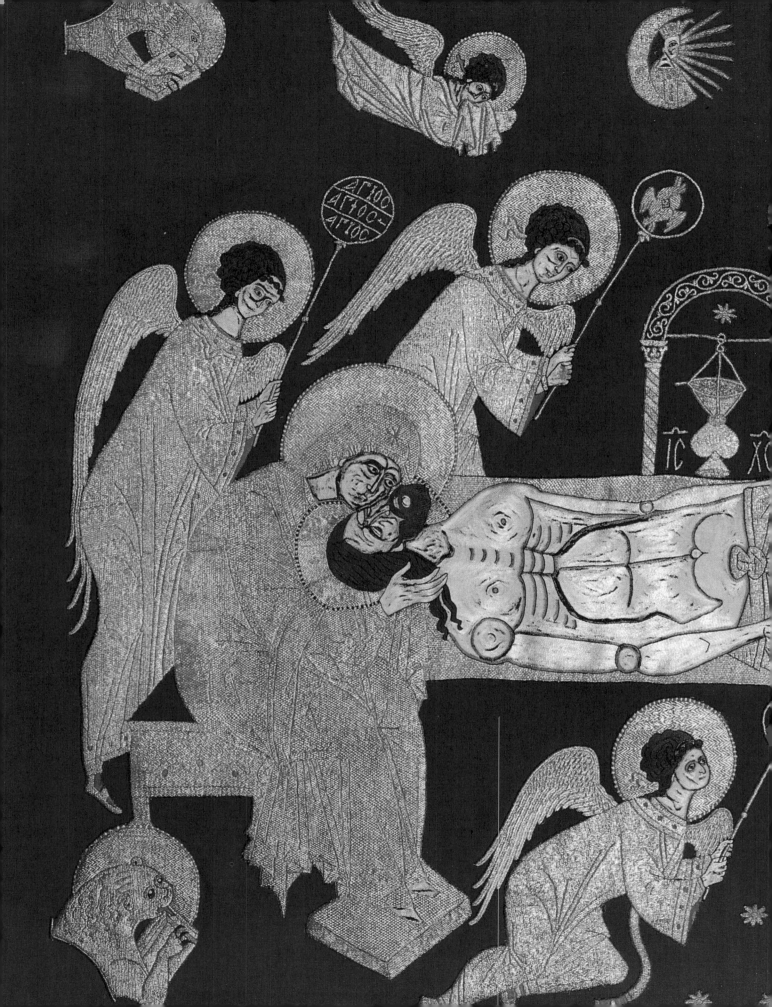